WaMu®

President's Club

Atlantis, Paradise Island, Bahamas
February 17-21, 2008

UNDERWATER EDEN
365 DAYS

For Asher Gal:

"Woe to him that is alone when he falls and has not another to lift him up."
Ecclesiastes 4:10

UNDERWATER EDEN

365 DAYS

▲ABRAMS JEFFREY L. ROTMAN

Introduction

I knew that nothing could adequately prepare me for the wonder that awaited me—not the stories I had heard, not the film on a giant screen, not even the expectation of surprise. Jittery with excitement and anticipation, I dove into the cold water. A great white shark—or "Mister Big," as I called them—was out there! I had always been aware of his presence even when he wasn't in sight. I couldn't wait to see him surge out of the depths and appear before me in the flesh. I was certain that I had fully prepared myself for his arrival: a spare camera battery was hanging inside the steel cage with me, there was plenty of air in the tanks, and copious blood poured onto the surface of the water to lure him in to me. We had been at this for ten days, when he finally, miraculously appeared—a blurry gray stain stealing its way through the sun's rays. I saw the slightly open jaws of the great white.

It wasn't until later, when I was back in the boat, that I began to piece together that first encounter. Yet he had come so close at such high speed that I might as well have been reconstructing the path of a flash of lightning. And when I finally realized that the film in my camera was blank, I tried to rationalize why I, a professional photographer, who had been waiting and planning for this very event with such great care and enormous investment, why I had failed to take a single shot. Looking back, I understood that being in the presence of such power so stunned me that it erased my very purpose and literally made me forget my mission.

At our second meeting, I managed to atone for my professional failings. Ironically, the paralysis that gripped me on that first occasion ultimately became the essence of my success. Even after 34 years of underwater photography, I still have that child-like wonder and enthusiasm that first overwhelmed me the moment I discovered the world beneath the seas. It is that passion that has transformed my initial casual interest in underwater photography into a full-blown career and a way of life. Much has changed with the passing of the years: The equipment is far more sophisticated, the competition more fierce, the horizons have expanded to encompass the entire globe, and, by the bye, my diving suit has expanded a few sizes as well. Throughout all those years, one consistent thread has held it all together: my excitement at the beginning of every photographic assignment and at the end of each, the rich taste and deep thirst that fill me until the next dive.

A long time ago, there was a first dive, the very first time I was exposed to this new world. It was a brisk morning at Marblehead, Massachusetts, when a good friend pulled me into the cold ocean waters to show me how to free dive. As I entered the water, it was my initial instinct to keep the air in my lungs—what a strange sensation to learn how to breathe underwater! I'm

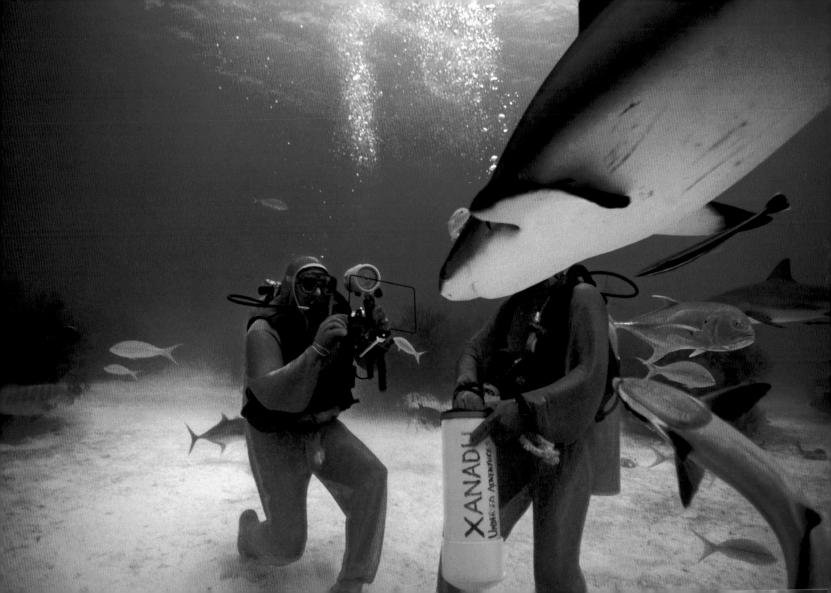

convinced that only an astronaut can relate to this feeling, can understand the true meaning of "alien world." I think it was this first encounter with the wild and free that stirred in me the urge to hunt. The silence surrounding me and my movements in foreign territory—their territory—allowed me to get within touching distance of my "prey." All it took was to paralyze it with a single flash "shot" and I had it on film. The sight of those first developed pictures awoke in me the desire to pursue this ritual of stalking prey to photograph it.

Right around this time, my attention was drawn, as tends to happen to those who tune in to the right chords, to an announcement that Jacques Cousteau was coming to town. His lecture at Harvard University only added fuel to the flame. Afterward, I plucked up enough courage to ask him what, in his opinion, was the most beautiful diving site in the world. Shortly thereafter, I packed a small backpack, boarded a plane, and flew to the Red Sea. During the next two months I dove day and night, in what many consider the richest coral sea on our planet. I had never seen the likes of this underwater paradise, except perhaps in my dreams. Back then, the sharks, turtles, and giant manta rays in these waters had little fear of divers, their curiosity often winning out over apprehension. The reefs then were so thick with dense clouds of fish, the corals so rich and varied, you could literally lose yourself in them.

During that first trip, while I was on a dive, I would keep my dozens of rolls of film in a special bag in a tent I had set up on the beach. I didn't want to develop them until the expedition was over. One night, while I was in the water, someone stole every last roll, together with some other worthless items such as my passport, money, clothes, cameras, and even the tent itself. I was devastated, but in hindsight, this event could very well have been the deciding factor in my choice of future profession. More determined than ever, I went back to those same waters to photograph in them again, muttering all the way: "Someone is going to pay for this."

The harvest gathered from that second attempt was published in magazines around the world. One thing led to another, and I found myself being flown around the world on photographic assignments for a variety of magazines. I met so many amazing people on those shoots, among them Joe Levine, a PhD in marine biology, and Mary Cerullo, both experts and single-minded enthusiasts about marine life, with whom I have written a number of books about undersea life. They broadened my horizons and helped me see that world through a different set of spectacles. They helped me to see that changes in the marine and shore environments that I had witnessed, along with the rapid deterioration in the quality of those environments, had been caused by

humans. This understanding totally changed my attitude toward my profession and charged me with a sense of mission.

But I didn't begin to see it until I fell in love with sharks. It's mildly embarrassing to admit, but my romance with sharks began in a movie theater. Like many other good men and true, I could not resist getting caught up in the shark phobia that developed in the wake of the film *Jaws*. Every time I entered the water, I could hear that music in the back of my mind, keeping tempo with every motion. I was well aware of the enormous gap between fear and reality, but my imagination often got the best of me. Perhaps it was the tension in this polarity that changed my interest in sharks into something closer to an obsession. As time passed, fear slowly turned to reverence for these primeval creatures and from that point on, it became a love story.

Over the years, while observing sharks around the globe, I have witnessed the development of widespread interest in these marine animals, but also how economic interests have turned them into valuable commodities. They became a prime hunting target when shark-fin soup became much in demand, and special fishing fleets were built to hunt them down. In many places around the world, this fishing has become a cruel, indiscriminate hunt; hundreds of thousands of sharks are killed just for their fins, which are sold in Asian markets. The super-predator great white is now facing extinction, also at the hands of man.

The plight these creatures now face is a reflection of the status of the marine environment as a whole: impoverishment of a wide range of species created by pollution and uncontrolled fishing. When I return to photograph places visited years before, I see with great sorrow that they are slowly fading and even disappearing before my eyes.

The images in this book present nature's handiwork—all I have done is capture it in the camera lens. But if, through these pictures, I succeed in inspiring someone, anyone, with the same love that has fueled me and my work, I will be content with this, my modest contribution. Perhaps that love, encouraged by these pages, will help return a small drop of life to the oceans.

1

Coral atoll, Palau Islands, Micronesia

Viewed from a distance, coral reefs are among the most awe-inspiring creations of life on earth. The magnitude of the reef structure that forms the Palau Islands is almost inconceivable, formed by 425 species of coral. Tragically, global warming and increased levels of carbon dioxide in the atmosphere and oceans are raising sea temperatures and bleaching corals, killing off entire reef systems. Some environmental organizations are experimenting with ways to counteract this destruction by accelerating coral growth using low-voltage electrical currents.

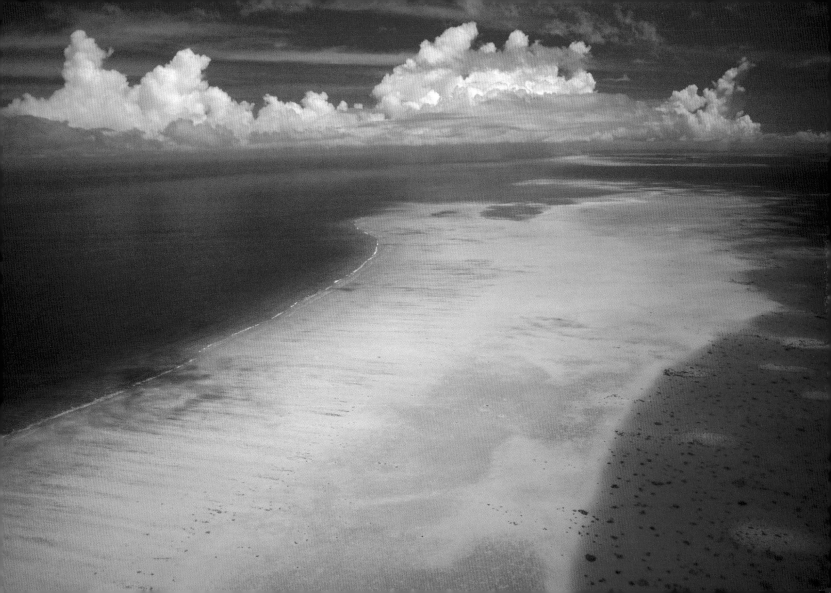

2

Sandy lagoon, Jackson Reef, Sinai Peninsula, Egypt

I have been diving in this sandy lagoon for more than thirty years. In fact, it's where I taught two of my children to dive. The wreck of a freighter on the northern end of the reef provides the perfect playground for dozens of species of reef fish. Although thousands of divers visit this site each year, rich nutrients carried on strong currents feed the reef, keeping it in pristine shape.

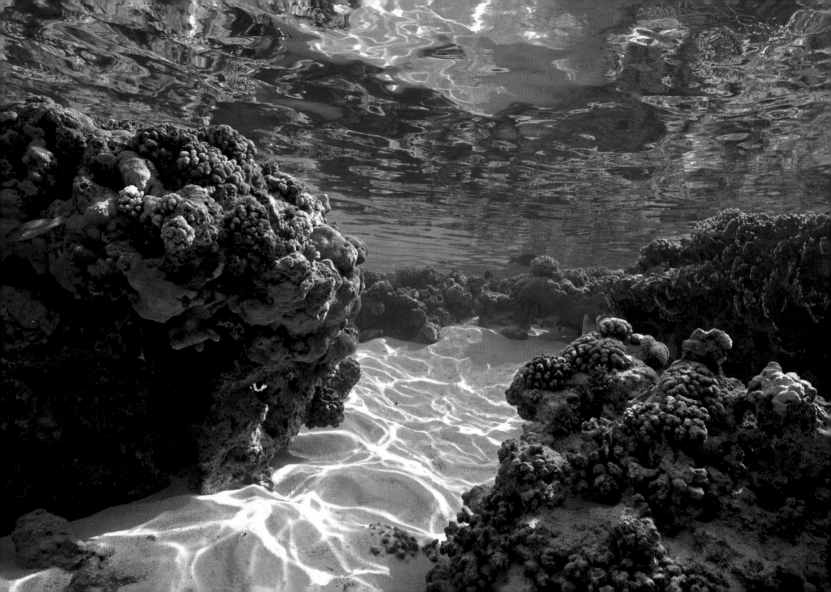

3

Late afternoon light, Moses Rock, Eilat, Israel

At the end of the day, this is the calm before the storm. In a half hour, this peaceful underwater scene will be transformed into a feeding frenzy that is a textbook example of the food chain at work. Soon, large predatory fish, like sharks and jacks, will hunt schools of small baitfish, prowling for their own dinner. This might not be the case for long, however. In 2003, scientists announced that industrial fishing has reduced the number of large predatory fish to an alarming 10 percent of the ocean's 1950 population.

4

Shallow cave, Ras Nas Rani, Sinai Peninsula, Egypt

Shallow caves are a common feature among Red Sea reefs. The absence of direct sunlight, the relative quiet, and the protected location make caves a safe sanctuary for shy or delicate life not found elsewhere on the reef. Many cave-dwelling species have uniquely evolved in accordance with their environment.

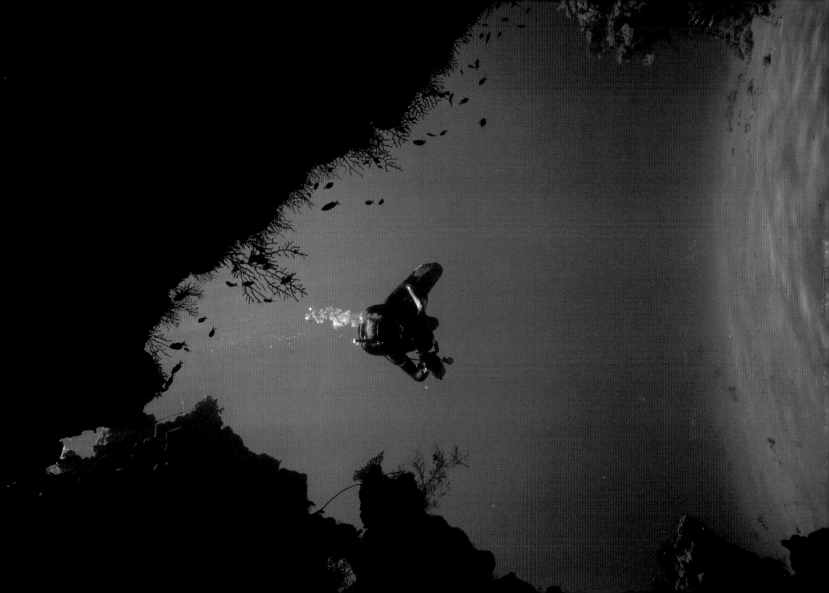

5

Shallow cave, Ras Mohammed, Sinai Peninsula, Egypt

Ras Mohammed, an Egyptian national park off the southern tip of the Sinai Peninsula, has a reputation as one of the most popular diving destinations in the world. The peninsula is a 75,000-year-old fossil coral reef surrounded by reef tables. Nearly one thousand species of fish dart in and among the underwater plateaus and caves. For divers, the light in caves like this one, with an opening through the reef table, can be almost magical.

6

Giant sea fan, Ras Mohammed, Sinai Peninsula, Egypt

This giant sea fan, easily more than one hundred years old, grows out from a prime piece of reef real estate about eighty feet down, along the shelf's drop-off. As a sea fan grows taller and wider, it turns to face the current perpendicularly, so that it will be constantly bathed in the rich flow of nutrients. Tiny polyps on the fan's branches extract food from the current.

7

Scalefin anthias, Ras Nas Rani, Sinai Peninsula, Egypt
Nibbling at bits of floating plankton, a territorial school of scalefin anthias is a common sight on Red Sea reefs. These fish are all born female, but at a later point in life, a lucky few change sex to become "super males" responsible for breeding with the rest of the school.

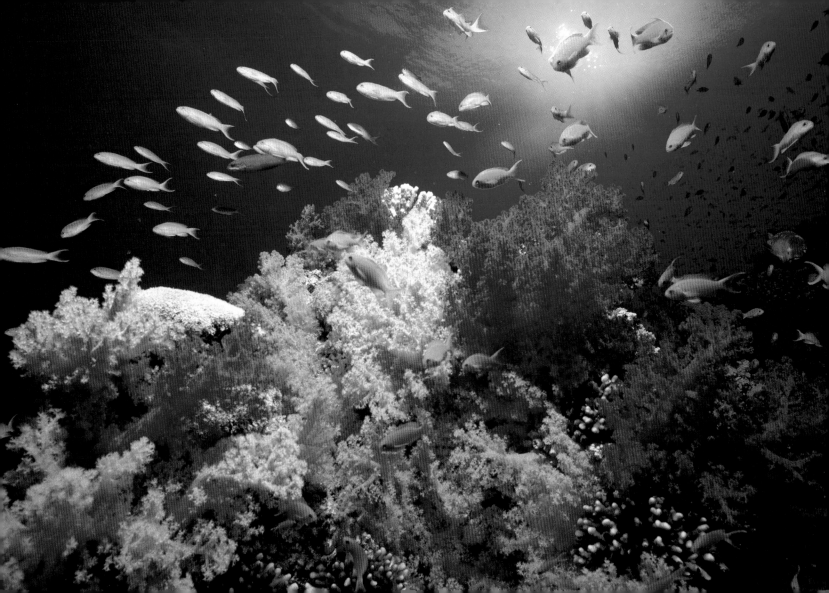

8

Pacific cownose rays, Targus Cove, Gálapagos Islands, Ecuador

Some fish seek safety in numbers, schooling being a defense mechanism. A school of cownose rays in flight formation was my reward for entering the sea at sunrise on this day. Sunrise and sunset are "changeover periods" for many species, a time when the ocean explodes with activity. They are times for feeding—or for the unlucky, times to be fed upon. They are also some of the best times of day for taking photographs.

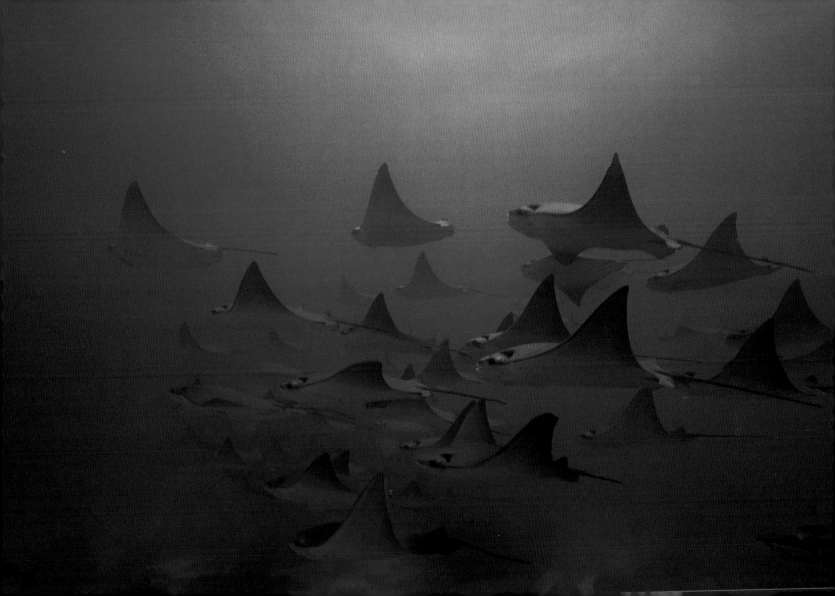

9

Eye of Garibaldi, San Clemente Island, California

A black eye peering out from a bright orange background is a common sight when diving in the dark kelp forests off Southern California's San Clemente Island. Legend has it that the flame-colored garibaldi fish got its name from Giuseppe Garibaldi, an Italian military hero whose men wore similarly colored red-orange shirts. A popular species for tropical aquariums because of its electric color, the garibaldi has enjoyed protection from collectors and spear fishermen since California named it the state marine fish in 1995.

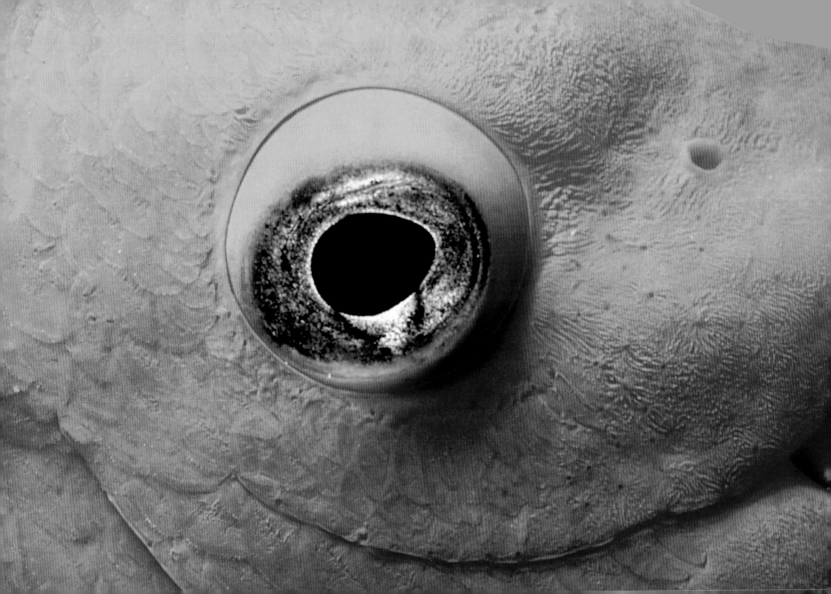

Garibaldi, San Clemente Island, California

The garibaldi is one of few fish to use the same nesting site year after year. Males are particularly territorial. After preparing his selected "home" site, by clearing it of unwanted organisms and algae, a male garibaldi will lure a female to deposit her eggs, which he then guards. A diver or snorkeler who wanders upon a nest can expect to be approached by the (harmless) male, who will emit an audible thumping sound to scare off the intruder.

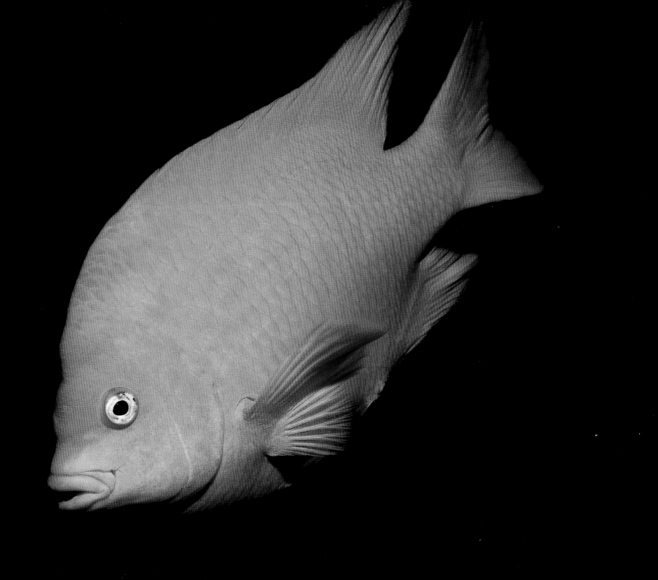

11

Garibaldi, Santa Catalina Island, California

The pectoral fin helps to position the garibaldi as it picks for prey hidden in the recesses of the kelp forest. Besides propelling them, fins keep fish from swimming in circles. Pectoral fins, on the sides of a fish's body, help it hover and lift vertically, like the wings of a plane. Dorsal fins, on the back, and caudal fins, at the tail, act as a keel and keep the fish from rolling or veering off course.

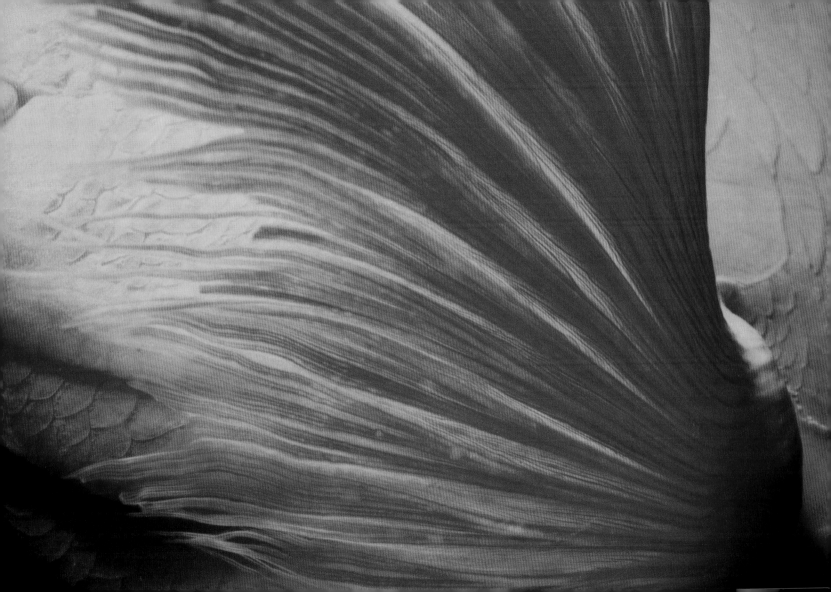

12

Garibaldi, Santa Catalina Island, California

Scientists are able to estimate the age of some fish by looking closely at their scales. As a fish with ctenoid or cycloid scales grows, so do its scales. At different times of year, and in different water temperatures, the scales grow faster or slower. This growth pattern creates visible rings on the scale, called annuli, much like the rings of a tree trunk. By counting them, a biologist can tell how many years a fish has lived.

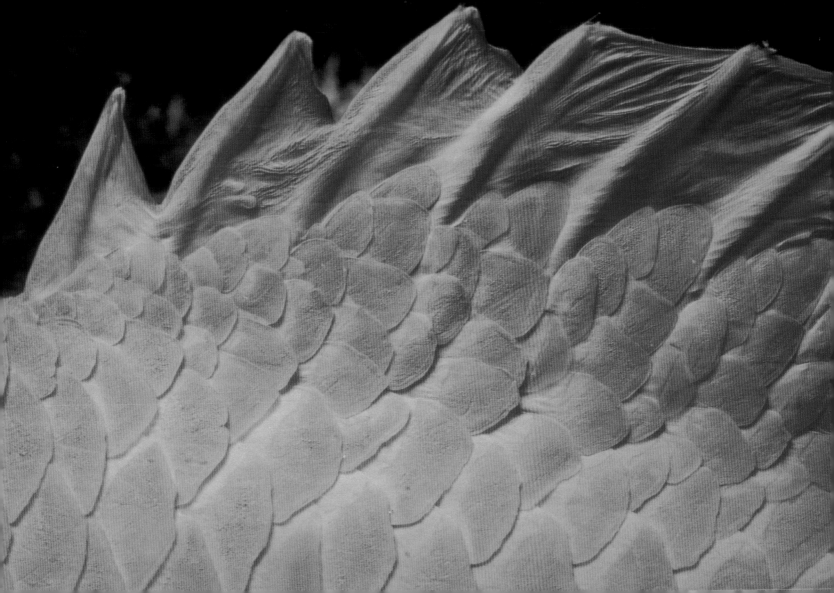

13

Garibaldi, Santa Catalina Island, California

Most bony fish secrete a layer of mucus over their scales to protect from infection and keep them "waterproof." Scientists have discovered that this mucus contains chemical compounds equivalent to sunscreen with SPF 15 for humans. Handling a fish, however, can wipe away the mucus and endanger the fish, so it's best to look but not touch.

14

False clownfish and magnificent sea anemone, Walindi Bay, Papua New Guinea
Here is a textbook case of symbiosis. The clownfish, covered in a special protective mucus, seeks protection from potential predators in the otherwise poisonous tentacles of a sea anemone. In return, the clownfish maintains the health of the anemone by picking it clean of parasites. Such mutually beneficial relationships are common in the ocean and can lead to some pretty unlikely and interesting friendships between species.

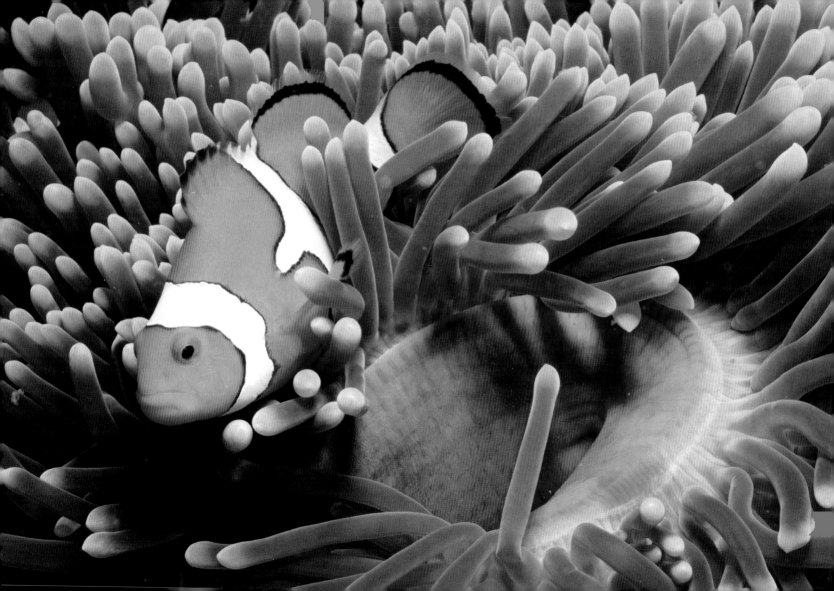

15

Magnificent sea anemone, Sipadan Island, Borneo

The tentacles of this anemone sway gently back and forth in the current. Such beauty hides the fact that the tentacles are covered with poisonous, microscopic organelles called nematocysts, or stinging cells, that will quickly paralyze any small fish careless enough to brush up against them. Most fish seem to inherently know this and give the anemone a wide berth while swimming past.

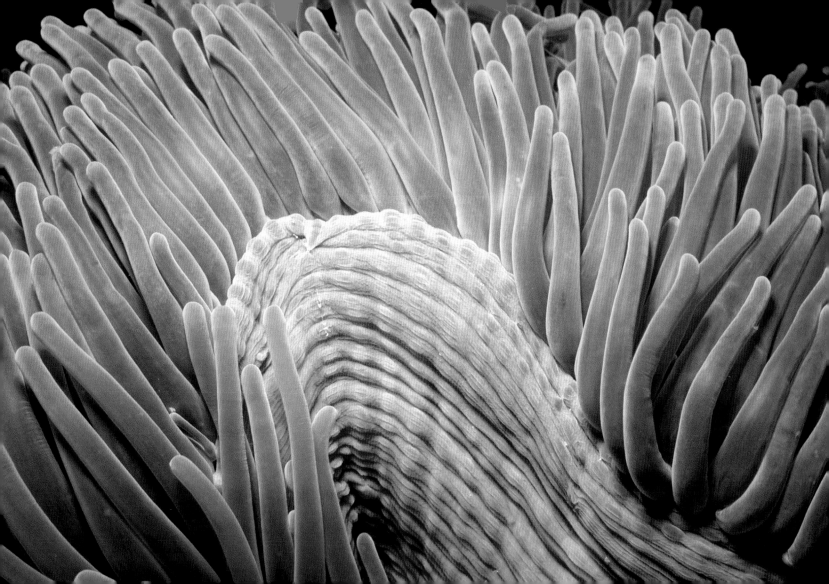

16

Cup coral, Ras Umm Sid, Sinai Peninsula, Egypt

To the inexperienced diver, coral may look like a rock, but it's really an animal that secretes limestone in order to build a hard external shell. At night, under the protection of darkness, this tiny cup coral explodes into a burst of orange, stinging and paralyzing the plankton it feeds on. At the approach of danger, it will immediately retract into its stony exoskeleton for protection.

Cup corals, Ras Abu Galoum, Sinai Peninsula, Egypt

Cup corals are solitary polyps, as opposed to the colonial corals that build reefs, but as this wall virtually blanketed with them suggests, solitary polyps may still reproduce and congregate in one place. Corals reproduce sexually, releasing eggs and sperm into the water, where the fertilized zygotes will mature free-floating until settling on a solid surface. Colonial polyps can reproduce asexually as well—not nearly as romantic.

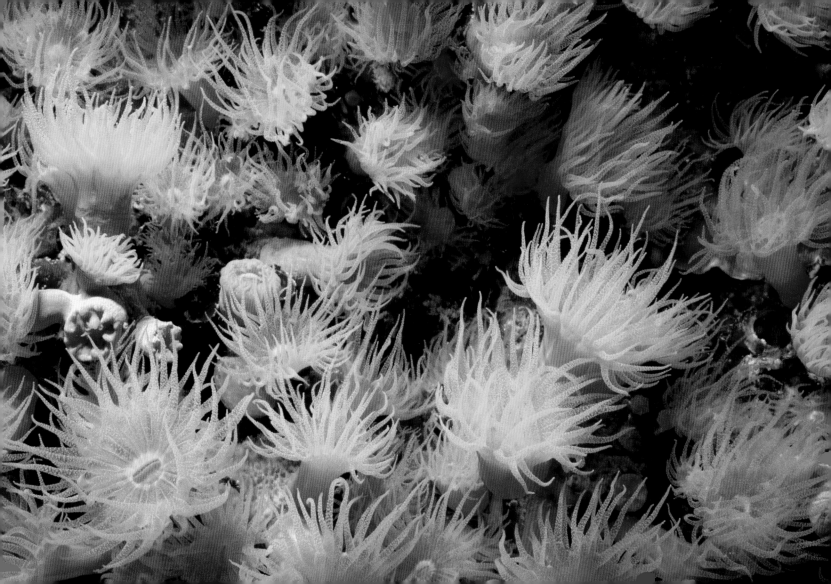

18

Knotty gorgonian coral, Palau Islands, Micronesia
Skeletal, treelike gorgonian corals are striking even by day, but they reveal their full beauty at night, when the polyps on their branches open and feed. Known as octocorals, each polyp has eight tiny, feathered tentacles that catch plankton in the passing current. The appearance is of an underwater tree in bloom.

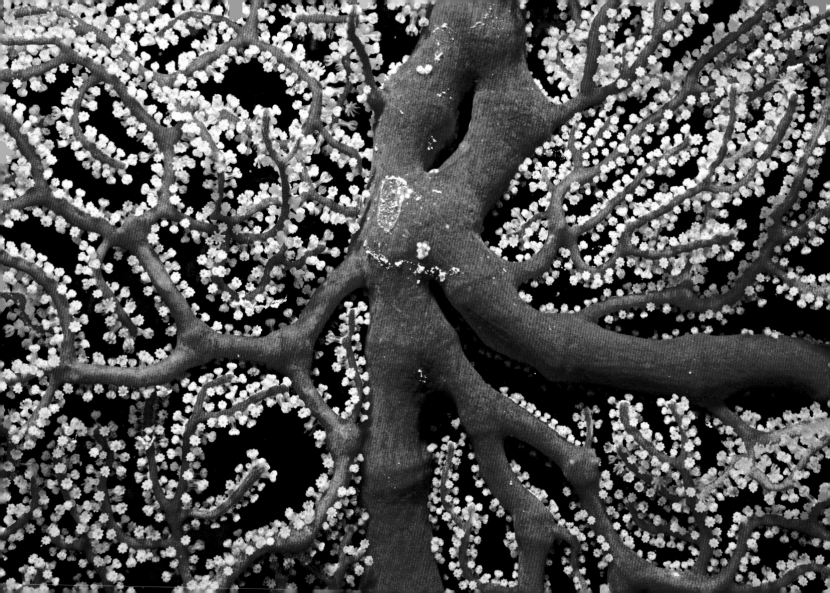

19

Mushroom coral, Palau Islands, Micronesia

This is a giant individual coral polyp, measuring four inches across, which is considered quite humongous in the world of coral. The gill-like skeletal walls on the disc-shaped polyp resemble the underside of a mushroom cap, giving the species its name: fungia. Mushroom corals are actually mobile, traveling across the ocean floor on tidal currents, and even have the ability to flip themselves over if upturned.

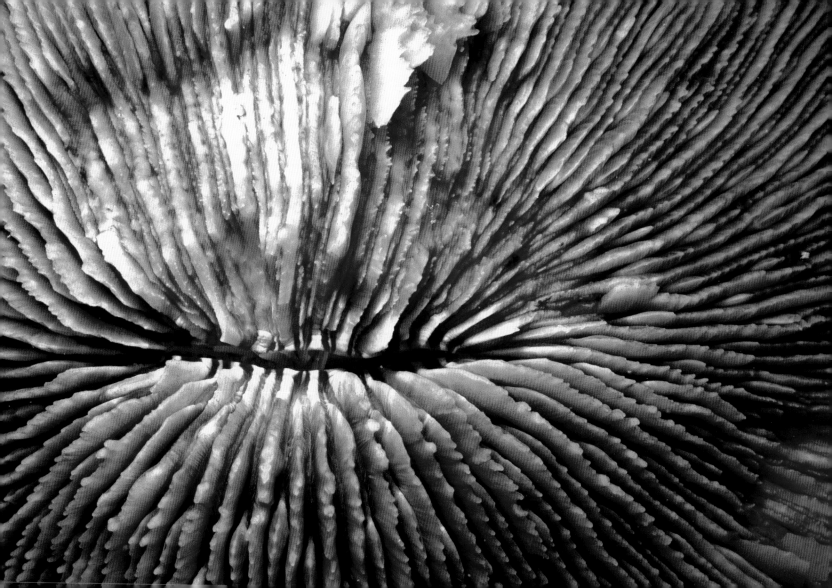

Brittle star, Sipadan Island, Borneo

In the protection offered by night, a delicate brittle star (also called a serpent star due to its five snakelike arms) scuttles across an alcyonarian coral in its quest for a meal. These spiny sea stars are scavengers that feed on the organic detritus they find when out foraging. Daytime, which offers no protection, finds this animal hidden in the cracks or crevices of the reef.

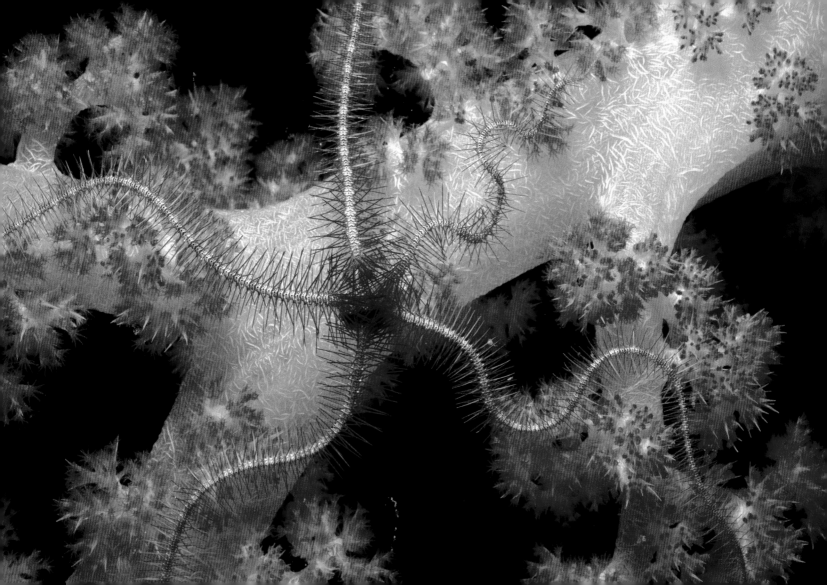

21

Crinoid, Walindi Bay, Papua New Guinea

This crinoid, photographed from below, is a striking and unusual relative of the more familiar starfish and sea urchins. Crinoids have two kinds of arms in multiples of five. The smaller, more ropelike arms visible in this photo are used for "walking" over or grasping onto coral formations. Featherlike arms collect organic particles in the current.

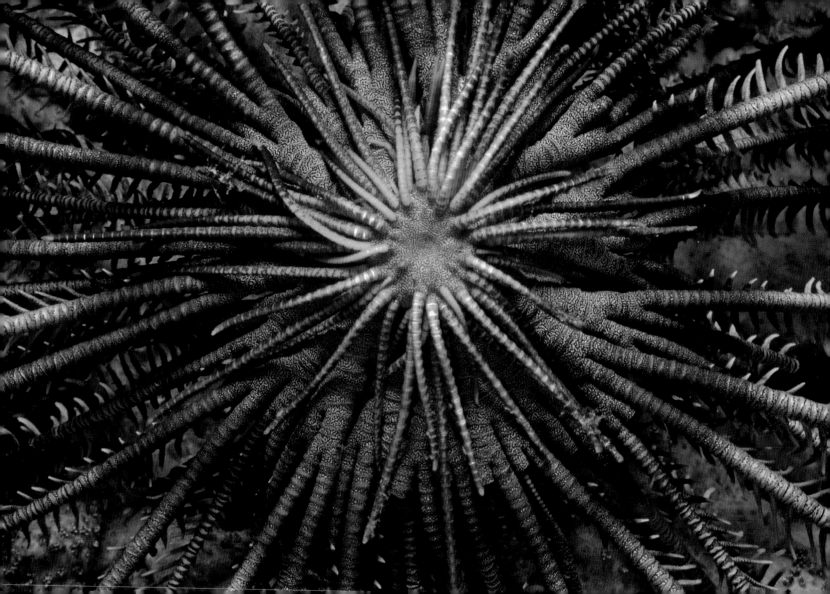

22

Green-eyed hermit crab, Ras Umm Sid, Sinai Peninsula, Egypt

Perched on a branch of fire coral, this green-eyed hermit crab seems to be surveying its kingdom. The photograph was taken at night, but hermit crabs are active around the clock. Always in search of a meal, they scavenge the bottom in search of worms, plankton, and decaying matter. Almost nothing is turned down as a hermit crab tries to satisfy its seemingly insatiable appetite. They're the Hoovers of the ocean floor.

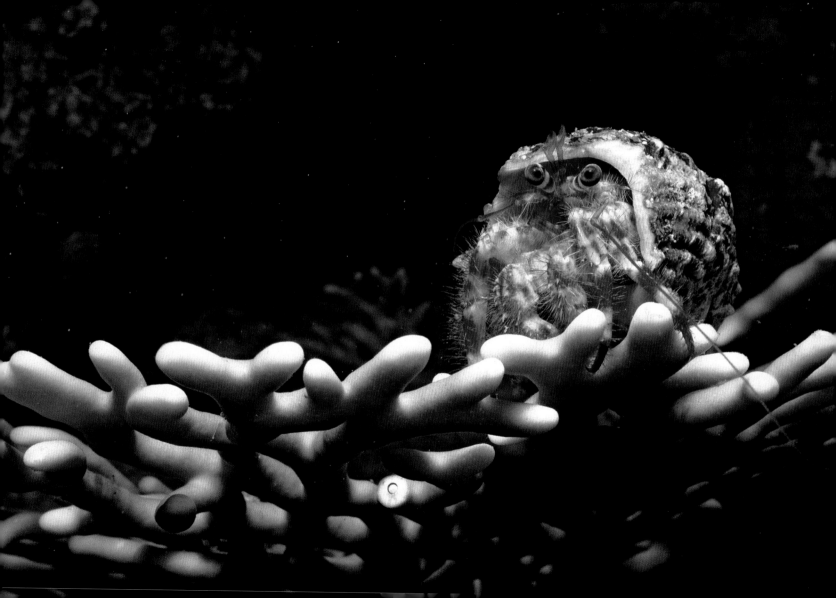

Crown-of-thorns starfish, Ras Umm Sid, Sinai Peninsula, Egypt

Sharp spines cover the nearly twenty arms of the crown-of-thorns, making it far less appetizing than other sea stars. A spine prick is followed by the release of a toxic venom, lethal to marine animals and painful to humans. Still, starfish can lose arms to predators or even to stress; luckily, for them, the arms grow back over time.

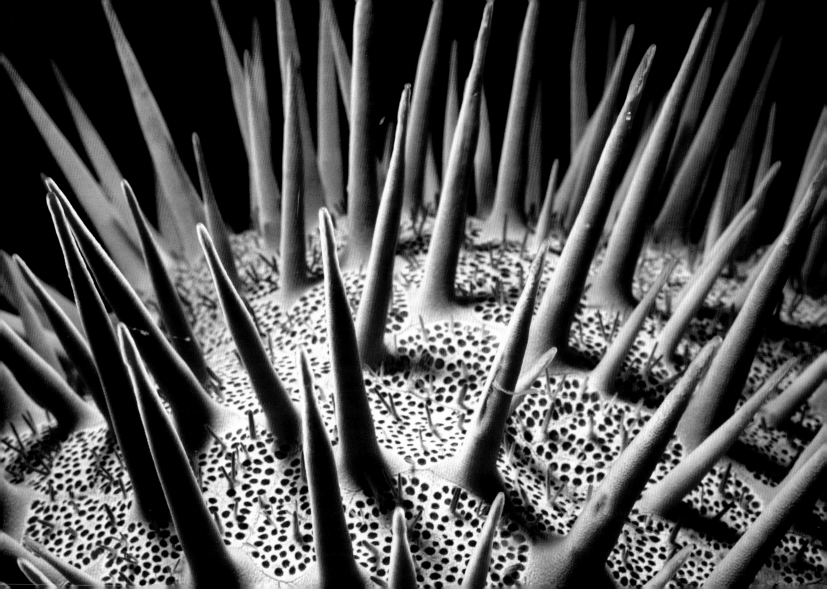

24

Pink clownfish in magnificent sea anemone, Palau Islands, Micronesia

This clownfish peeks out from the embrace of its symbiotic protector, the anemone. Fish have specially shaped spherical lenses in their eyes that are able to correct for refraction of light in water. Whereas the lenses of humans stretch to focus, those of fish lack the necessary muscles. Instead, their lenses move forward or backward to view objects near or far, like the lens of a camera. And because their eyes are often placed so far apart, on opposite sides of the body, their vision is "monocular," meaning each eye sees a different view.

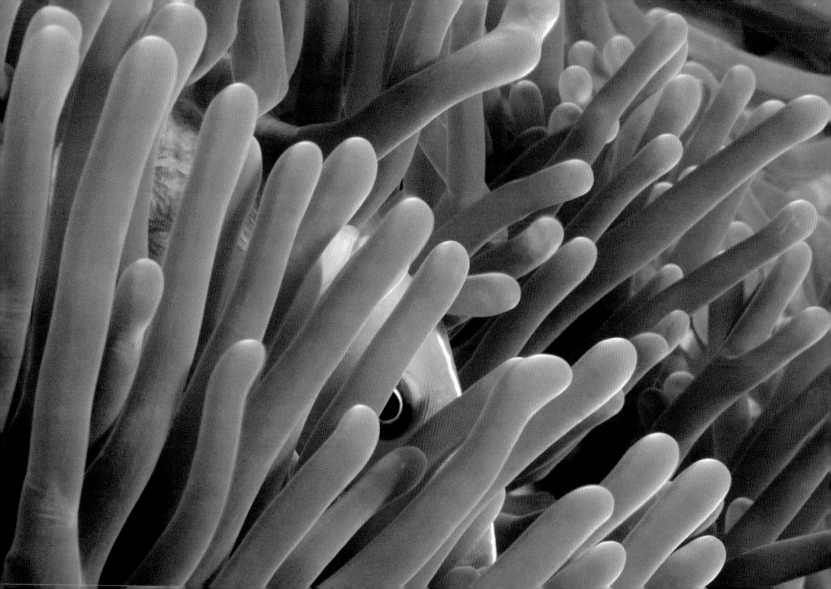

Longnose hawkfish, Sipadan Island, Borneo

The longnose hawkfish is difficult to photograph because it becomes very skittish when approached by a diver. However, after this fish gorges itself on shrimp and other small crustaceans in the late afternoon, it will go take a rest in the branches of a gorgonian sea fan, where it will relax sleepily while it digests its meal. It was at that time, just before sunset, that I was able to capture this on film.

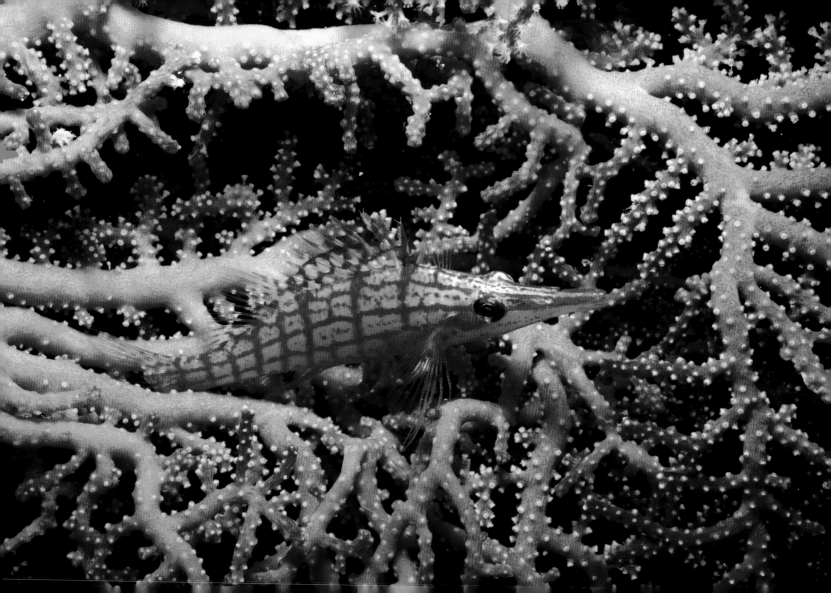

Spiny dogfish, Hodgkins Cove, Gloucester, Massachusetts

This rare photograph shows a newborn spiny dogfish with its yolk sac still attached. Normally, by the time this baby shark emerges from its mother, this internal food supply will have been absorbed. Spiny dogfish have a gestation period of almost two years and are born in litters of two to sixteen. It is possible this fetus was spontaneously aborted with its brothers and sisters when its mother was netted by fishermen.

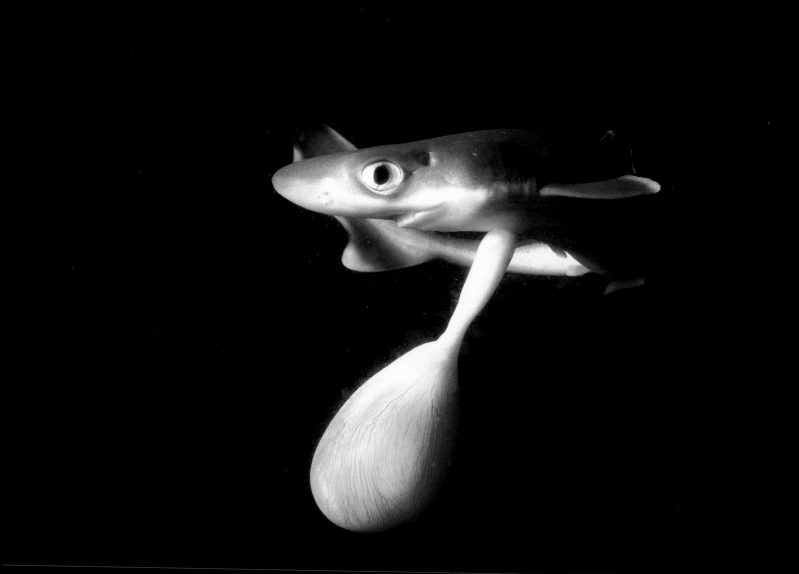

Little skate, Folly Cove, Gloucester, Massachusetts

During the spring months, skates such as this one pepper the bays and coves of coastal New England. A close relative of both sharks and rays, skates have a skeleton made of cartilage rather than bone. Their hallmark "wings" let them gracefully float along the ocean floor, scouring for mollusks and crustaceans to prey on. I have seen the bottoms of coves entirely covered with these remarkable creatures.

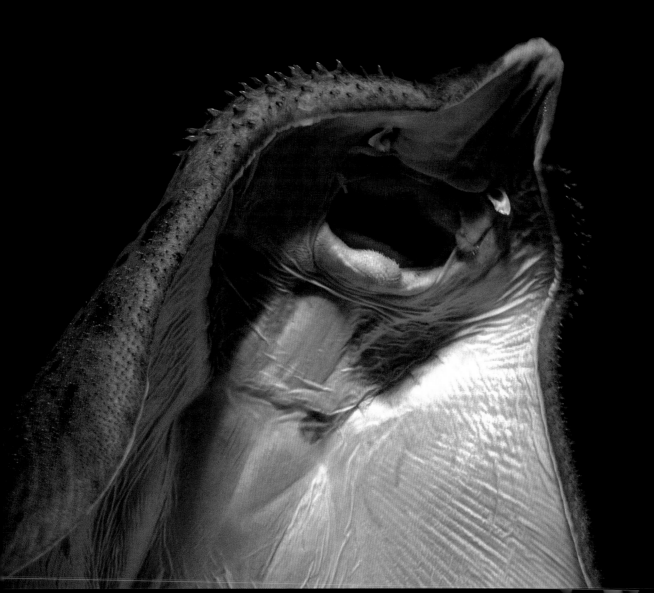

28

Blue-spotted ribbontail stingray, Perth, Australia

This juvenile stingray was about the size of a typical breakfast pancake. For me, it encapsulates the beauty of its species. This one was a grayish brown with light blue spots that looked electric under the strobe light. Ray "pups" are born fully formed in litters. Just like humans, newborns have almost flawless skin. But, also like humans, with years of aging come the scars of survival.

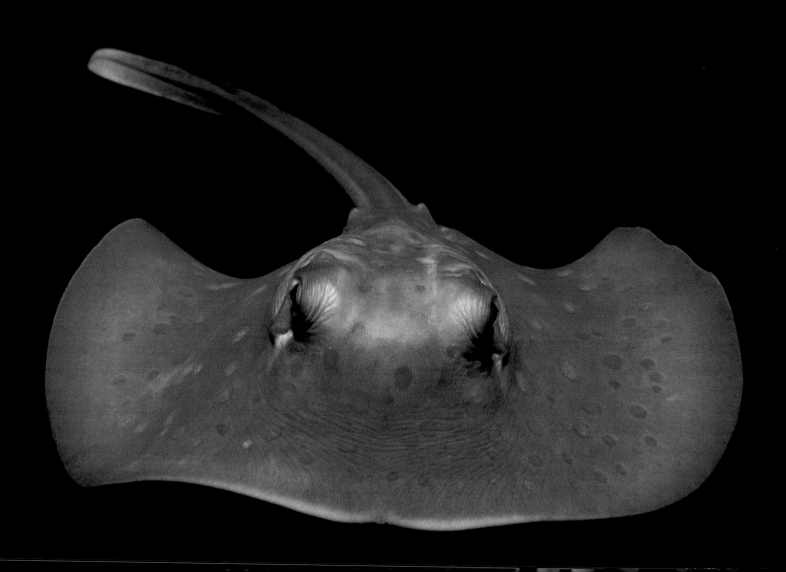

Spider crab, Ras Umm Sid, Sinai Peninsula, Egypt

This spider crab would quickly become lunch if it surfaced in daylight, but under the cover of darkness it emerges from its home, a crack in the reef, and scavenges for organic leftovers on this alcyonarian coral. Not every species of spider crab is so delicate, however. The largest, the Japanese spider crab, can measure up to eleven feet from claw to claw.

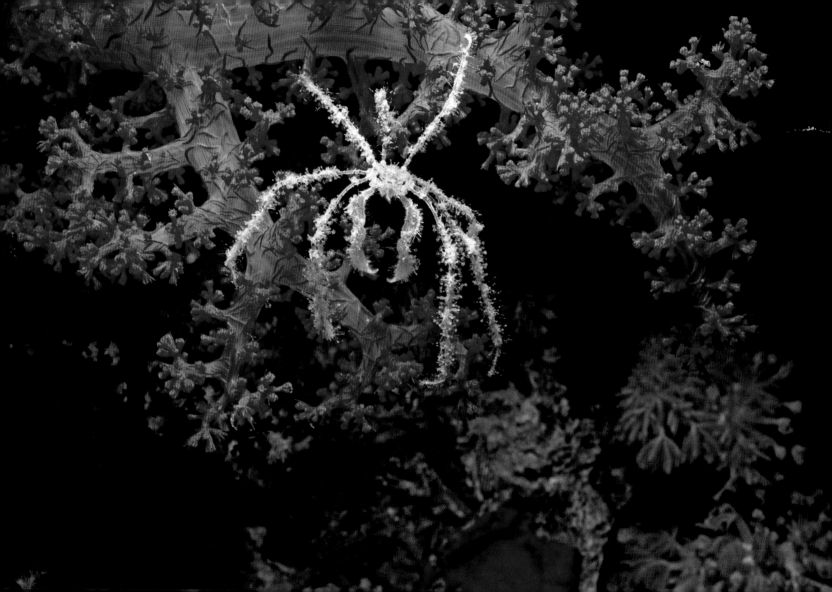

Reef octopus, Moses Rock, Eilat, Israel

If an octopus can't escape a predator, camouflage may protect it. An octopus's skin can become smooth or pebbly, depending on the texture of its background, and for an animal that can't see colors, the octopus has a surprisingly acute color sense. Tiny sacs in the skin lighten or darken to create a range of shades and patterns that mimic the animal's backdrop. Chromatophores, the color cells in its skin, contract into small dots, revealing a lighter underlying layer of cells called leucophores. When the chromatophores expand, the octopus appears to regain its color. When not excited, they're light to dark reddish brown in color.

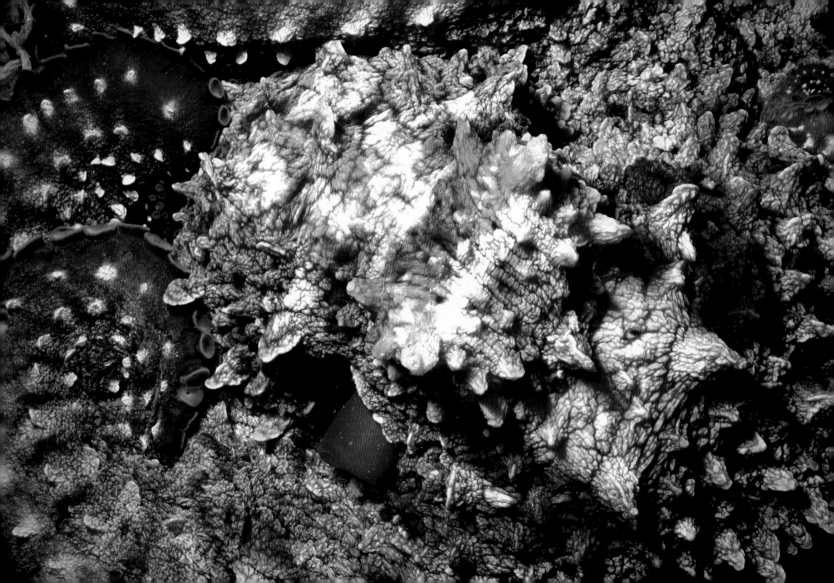

31

Snubnose chub, Jackson Reef, Sinai Peninsula, Egypt

In the early morning or late afternoon, I could always count on finding this snubnose chub at the same spot on Jackson Reef. He would just hang there, at a forty-five-degree angle. Sometimes he would appear with a few friends, other times alone, but I always knew it was him because of the scar on his tail.

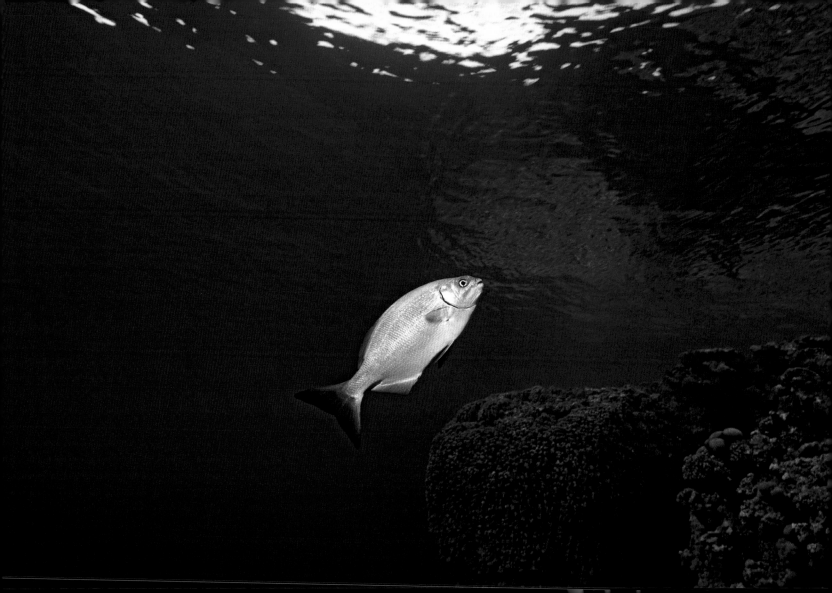

Humphead wrasse with attached remora, Ras Nas Rani, Sinai Peninsula, Egypt
A humphead wrasse can get rather large, sometimes approaching close to 440 pounds. Despite its size, it's a wary fish, and for good reason: In the Indo-Pacific, the humphead wrasse has historically been considered a "royal" fish and still fetches an unusually high price at market. It has been listed by the World Conservation Union as endangered. This fellow, however, was a fearless exception. Perhaps accustomed to divers, he allowed my wife, Isabelle, to get close.

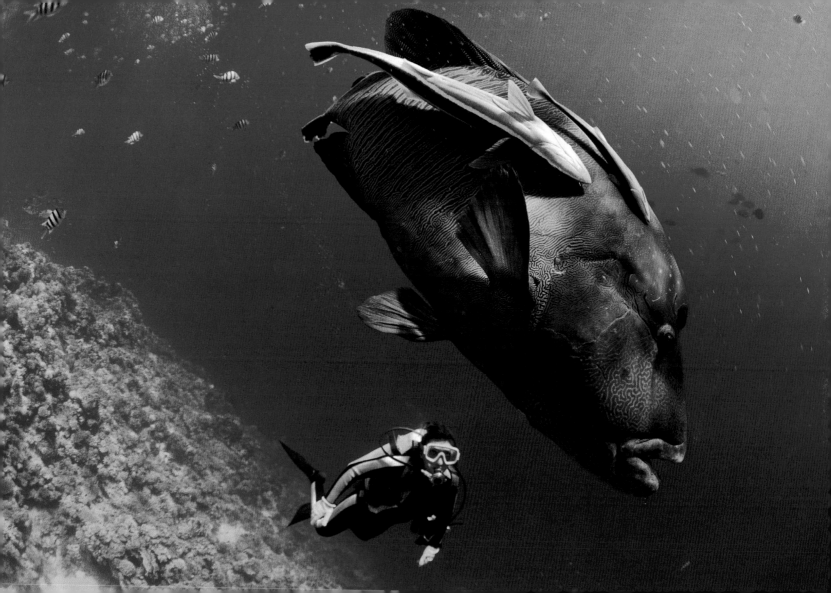

33

Coralline sculpin, San Clemente Island, California

This tiny sculpin, less than two inches long, was so well camouflaged against the background of coralline algae that I was startled when I stumbled upon him. Even though I came within touching distance, he didn't move. Sculpins are tidal fish, living on the bottoms of coastal tidal pools. Their color helps them hide not only from other predatory fish but also from birds.

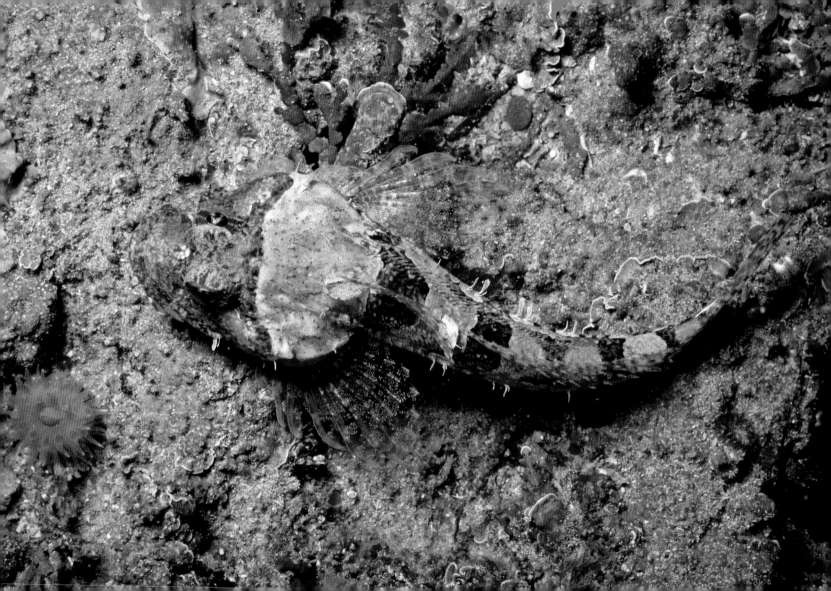

Bat stars, San Clemente Island, California

When you see webbed bat stars foraging on the holdfast of a giant kelp plant, you know you're diving in California. Armies of these starfish, normally five-armed but with sometimes up to nine appendages, march through the giant kelp forests, keeping the seafloor clean as they go. A bat star will extend its stomach—located where the mouth is, beneath the starfish at its center—over its prey, liquefying it with digestive juices before slurping it up.

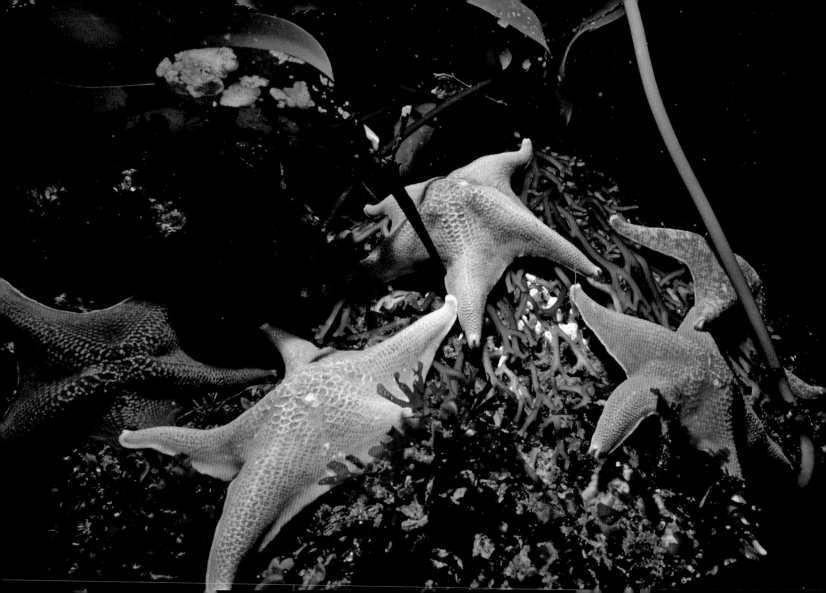

35

Giant kelp forest, Santa Catalina Island, California

Some of the world's fastest-growing multicellular organisms are giant kelp, particularly members of the Southern California species *Macrocystis pyrifera*. This species can grow to more than ninety-eight feet in a single year; that's more than three inches a day. If you can withstand the cold temperatures, often down to 53 degrees Fahrenheit, these giant kelp forests provide a unique and exciting marine environment, ripe for exploration.

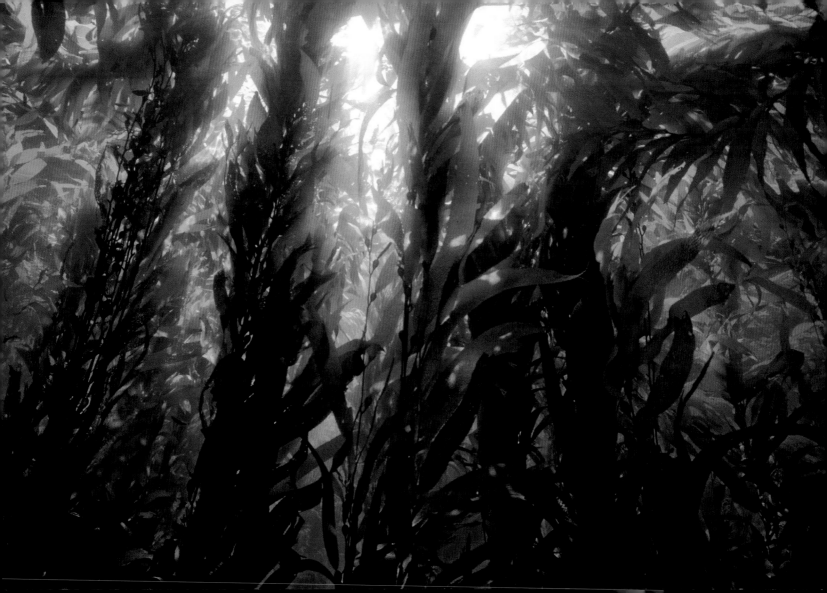

36

Blade of giant kelp, Santa Rosa Island, California

Each serrated blade of kelp is attached to its stipe by a short stem and an air bladder. If you try to press one between your thumb and forefinger, it'll burst. These hundreds of natural floats buoy the fronds to the surface. The more the kelp is exposed to wave motion, the narrower its blades grow. Those plants in more sheltered areas have wider blades.

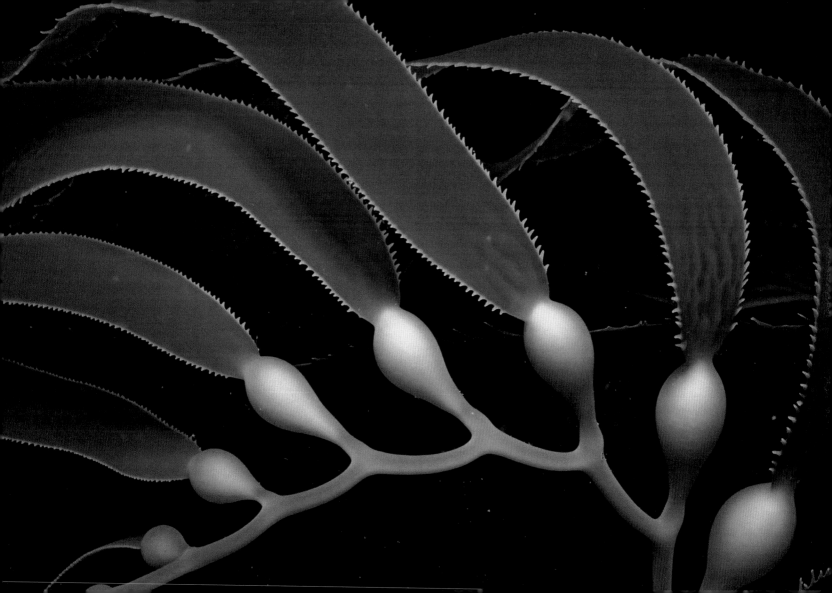

37

Purple sea urchins, Santa Rosa Island, California
Spines help these purple sea urchins creep imperceptibly along the bottom of the ocean as they feed on algae and other organic matter through clawlike mouths on their underbellies. The sharp, stinging spines also keep predators at bay, such as sea otters, starfish, crabs, and even humans, who harvest these invertebrates and their red cousins for their roe, considered a delicacy in Japan and the Mediterranean.

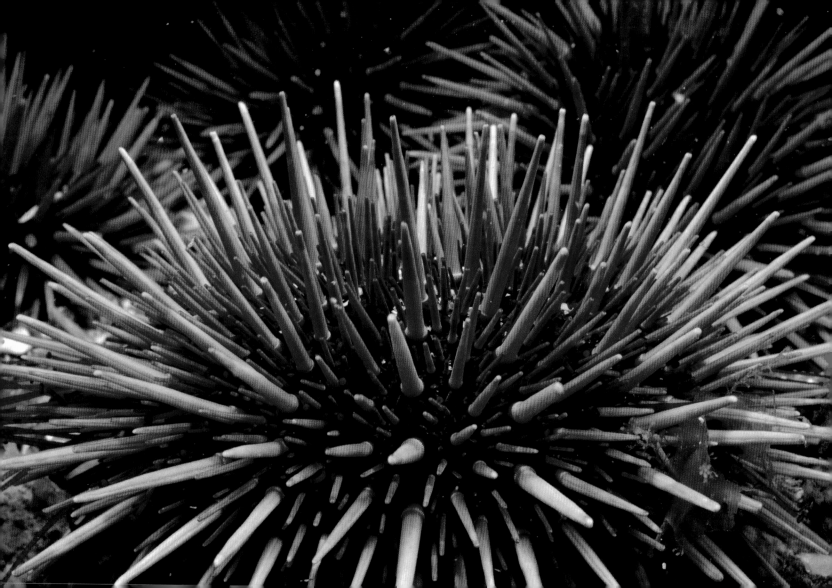

38

Spanish shawl nudibranch, San Clemente Island, California

This colorful sea slug, only one inch long, swims by doubling and twisting its body. The bright pigmentation of this and most other nudibranchs is thought to signal to potential predators the poisonous nature of these small mollusks. I've seen fish try to eat them, but they almost always spit them back out. Colors like these have earned nudibranchs the nickname "butterflies of the sea."

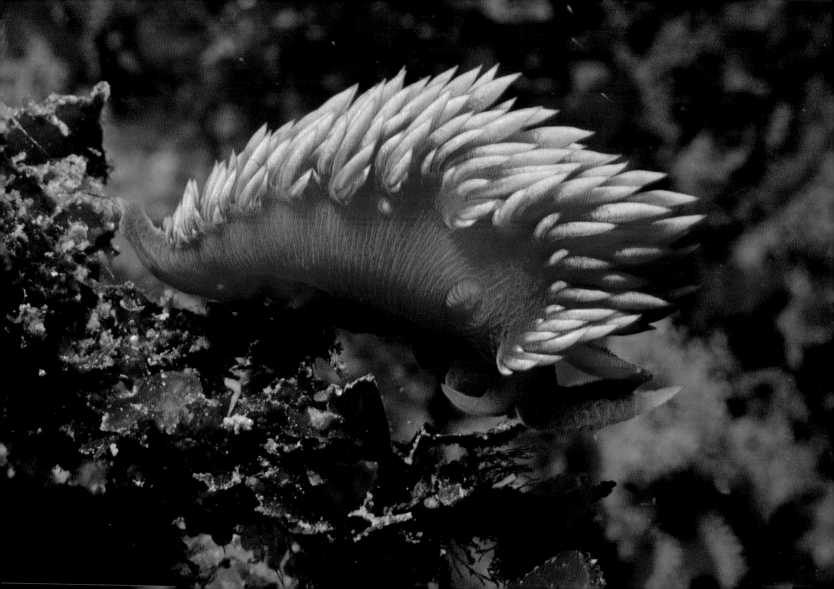

Giant kelp holdfast, Santa Cruz Island, California

The interlaced branches of a giant kelp holdfast anchor the plant to the ocean floor. While the holdfast looks like the root system of a tree, it does not, like tree roots, take in nutrients. As the kelp stems grow upward, newer holdfast branches will spread down and outward, creating a conical shape. Creatures like the brittle starfish, whose hundreds of arms you can see intertwined here, will eventually eat the older, inner branches, creating a hollow center in the holdfast, a perfect home for hundreds of species.

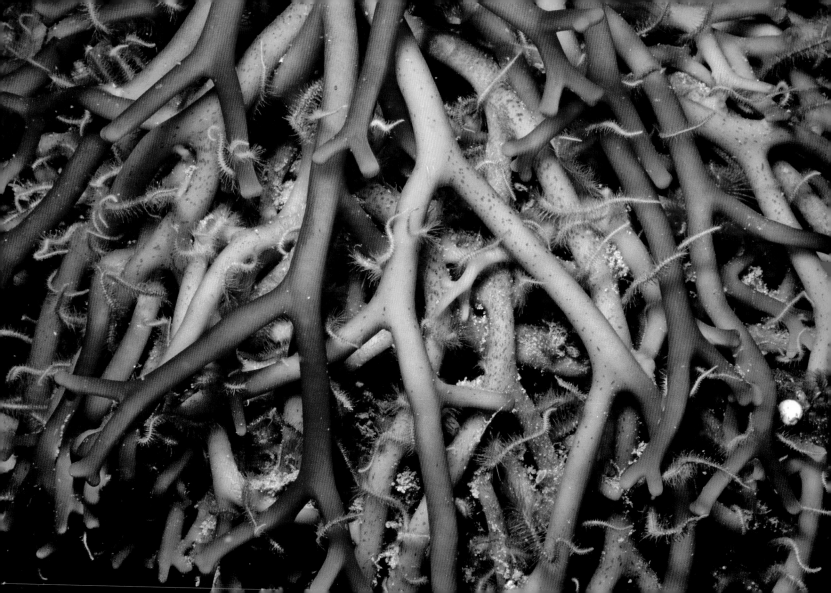

Red moon kelp snail, Santa Catalina Island, California

This two-inch-long red moon kelp snail grazes its way up the full length of a giant kelp plant, removing a thin layer of cells along the way. When it reaches the top, the snail will release itself to free-fall to the bottom, where it begins its food-gathering journey once again. (Turn the book clockwise to view the image in its proper orientation.)

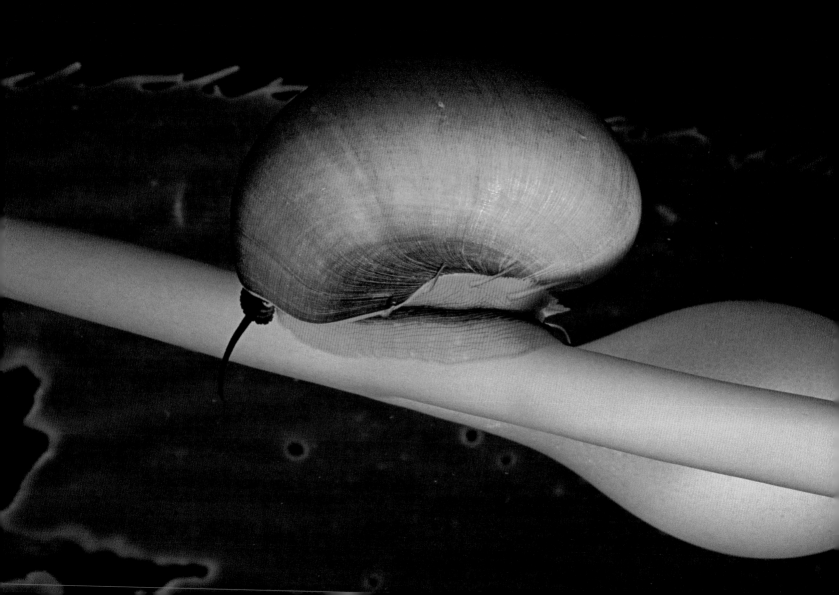

Atlantic wolffish, Eastport, Maine

This wolffish, also called an Atlantic catfish, is about to crack open a whelk with its powerful "canine" teeth. Growing to five feet, I've seen formidable-looking creatures like this one trained to eat like a puppy dog from a diver's hand. Non-migratory, once these fish find an appropriate rocky crevice to call home, they move in and spend the rest of their days sharing the lair with a mate. I know of one pair that's still in the same home ten years later.

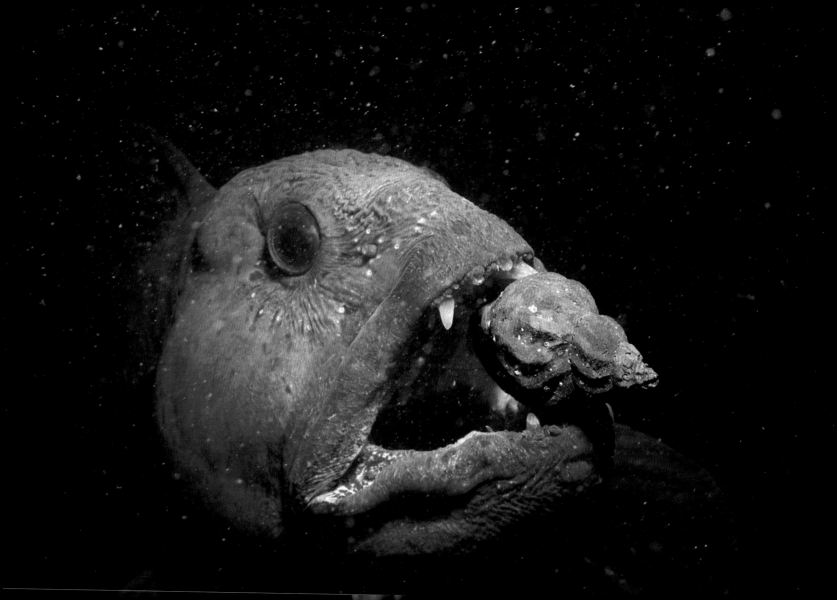

42

Knotty gorgonian coral, Palau Islands, Micronesia

On every tentacle of every polyp on this gorgonian coral, there are nematocysts, which are responsible for hunting the coral's food. In a microsecond, the nematocyst will fire tiny threads that inject a paralyzing toxin into any plankton unlucky enough to come in contact with it. The immobilized prey is then drawn into the polyp's mouth.

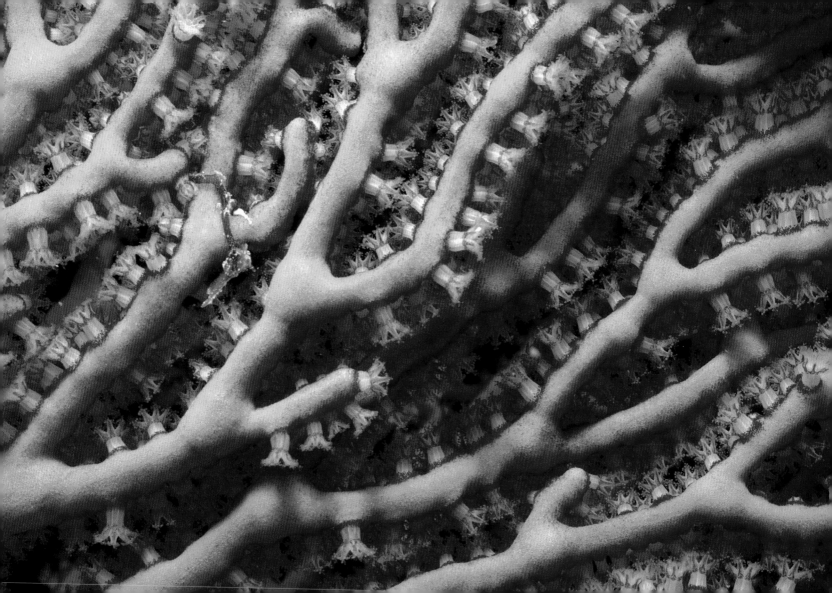

43

Shrimp and anemone, Jackson Reef, Sinai Peninsula, Egypt

Perched on the living ledge of its host anemone, a tiny, transparent anemone shrimp eyes the camera. Yet another example of a mutually symbiotic ocean relationship. The anemone is covered with poisonous stinging cells, to which the shrimp is conveniently immune, providing a safe home for what many residents of the reef would consider a gourmet treat. In return for these fantastic accommodations, the shrimp keeps the host anemone clean. While they prefer their namesake, anemone shrimp have been known to form similar symbiotic relationships with other species, like mushroom coral.

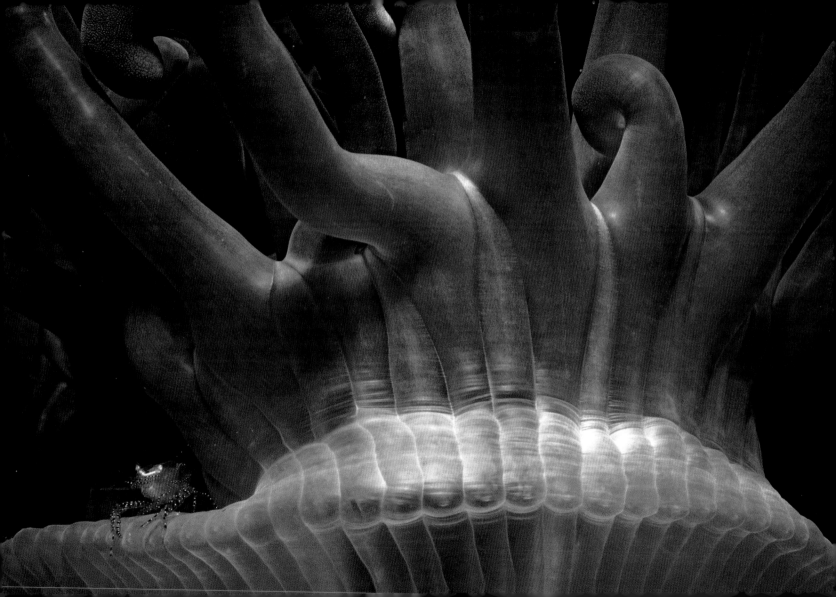

Thornback ray, Santa Cruz Island, California

Thornback rays, also called guitarfish or banjo sharks, are common off the coast of California. They rest in small groups during the day and venture out at night to feed. That was when I caught up with this specimen, accompanying it for the better part of an hour. Periodically it would tire of my flashing strobe and try to bury itself in the sand, only to discover that its camouflage didn't work with me.

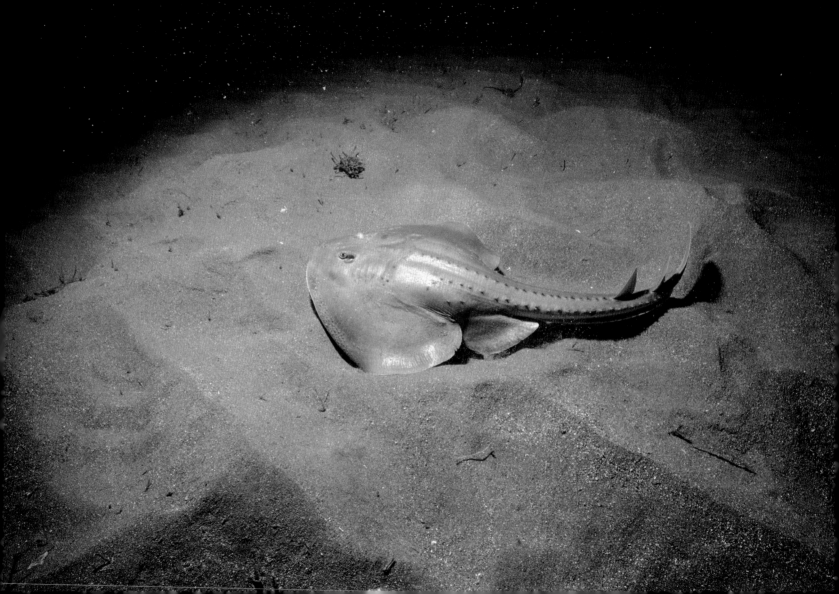

Sea raven, Bass Rocks, Gloucester, Massachusetts

This bearded visage of a sea raven, photographed twenty-nine years ago, never seems to lose its power for me. This specimen exhibits an uncommonly bright coloration; most of the species are a muted brown. Its fleshy beard blends into the New England coastal environment, especially in the intertidal zone, where beds of red algae called Irish moss cover the rocks.

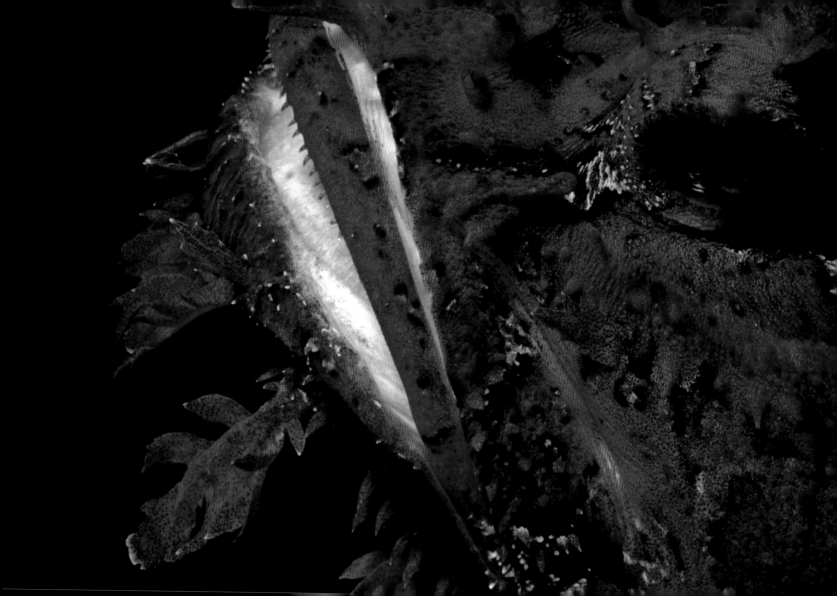

Blackback flounder, Folly Cove, Gloucester, Massachusetts

This blackback flounder is right-eyed. Whether a flounder is right-eyed or left-eyed is species-specific. Early in its life this flatfish swam upright, with one eye on each side of its head. Later in its life cycle, the fish lay down on its side and its lower eye, rather than stare forever into the featureless sand, migrated around its body to join its fellow (in this case the right eye). The adult flounder retains the use of both eyes, to detect predator and prey alike.

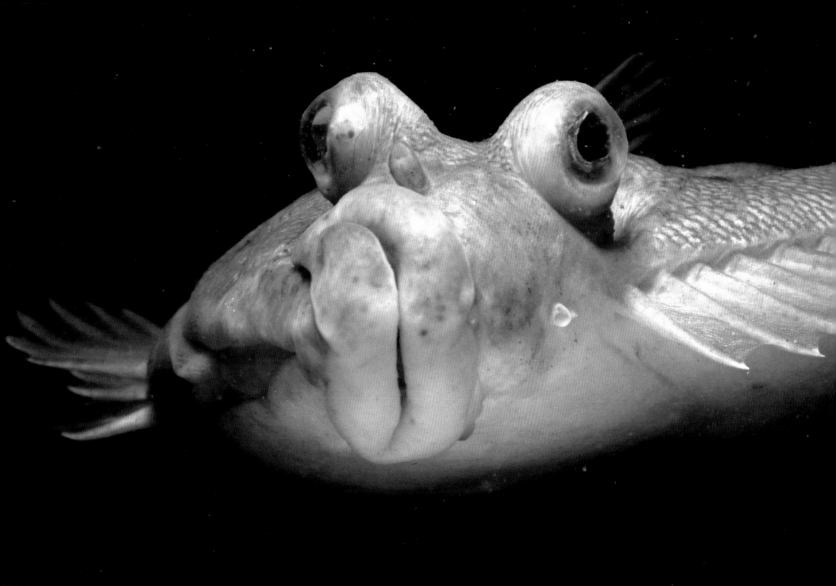

Scorpionfish, San Clemente Island, California

Imagine yourself a tiny fish, swimming along, minding your own fish business, when you are suddenly confronted with the humongous, gaping mouth of this camouflaged scorpionfish—it would be the last thing you see. When this fish opens its large mouth, it creates a powerful suction that pulls in its prey, all within a split second. The mouths of some scorpionfish are so large, they can swallow an animal more than half their own size.

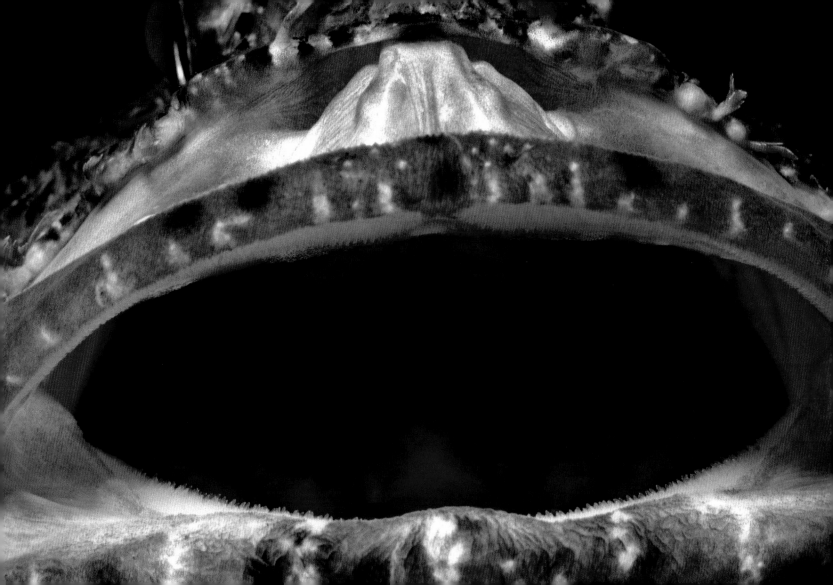

Giant Pacific octopus, Vancouver Island, British Columbia, Canada

An octopus depends on its exceptionally acute senses to track its prey. By poking its arms inside cracks and crevices, this giant Pacific octopus has located a cabezon fish hiding under rocks. Sensory chemoreceptors on the rims of octopus suckers not only feel but also taste and smell. Experiments have shown that an octopus's sense of touch is so sophisticated that a blind octopus would be able to differentiate between objects as well as an octopus with normal sight.

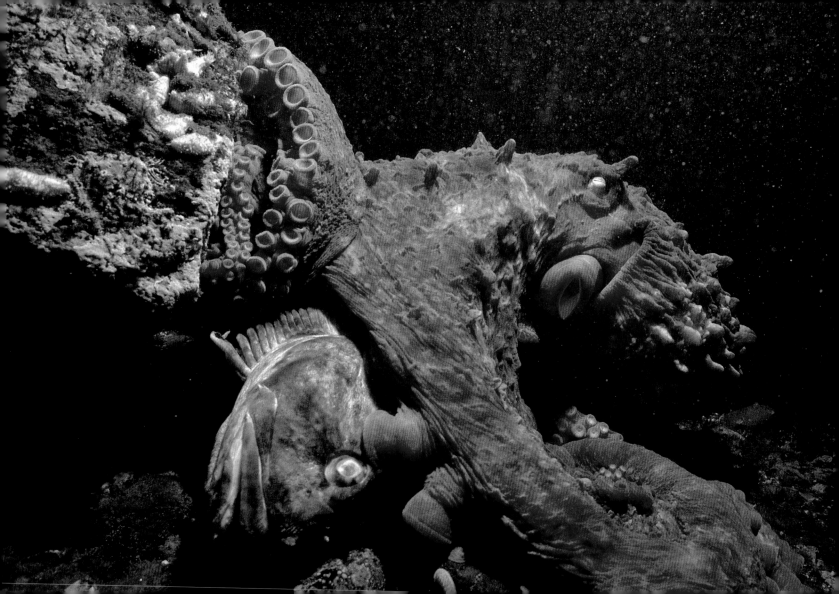

Red hermit crab, Ustica Island, Sicily

At the slightest hint of danger, this red hermit crab will retreat into the safety of its shell, only to reappear when the coast is clear. As a hermit crab continues to grow, it will abandon its shell in search of a new and larger one to call home. With more than five hundred known species of hermit crabs and a limited number of vacant seashells, competition for available shells can be fierce.

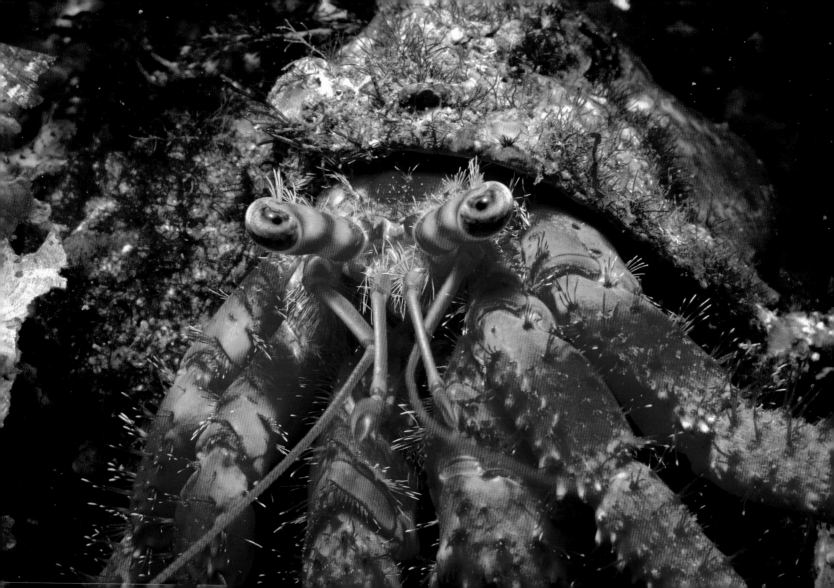

Purple anthias, Walindi Bay, Papua New Guinea

Purple anthias are a common fish on the reefs off Papua New Guinea. Their home turf is perhaps only ten square yards; they will not venture out farther than this. This school sticks close to the reef, ready to dart into the protection of the nearby knotty gorgonian coral at the slightest sign of danger. The Bismarck Sea is part of the Coral Triangle, a marine region that is home to almost three-quarters of the world's species of coral.

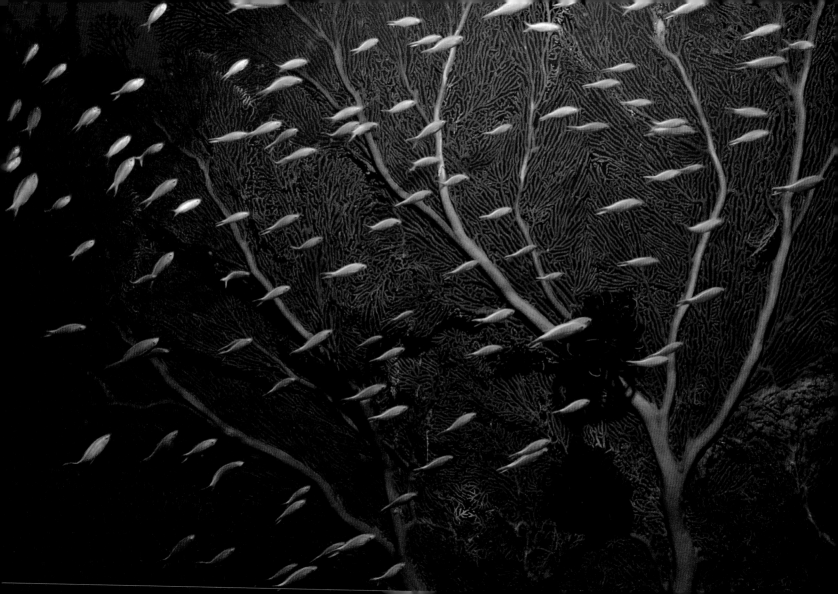

Golden damselfish, Walindi Bay, Papua New Guinea

I haven't had as many opportunities to dive at night as I would have liked in Papua New Guinea, but when I have, I was sure to find powerful images. I captured this moment with a golden damselfish at 3:00 a.m. (I had the element of surprise on my side.) The topography and relative isolation of the Asia-Pacific region have created an environment of unparalleled marine biodiversity. It's estimated that there are as many as 1,500 species of fish and 10,000 species of plants and invertebrates surrounding the islands of Papua New Guinea, Indonesia, and Fiji.

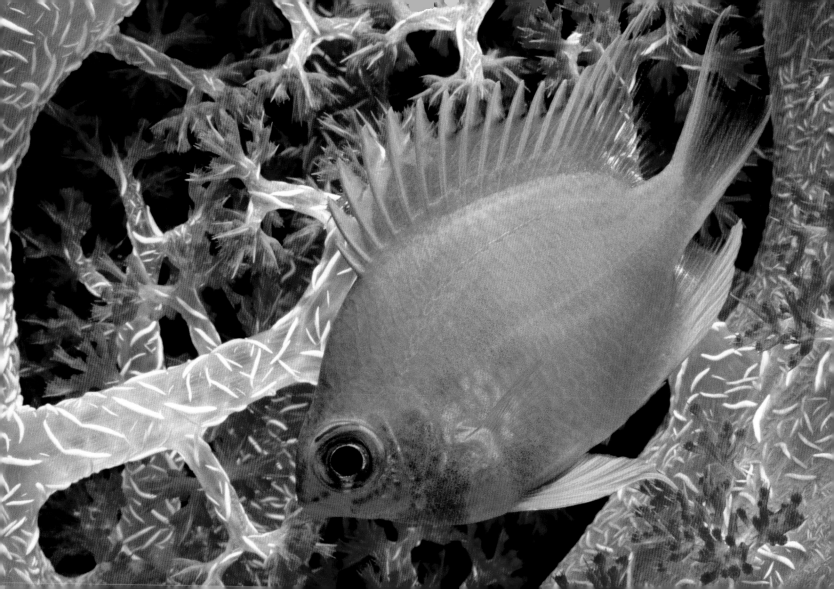

Whitetip reef sharks, Cocos Island, Costa Rica

Scenes like this one reinforce my belief that diving at night off Cocos Island is one of the premier events in a diver's life. Whitetip reef sharks in the reefs off this island hunt in roving packs of a hundred plus. When they find a chunk of volcanic reef where they think a tasty fish is hiding, they will frantically attack every hole and crevice, forcing their sandpapery snouts into the openings. A cornered fish will often try to shoot out in an effort to escape. Not a wise decision, and most likely the last decision that fish will ever make. I've only seen this behavior in whitetips off Cocos Island.

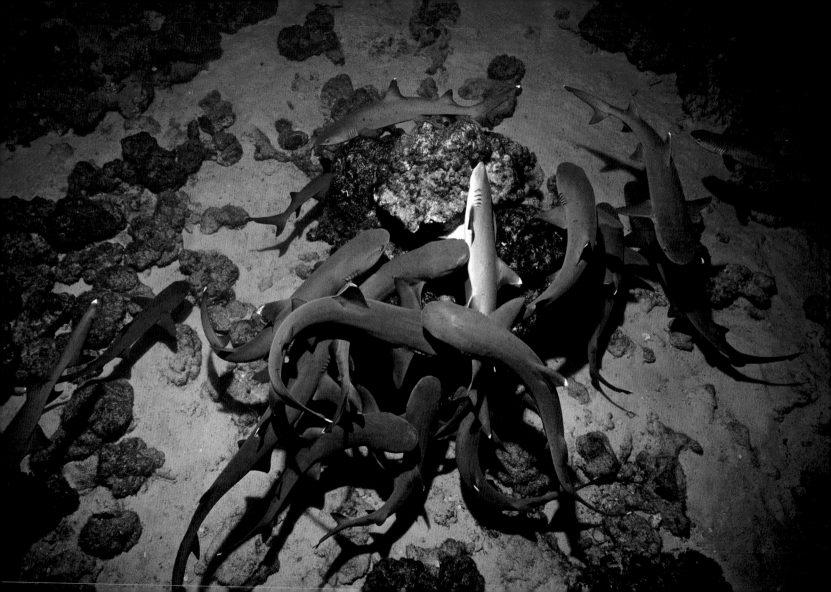

Whitetip reef shark, Cocos Island, Costa Rica
In the late afternoon, whitetip reef sharks—so named for the white on the tips of their first dorsal and upper caudal fins, as seen here—gather in groups and surf the swift two-knot current around the perimeter of Manuelita Island. It was great fun to join them and allow myself to be swept down current for more than half a mile.

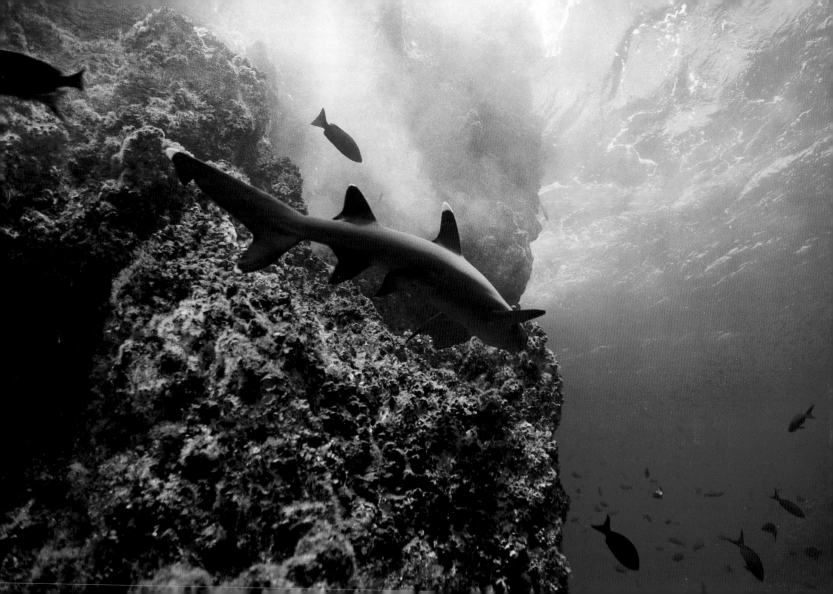

Juvenile whitetip reef shark, Cocos Island, Costa Rica

For one month, my assistant, Asher, and I worked with the largest population of whitetip reef sharks we had ever encountered. What surprised us was that we saw only adults, no juveniles. Then finally, at a depth of about fifty feet in a tiny cave, we found these five juvenile whitetips lying one on top of the other. They were slightly less then two feet long and probably no more then a few months old. I had come across this behavior on several occasions in various oceans, but this was the first time I had witnessed it in juveniles. When night comes, they will leave the cave and hunt for lobsters, crabs, and small fish; at first light they will head back to the safety of this same cave.

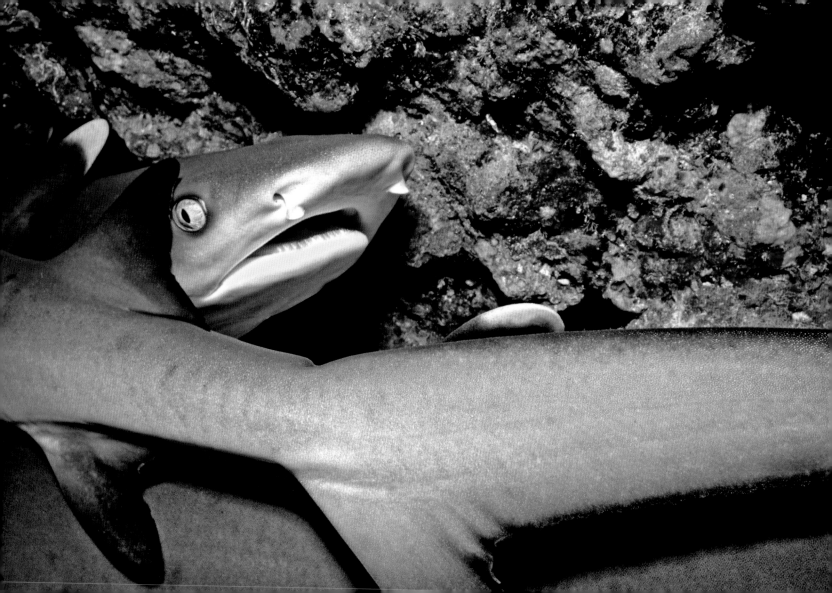

Scalloped hammerhead sharks, Cocos Island, Costa Rica

The big attraction for divers at Cocos is the sharks, and few are more thrilling than the schooling hammerheads. They congregate in the hundreds here. This picture was taken from a depth of 130 feet. The sharks were about 50 feet above me, swimming in circles. The scalloped is one of eight species of hammerhead sharks. Prior to World War II, hammerheads were hunted for the vitamin A in their livers; fortunately, scientists discovered ways to synthesize it.

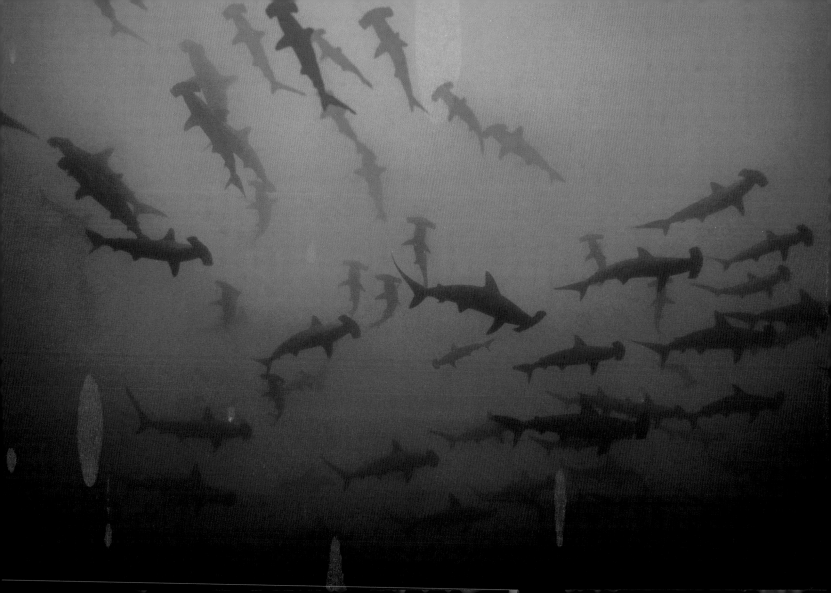

Scalloped hammerhead, Kane'ohe Bay, Hawaii

During the spring, scalloped hammerhead sharks come into Hawaii's Kane'ohe Bay to give birth. The females deliver in the bay because it offers their newborns some degree of protection. In the bay, there are fewer large predators to bother the juveniles and a plentiful food supply on the sandy bottom. This individual is no more than one month old and about sixteen inches in length; with luck, it will grow up to thirteen feet as an adult.

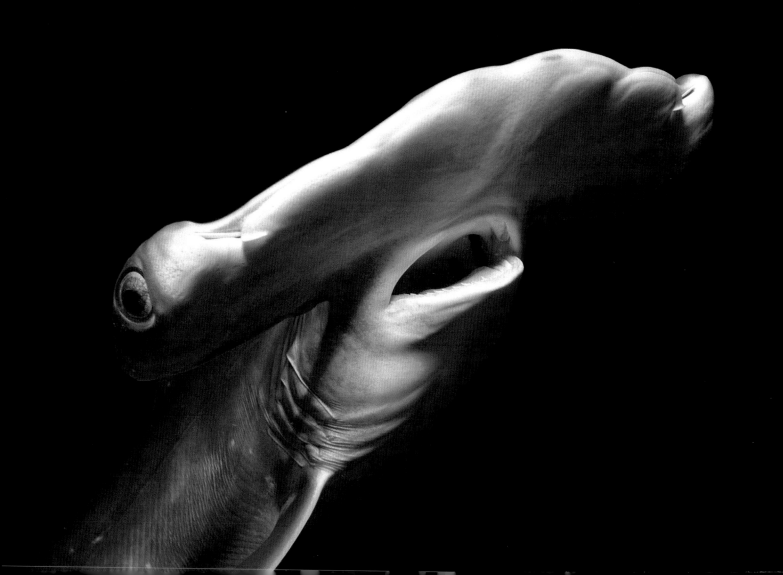

Scalloped hammerhead, Cocos Island, Costa Rica

The evolution of the hammerhead has been a topic of some debate among scientists.
Some believe its elongated, flattened head, called a cephalofoil, provides hydrodynamic
lift and increased maneuverability. Others think the nostrils placed farther apart,
on either end of the head, give hammerheads an improved sense of smell. Still
others believe the evolutionary advantage of its uniquely shaped head is increased
electroreceptive ability. No one knows for sure, and in fact all of these factors could
have played a part in the evolutionary selection that produced such a fascinating and
bizarre-looking creature.

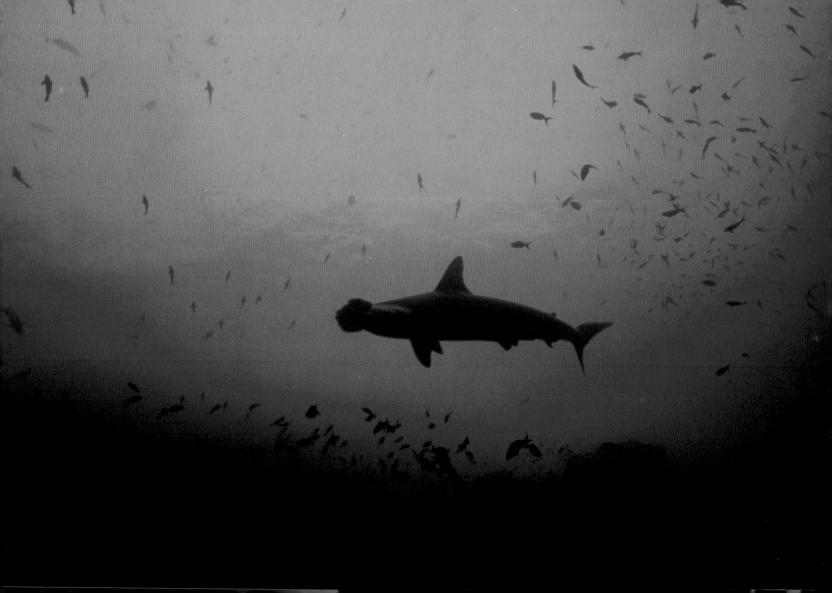

Bottlenose dolphin, Nuweiba, Sinai Peninsula, Egypt

We often think of dolphins as the friendly Flipper or the clapping entertainer at Sea World, but in the wild, dolphins can be fierce predators. Groups of dolphins, called pods, hunt together, herding and trapping schools of fish or stunning larger prey with a swift, well-placed shove of the tail. Pods have even been known to attack sharks, when threatened. Though a dolphin is a toothed whale, it doesn't chew; it swallows its food whole. This dolphin played with the reef octopus you see in her lower jaw for a full twenty minutes before gulping it down.

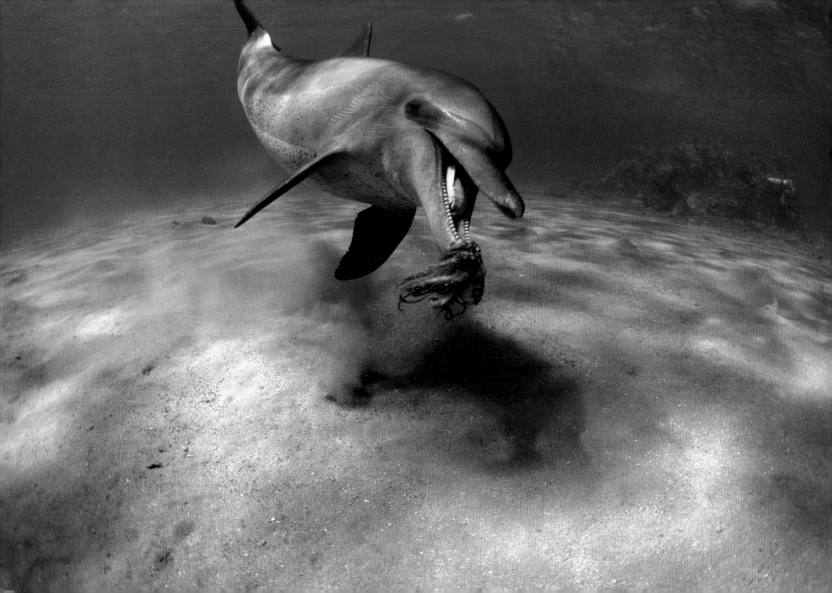

59

Bottlenose dolphins, Dolphin Reef, Eilat, Israel

Dolphin Reef in Eilat, Israel, is a 100,000-square-foot enclosure that is home to thirteen bottlenose dolphins. The dolphins are used in a dolphin/child therapy program. The dolphins at Eilat seem to be gentler with disabled people, sensing there is something special about them. Whether or not this is true, seriously ill people, especially children, make impressive gains after petting, swimming with, and befriending dolphins.

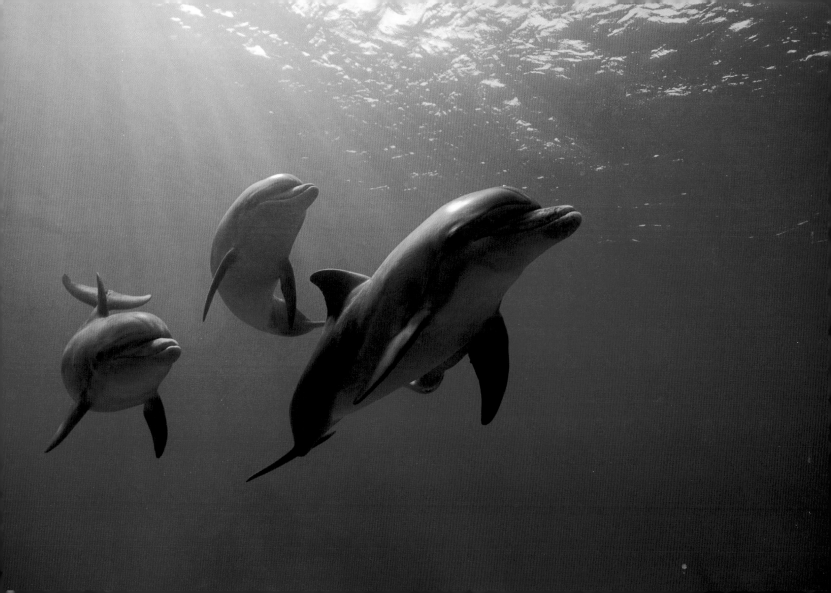

Great white shark, Guadalupe Island, Mexico

Great white sharks seem to have the uncanny ability to approach a diver from the blind side, and at times it seems they suddenly appear out of the murk. But even from a distance there is no mistaking this lord of the sea. We still know so little about these animals. When caught and placed in captivity, most die within weeks or must be released. Until 2005, when a female great white broke the record at 198 days, captivity lasted at most sixteen days. These fish are meant for the wilds of the ocean.

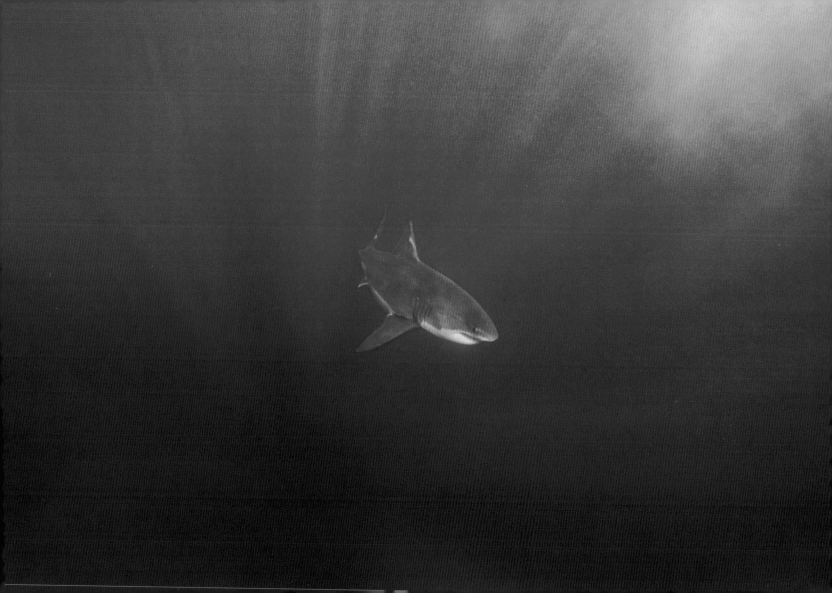

Whitetip reef sharks, Cocos Island, Costa Rica

As I watched, these four whitetip reef sharks picked up the faint electrical signal emitted
by the movements of a soldierfish. Attacking the tough volcanic rock it was hiding
behind with their pointed snouts, the sharks succeeded in scaring the doomed fish
out of its hiding place. As it darted out, trying to escape to safety, one shark was lucky
enough to grab it. If you look carefully, you can just see the red tail disappearing into the
shark's mouth.

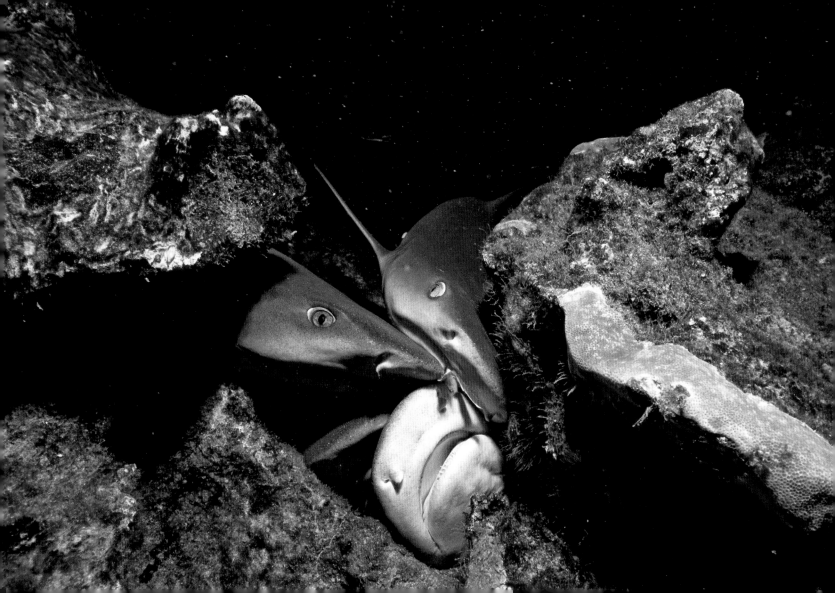

Great white shark, Guadalupe Island, Mexico

This great white is approaching some bait (not in the frame) and just beginning to open its maw. A great white shark has many rows of very sharp, serrated teeth. The front rows, on the upper and lower jaws, are used for ripping prey into bite-size pieces, which are then swallowed whole. If a tooth falls out or gets worn down, a new one from a back row quickly grows forward to replace it.

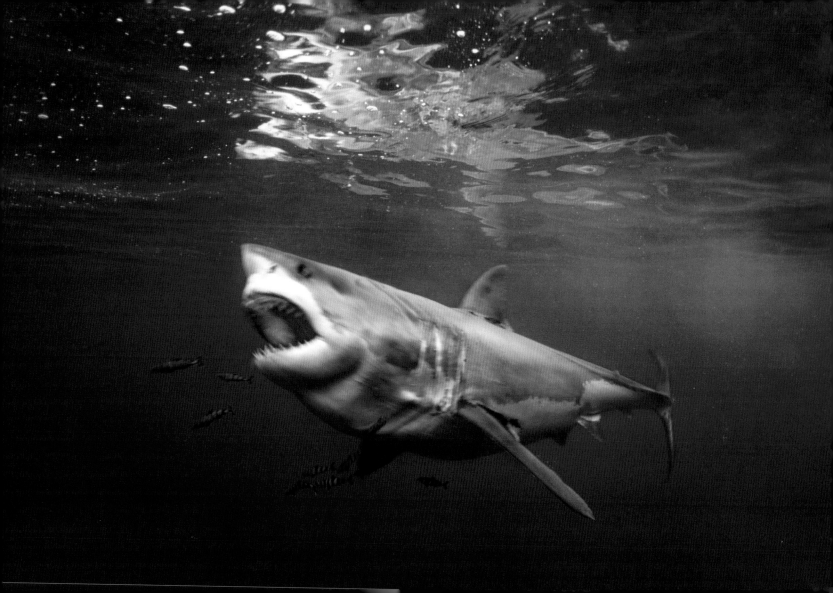

Slate pencil sea urchin, Maui Island, Hawaii

Sea urchins may seem sedentary, but at night, they venture out from the coral reef on hundreds of tiny, adhesive tube feet, scavenging for organic remains or feeding on algae and seaweed. The spines are connected to the skeleton, called the test, by ball joints, so they're movable. The rust-colored spines of slate pencil urchins are triangular or rounded in shape and fairly blunt. It's said that ancient Hawaiians used them as writing instruments.

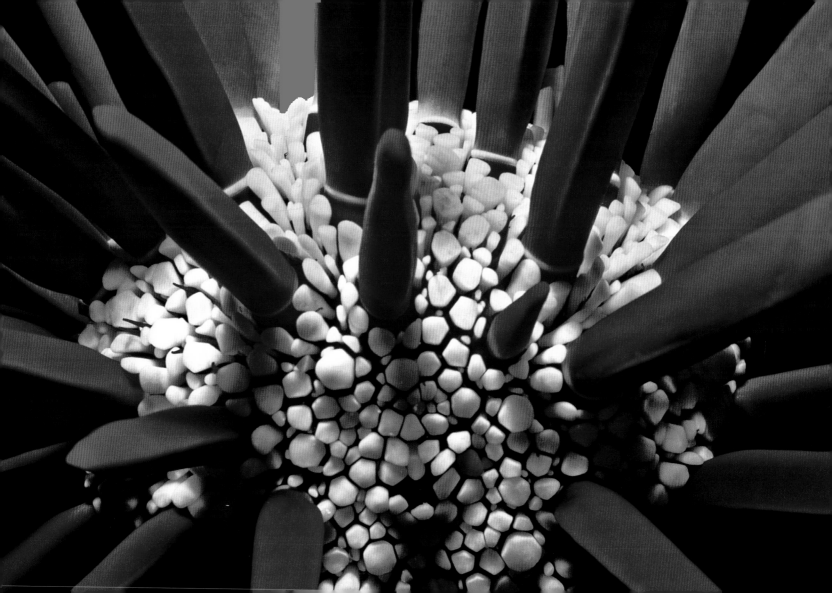

Spider crab, Kimbe Bay, Papua New Guinea

This spider crab was spotted at night on an alcyonarian soft coral scavenging for organic remains. Crabs and spiders are both arthropods, which means they are, in fact, distantly related. Like a spider, this crab has a hard exoskeleton and a segmented body with multiple paired, jointed legs. Tiny hooklike hairs on the crab's shell collect algae and other matter that will help the crab camouflage itself from predators.

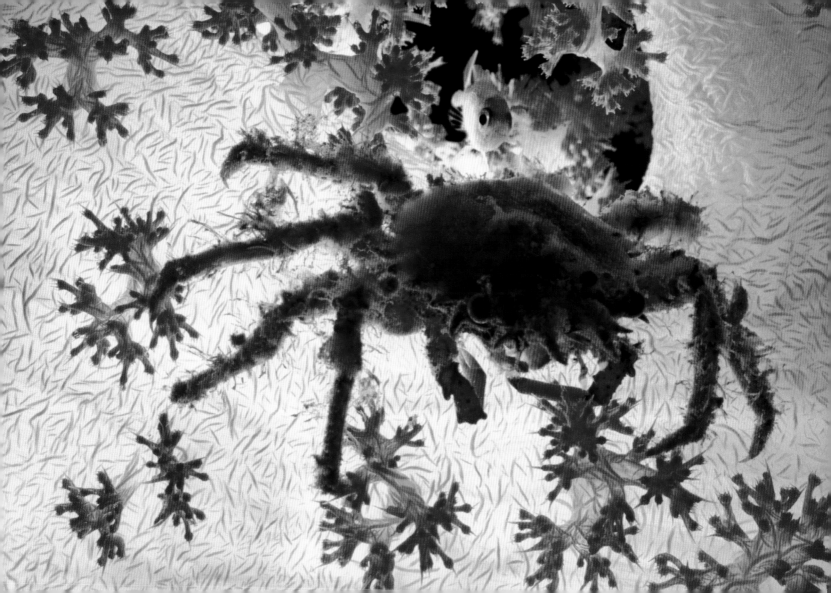

Crown-of-thorns starfish, Jackson Reef, Sinai Peninsula, Egypt

This shot of the underside of a crown-of-thorns starfish is backlit. This lighting technique allows you to see the central mouth surrounded by rows and rows of tubed feet. These tiny suction cups on the undersides of the star's arms help it creep along the coral reef. When it's time to feed, the tube feet will actually pull the stomach out of the starfish's mouth, passing it along until it covers the coral. Digestive juices will then break down the coral polyps, so the starfish can ingest them, leaving only the coral skeleton.

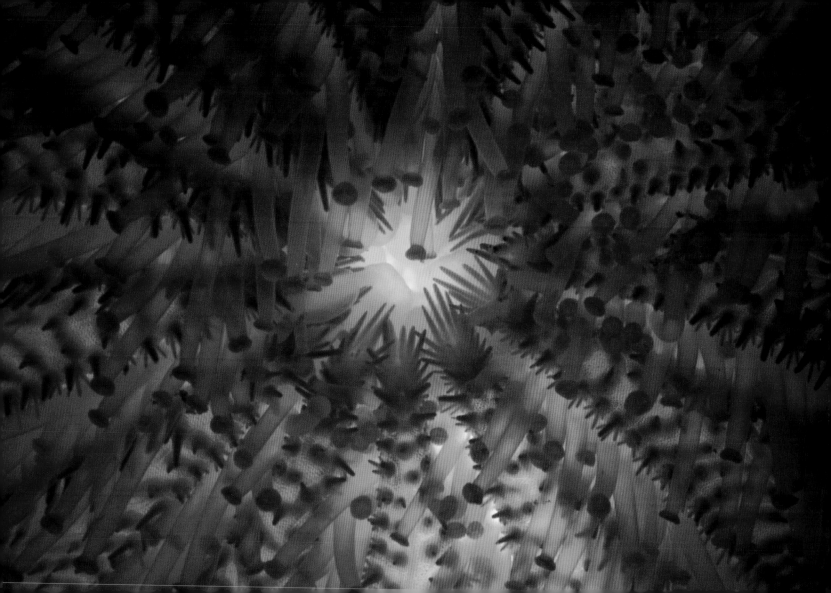

66

Coral grouper, Ras Nas Rani, Sinai Peninsula, Egypt

Using levers of bone and hinges of cartilage, a grouper can distend its mouth—sort of like unhinging its jaws—into a tube, enabling it to swallow large prey whole within a fraction of a second. Its sharp, inward-pointing teeth help to prevent the prey, usually fish, from slipping away. Grinding plates farther back in the grouper's throat crush the prey into digestible pieces.

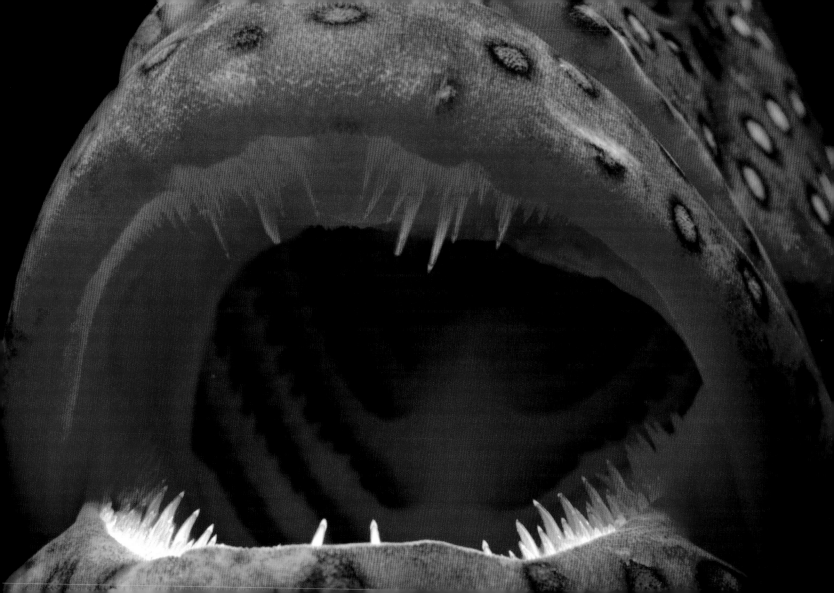

Orange ball corallimorph anemone, Grand Cayman Island

The orange ball anemone isn't really an anemone, it's a corallimorph—a group of cnidarians that are coral-like but without an exoskeleton—but because it looks so much like an anemone, this common name has stuck. At night orange balls make their appearance, like flowers magically blooming from the sand.

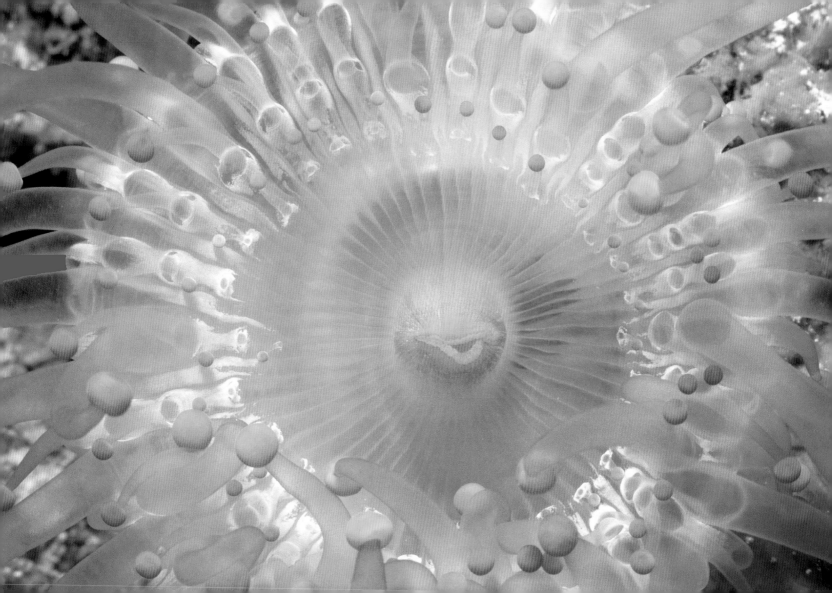

Jewel anemones, Isles of Glénan, Brittany, France

This colony of spectacular jewel anemones on the otherwise dark, cold reefs of the
French Atlantic had me conjuring up images of Neptune scattering precious gems
about to tempt divers. Each of these colorful corallimorphs may have up to a hundred
bulb-tipped tentacles and come in bright shades of pink, purple, green, orange, and
red. Separate colonies can be identified by their different colored bulbs.

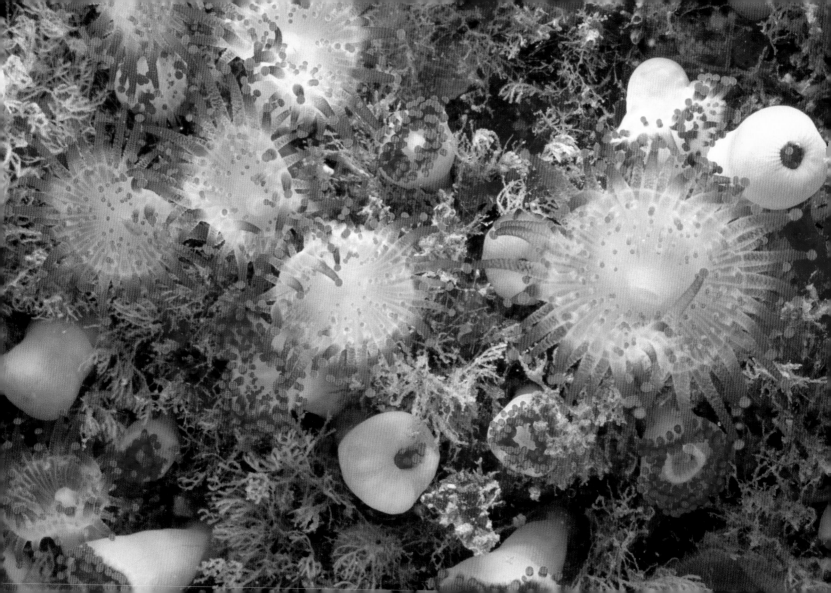

Club-tipped anemones, San Clemente Island, California

Night feeders, these club-tipped anemones hungrily sweep the water with their tentacles. The "clubs," or bulbs, on the ends of their translucent tentacles are concentrated with stinging cells that will attack any prey wandering by. Their reddish to pinkish color also lends them the name "strawberry anemone," but like the orange ball and jewel anemones, these organisms actually fall under the classification of corallimorpharia.

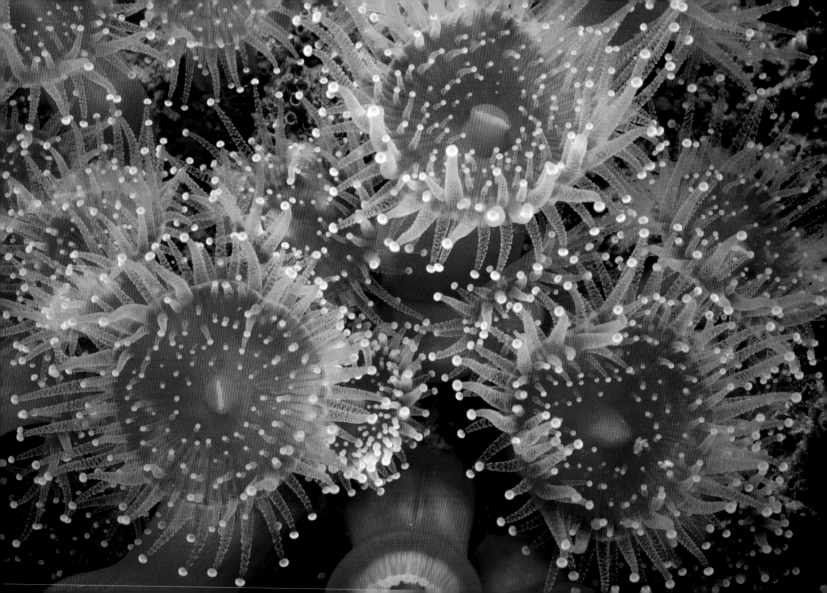

Northern red anemone, Vancouver Island, British Columbia

Like peppermint sticks, the bright, banded tentacles of the northern red anemone are arranged in three concentric circles. This individual has drawn the first circle of tentacles to its mouth in what may be feeding behavior. Growing up to eight inches in diameter when its tentacles are extended, the northern red anemone is capable of eating small crustaceans and fish.

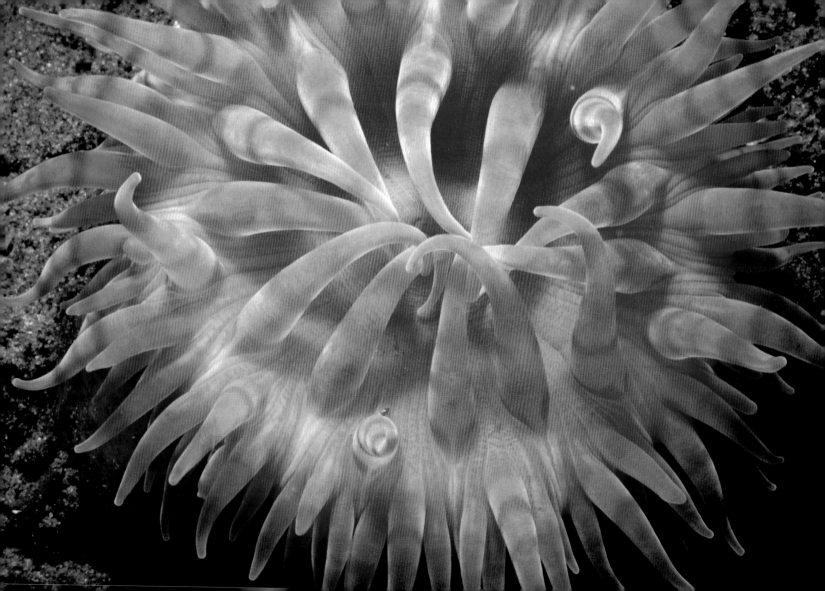

Cup coral eating juvenile reef octopus, Jackson Reef, Sinai Peninsula, Egypt

In the dead of night I came across this rare sight: a juvenile reef octopus being eaten by a cup coral. The nematocysts on the tentacles of the cup coral have paralyzed the tiny octopus. A healthy octopus would never allow itself to be caught by an anemone; this one quite possibly stumbled onto the coral while already in a weakened state, a potent example of survival of the fittest.

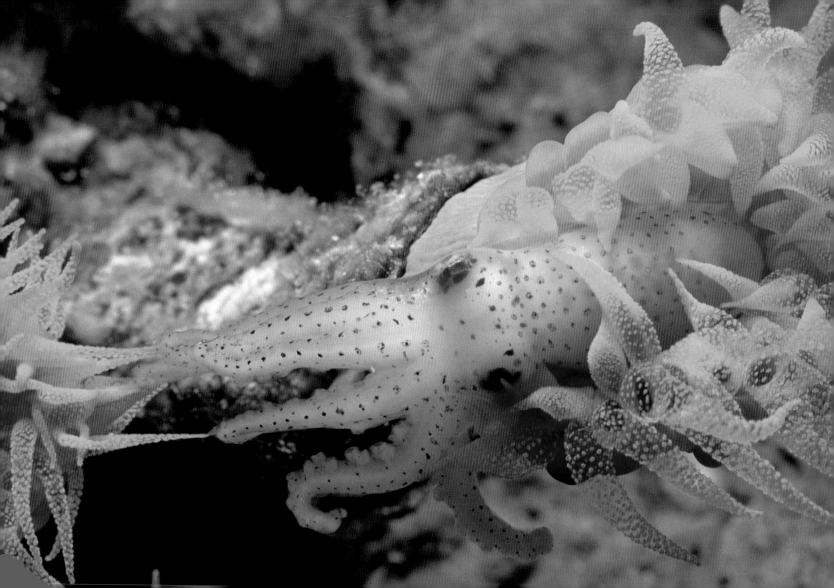

Sea anemone eating striped butterflyfish, Sharks Bay, Sinai Peninsula, Egypt

A paralyzed striped butterflyfish disappears down the gullet of a large sea anemone. The digestive system of an anemone consists of a simple stomach sac that secretes digestive enzymes. When the anemone is done with its meal, the inedible bits and pieces that are left of the butterflyfish will be ejected back out of its slitlike mouth (anemones do not have an anus).

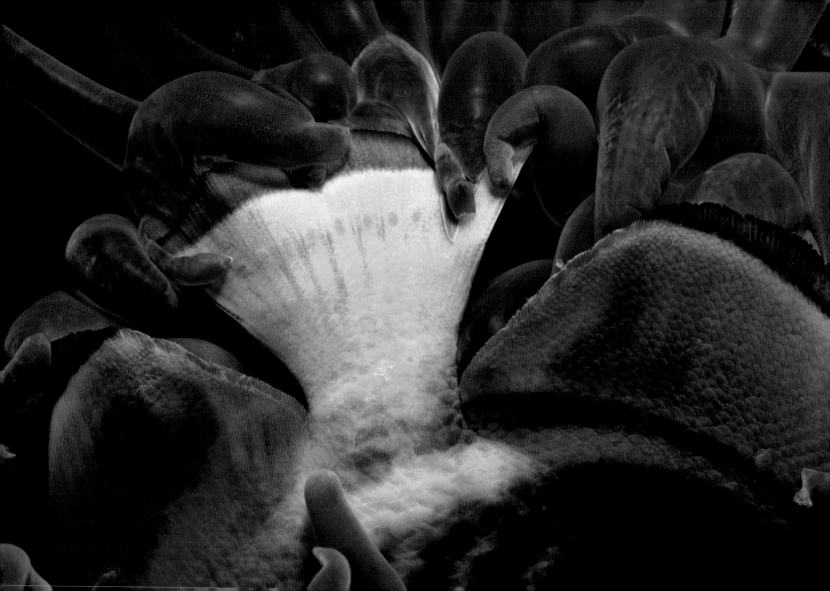

Golden jellyfish, Jellyfish Salt Lake, Palau Islands, Micronesia

What has no head, no spine, no heart, and is 95 percent water? A jellyfish. Actually, scientists now call them jellies because they aren't fish at all, but cousins of sea anemones and corals. This species, Mastigias, is known to migrate toward sunlight, prudent behavior if they want to keep the symbiotic algae living in their tissue, whose photosynthetic sugars they feed on, happy. (Turn the book clockwise to view the image in its proper orientation.)

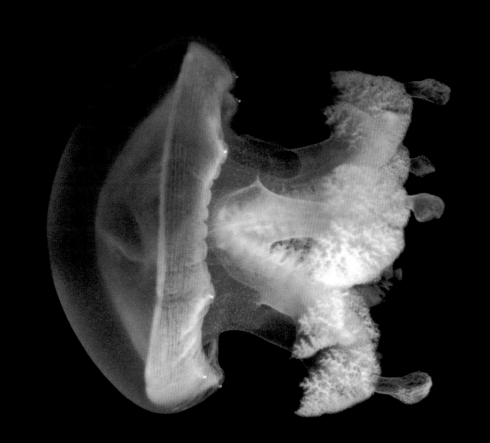

Sea anemone eating golden jellyfish, Jellyfish Salt Lake, Palau Islands, Micronesia
Jellyfish Lake is one of about seventy marine lakes that pepper the limestone islands
of the Palau archipelago. In a population explosion of five million Mastigias jellies
pulsing through the water, one is bound to pass near the bottom, which is carpeted
with anemones that feed on the jellies. (Turn the book clockwise to view the image in its
proper orientation.)

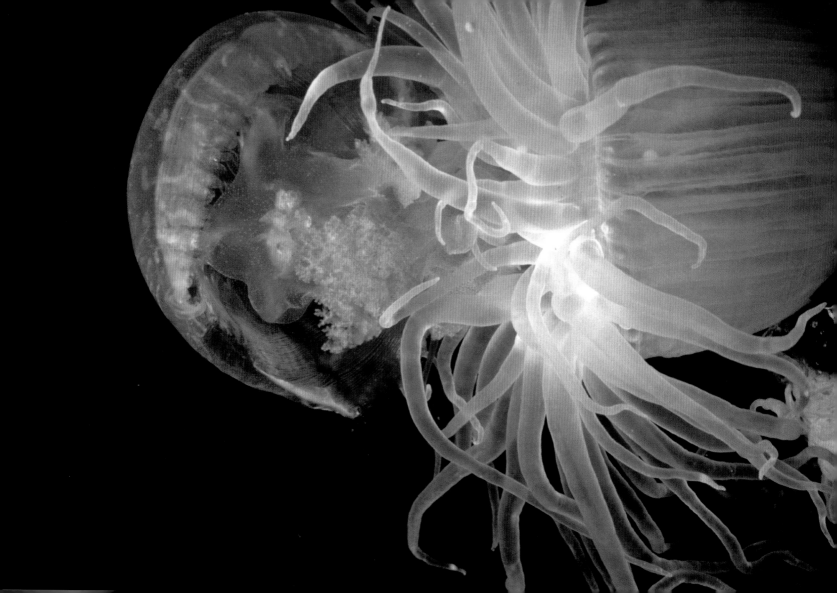

Northern red anemone, Deer Island, Bay of Fundy, Canada

When does photographing nature cross the line into art? I don't have the answer, but for me this image at least straddles that line. These rosy, puckered lips look for all the world like a human's, but of course this is an anemone's mouth, guarded by the tentacles that bring food to its lips. This one-of-a-kind shot is the sort of elusive prize I seek every time I enter the sea. (Turn the book clockwise to view the image in its proper orientation.)

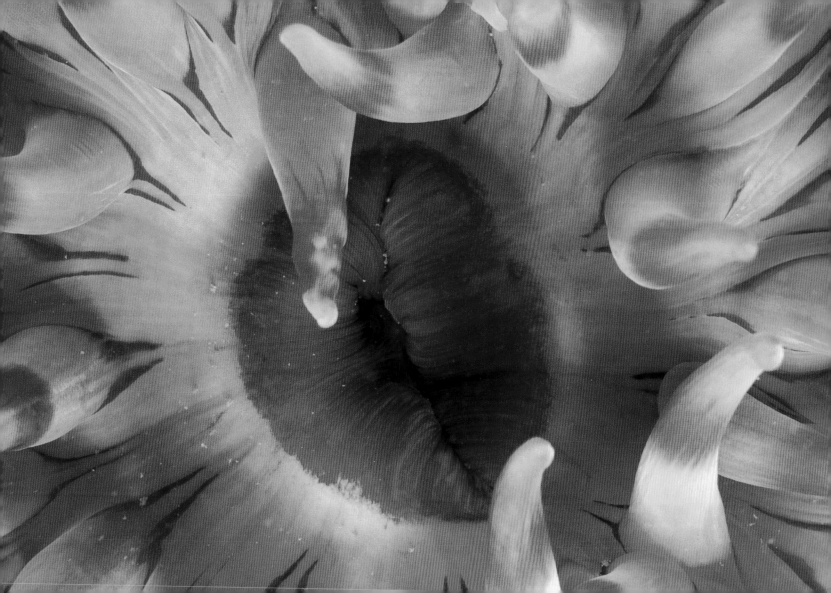

Tasseled scorpionfish, Ras Umm Sid, Sinai Peninsula, Egypt

This scorpionfish virtually disappears in a bed of sea grass, sand, and algae. Scorpionfish are masters of camouflage—not only do they seek out places where they'll blend in well with the background, they also have the ability to change color to adapt to a background. Fleshy growths, spiny protrusions, and a mottled color make them rather ugly but deadly. Thinking it has found a nice algae-covered rock to feed on, an unsuspecting crustacean may, in fact, be approaching the jaws of one of its worst enemies.

Giant frogfish, Moses Rock, Eilat, Israel

Exceptional camouflage allows this frogfish to go easily undetected. Often mistaken for a clump of sponge and hydroids, frogfish are one of the most difficult fish to spot. This specimen must have been living near some pink and yellow sponges, because frogfish change coloration in order to blend in with their surroundings. You can barely make out its gaping mouth and eye. Frogfish are also known to hang upside down, to obscure their outline.

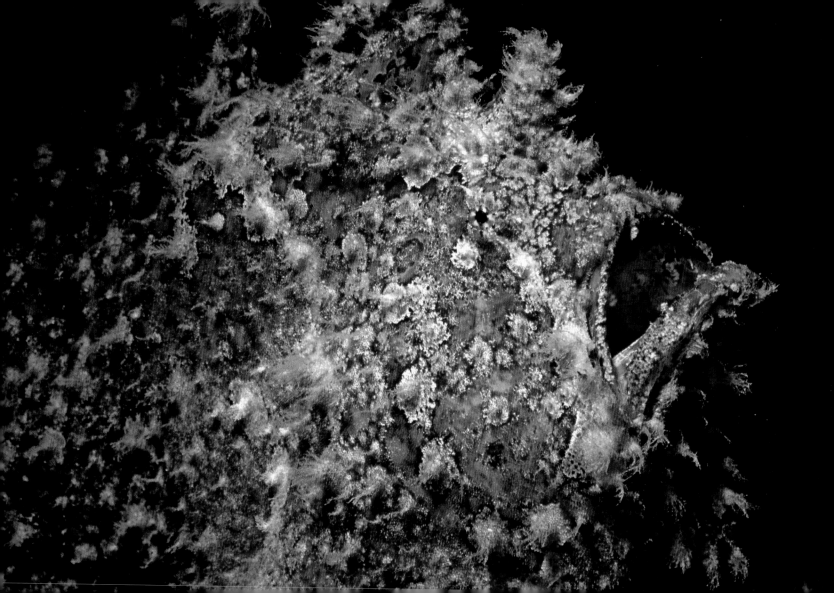

78

Anemone shrimp on tentacles of sea anemone, Ras Abu Galoum,
Sinai Peninsula, Egypt

This tiny, transparent shrimp, perhaps an inch long, lives hidden among the tentacles of its symbiotic anemone. It picks and eats organic material off of its host anemone's club-footed tentacles, helping to keep it clean and free from disease. The shrimp has an exoskeleton and occasionally molts to grow a new, larger shell, after which it will have to readjust to the toxicity of its host.

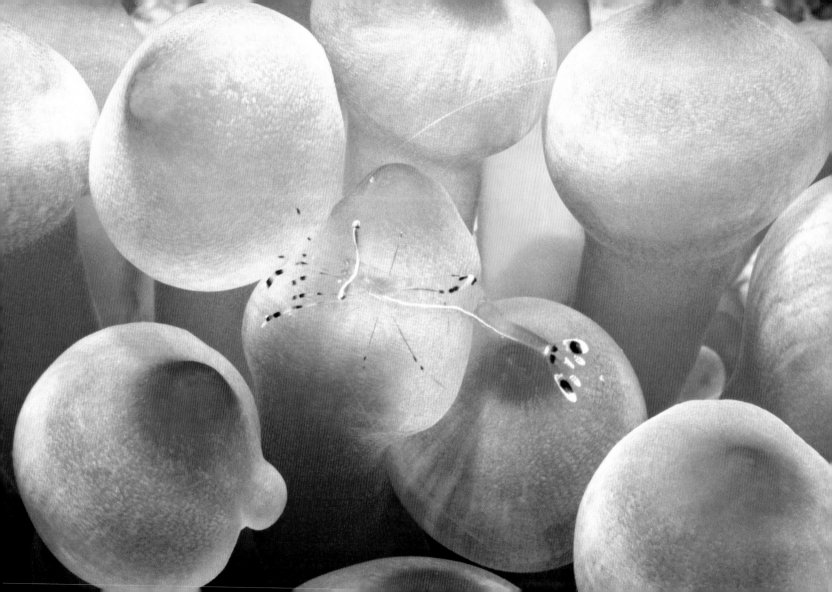

79

Bubble coral, Gordon Reef, Sinai Peninsula, Egypt

Each polyp of this bubble coral is filled with water, making it look like a bunch of white grapes. During the day, these bubbles expand to absorb sunlight the coral will use in photosynthesis. At night, long tentacles extend, sweeping its vicinity to keep predators and any corals encroaching on its territory at bay, and to sting prey that happen by on the current.

Urn tunicates, Sipadan Island, Borneo

Tunicates, also called sea squirts, are sedentary filter feeders. They begin life as free-swimming larvae, complete with tails and primitive spinal cords. Eventually, though, like all good sea squirts, they settle down onto a hard surface, losing their tail and their ability to move and even digesting what beginnings of a brain they have. Adults, like the ones here, are essentially sacs that sit around attached to the substrate, looking pretty, and filtering the water for nutrients.

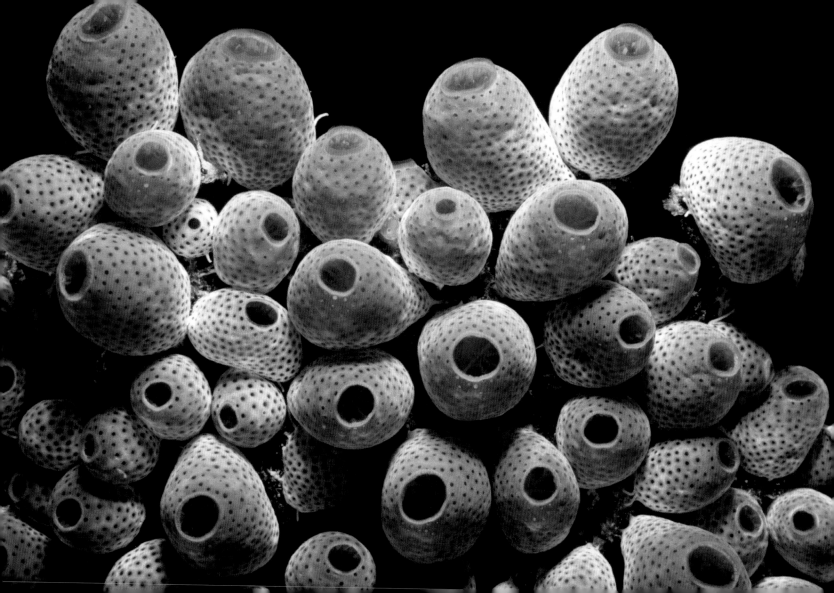

81

Fringehead fish, Monterey, California

This fringehead fish is marvelously camouflaged as it peers from its hole. Its head is the size of a pencil eraser, and the fleshy fringe on top, for which it is named, helps it to blend with the algae around it. Sometimes called the "sarcastic fringehead," this fish is aggressive and territorial. If a diver comes near its home in the cracks of a reef, it won't hesitate to charge. The fringehead also has relatively huge jaws, its mouth being almost half as wide as the fish is long.

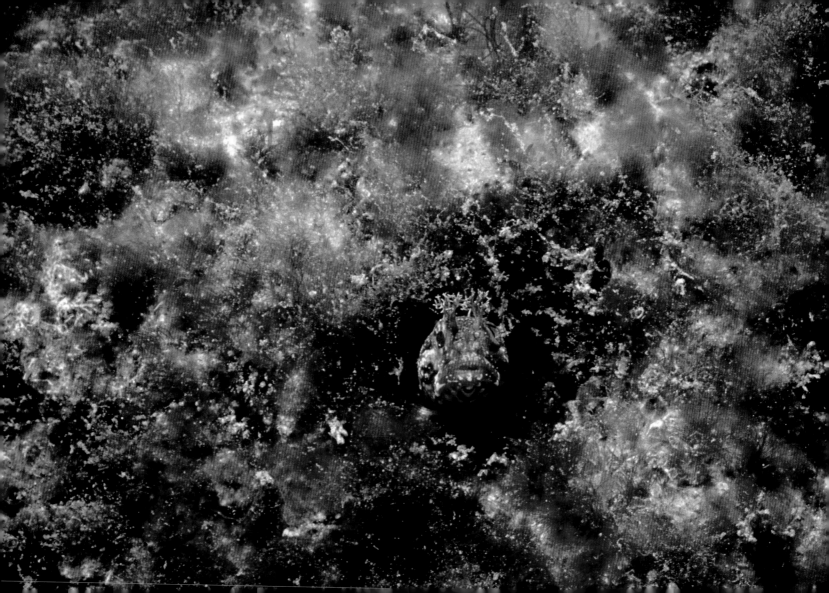

Trumpetfish, Grand Cayman Island

During the day, I would have difficulty getting this close to this very shy trumpetfish. When I came across it on a night dive, however, it froze in the glare of my dive light because it couldn't see me—all it saw was a bright glow moving toward it in the darkness. Trumpetfish often hang out vertically suspended, their long, thin bodies blending in with the gorgonian corals and rod sponges.

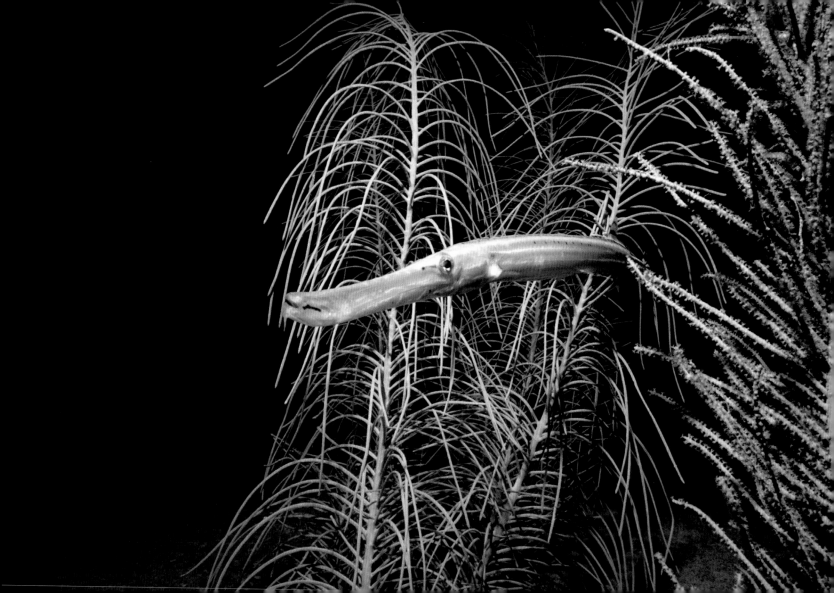

83

Yellow tubinaria coral, Ras Nas Rani, Sinai Peninsula, Egypt

I found this amazing yellow tubinaria coral in the Red Sea. Its voluptuous folds also lend it the common names "scroll coral" and "lettuce coral."

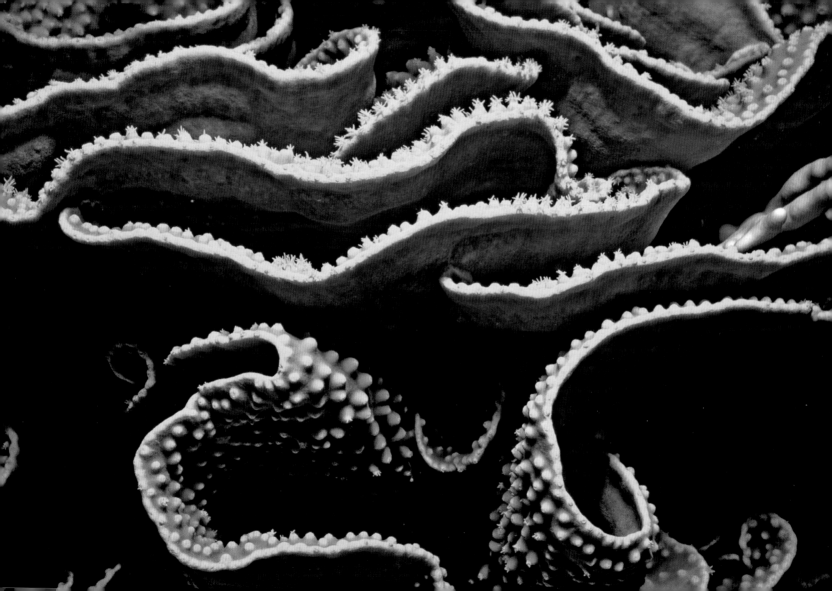

Two-stick stingfish, North Beach, Eilat, Israel

I love the eccentricities of bottom fish. As an underwater photographer you have to—they offer what I like to call "showstopping power." I spent an exciting weeklong adventure in Eilat, trying to find and photograph this rare two-stick stingfish, *Inimicus filamentosis*—its name sounds more like some kind of awful disease than a beautiful fish! This species of scorpionfish uses the two sticklike protrusions on its fins to literally "walk" across the ocean floor, giving it its other name, "the Red Sea Walkman."

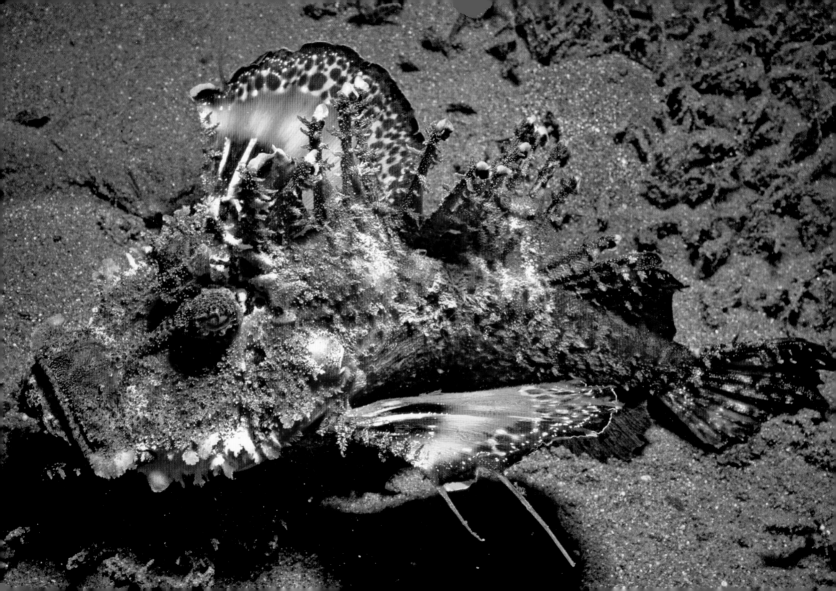

Opposite

Anemone and clownfish, Ras Mohammed, Egypt

This tiny clownfish (far right) is safe in the anemone's stinging tentacles. The symbiotic relationship between these fish and their hosts is considered "obligate," meaning the clownfish probably wouldn't survive for a normal life span without the anemone. In those rare situations where a clownfish is without an anemone host, they've even been observed simulating the relationship with algae or by digging a hole in the sand, which they will then guard and "feed."

85

86

Overleaf Left and Right

Giant Pacific octopus, Vancouver Island, British Columbia

A full-grown giant Pacific octopus can grow to more than one hundred pounds with an arm span of more than ten feet in just three to four years, but contrary to popular belief and science-fiction movies, this animal is harmless to humans and rather shy. This one released close to five gallons of dark brown ink to camouflage its retreat, producing what some biologists call a "ghost image," as it jetted off.

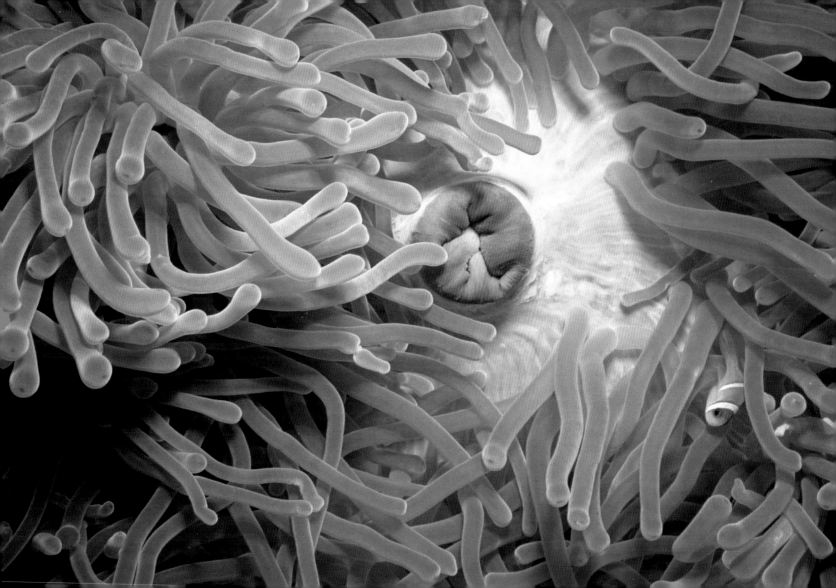

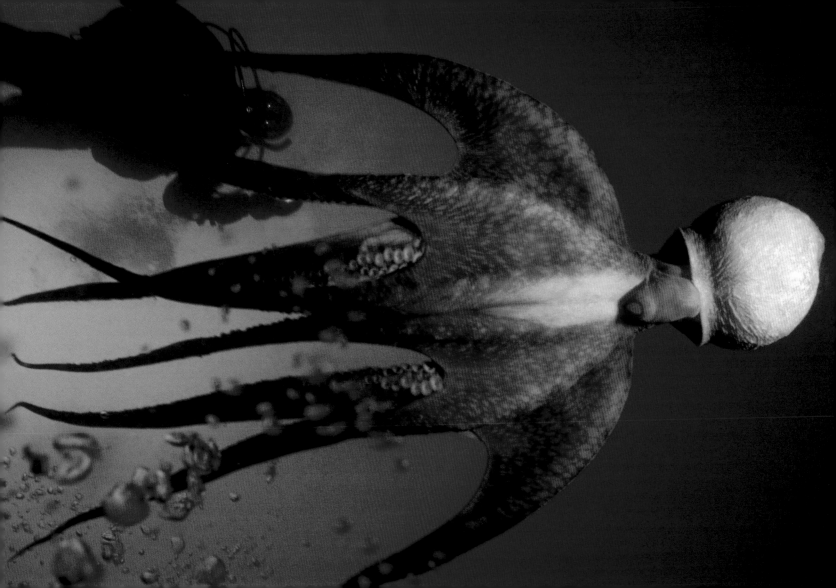

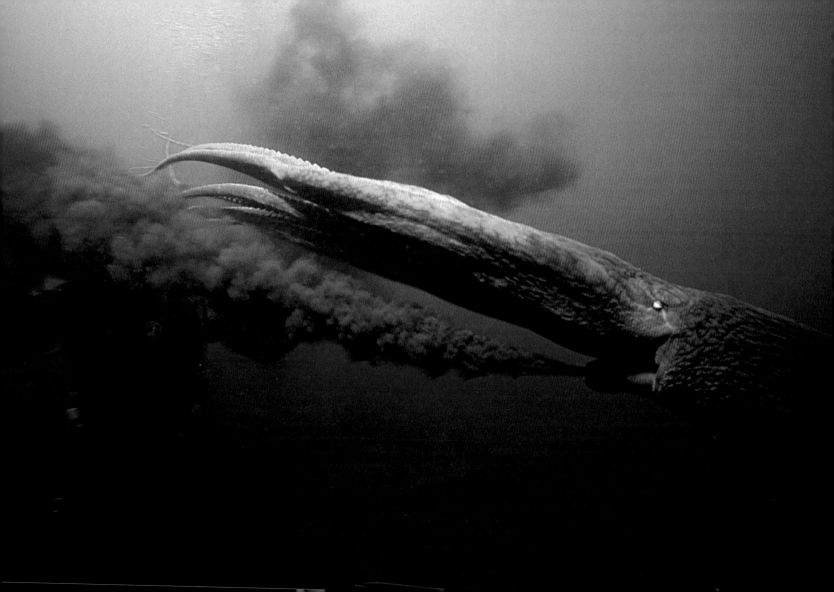

Bigeye, Jackson Reef, Sinai Peninsula, Egypt

Shown here, larger than life, is the most prominent feature of a Red Sea fish known as the bigeye. This fish's very large eyes are actually indicative of its nocturnal habits. They hide during the day in caves and crevices, only to come out at night. Just as our pupils dilate in the dark to make the most of available light, these fish have developed, through evolutionary adaptation, larger eyes, which allows them to see through the black waters of the ocean at night.

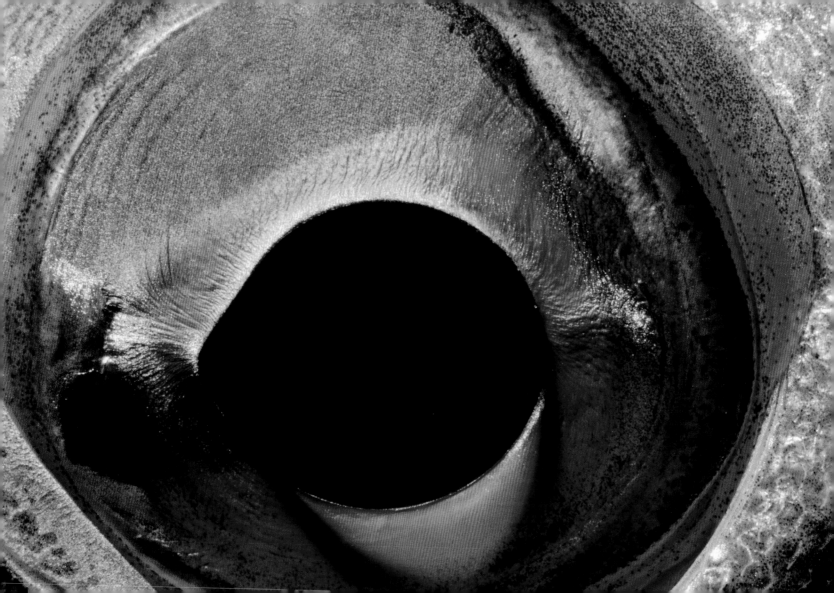

88

Armored tail of orangespine unicornfish, Gordon Reef, Sinai Peninsula, Egypt
Forward-pointing spines as sharp as scalpels grace the tail of this orangespine unicornfish. It erects these weapons, normally hidden in its tail, only when it senses danger. I learned this the hard way on a night dive in the Red Sea. The flash from my camera startled a unicornfish sleeping in a cave. As it fled the scene, its tail sliced through my wetsuit and slashed my thigh, resulting in the need for six stitches.

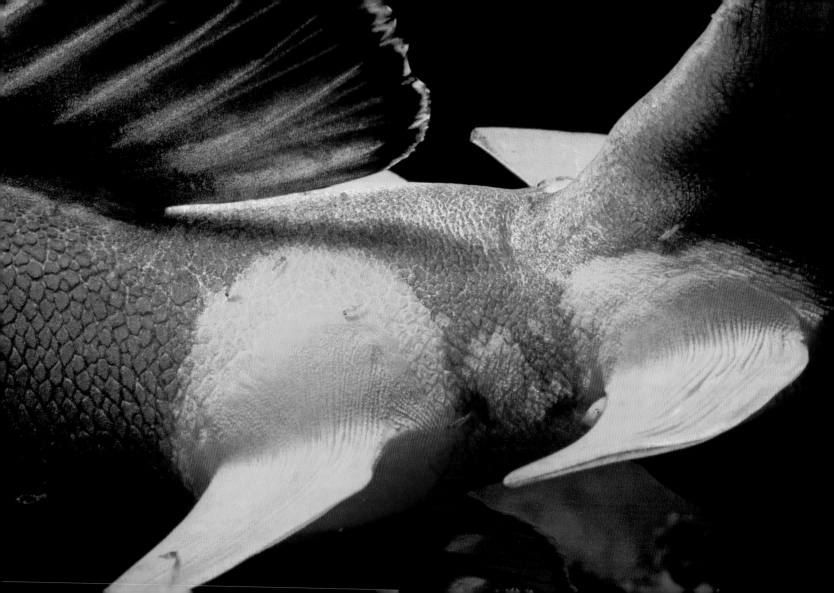

Opposite
Tail fin of a violet-lined parrotfish, Great Barrier Reef, Australia
Biologists have long believed that the vibrant colors of marine fish, like this violet-lined parrotfish, are territorial, defensive, and sexual clues to other fish. But the intricacies of hue and pattern and what they signal still puzzle scientists. Furthermore, different species of fish are capable of processing different channels of light. Humans can see four, but some marine animals, like the peacock mantis shrimp, can see sixteen!

89

90

Overleaf Left
Skin of a lunartail grouper, Tiran Island, Egypt
Most fish have scales: some have different kinds of scales on different parts of their bodies; others have scales on some places but not on others. On most of its body, a lunartail grouper has scales, but this picture shows its "naked" area—the part without scales. The mucus the fish secretes will protect this scaleless skin.

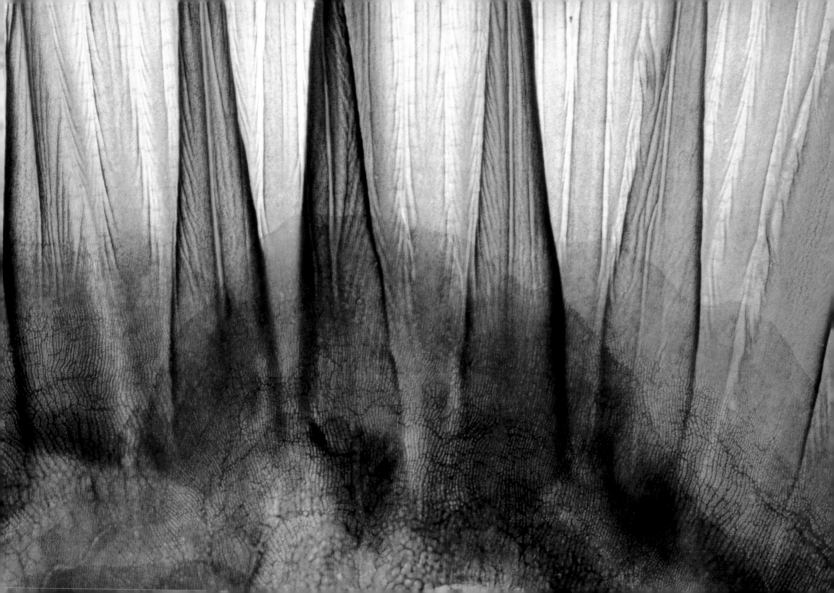

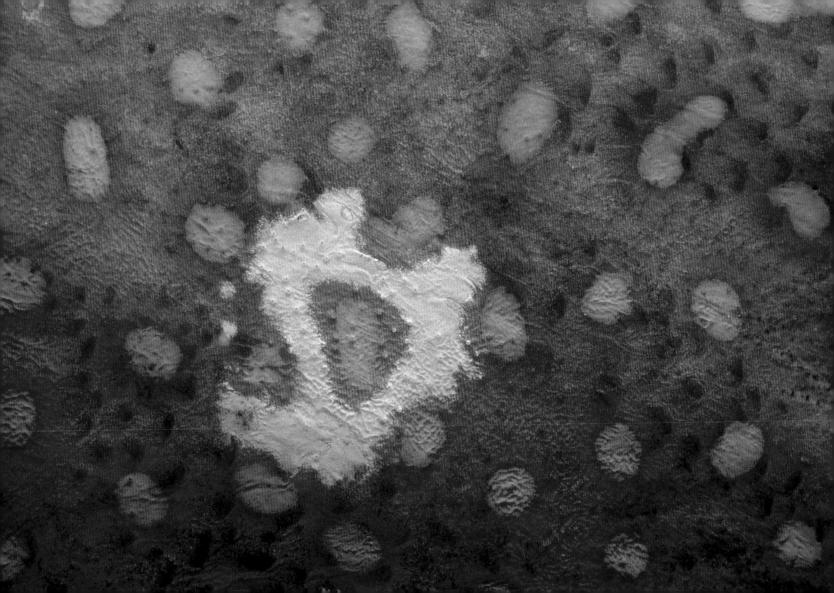

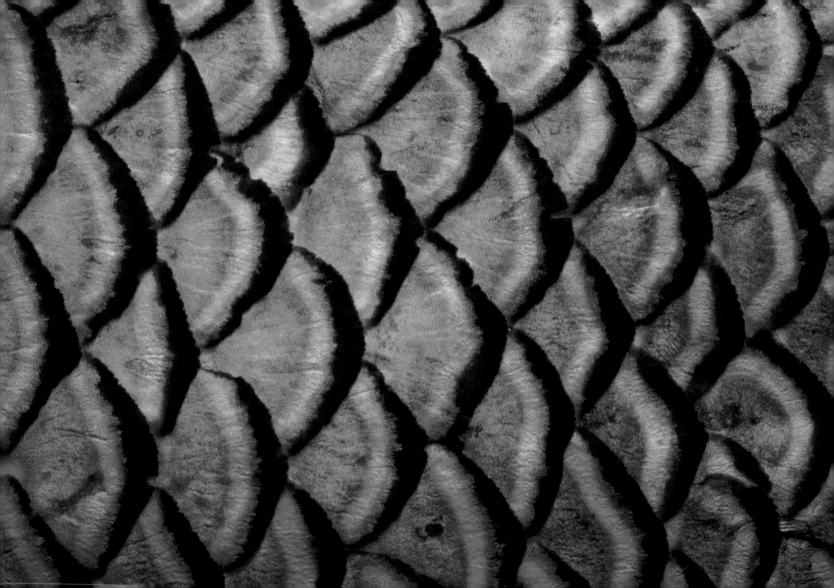

Preceding Page
Skin of female bicolor parrotfish, Jackson Reef, Sinai Peninsula, Egypt
The most common kinds of scales in bony fish are ctenoid and cycloid scales. These overlapping scales are composed of an under layer of flexible collagen and a calcium-hardened outer layer. Cycloid scales are round at the back, while ctenoid scales have a jagged edge, like a comb. Thanks to its bright coloring, you can clearly see the cycloid scales covering this bicolor parrotfish.

90

91

Opposite
Midas blenny, Moses Rock, Eilat, Israel
This tiny, reclusive blenny is living inside the abandoned home of a tubeworm. Tubeworms live in tube-shaped chitin shells. Some species of tubeworms live near hydrothermal vents in the deepest extremes of the ocean. Having no mouths or stomachs, they have to depend on bacteria living within them to convert minerals spurting out of the hydrothermal vents into food. This conversion process is called chemosynthesis.

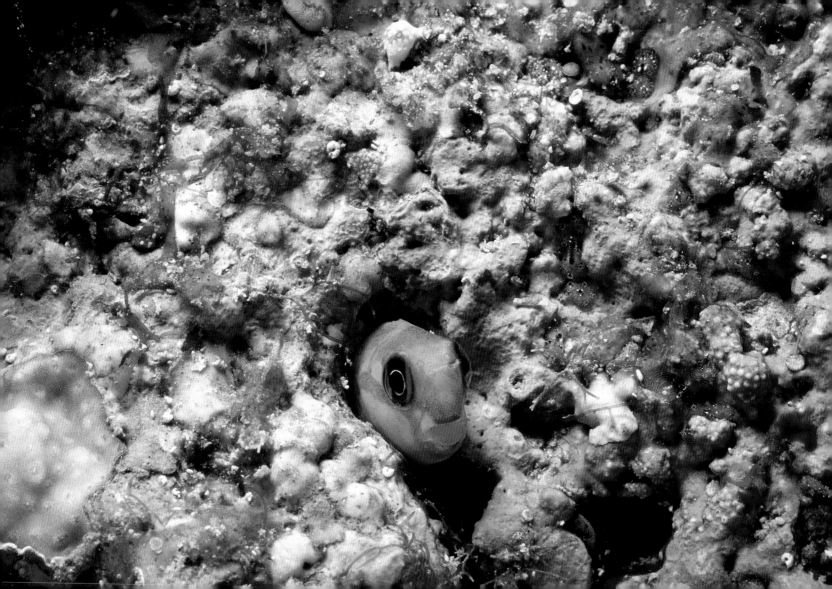

Violet-lined parrotfish, Great Barrier Reef, Australia

Among parrotfish (even between species), male coloration often differs from that of females, with one displaying drab neutral tones and the other sporting vibrant purples, blues, greens, yellows, and oranges. Juveniles of both sexes may carry patterns different from adults and have been known to temporarily change colors, as well as sex. There is even quite a lot of color variation among members of the same species. All this color variation has confused efforts to classify more than a few parrotfish.

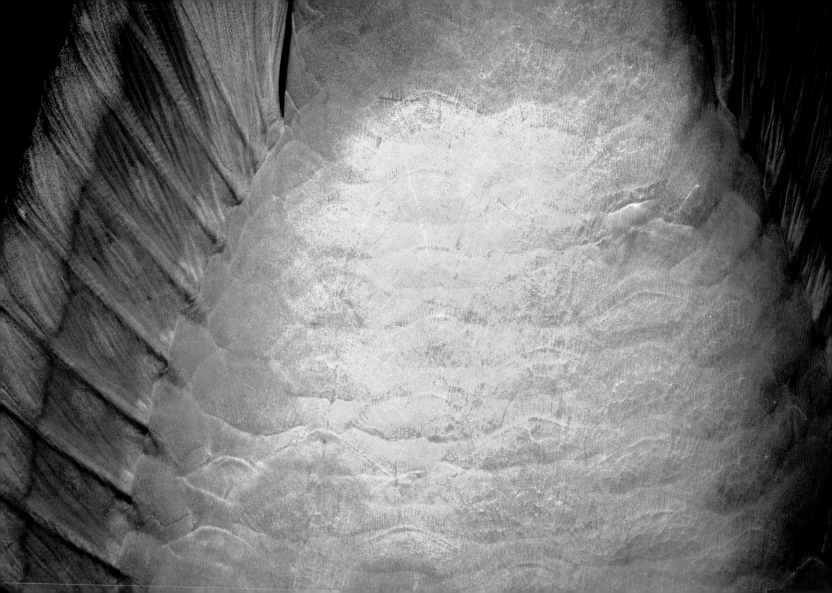

Dorsal fin of a white grunt, Andros Island, Bahamas

The white grunt has two connected dorsal fins, a spiny one and a soft one with rays. Both are totally covered with scales. The fish acquired its name from the odd grunting noises it makes when disturbed by grinding the teeth located in its pharynx. When fighting to protect its territory, it will push back at the other fish by pushing its mouth against the other's mouth in what's called a "kissing display."

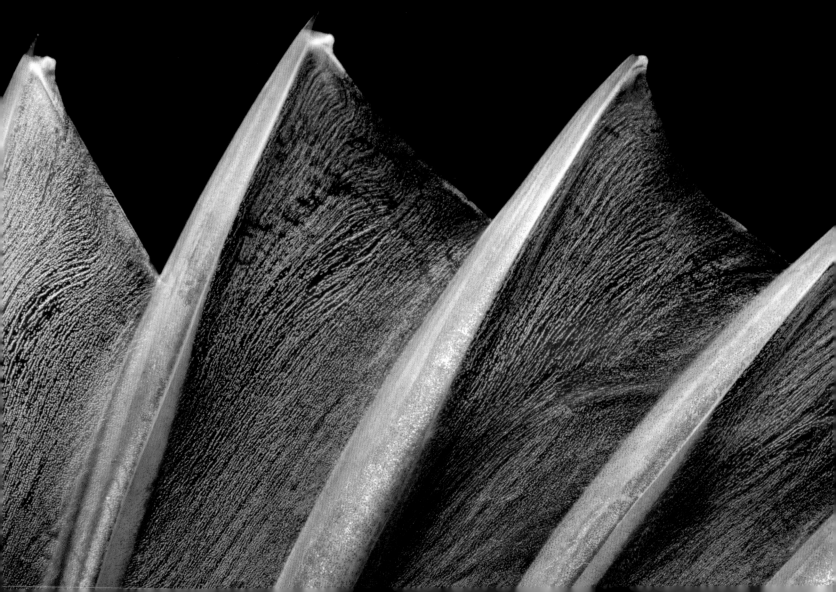

Whitespotted filefish, Andros Island, Bahamas

The elongated snout, specialized mouth, and sharp teeth on this whitespotted filefish help it pick away at small invertebrates attached to the reef and the substantial amount of plant material it feeds on. Its laterally flattened shape helps it fit into narrow cracks and crevices, and the spine on top of its head, actually a modified dorsal fin, is retractable. When the spine is extended, it can be difficult for a predator to pull the fish from its protective hiding place. However, it's not the spine that gives the filefish its name—it's the tiny, sandpapery scales.

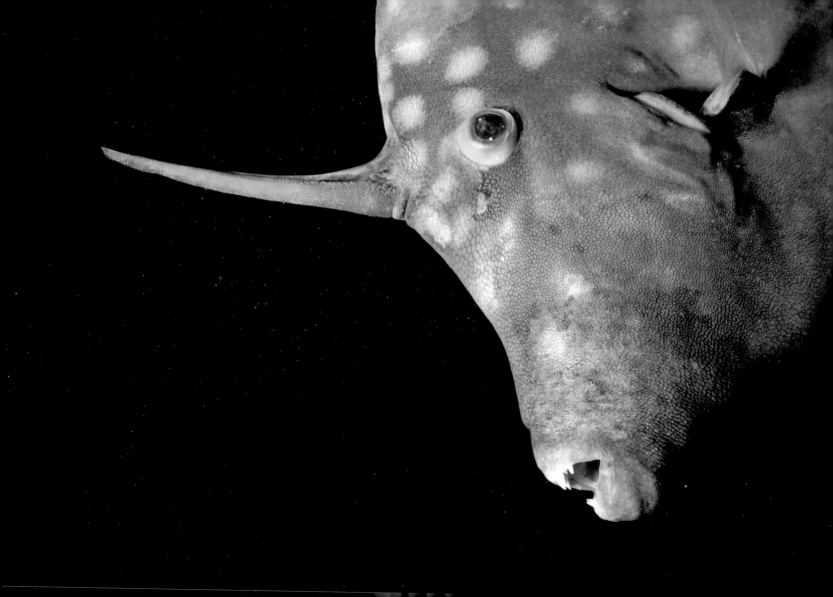

Windowpane flounder, Hodgkins Cove, Gloucester, Massachusetts

Flatness is this flounder's disguise. A windowpane flounder hides on flat sea bottoms, exploiting its shape as well as the ability of its pigment-bearing chromatophores to alter its coloration. Though it can be eaten and is fished commercially, this fish is of little value on the market and certainly not worth the bottom-trawling usually required to catch it. It's so thin that if you held it up to sunlight, its body would appear almost translucent, hence its common name—windowpane flounder.

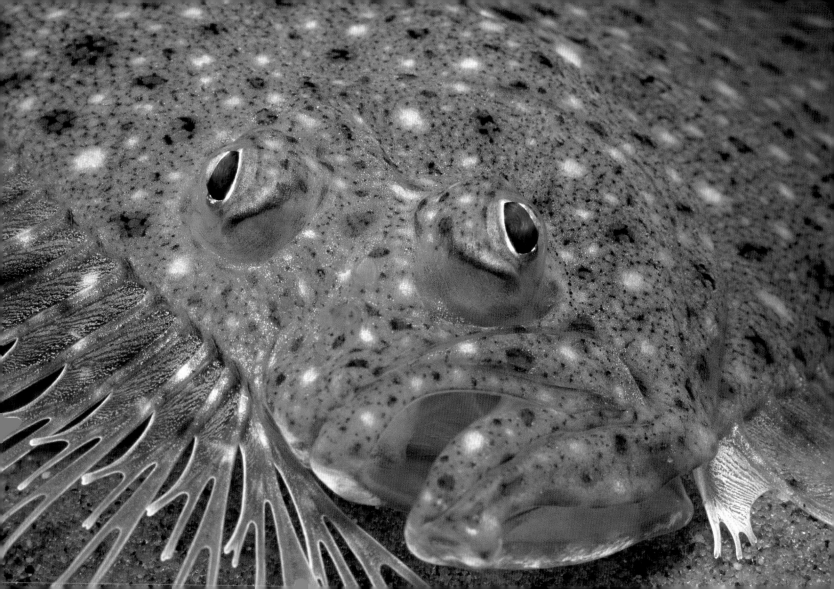

Steepheaded parrotfish, Great Barrier Reef, Australia

I have seen this fish in schools of more than five hundred, grazing on algae-covered reefs. The school moves through the reef, slowing to feed in areas of high algae concentrations. At night, during the calm that accompanies the fish's mucus-covered sleep, I was able to photograph its eye, always open, even in sleep.

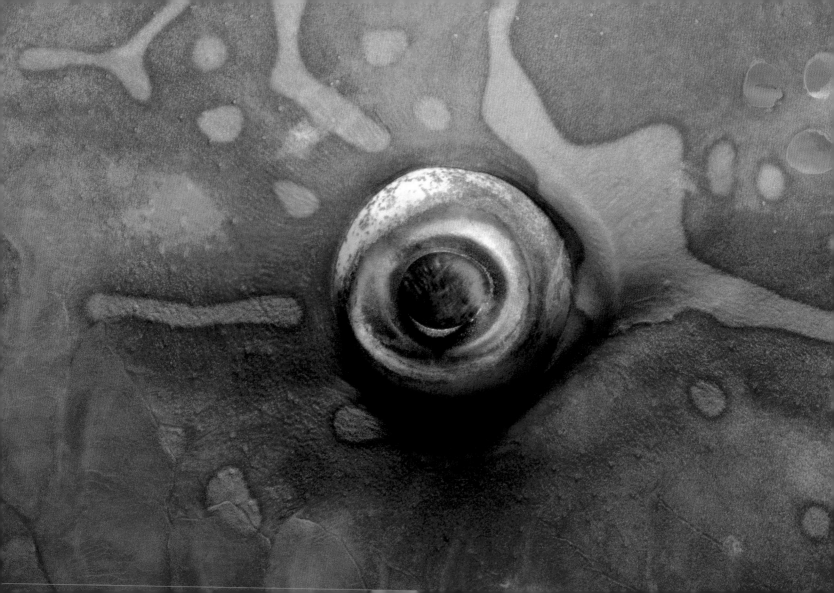

Abudjubbe wrasse, Tiran Island, Egypt

Predators sometimes aim for the eye of a fish when attacking. The orange-red lines radiating from the eye of this abudjubbe wrasse blend in with the rest of the fish's striped body, making it difficult for a predatory fish to isolate its would-be target. Another interesting camouflage is the so-called false eyespot found toward the back and on the tail fins of some of these fish.

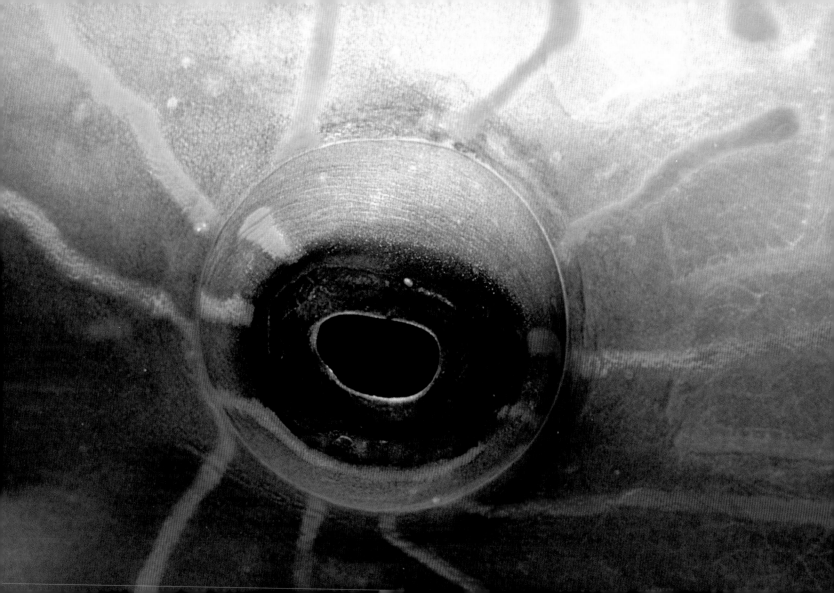

Bluebarred parrotfish, Woodhouse Reef, Sinai Peninsula, Egypt

Parrotfish get their name from two distinct parrotlike characteristics: When swimming, they flap their pectoral fins in a rowing motion, and their fused teeth, joined at the front in a groove, form a pair of beaklike plates. Along with their vivid coloration, this makes for an apt comparison to the tropical bird.

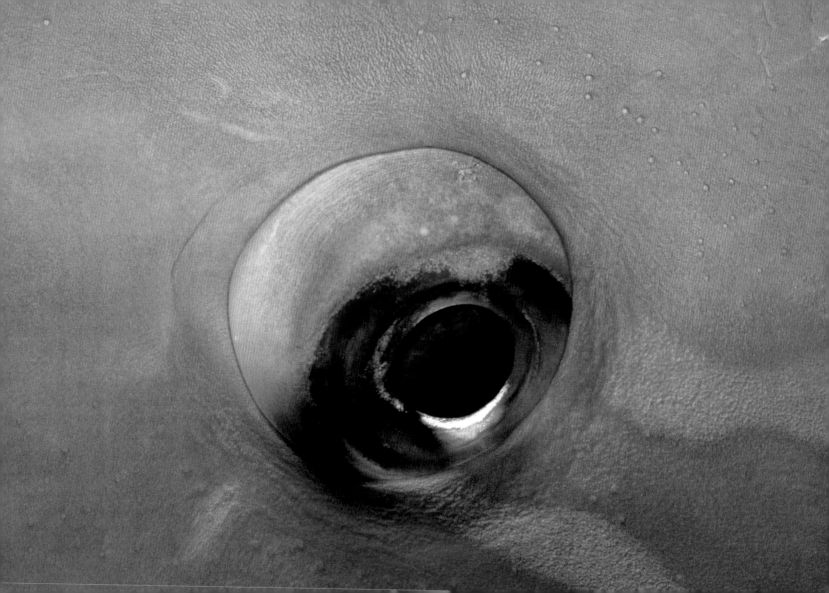

99

Coral grouper, Tiran Island, Egypt

Fish eyes are visual feasts in and of themselves. The pattern of repeating spots surrounding the eye of this coral grouper allows the eye to blend in with the rest of its body and perhaps even the coral it hangs out in. Although it may look as though this fish has an eyelid, it cannot close it for protection like humans can.

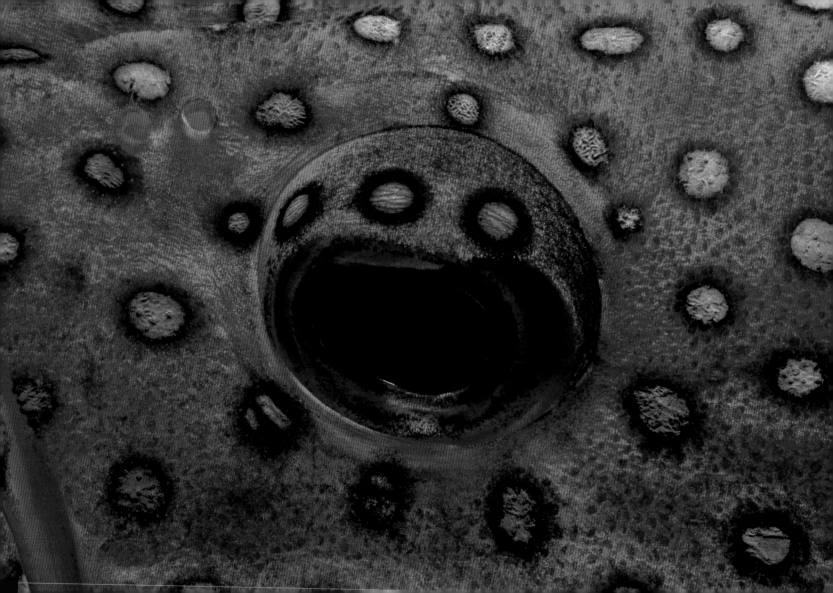

Encrusting sponges, Ras Umm Sid, Sinai Peninsula, Egypt

There are at least five thousand known species of sponges, and they are some of the ocean's most primitive creatures. Attaching themselves to almost any hard surface, encrusting sponges often dominate on the substrate but live in communion with other sessile life forms attached there. Without muscles, nerves, or any internal organs, sponges are filter feeders, filtering the water through their thousands of pores for bacteria and tiny organic particles.

101

Encrusting sponges, Ras Mohammed, Sinai Peninsula, Egypt

Encrusting sponges are an important source of color on the reef. Many of the animals that feed on the sponges, such as nudibranchs, actually incorporate these colors into their bodies as a kind of warning coloration to other fish—the bright colors suggest they are poisonous and might taste bad, so fish avoid them. This photograph was taken on the underside of an overhang at the entrance to a cave.

Gorgonian coral and dead man's finger sponge, Ras Umm Sid, Sinai Peninsula, Egypt

The increased pressure of nitrogen that occurs when diving with an air tank at great depths can literally make you feel drunk. It's called nitrogen narcosis and can be fatal. Divers even have an informal rule measuring its effects called "Martini's Law": Every thirty feet below sixty feet is like consuming one martini. By the time I found this open coral at 230 feet, I wasn't quite sure if its beauty was real or caused by what Jacques Cousteau called "the rapture of the deep."

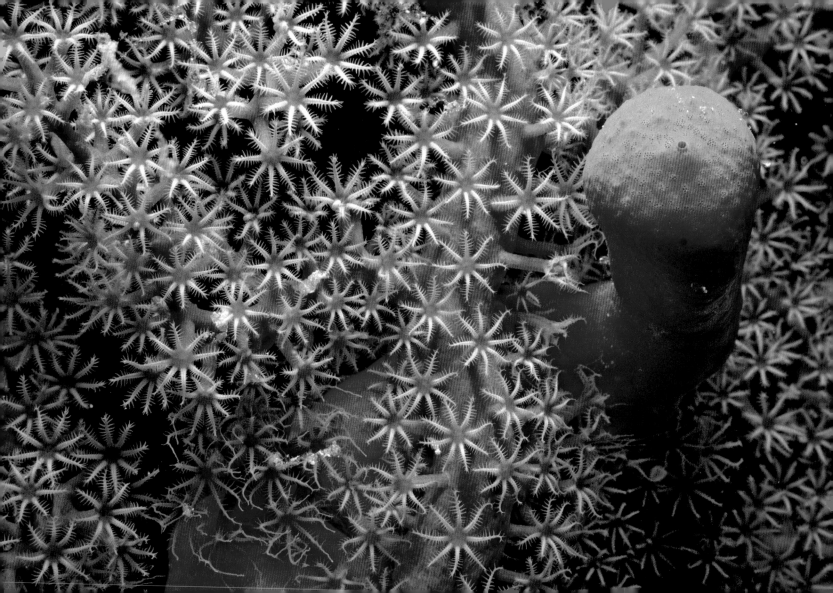

Cup corals surrounded by alcyonarians, Ras Umm Sid, Sinai Peninsula, Egypt

This photograph was taken at ten feet in a shallow cave entrance. The cup corals were attached to the roof of the cave. It was night and both the cup corals and the alcyonarian corals around them were in full bloom and feeding. Alcyonarians are soft corals, while the cup corals in the middle are true, or stony, corals. The alcyonarians lack the hard external shell of the cup corals and their polyps have eight tentacles instead of six.

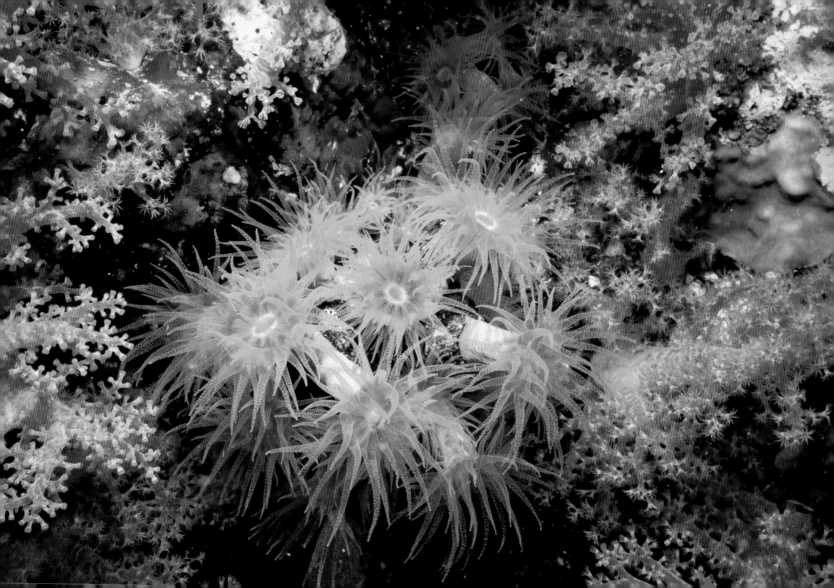

Siphon of a reef octopus, Moses Rock, Eilat, Israel

An octopus moves by jet propulsion. It takes water in through an opening in its mantle—its bulbous, muscular body—by expanding. Then, with a strong contraction of its muscles, it forces the water out through a funnel-shaped crevice called a siphon. The octopus rockets backward, like a balloon suddenly releasing its air. By aiming its siphon, the octopus can move in any direction.

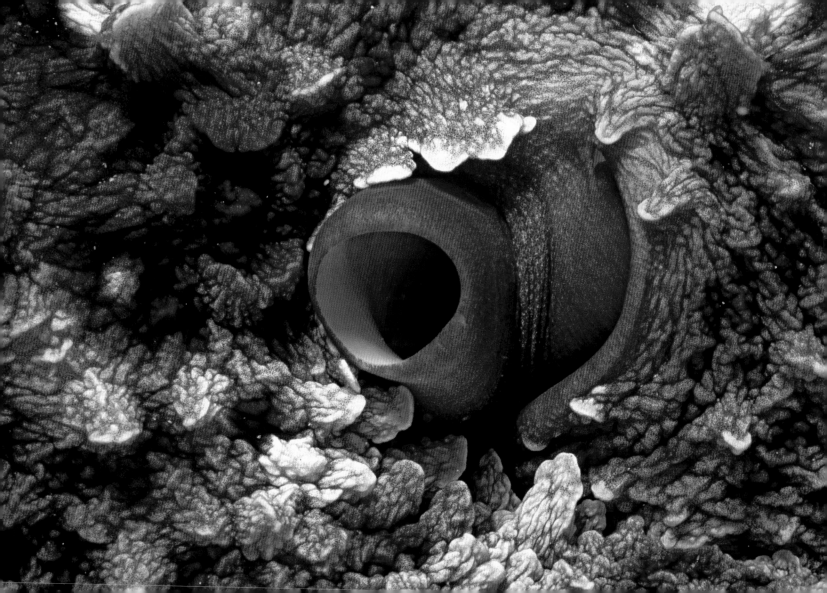

Opposite
Long-armed octopus, Moses Rock, Eilat, Israel
Without a doubt, the octopus is a creature of contradictions. Soft, supple skin encloses a boneless body of surprising strength. Even a four-pound octopus can hold onto a diver with fifty-five pounds of force; a large octopus can exert more than six hundred pounds of pull. Yet, while it is well equipped with eight powerful arms, a sharp beak, and poison, an octopus would much rather retreat than fight.

105

Overleaf Left
Remoras attached to a manta ray, Revillagigedo Islands, Mexico
These remoras—or, as some call them, sucker fish—have the best seat in the house. Their modified dorsal fin is actually an oval-shaped disc that suctions to the skin of their larger host, in this case a manta ray, but they also attach themselves to whales, sharks, tuna, turtles, and even boats. Not only does this offer remoras some protection, it also positions them to take advantage of the host's leftovers after a feeding, for which they will detach themselves.

106

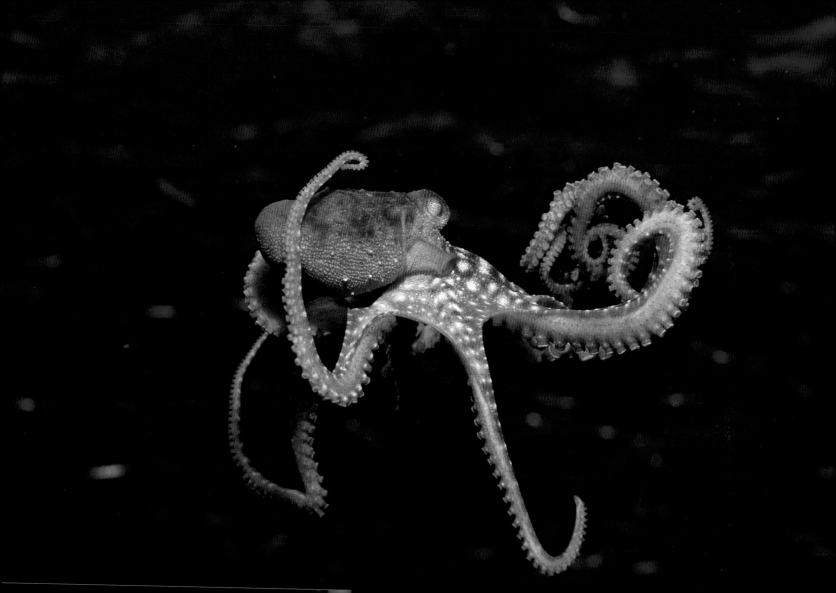

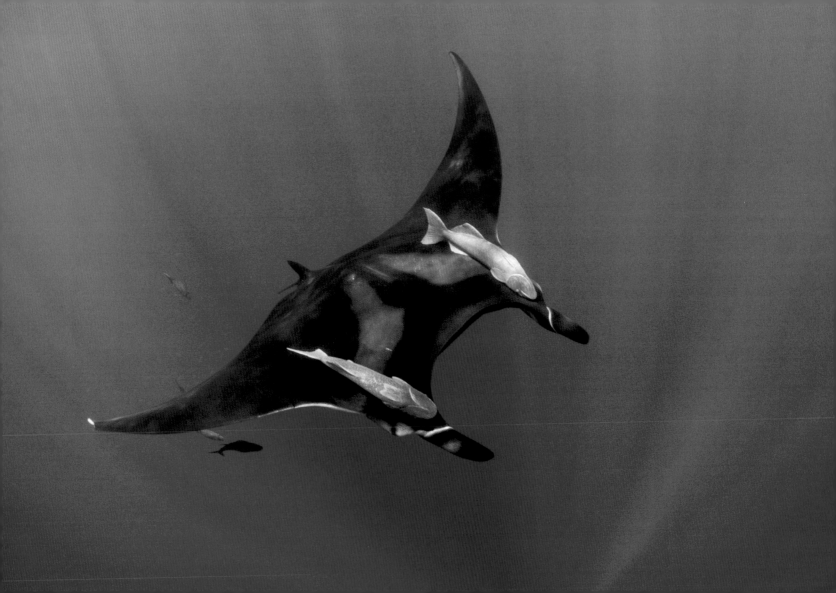

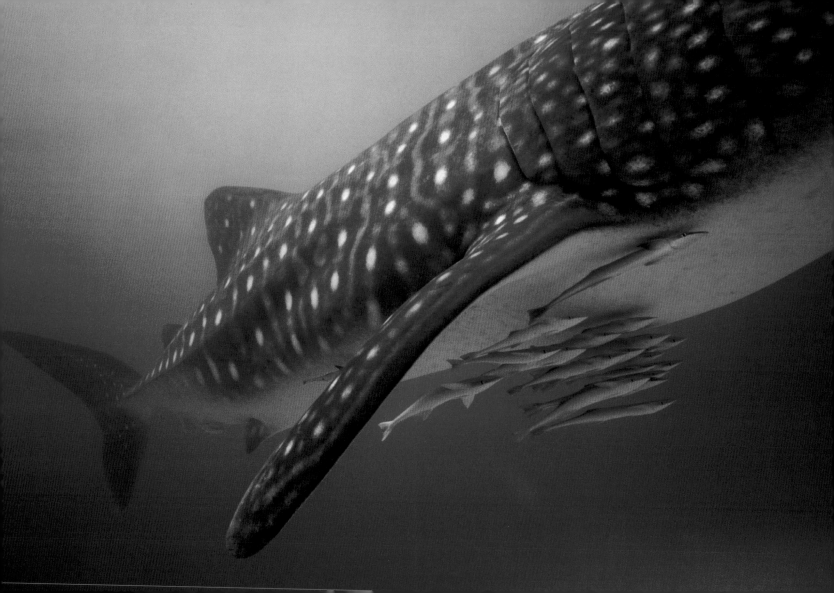

Preceding Page

Remoras accompanying whale shark, Ningaloo Reef, Western Australia

The relationship between a remora and its host is generally commensal. Unlike the mutual symbiosis of a clownfish and a sea anemone, where both parties benefit from the relationship, in commensalism, only one of the organisms, in this case the remora, benefits. This whale shark isn't being harmed by his hitchhikers, but it's not being helped either.

Opposite

Lionfish, North Beach, Eilat, Israel

Beautiful but dangerous, lionfish are common on Red Sea reefs. I have seen them everywhere from the surface down to depths of more than two hundred feet. Their needle-sharp dorsal, anal, and pelvic spines are highly venomous: Two friends of mine have been stung by lionfish and both described the pain as agonizing. Notice that the dorsal spines in this photograph are directed forward—this is defensive posturing, letting any potential threats in the area know that, if provoked, this fish will strike.

106
107

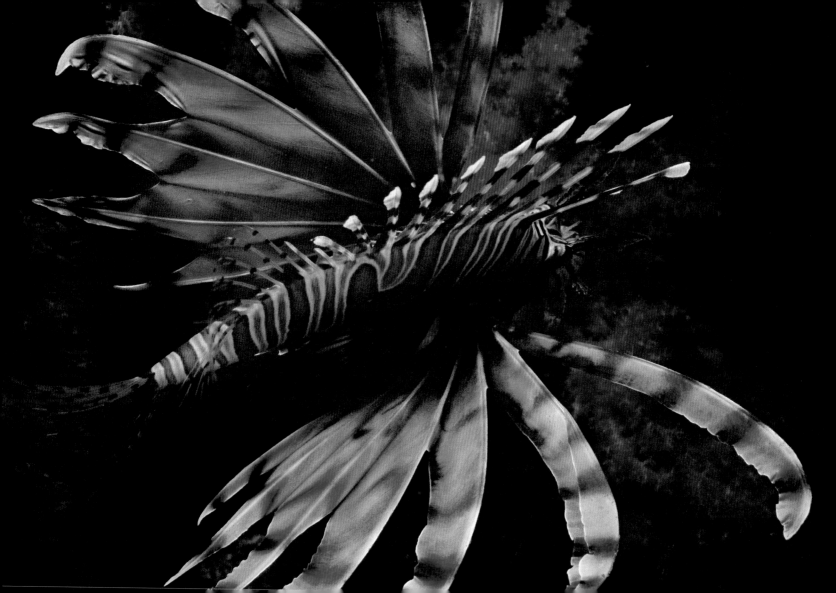

Golden jellyfish, Jellyfish Lake, Palau Islands, Micronesia

Jellies may look delicate, but human reactions to their sting can range from a mild ache to convulsions and even death. Even a dead jelly should be avoided, because its stinging cells are still automatically released when touched. Luckily, I didn't have to worry about this when snorkeling in Micronesia's Jellyfish Lake. Jellyfish Lake is connected to the sea, but by virtue of its being a lake, it is naturally protected, and the jellies have few predators. Without the need to defend themselves, Mastigias jellies have lost most of their sting.

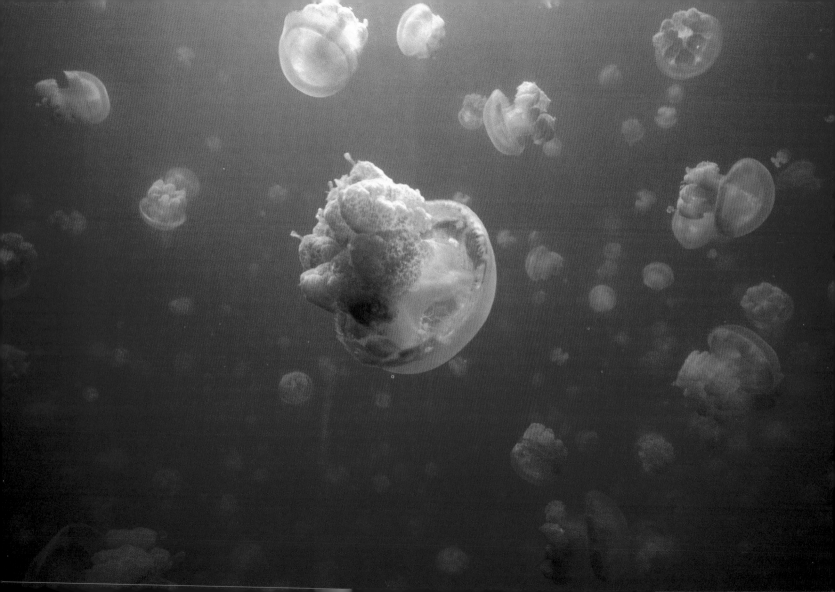

Sea thimble jellyfish, Bahamas

I spent two hours trying to capture this scene on film and ended up covered in welts. It was worth it, though. In some areas, voracious jellies become overpopulated and swarm in the hundreds of thousands, called jellyfish blooms, wreaking havoc on delicate ecosystems. Scientists are still puzzled by the cause of these blooms but suspect they have something to do with the pollution and environmental disruption caused by humans.

Upside-down jellyfish, Gulf of Suez, Sinai Peninsula, Egypt

The upside-down jelly is different in many ways from other jellies. When it swims, it does so with its bell facing toward the sea bottom. In fact, much of the time it can be found lying on the ocean floor—upside down, of course—where it can easily be mistaken for some kind of greenish-brown coral or anemone. Upside-down jellies have symbiotic algae living in their tissue; by extending their frilly tentacles upward, they get their meals two ways: first, by exposing the algae to the sunlight it needs to perform photosynthesis (making sugar and oxygen), and second, by setting a stinging trap for zooplankton.

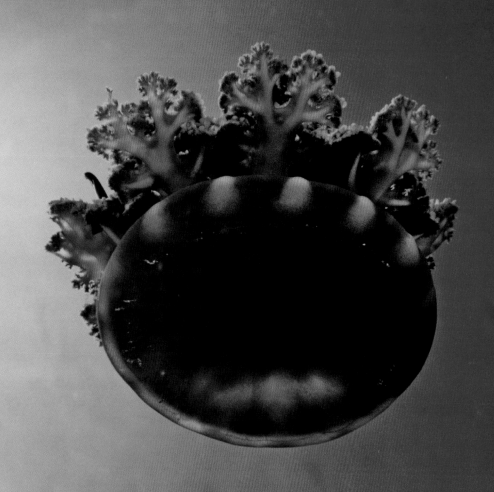

Mantle of Tridacna clam, Ras Mamlach, Sinai Peninsula, Egypt

In self-defense, this giant clam closes its shells together as soon as it feels a touch against its mantle, the soft, colorful (blue, in this case) tissue lining the inside of its shells seen here. A strong muscle inside, at the base of the two shells (the same muscle we eat in scallops), keeps the shells clenched tightly together until it feels no more pressure. No account of a human death by giant clam has ever been substantiated, but if you did manage to get yourself stuck in one, you would need to cut this muscle to free yourself.

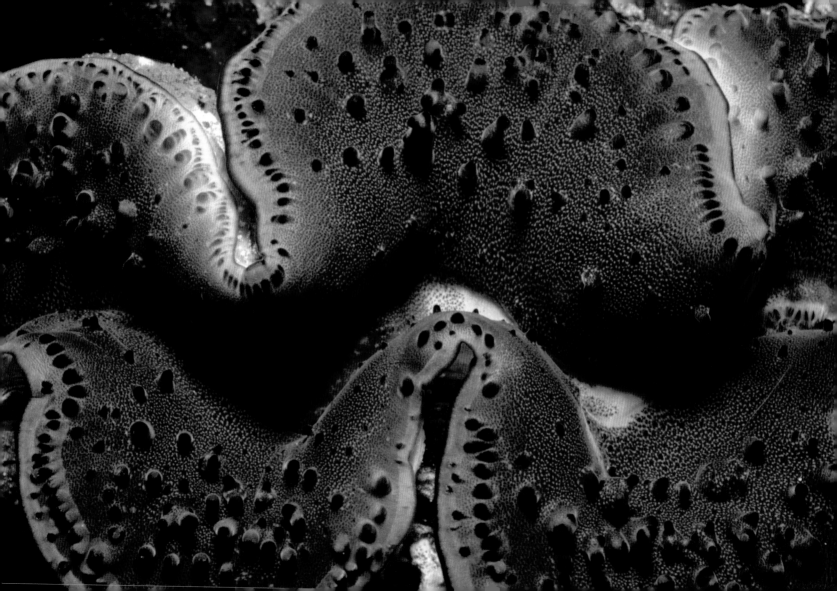

Whitetip reef sharks, Cocos Island, Costa Rica

Cocos Island is appropriately known in shark circles as Island of the Sharks. Indeed, to see in excess of one hundred whitetips working the reef in search of prey is a sight not easily forgotten. As bottom dwellers, these sharks rarely come to the surface; instead, they poke their noses around the substrate for octopuses, crabs, lobsters, and many kinds of fish.

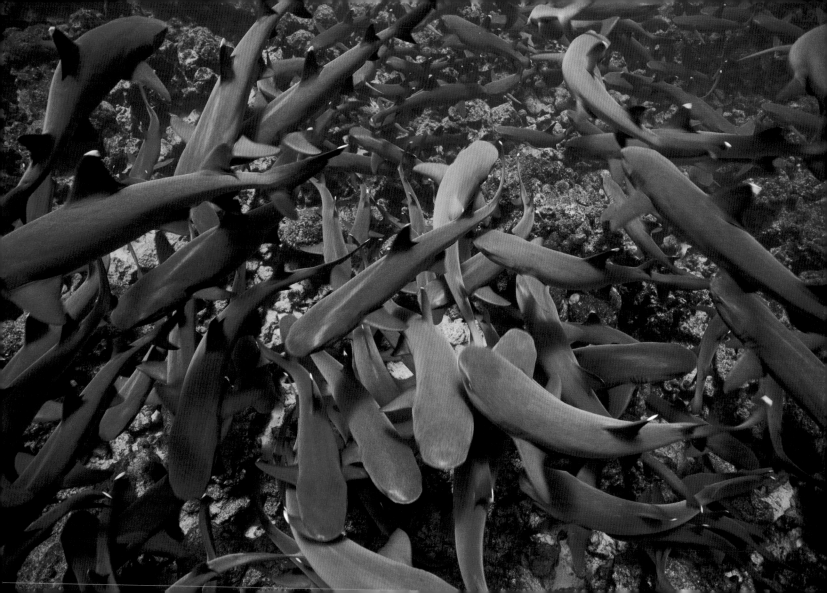

Venomous catfish, Kimbe Bay, Papua New Guinea

I couldn't believe my eyes—a giant school of venomous catfish was swimming in this ball-like formation, something I'd never seen before. This school would split and rejoin many times over the course of my dive. You might not think of catfish as poisonous, but some species have extremely sharp, venomous spines on their dorsal and pectoral fins. They're used for defense, not attack, but you still wouldn't want to run into one!

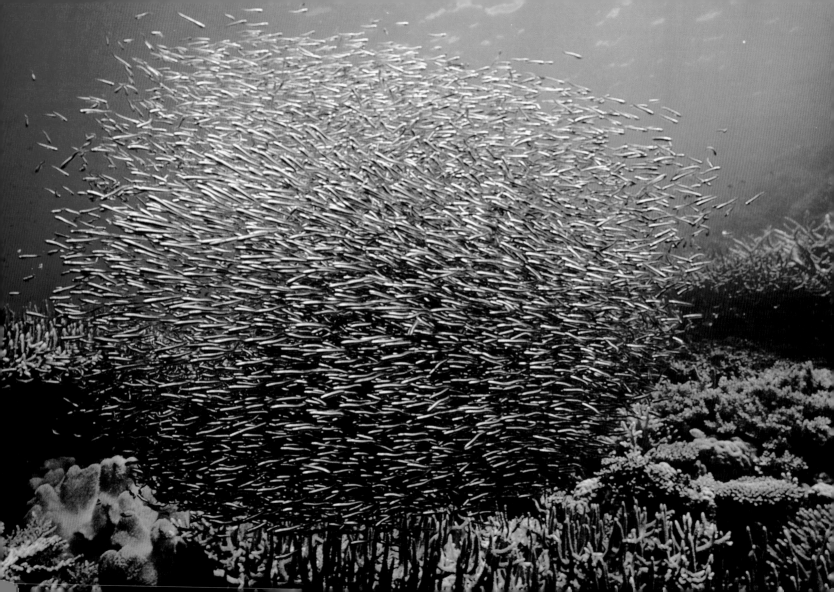

114

Coral Garden, Tiran Island, Egypt

A fellow diver told me one day that he had found a reef that had to be seen to be believed. When I did, my jaw dropped: An area the size of a football field and only forty feet deep, this reef is a collection of the most fantastic coral architecture I have ever seen. Every size and shape of coral imaginable is represented. The reef is protected on all sides from the open sea, but clearly it receives a healthy exchange of water and nutrients. The abundant caves absolutely delighted my son. The array of fish life is stunning; schools of needlefish and parrotfish swam all around us. We felt we had discovered the Garden of Eden.

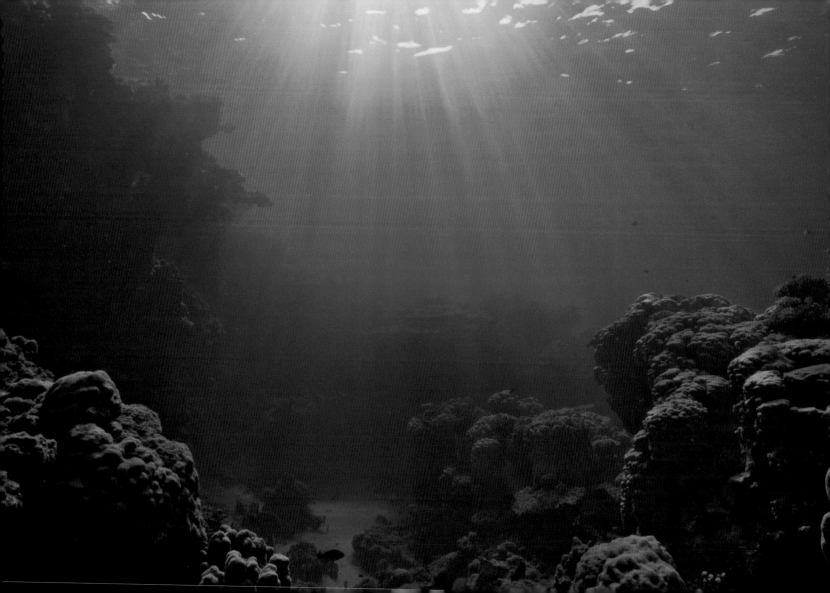

Encrusting sponge, Ningaloo Reef, Western Australia

Sponges are hermaphrodites, which means that an adult sponge can produce both eggs and sperm. First, sperm is released into the open water where it may meet with another sponge's eggs and become fertilized as it free-floats. More often, however, the sperm finds its way to another sponge and fertilizes an egg there. The larva is released and floats about on tiny hairs before settling onto the substrate or reef and maturing into another sponge. Then the process begins all over again—the circle of life.

Sea horses on alcyonarian coral, Dolphin Reef, Eilat, Israel

Sea horses display unique reproduction behaviors. They're generally monogamous creatures, which is unusual in the animal kingdom, but the most unusual aspect of sea horse reproduction is the fact that the male is the one who becomes pregnant. First, the female lays her eggs in a brood pouch located in the stomach area of the male. The male then fertilizes the eggs, carries them for approximately forty-five days, and gives birth to 15 to 1000 sea horses, which are perfect miniatures of their parents and totally self-sufficient. Now, that's a real Mr. Mom!

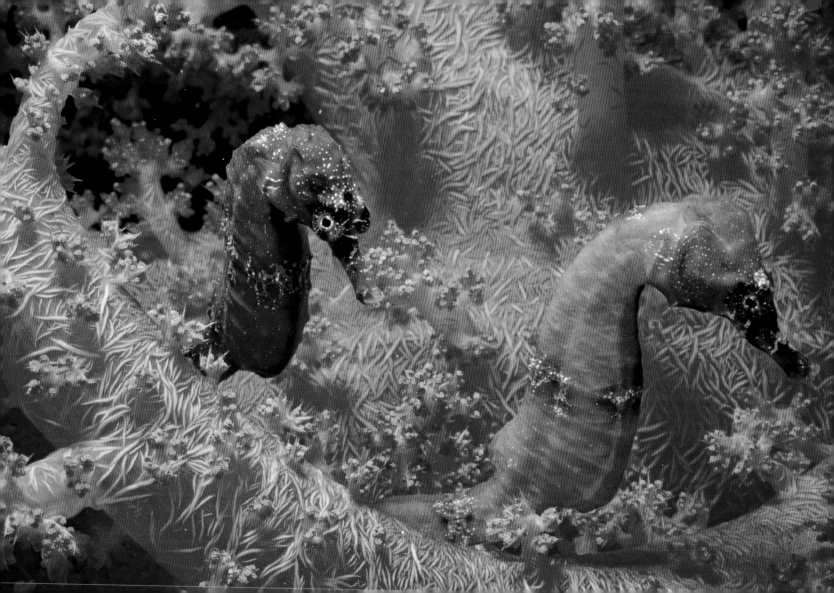

Branched gorgonian coral, Kimbe Bay, Papua New Guinea

Soft corals, like this gorgonian swaying in the ocean current, animate the reef. Rather than the hard, calcium carbonate exoskeletons of "true" corals, these sea fans have flexible internal skeletons. Structures in their tissue called spicules give the soft corals their shape and some stiffness but allow them to bend without breaking.

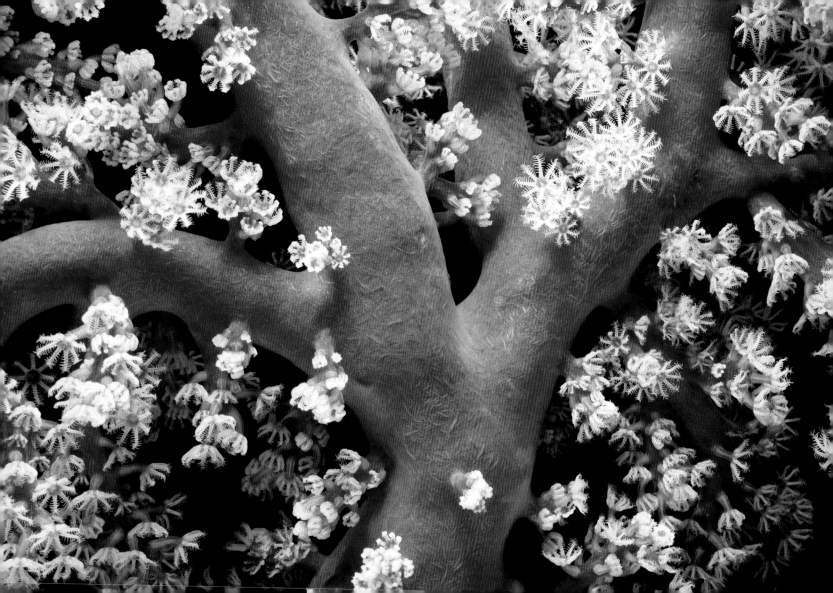

Purple sea urchin, Ustica Island, Sicily

The mouth on the underside of a sea urchin has five clawlike teeth. Together with the digestive juices in the urchin's five-chamber stomach, these plates do the chewing and are known as "Aristotle's lantern," after that philosopher's description of the animal in his *History of Animals*. The mouth of the sea urchin is its weak point. When exposed, this purple urchin points its spines toward its mouth to protect itself from attack.

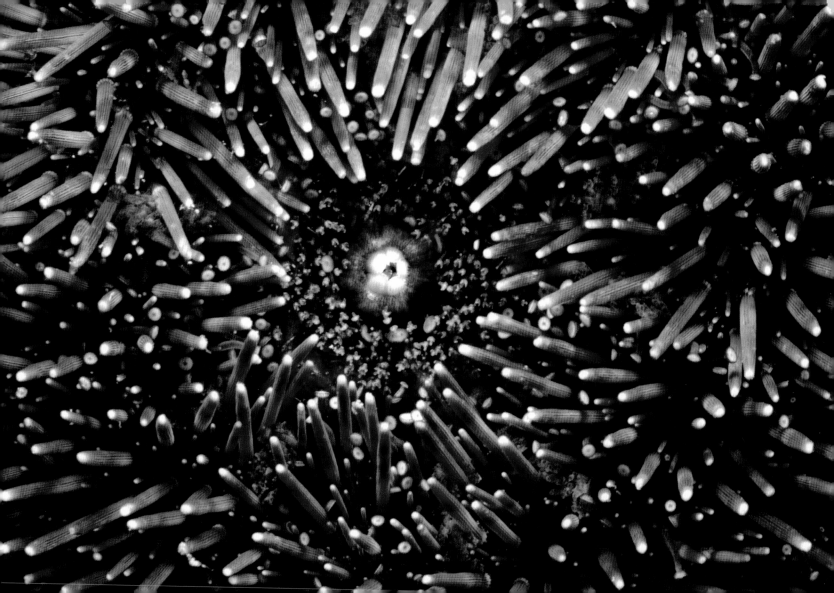

Brittle star, Grand Turk Island, Turks and Caicos

Brittle stars are so named because they can voluntarily break off their arms to distract predators—whatever "voluntarily" means when applied to an animal with nothing even remotely resembling a brain. The severed arms, which grow back rapidly, continue to twist and squirm by themselves, giving the star itself a chance to head for cover. Despite this clever defensive strategy, brittle stars invariably make themselves scarce by day, squeezing their flattened bodies into tiny crevices. By night, however, many of them emerge, as did this one pictured here, to roam across the reef in search of food and, occasionally, mates.

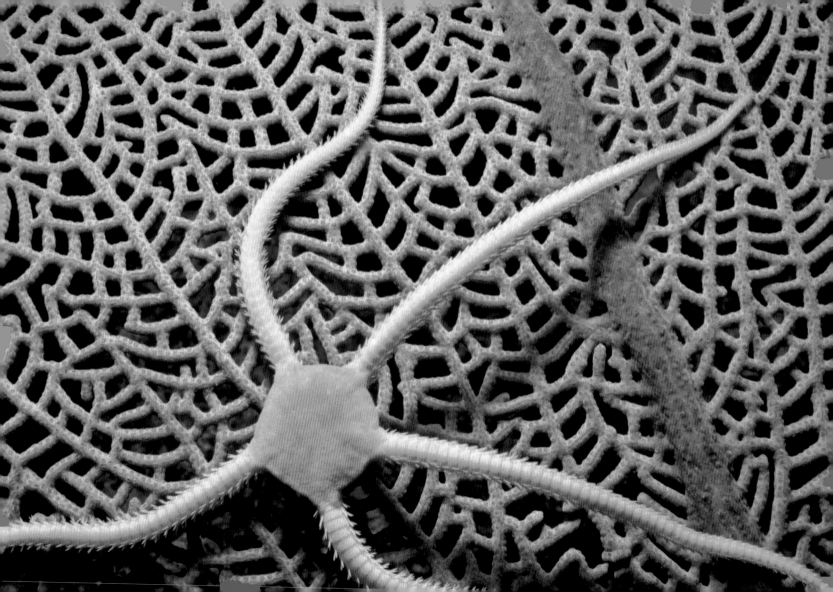

A blue-spotted stingray, Ras Mamlach, Sinai Peninsula, Egypt

This blue-spotted stingray injects poison into a victim by stabbing it with a spine located about halfway down its tail. While stingray attacks have been known to kill humans, most notably the recent death of "Crocodile Hunter" Steve Irwin, this is primarily a defensive, not an offensive, mechanism. A stingray would much rather flee than fight.

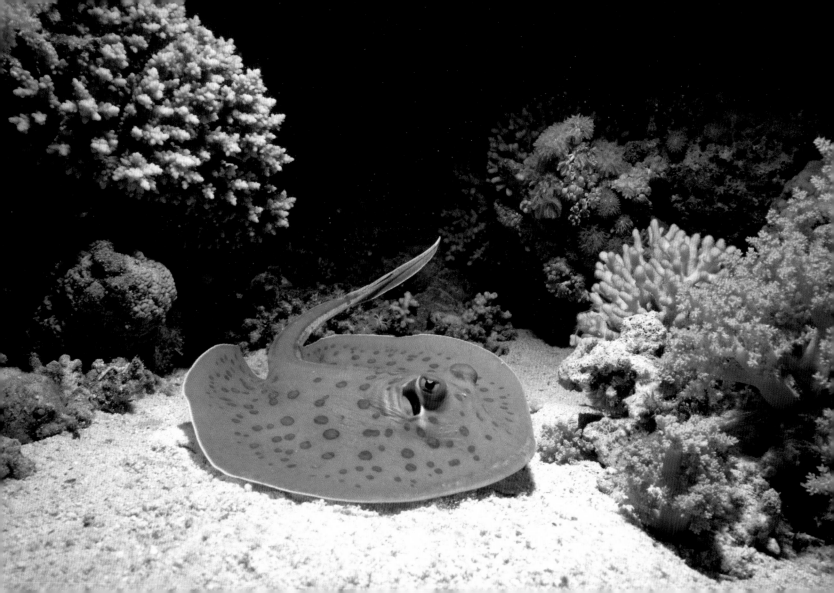

Blue-spotted stingray, Perth, Western Australia

Sometimes humans are a marine animal's number one predator. Their unique coloration makes blue-spotted stingrays popular in the aquarium trade, but they are difficult to care for in captivity. When I first started diving in the northern Red Sea in 1972, this blue-spotted stingray was ubiquitous in many areas. Far fewer of these beautiful creatures grace these waters today, casualties of unregulated fishing and intensive development along the Sinai Peninsula.

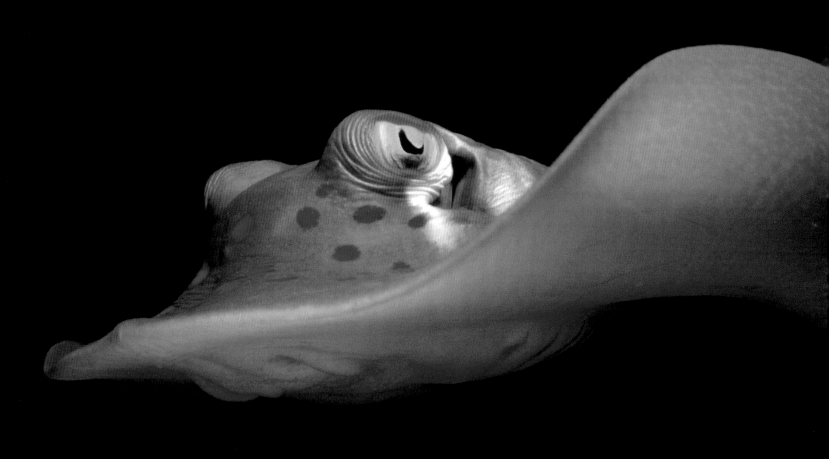

Bigeye thresher shark, Cocos Island, Costa Rica

This majestic bigeye thresher shark was easily more than ten feet long (adults can grow up to almost sixteen feet). It has purplish gray skin and huge eyes set in a flat-topped head, but its most startling feature is a long, curving upper tail-fin lobe, nearly as long as the rest of the shark, which it uses to stun the pelagic fish it hunts. This also makes it a very good swimmer that can even jump out of the water.

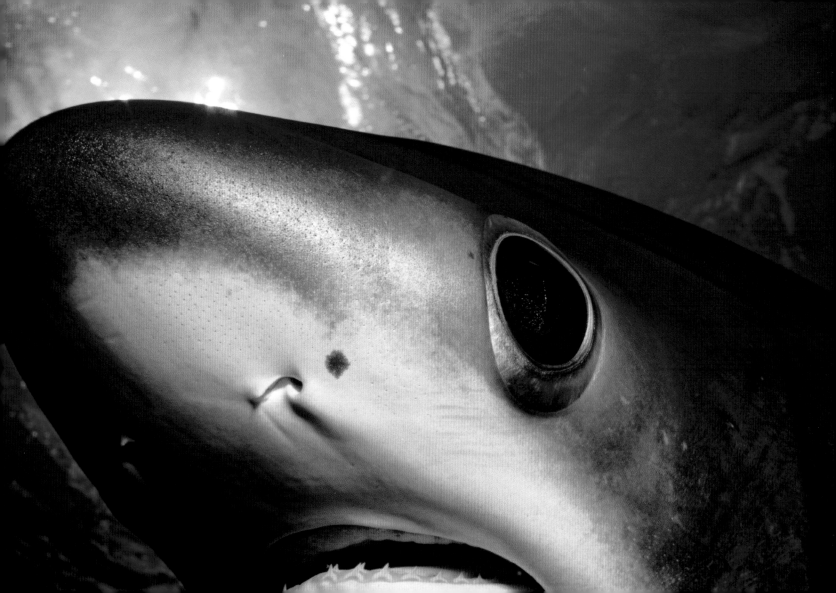

Great white shark, Guadalupe Island, Mexico

Diving with great whites has become the holy grail for divers interested in sharks. It had long been known that they could be found close to Guadalupe Island in Mexico. Back in the 1970s, an American spear fisherman lost his life to an attack here. In 1999, divers began going down in antishark cages to film and observe these alpha predators, which is how I got this shot. In late August through early December the sharks make their appearance, and the excellent visibility of these waters promises an unforgettable experience with these rulers of the food chain.

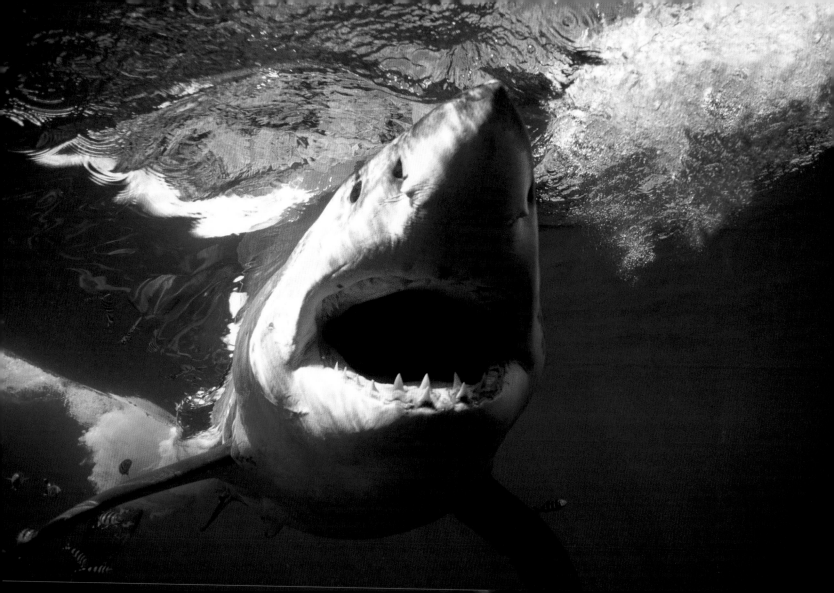

Caribbean reef shark, Walker's Cay, Bahamas

No one would dare to encroach on the grace and dignity of this pregnant Caribbean reef shark. It's the opportunity to meet majestic creatures such as this that draws visitors to shark-diving resorts. Shark feeding is not prohibited in most Caribbean waters, and many dive operations in the area now include the activity. But thanks to the recent intervention of environmentalists, Florida now bans the feeding of all marine life in its waters.

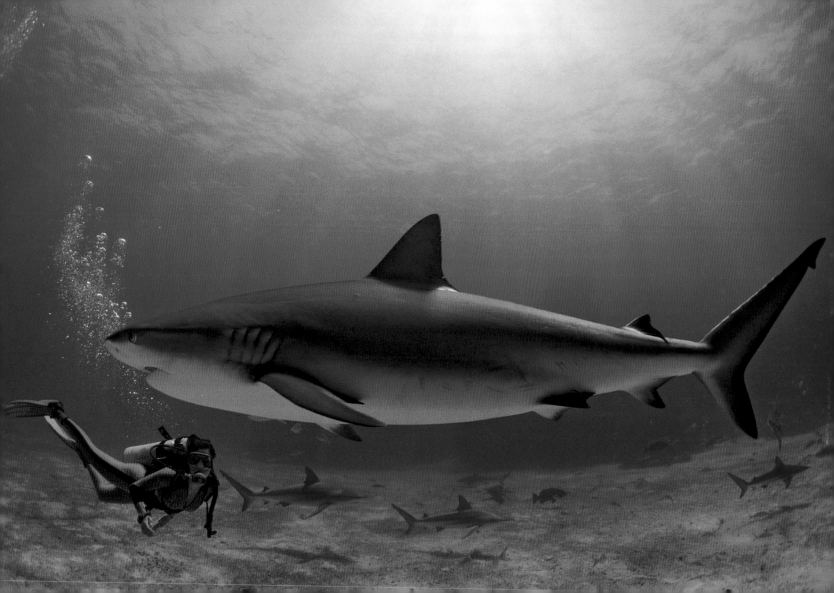

Whale shark, Ningaloo Reef, Western Australia

This photo was taken within feet of a massive whale shark—can you see the diver just to the left of it? This species is the largest of all fish, sometimes reaching up to fifty feet in length and weighing more than twenty tons—that's approximately three African elephants. Its enormous mouth impresses all but the plankton it consumes. Despite their bulk and daunting appearance, whale sharks are quite gentle creatures.

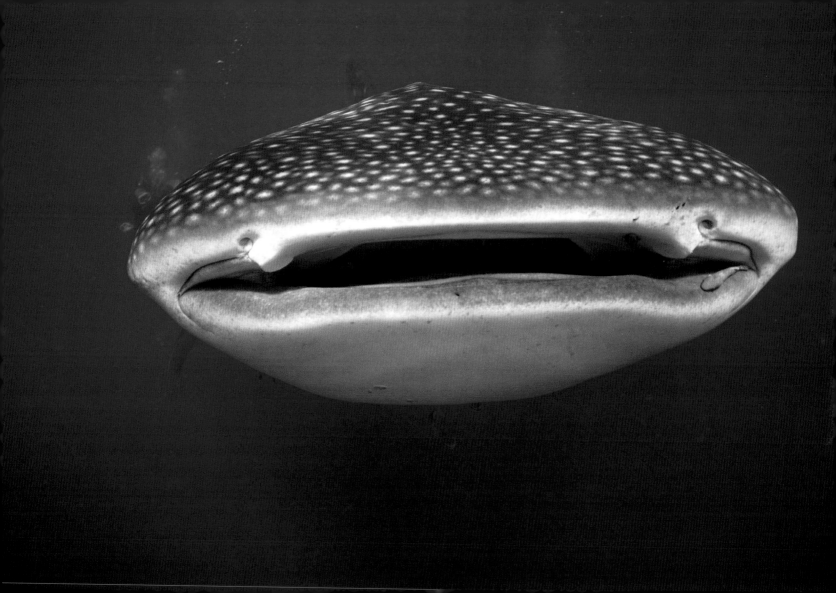

Opposite

Whale shark, Ningaloo Reef, Western Australia

The skin on the back of a whale shark, notable for its checkerboard design of spots and stripes, is extremely thick (sometimes up to four inches) and tough. Its white belly is made of a much softer tissue, and the shark only allows divers to approach its tougher side. Whale sharks are known to migrate, and large numbers collect around this particular reef, off the west coast of Australia, from March through June, possibly to take advantage of high concentrations of plankton from coral spawning that occurs at that time.

Overleaf Left and Right

Whale shark, Ningaloo Reef, Western Australia

Like a living reef, the whale shark is often accompanied by smaller fish, like this golden trevally, which either seek refuge in its shadow or forage for its leftovers. The whale shark feeds on microscopic, shrimplike plankton; small fish; and occasionally larger ones. It's a filter feeder, and it appears at Ningaloo Reef in April and May because it has learned that during this time deep upwellings trigger plankton and especially krill blooms.

126
127

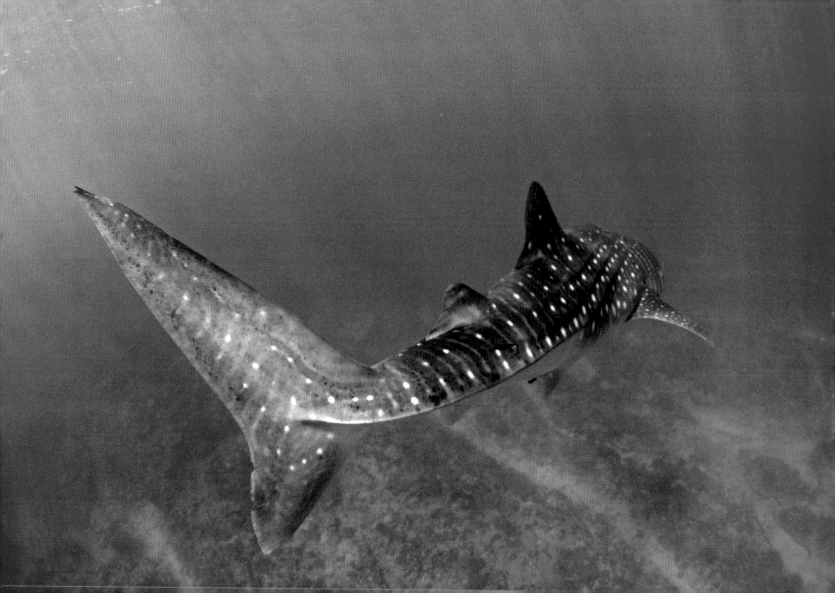

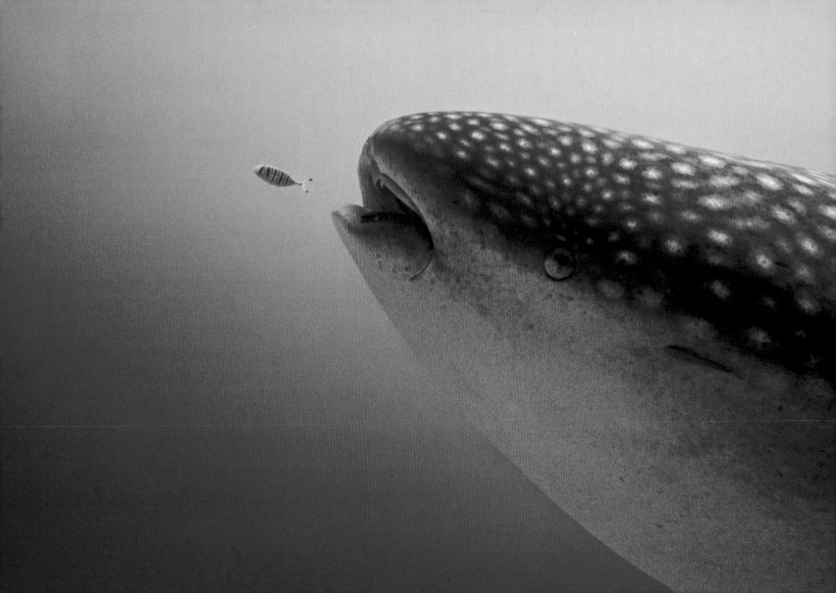

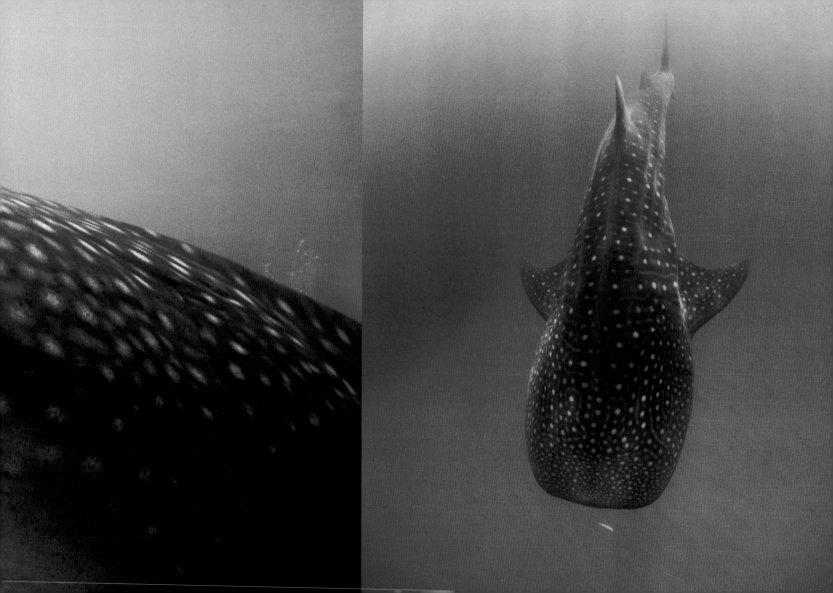

Basking shark, Isle of Man, United Kingdom

It only feeds on plankton; nevertheless the size of a basking shark's enormous mouth can be frightening. Its jaws, seen here, are lined with hundreds of tiny teeth that are mostly vestigial. Plankton is strained out as up to two thousand tons of water an hour flow through the shark's mouth and five large pairs of gills. Sightings of thirty-foot-long basking sharks lolling at the ocean's surface have inspired many a legend of sea monsters by ancient mariners.

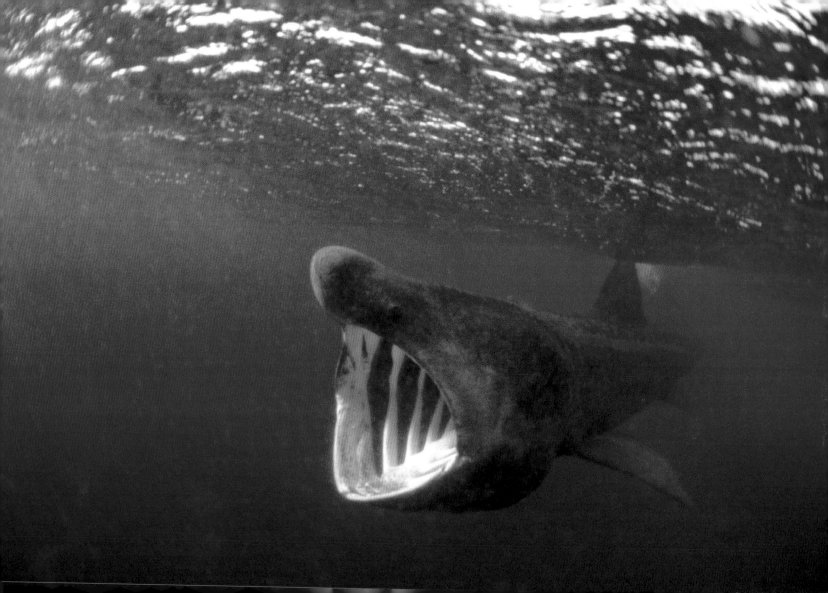

129

Acropora table top coral, Ras Abu Galoum, Sinai Peninsula, Egypt

It is the coral polyp skeleton that builds the actual structure of a reef. Long after the coral polyp dies, its corallite exoskeleton remains attached to the reef's surface. Billions of these coral skeletons, many as ancient as the Pyramids, have accumulated in countless layers over the centuries, making up some of the oldest, largest, and most beautiful structures on Earth. Scientists can guess at the age of coral structures, much as they can from the scales of a fish or the trunk of a tree, by their size and the pattern of internal growth rings.

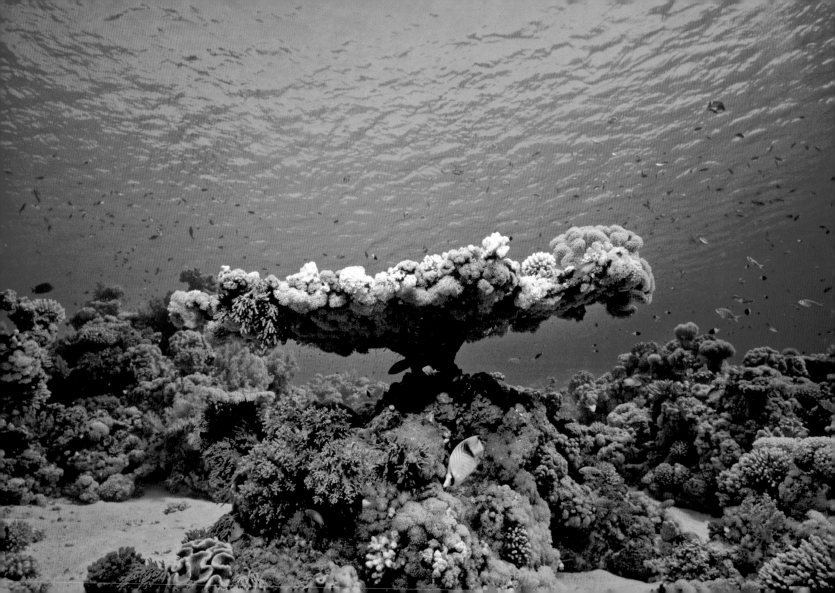

Scissortail sergeants, Ras Umm Sid, Sinai Peninsula, Egypt

In many ways, a coral reef is like a city: busy, crowded, and colorful. The reef provides food, protection, and an active social life for the creatures that squeeze into every available nook and cranny. A different set of residents occupies the various depths of a reef, like apartment dwellers in high-rise buildings. Once an animal sets up housekeeping in one area, it rarely moves (unless it is evicted by a new tenant) as new housing can be hard—and dangerous—to find.

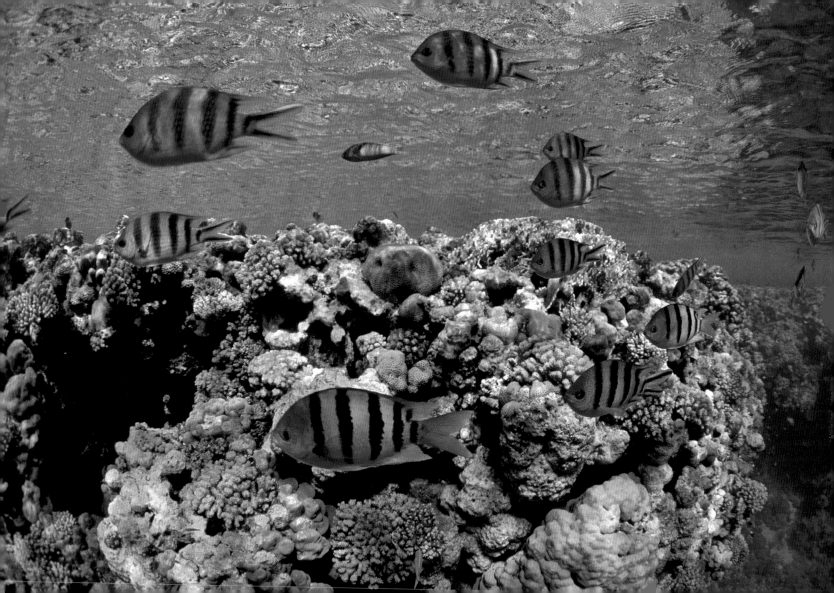

Coral reef table, Ras Umm Sid, Sinai Peninsula, Egypt

One might think that the distinctive black and white stripes of these scissortail sergeants give them away to predators. Actually, markings like these are known as disruptive coloration and have the opposite effect. The vertical lines break up the outline of the fish's body. In this photo, you can see how the dark lines blend with shadows and the white ones with light; it's hard to tell where the body of the sergeant fish ends and begins. Zebras and tigers use this camouflage as well.

Garden eels, Aqua Sport Reef, Eilat, Israel

To the inexperienced eye, the stalks sprouting from the ocean floor in this photo may look like sponges or sea grass, but they're actually eels. Garden eels make their home in holes they burrow in the sand. Colonies of hundreds or even thousands can be spotted extending their long, thin bodies about three-quarters out of the sand in order to feed on plankton in the current. But if the eels sense danger, they quickly retreat back into their holes, disappearing almost instantly.

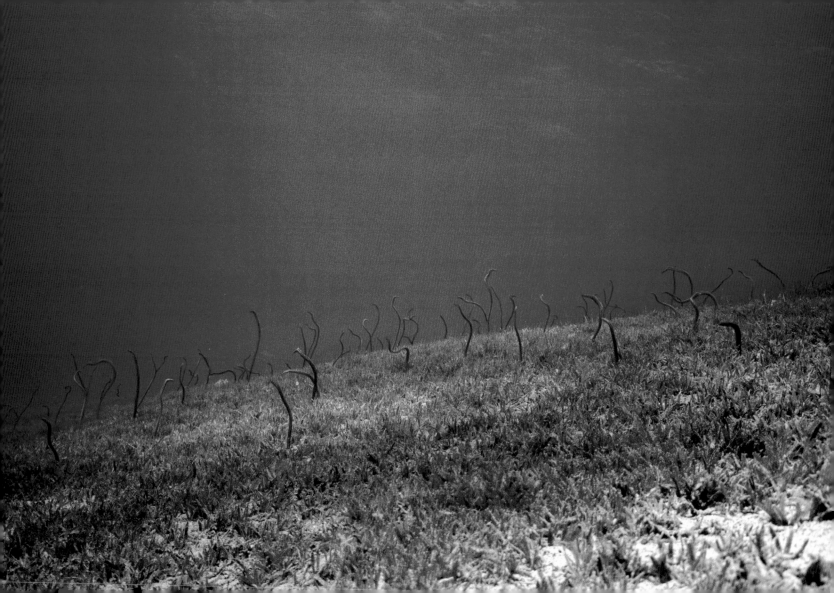

Glassy sweepers, Ras Umm Sid, Sinai Peninsula, Egypt

By day, this huge school of sweepers hovered near a cave in relatively shallow water, but a few minutes before sunset, something interesting happened. The entire school, numbering in the thousands, moved away from the reef and started to school back and forth in a furious frenzy. After three minutes of this, they took off like a swarm of bees down the reef slope and into the deep blue, where they usually spend the night feeding on zooplankton. I have no idea why they behaved like this, but perhaps it is the reason for their name.

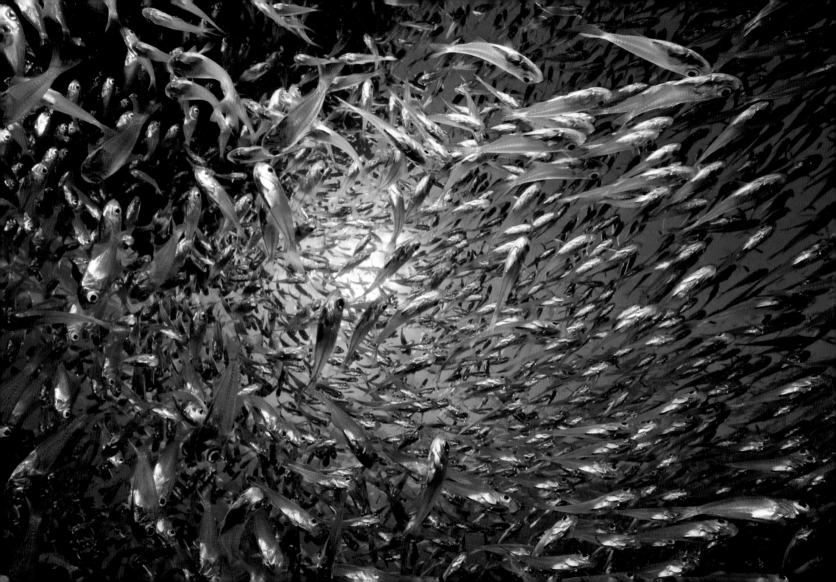

Opposite

Silvertip shark, Cocos Island, Costa Rica

This silvertip shark is at a cleaning station, a spot it comes to daily in order to allow resident cleaner fish—wrasses, gobies, cleaner shrimp—to feed on the parasites that inhabit its gills. The shark will slowly cruise in, almost coming to a stop as it reaches the cleaning station, signaling it means no harm. The cleaner fish immediately start picking through its gills and skin, sometimes even its mouth, for the parasites.

134

135

Overleaf Left

Long-armed octopus, Moses Rock, Eilat, Israel

Female octopuses may be the most selfless mothers in the ocean. After receiving spermatophores from a male, the female goes off to find a protected den. Here she'll lay strings of up to hundreds of thousands of eggs, positioning them gently with her suckers. For more than six months she guards and grooms them, blowing water over them to make sure they receive enough oxygen. Once the babies hatch and begin their journey to the surface, the mother will leave the den and die.

Red Sea

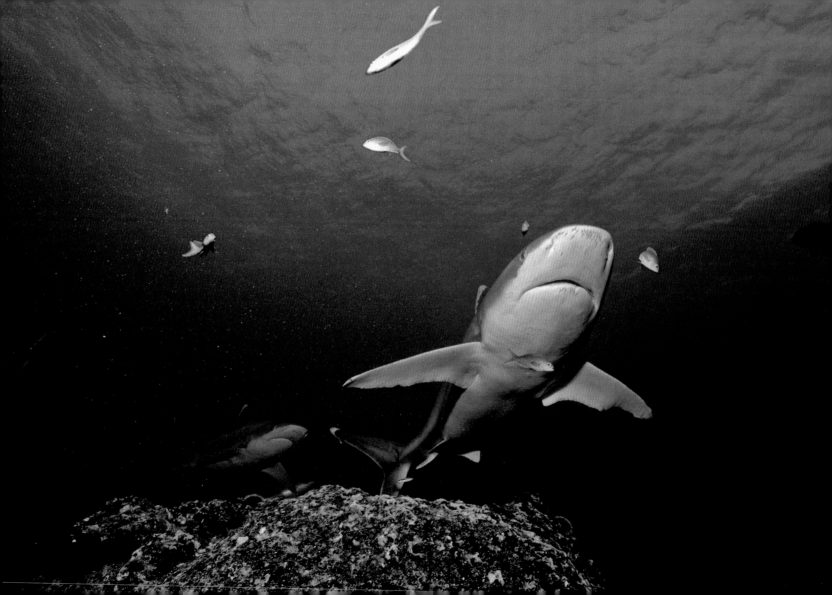

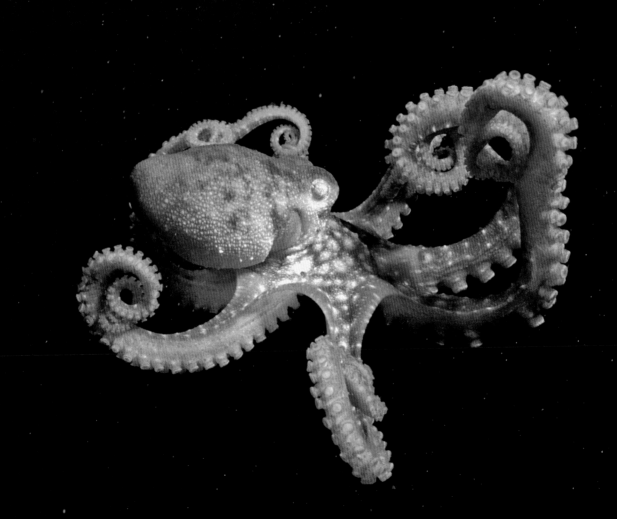

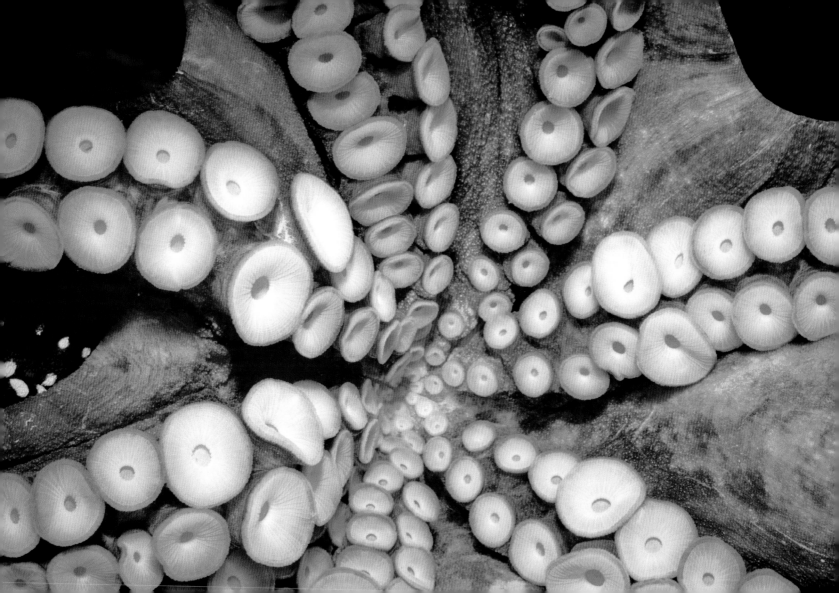

Preceding Page

Reef octopus, Moses Rock, Eilat, Israel

If you were a tasty crab on this reef octopus's menu, this might be your last view of the world. This cousin of lowly clams, oysters, and snails is one of the most advanced animals in the sea. It sees quite well underwater. It can solve problems, such as figuring out how to open a jar to get at prey, and it appears to be able to learn simple tasks just by watching other octopuses. It also has a memory. In fact, its intelligence is so remarkable, the octopus has been called "the primate of the sea," a flattering comparison to the mental capacities of chimpanzees.

135

136

Opposite

Giant pacific octopus, Vancouver Island, British Columbia

When an octopus is attacked by an enemy, such as a moray eel, the scene is a blur of writhing arms and snapping jaws. If the octopus loses an arm in the fight, the severed arm will continue to twitch for several minutes. Thus, while the predator continues its attack on the thrashing arm, the wounded octopus turns pale and is able to make its escape. It will soon grow back the lost limb.

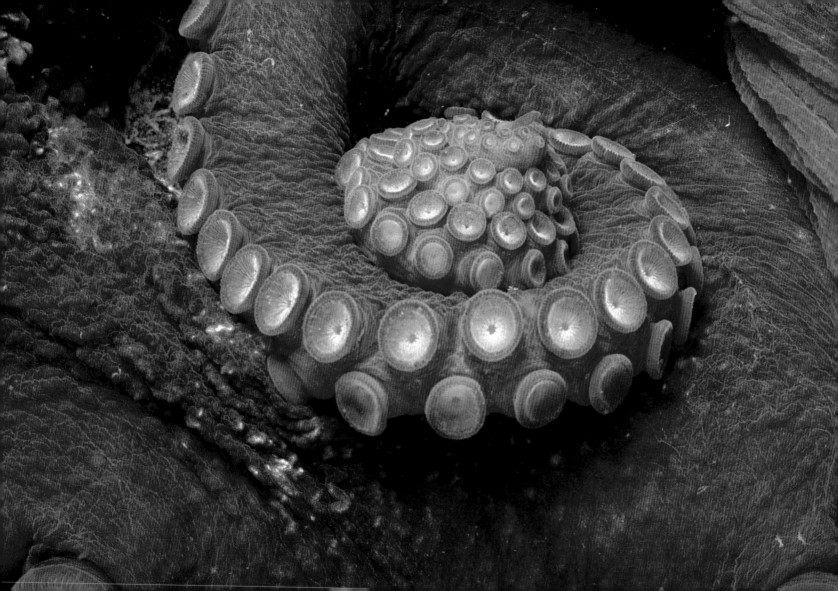

Opposite

Atlantic octopus, Folly Cove, Gloucester, Massachusetts

By opening the flexible web that grows between each arm, the octopus can drift down through the water like a parachute. When an octopus spies a crab on the ocean floor, it opens up its web, like an umbrella, and closes around the prey, creating a pouch, and carries its dinner back to its den inside a sac of water. The octopus secretes a chemical into this water-filled pouch that tranquilizes combative crabs and other prey. After that, it's bon appétit.

137

138

Overleaf Left

Giant Pacific octopus captures cabezon, Vancouver Island, British Columbia

This cabezon fish will soon be picked apart by the strong beak and sawlike tongue of this giant octopus. For harder prey, like crabs and clams, the octopus will partially dissolve the shell with its digestive juices, scrape a tiny hole in the weakened shell, kill the living animal inside with more saliva, and then pry it open.

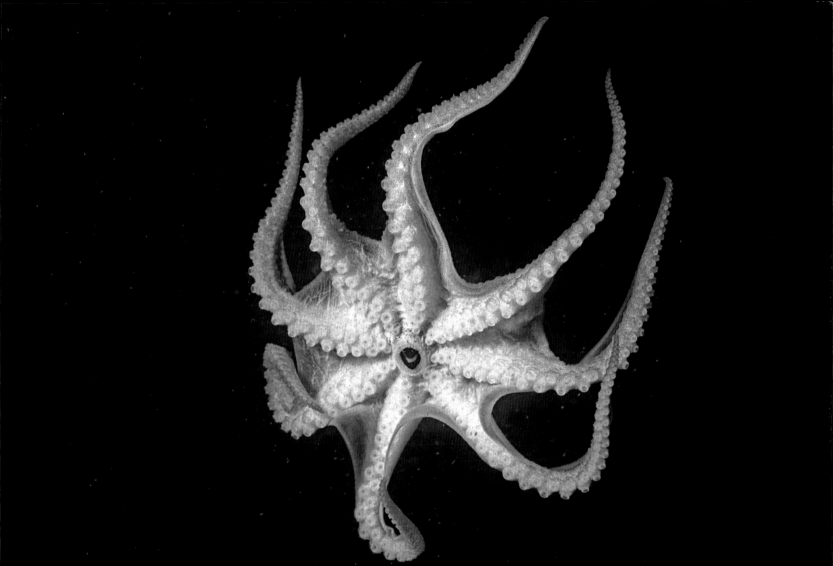

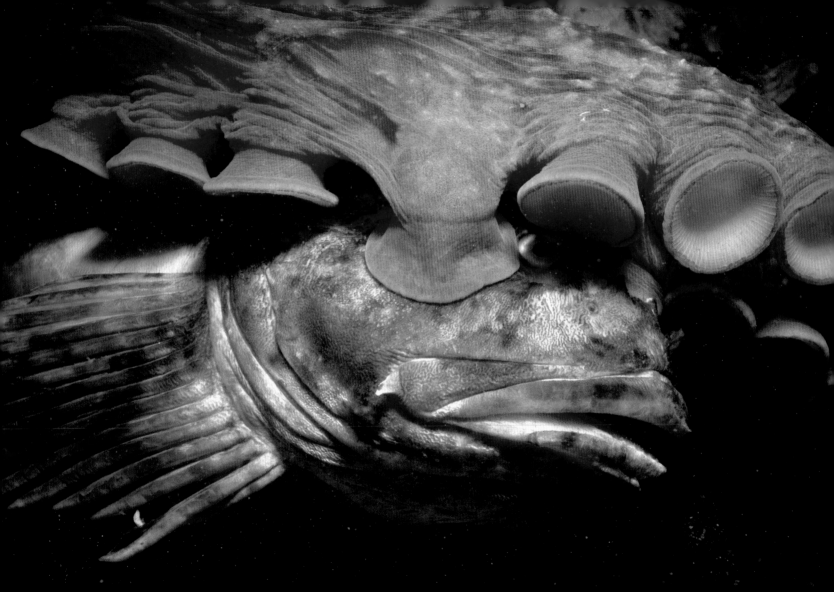

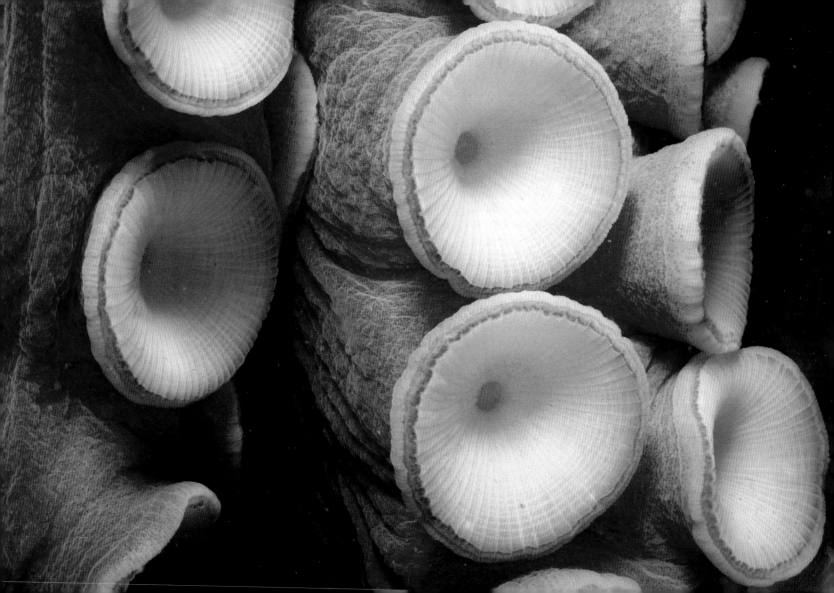

Preceding Page

Giant Pacific octopus, Vancouver Island, British Columbia

A giant Pacific octopus may have close to two thousand muscular suckers in two rows on its eight arms. (Some octopuses have a species-specific number.) These sensitive suckers are filled with nerves and can feel, taste, and exert a powerful grip.

138

139

Opposite

Masked butterflyfish, Moses Rock, Eilat, Israel

Competition is fierce on the coral reef. A single pair of butterflyfish, which may feed only on the tentacles of feather-duster worms, may live above one particular coral boulder. The fish's bold coloration and aggressive behavior warn others of the same species that they are not welcome on this patch of reef. Specializations in habits, diet, and color allow each animal to carve out its own very special niche in the complex reef community.

Red Sea

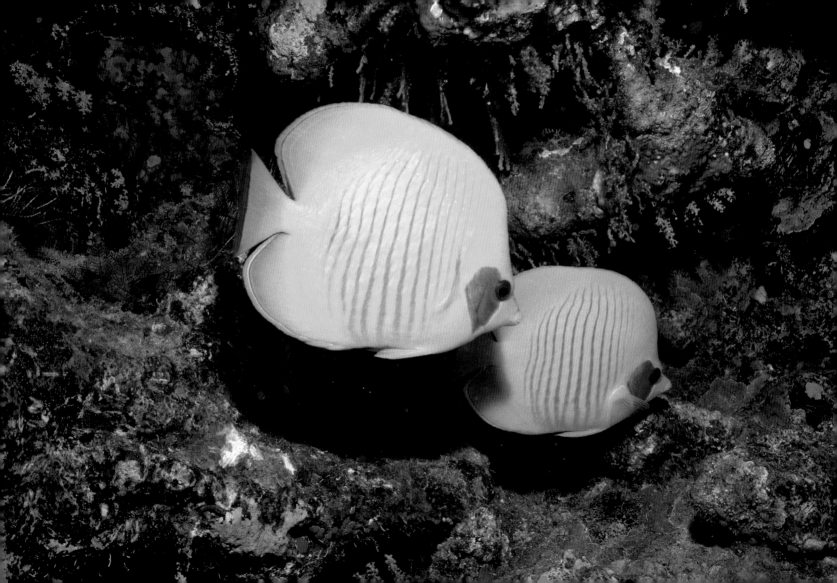

Short bigeye fish, Hodgkins Cove, Gloucester, Massachusetts

It never ceases to amaze me when I discover an animal I've never seen before at a site I've been diving at for decades. This juvenile short bigeye fish has quite a long name for a fish that is the size of a nickel. I was in only three feet of water, crawling through the eel grass, when I spotted this prize. The bright orange-red coloration just blew me away, especially since the North Atlantic is hardly famous for its colorful fish. Sometimes these brightly colored, unexpected finds are referred to as "tropical strays."

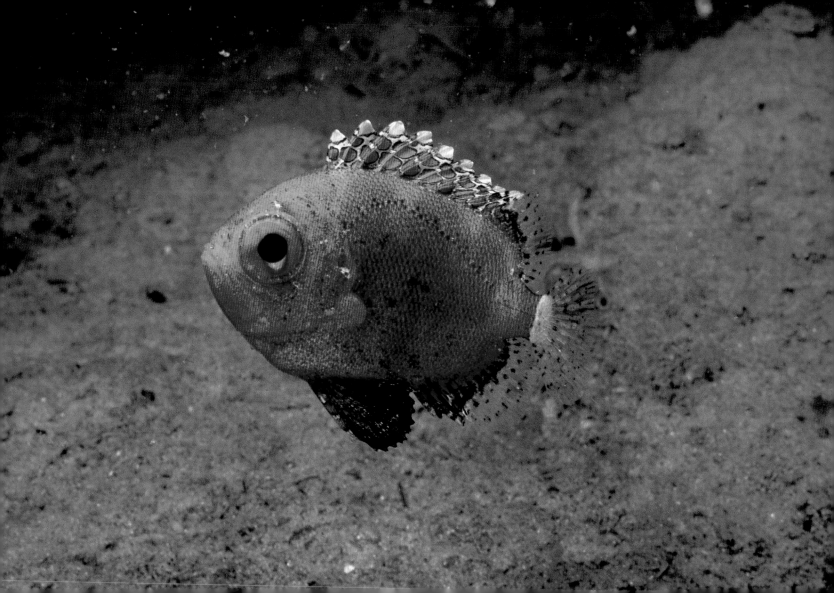

Margined sea star, Galápagos Islands, Ecuador

When I took this photograph, I didn't realize this starfish was making an obscene gesture as it turned itself over. Starfish move themselves on hundreds of suction-cup-tipped tube feet that act as tiny legs. For an invertebrate, starfish can move pretty fast: some have been clocked at a foot a minute. They're not going to win any races, however. This one took about five minutes to right itself.

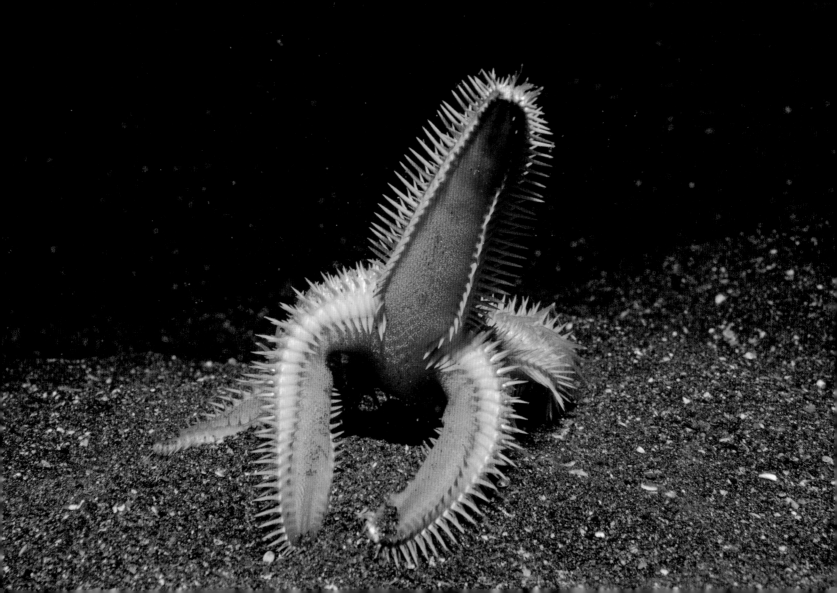

Royal angelfish, Ras Mohammed, Sinai Peninsula, Egypt

Few fish could win a beauty contest against a royal angelfish. But besides their good looks, they also have talent: Their laterally flattened bodies make them particularly speedy, as well as able to hide in the narrow cracks and crevices of the reef. These fish feed mostly on sponges and sea squirts, so although they're wonderful to look at, they're not wonderful for aquariums.

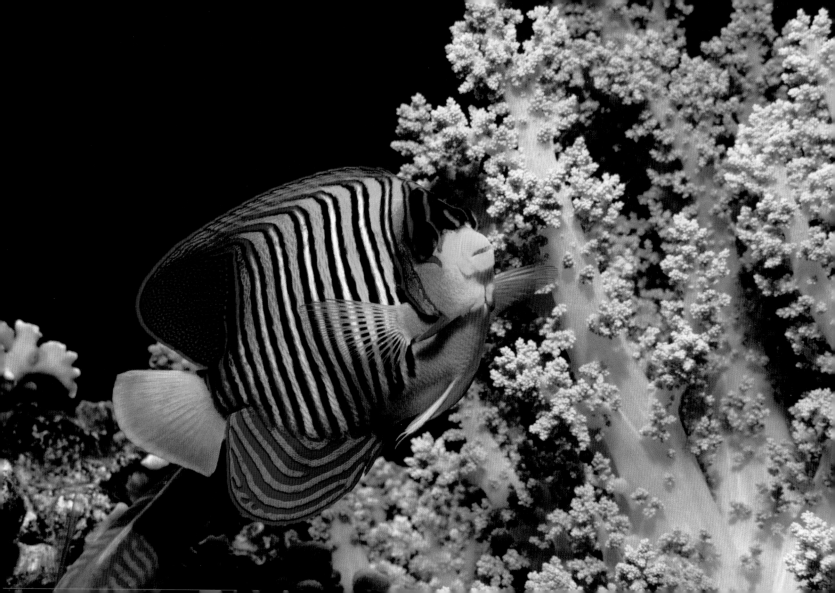

Spiny sea horse, Perth, Western Australia

Swimming in open water is not generally a good move for sea horses, as many passing fish would gobble them right up. These animals' tiny fins make them the slowest fish in the sea. They're most likely to be found holding onto coral or sea grass with their tails, which makes them difficult to spot. Storms are also bad news for these little guys, who can get swept to shore or out to sea, where they can die of exhaustion.

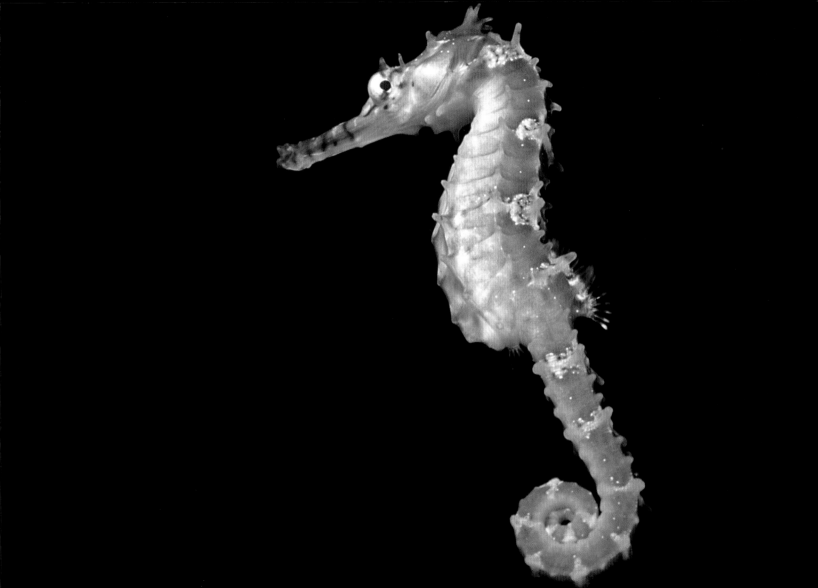

Ornate Turkish wrasses, Ustica Island, Sicily

Come and get it! When I mistakenly crushed a sea urchin with my knee (ouch!), I set off an unexpected feeding frenzy. This was a rare treat for these Mediterranean Turkish wrasses. The volcanic geology of Ustica Island, off the north coast of Sicily, and its marine reserve make it a great place to dive. Since this marine reserve opened 19 years ago, the improved management of the area—no fishing or spear fishing—has resulted in a limited improvement. The Mediterranean as a whole, however, is not in good shape—it has been exploited, polluted, and fished for centuries and is essentially an enclosed body of water, so the pollution stays in the environment.

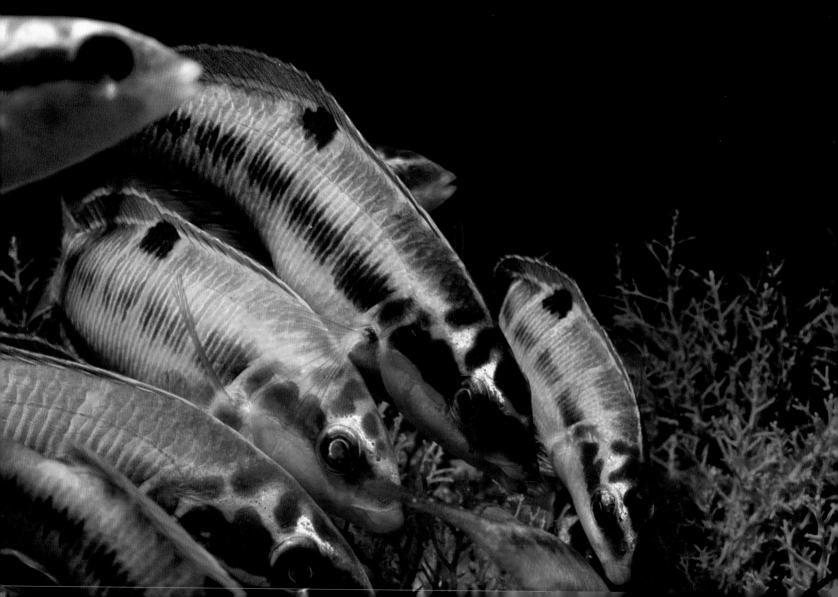

Two-bar clownfish, Jackson Reef, Sinai Peninsula, Egypt

Photographed in the dead of night, this clownfish sleeps peacefully in the protective embrace of its host anemone. This symbiotic relationship is dependent on a mysterious mucus that covers and protects the clownfish from the anemone's sting. Scientists disagree on whether the clownfish produce the mucus themselves or rub it off of the anemones. They also don't know exactly how the mucus tricks the anemone: Does the anemone recognize the fish is a foreign organism but accepts it, or does the anemone mistake the fish for itself?

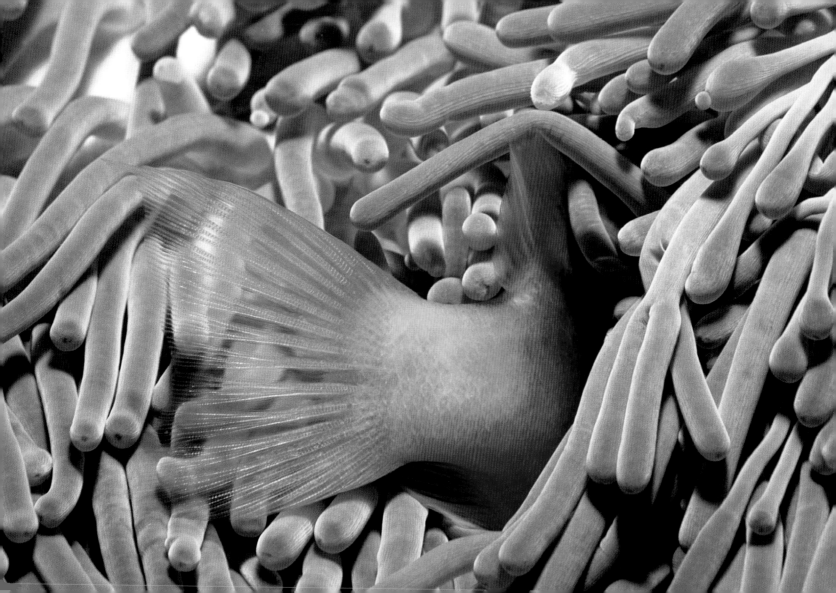

Pink clownfish and magnificent sea anemone, Kimbe Bay, Papua New Guinea
In most host anemones, there will be a small group of clownfish, complete with a
dominant pair responsible for breeding. All clownfish are born sexually immature males.
Some remain immature males, some become adult males, and the most dominant will
become female. In the anemone's little social hierarchy, when the breeding female dies,
her male second-in-command changes sex to become the new female.

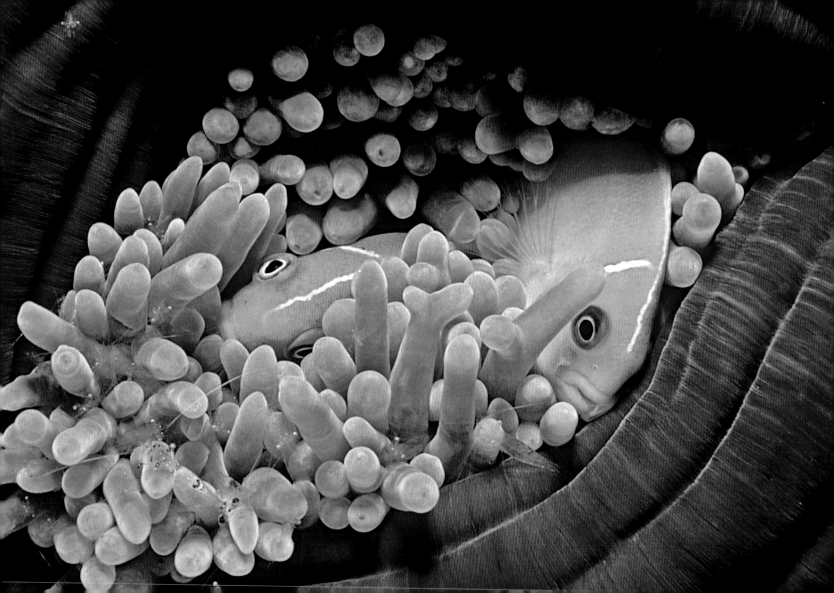

Striped anthias, Moses Rock, Eilat, Israel

The striped anthias is also transsexual, but in the reverse from the clownfish. The pronounced reddish hue of this anthias indicates she has undergone a sex change and is now a he—a "super male"—which will soon become purple. This sex change is also based on social hierarchy. Anthias create harems with a ratio of six to twenty females watched over by one super male. When the super male dies, the most dominant female takes his place.

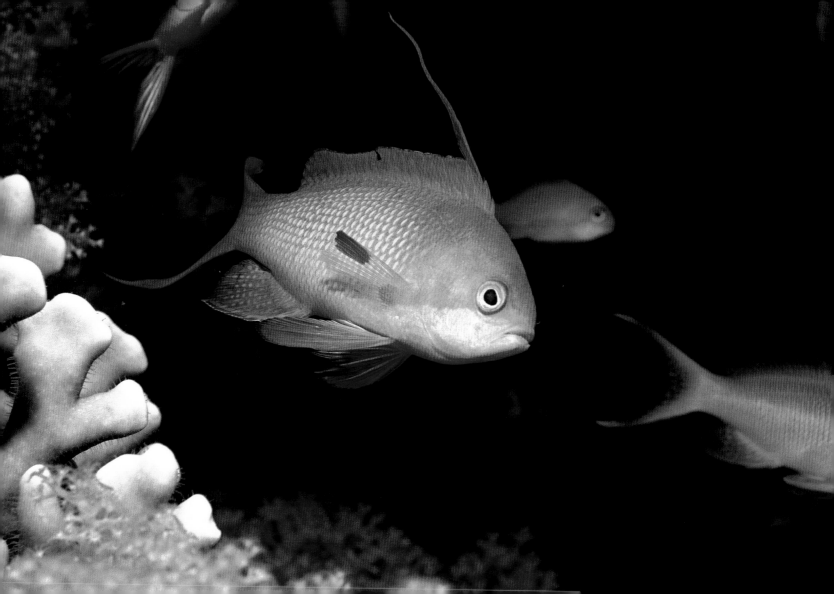

148

Acropora coral, Palau Islands, Micronesia

This Acropora coral has many branches, helpful in capturing sunlight from every angle.
Like many kinds of coral, these polyps get the majority of their nutritional requirements
from photosynthesis, performed by a symbiotic algae living in their cells, called
zooxanthellae. If a coral loses its zooxanthellae, due to environmental stresses like
warming water temperatures or increased sedimentation, it's likely to die, leaving only
a bleached, white skeleton.

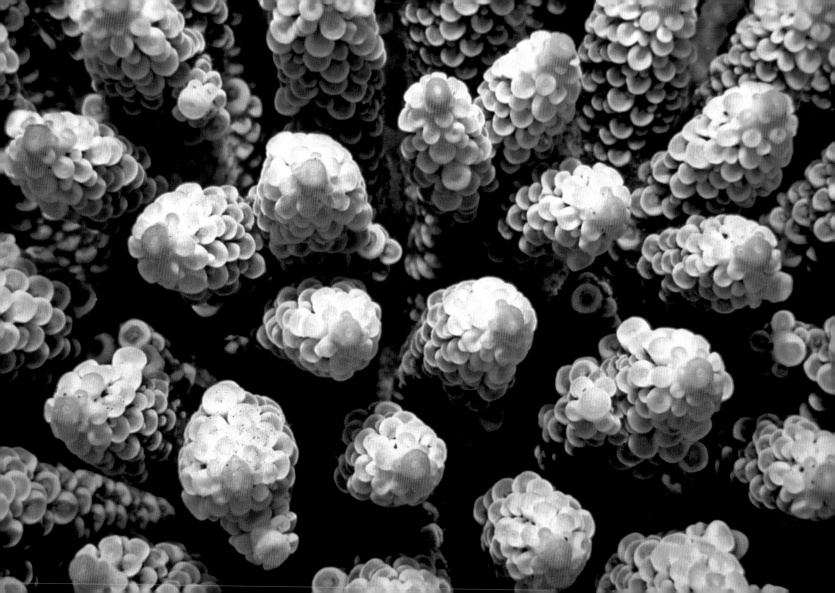

Sabre squirrelfish, Moses Rock, Eilat, Israel

As its large eye suggests, the sabre squirrelfish is nocturnal, hiding out in caves and crevices during the day. At night, it ventures forth hunting for its favorite food—crabs. In 1970, marine biologist William High did an interesting study with squirrelfish in an underwater lab called Tektite II. He discovered that the fish, out of curiosity, will explore a trap whether or not it's baited. Once the trap became crowded with curious squirrelfish, however, they would erratically dart around the cage, perhaps realizing it was a trap and warning other fish not to enter.

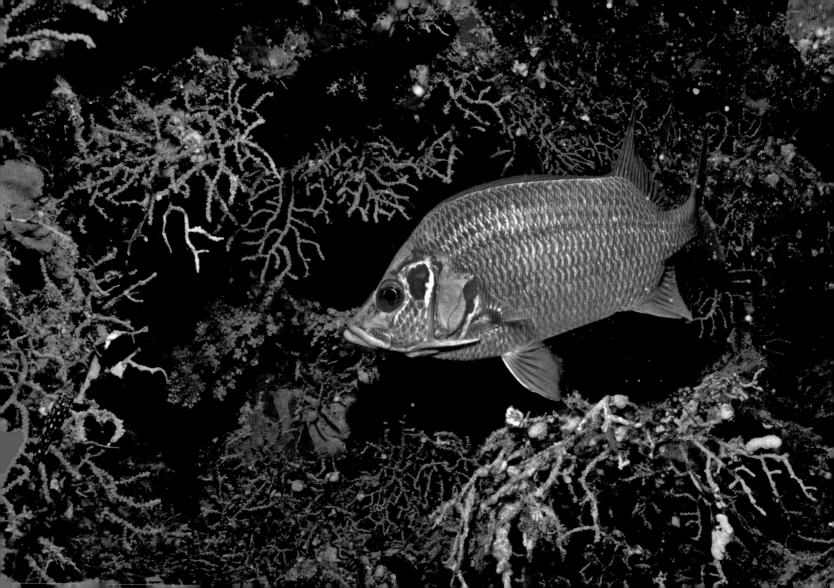

Panther flounder, Ras Mohammed, Sinai Peninsula, Egypt

Through evolution, bottom-dwelling flounder have adapted to their environment; their flat shape lets them glide close to the ocean floor, blending in and sometimes even burying themselves in the sand. While one of its eyes migrates to join the other on the upward-facing side of the flounder's head, its jaws retain their original orientation, reminding us that, pre-metamorphosis, this fish swam upright. Those jaws will be used to ambush crustaceans and small fish. (Turn the book clockwise to view the image in its proper orientation.)

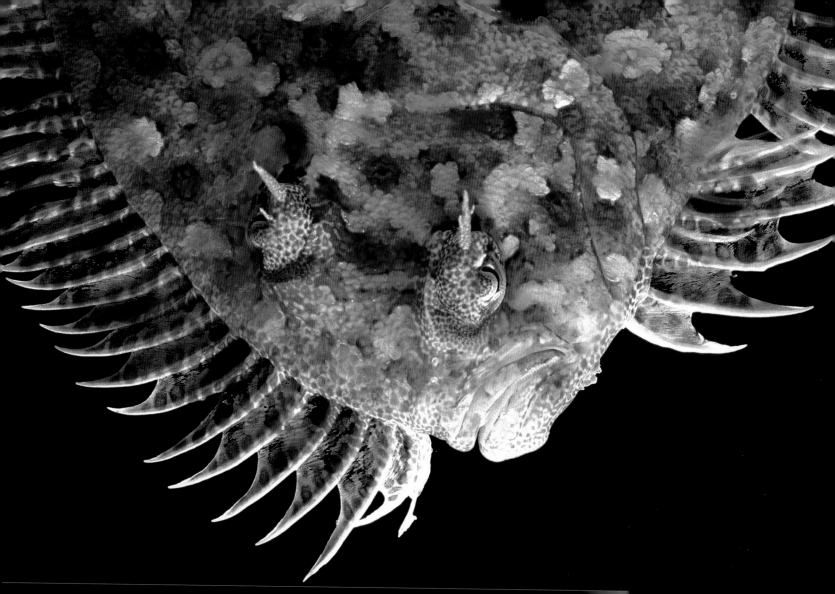

Bearded scorpionfish, Ras Nas Rani, Sinai Peninsula, Egypt

This motionless scorpionfish imitates both the color and texture of the coral outcropping on which it rests. Its mottled color and fleshy protrusions make it a master of surprise and also one of the most deadly fish on the reef. The venom in the spines of a scorpionfish is toxic to the nervous system and blood vessels of its victim. A wound from a scorpionfish can be very painful to humans as well and, in some cases, even cause death. It's always best to make sure that the coral formation you're about to touch isn't a scorpionfish! (Turn the book clockwise to view the image in its proper orientation.)

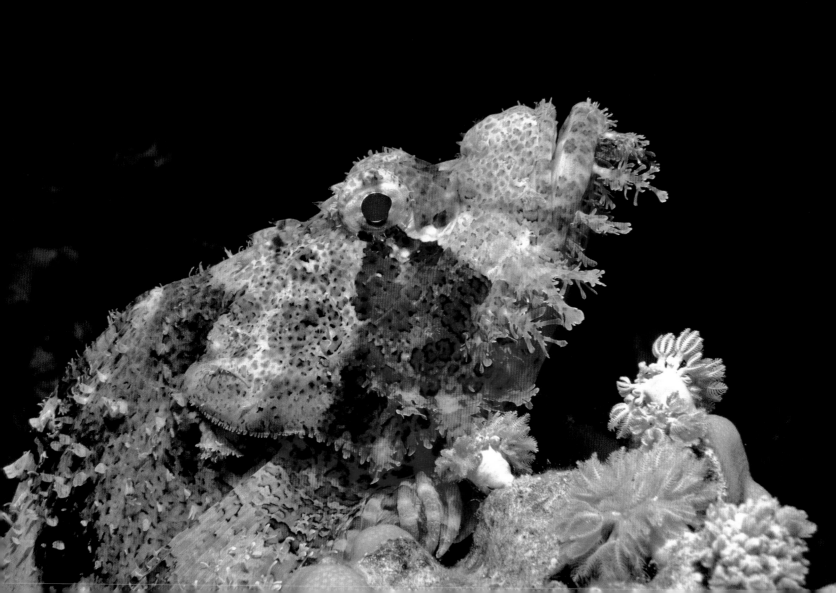

Tubed feet of a starfish, Isles of Glénan, Brittany, France

These sucker-tipped tube feet of a starfish are its primary mode of transportation. Water is pumped, through a system of internal channels that act as the starfish's vascular system, into the tube feet, extending them. The suction cup on the end grips the floor, and muscles pull the starfish forward. The water pressure then reduces and the foot relaxes, releasing from the floor before starting all over again to take another "step." The tube feet are also sensory organs. In this photo, they are reaching out to "see" the environment.

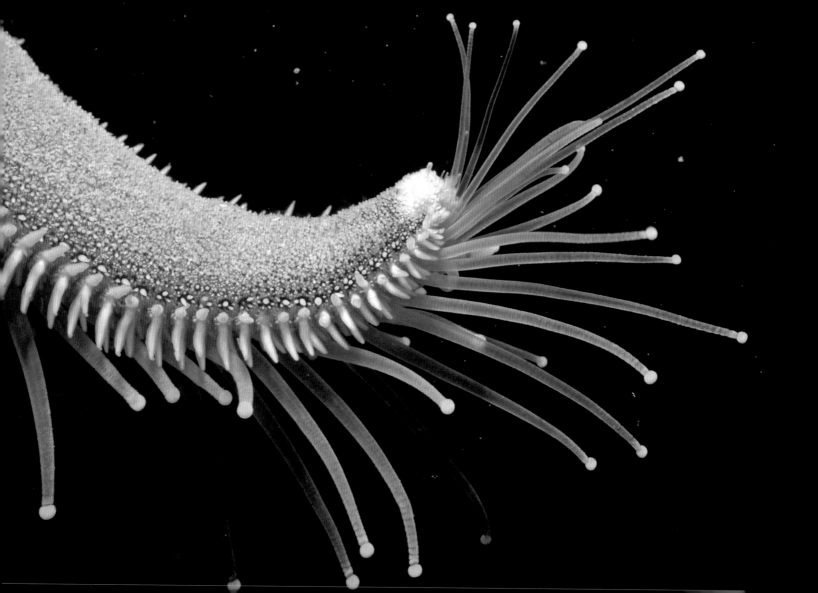

153

Spiny parrotfish, Maui Island, Hawaii

This parrotfish isn't dead, it's simply resting on its side at some distance from the reef and its dangers. Fish don't sleep in the same way that humans and other land animals do, but most bony fish do have to rest. Fish don't have eyelids, but they can slow their activity and lie motionless, reserving energy.

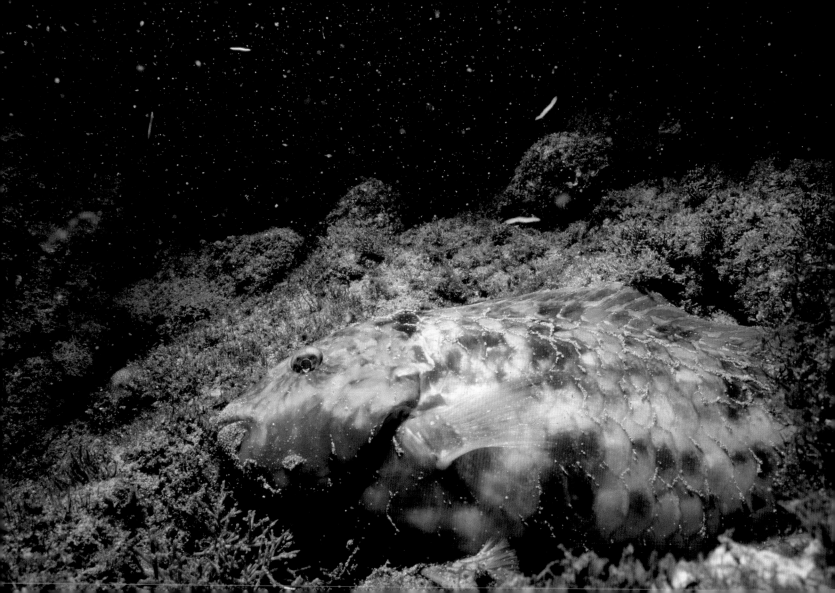

Tail of a hieroglyphic hawkfish, Cocos Island, Costa Rica

Hawkfish don't move around much; they seem to sit back and take it all in. They can afford the luxury of relaxation because their color pattern, called cryptic coloration, seen here on the tail fin, allows them to blend in with their surroundings. Coloration in fish is the effect of cells called chromatophores. Some chromatophores contain their true pigment; others simply reflect a certain color.

Stony coral, Kimbe Bay, Papua New Guinea

It's hard to beat the waters that surround Papua New Guinea if it's coral you're after. Scientists have identified more than four hundred different species of coral in Kimbe Bay alone; that's about 60 percent of the species that grow in the Indo-Pacific region. Unfortunately, population growth, overfishing, logging, and runoff from palm-oil plantations are threatening this precious ecosystem, which prompted the Nature Conservancy to set up a conservation program there in 1993.

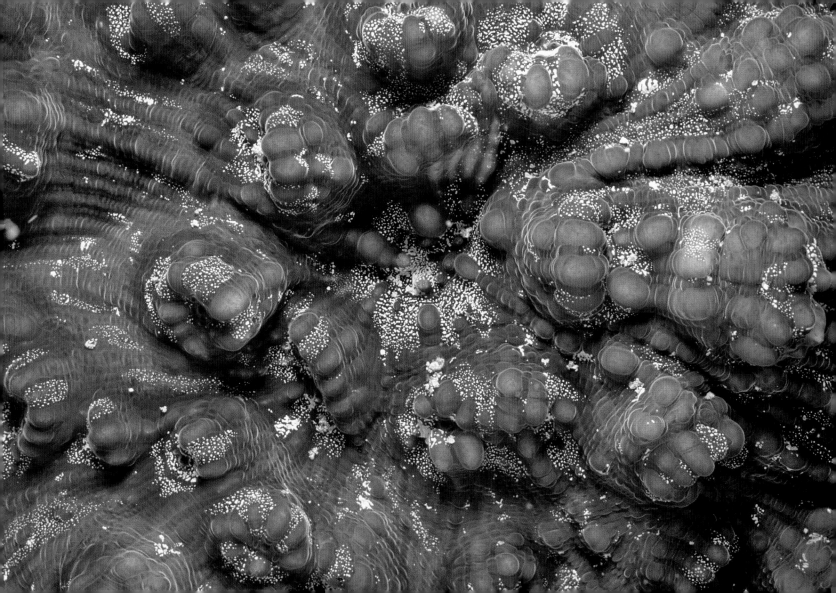

Pink clownfish and magnificent sea anemone, Palau Islands, Micronesia

These clownfish, living in the safe refuge of their sea anemone, will chase all other clownfish away from this particular anemone, although they may lure other kinds of fish into the anemone's deadly grasp. Here, you can see a "family" of clownfish—the largest is the dominant female; the second largest, the dominant male; the other two, subordinates. Each stays a certain size according to its place in the hierarchy, until a more dominant fish dies or leaves, at which time the remaining fish in the group can grow to claim a new position. I have seen as many as a dozen clownfish living in one large anemone, however it more typically varies between two and six fish.

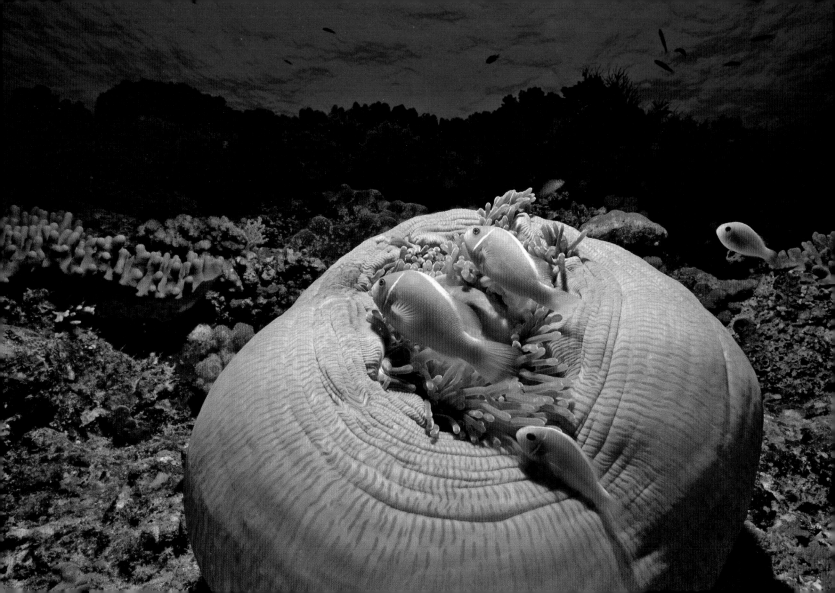

Trumpet fish in a school of blue-striped snappers, Cocos Island, Costa Rica

This trumpet fish is seeking protection within a school of blue-stripped snappers. By following and hiding behind larger fish, trumpetfish are able to sneak up on potential prey. When a small wrasse happens by, the lurking trumpetfish will suddenly lunge down on it, snapping it up in its long, snoutlike mouth. Some trumpetfish can even change colors to enhance their camouflage.

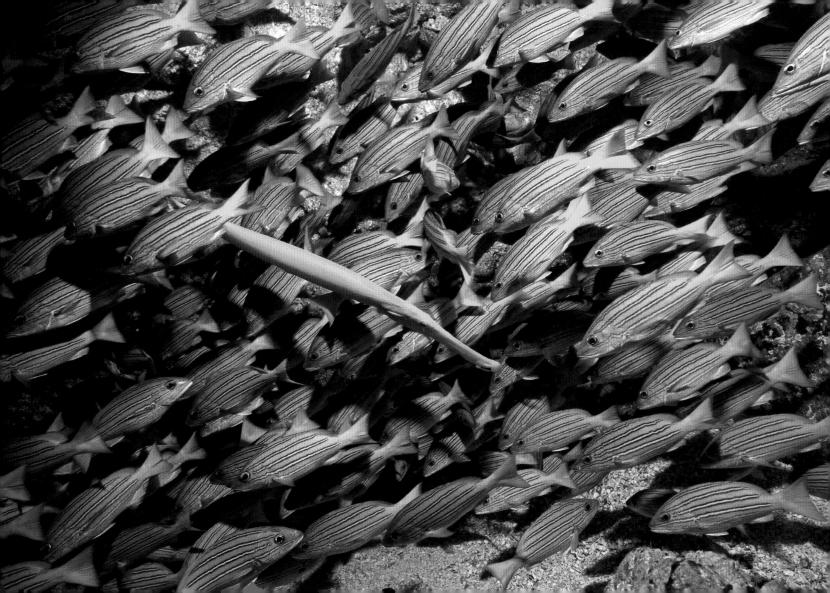

Metridium anemone, Folly Cove, Gloucester, Massachusetts

People often ask me why I dive in New England because the water there is more than cold—it's freezing! On top of that, the visibility sometimes drops to less than three feet, and the Atlantic often tosses you around like a rag doll. But diving the North Atlantic allows me to photograph marine life that I won't find anywhere else. When I return from a dive in the waters off Cape Ann, Massachusetts, I'm in such a state of excitement that I'm already dreaming of my next dive there.

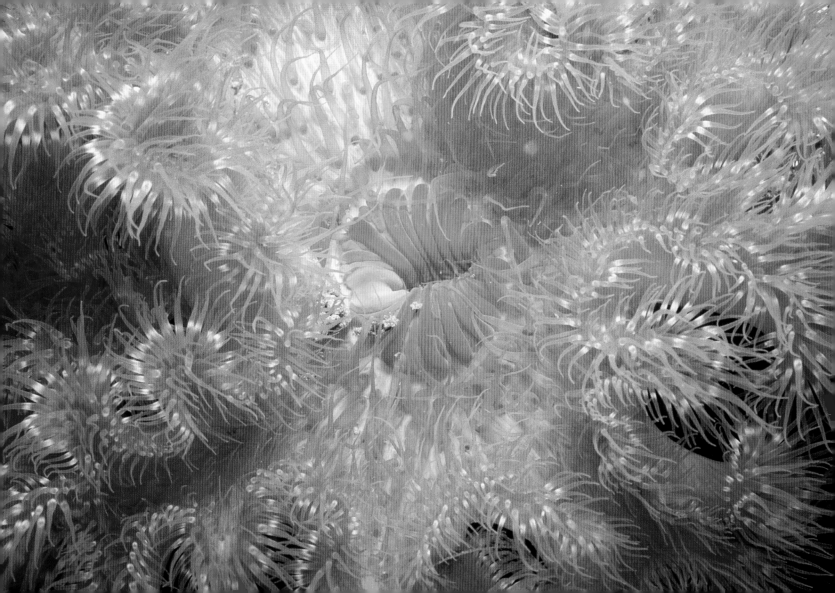

Stove-pipe sponge, Andros Island, Bahamas

The Caribbean is one of the best places to see sponges. I once saw a gigantic barrel sponge large enough for a diver to fit inside. The tubular filter-feeders on this purplish brown specimen can grow up to five feet in length.

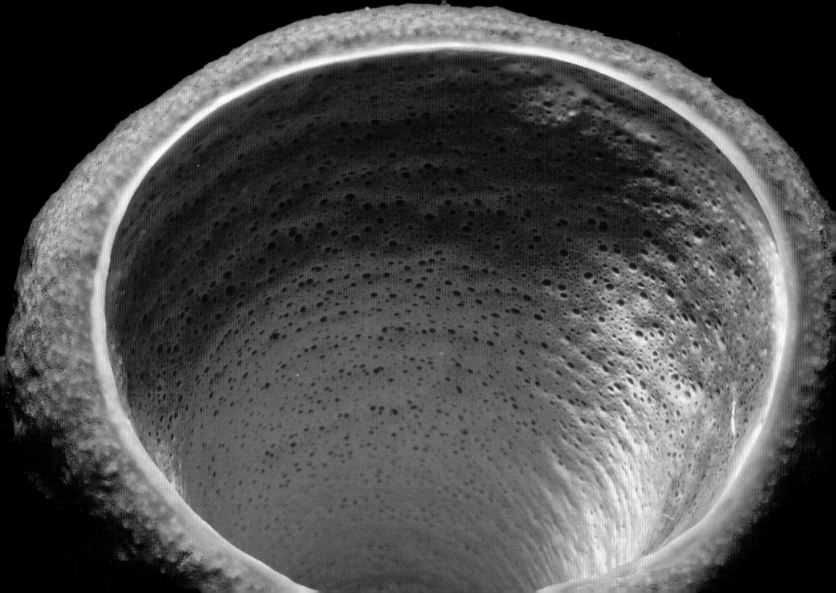

Spiny sea horse, Perth, Western Australia

This juvenile sea horse has wrapped its tail around a branch of gorgonian coral. Besides their prehensile tails, sea horses have a few other defining features. They have an upright, elongated face topped by a crownlike set of small spines, called a coronet. Their eyes are capable of moving independently of each other, and rather than scales, they have a series of bony plates covered by skin. Slow-moving creatures, sea horses depend on camouflage for safety (such as hiding in coral, like this one), and all species can change colors to match their environment.

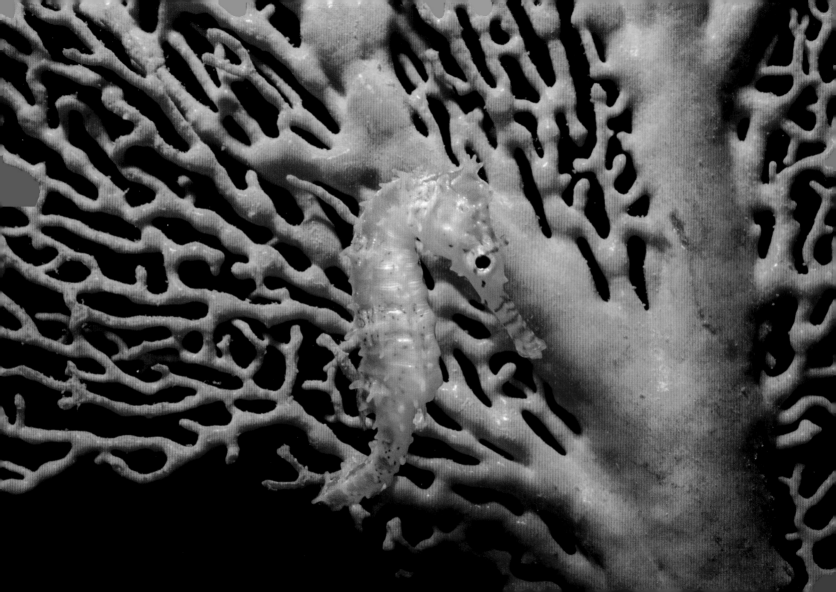

Coral gobies on a prickly alcyonarian coral, Brother Islands, Egypt

Many symbiotic relationships involve such expert camouflage that partners are nearly impossible to spot, especially by day, when the grand vistas of the reef beckon. But at night, when a diver's attention is necessarily focused on nearer, smaller, more intimate details, otherwise hidden associations reveal themselves to experienced eyes. Here, a mated pair of coral gobies, each only one-third to three-fourths of an inch in length, perches on the main trunk of a prickly alcyonarian—a soft coral whose fluorescent hues the gobies match with uncanny precision.

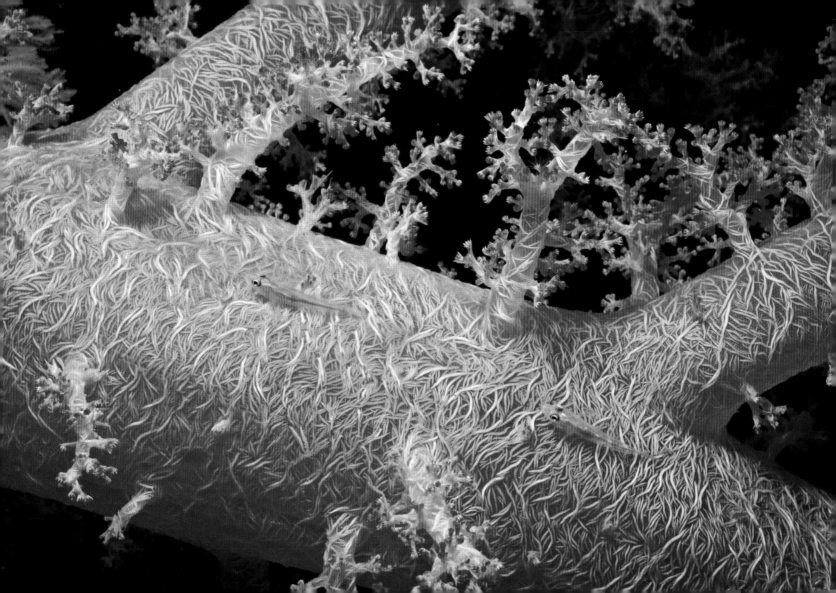

162

Scarlet sea fan, Palau Islands, Micronesia

Under my strobe light, this scarlet sea fan, undulating in the gentle current, appeared to my eyes a stunning red, but at depths below fifteen to twenty feet, the color red is not visible to humans. This is because the farther light has to travel through water, the more wavelengths are absorbed. Of the visible light spectrum, red is the longest wavelength, and is the first to fade out as you go deeper underwater.

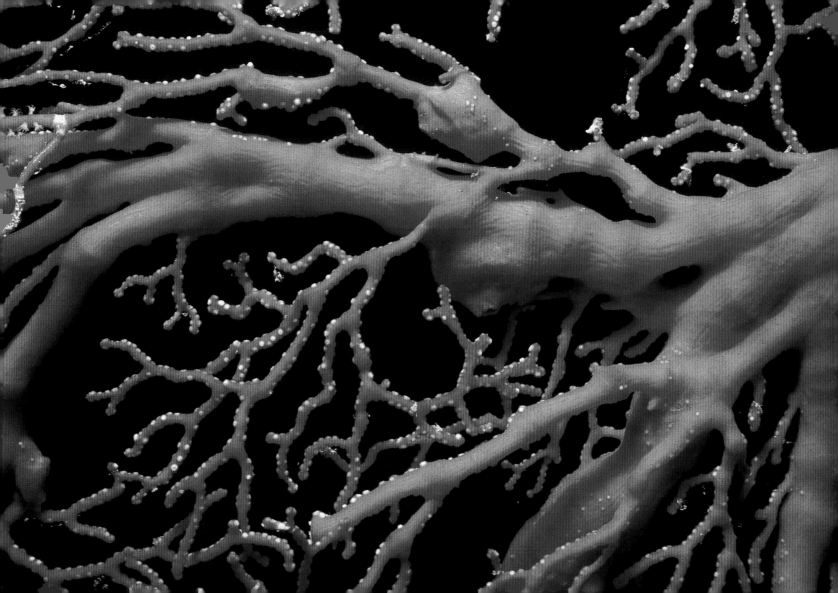

Magnificent sea anemone, Ras Abu Galoum, Sinai Peninsula, Egypt

I try to take pictures that reveal something totally new, wondrous, and otherworldly. I have taken thousands of photographs of sea anemones—more than a thousand species are found in almost every undersea environment from the tidal zones to the greatest depths of every ocean—but few capture the essence of this flower of the deep as well as this one.

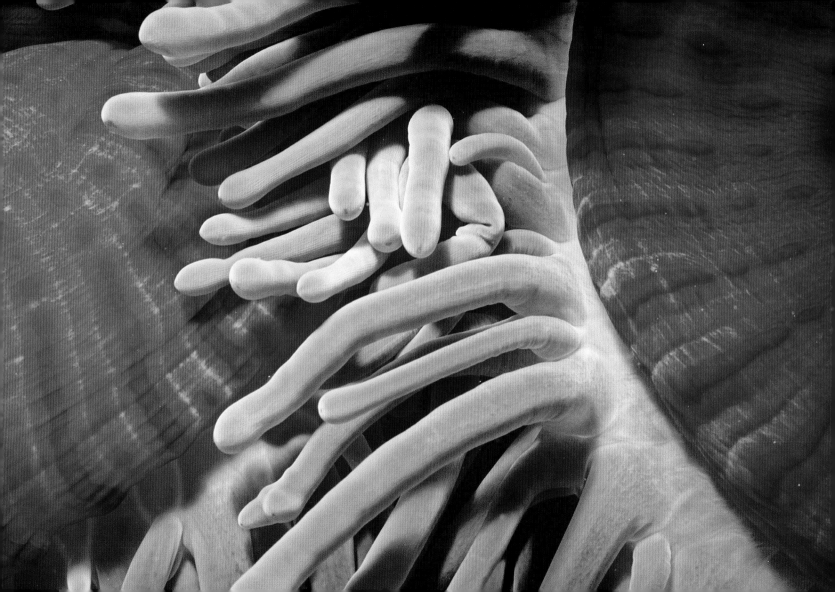

Gorgonian sea fan, Sipadan Island, Borneo

When I did my first night dive off Sipadan and saw the spectacular gorgonians open and feeding like this one, I knew I had come to the right place. Home to thousands of species of fish and a few hundred species of coral, as well as its famed green and hawksbill turtles, Sipadan Island, northeast of Borneo, is one of the most famous diving destinations in the world.

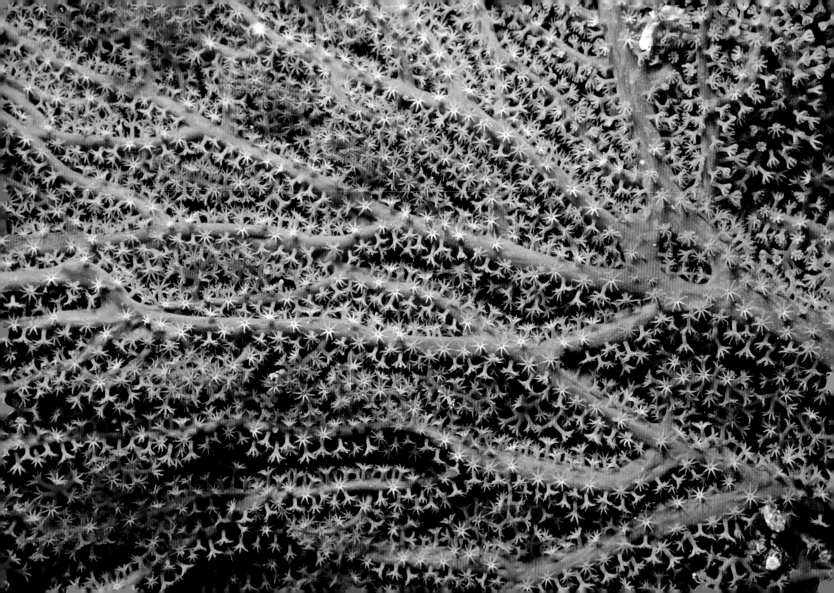

Chestnut cowrie, Santa Catalina Island, California

I searched in vain for this marine snail in daylight, but when I returned at night, I found six of these lovely nocturnal chestnut cowries in less than an hour. This one-inch-long specimen grazes on a red volcano sponge. When I see the beautiful porcelain sheen of its shell, visible under the folds of the snail's enveloping body, I can understand why the shells of some cowries were once prized as currency in Africa and are still used in jewelry today.

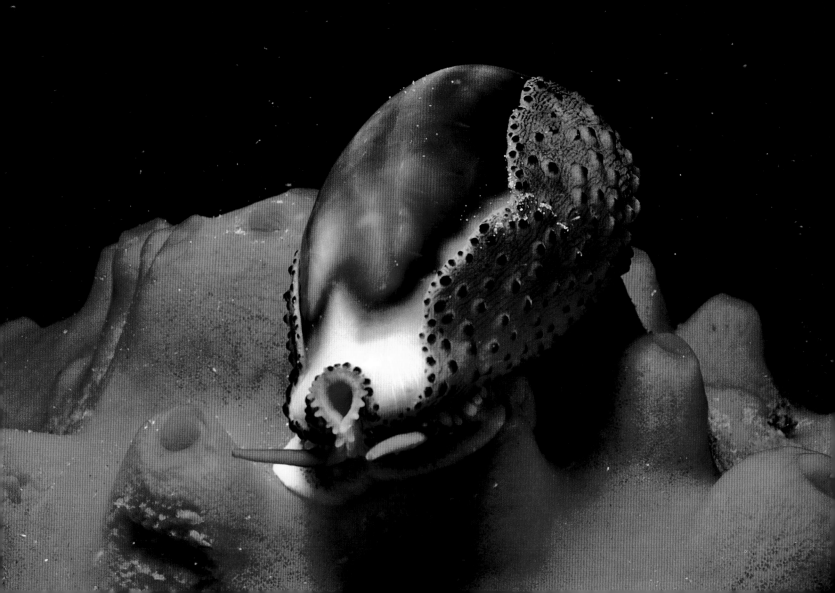

Prickly alcyonarian, Jackson Reef, Sinai Peninsula, Egypt

Lacking the symbiotic algae, called zooxanthellae, of their hard, or "true," coral cousins, alcyonarians are not restricted to sunlit spots on the reef and can grow deep, wherever currents bring them a dependable supply of plankton and dissolved nutrients. The ecological importance of shallow-water hard coral reefs has been known for quite some time, but scientists are just beginning to understand and study the biodiversity and vulnerability of deep-sea corals. In 2004, a group of 1,136 scientists submitted a landmark statement to the United Nations, urging for their international protection.

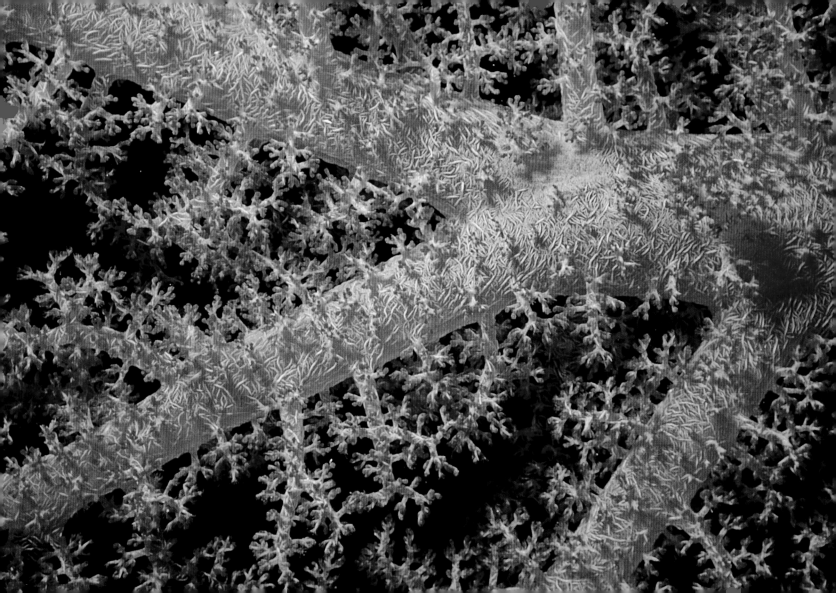

Opposite
Squaretail grouper, Ras Abu Galoum, Sinai Peninsula, Egypt
This blue-spotted squaretail grouper displays the evolutionary adaptations that make it such a fearsome predator. Feeding during the twilight hours of dawn and dusk, the squaretail has a large mouth with a slightly protruding lower jaw, which is equipped with small sharp teeth that enable it to grasp prey firmly, before swallowing them whole.

167

Overleaf Left
Needlefish, Tiran Island, Egypt
Needlefish have very slender bodies and extremely elongated jaws with thin, spiky teeth. They live at the surface, where they feed mostly on small pelagic fish. They slowly stalk their prey, then without warning, explode in a burst of lightning speed to grab the smaller fish with the teeth you see here. At night, it is possible to get so close you can touch them.

168

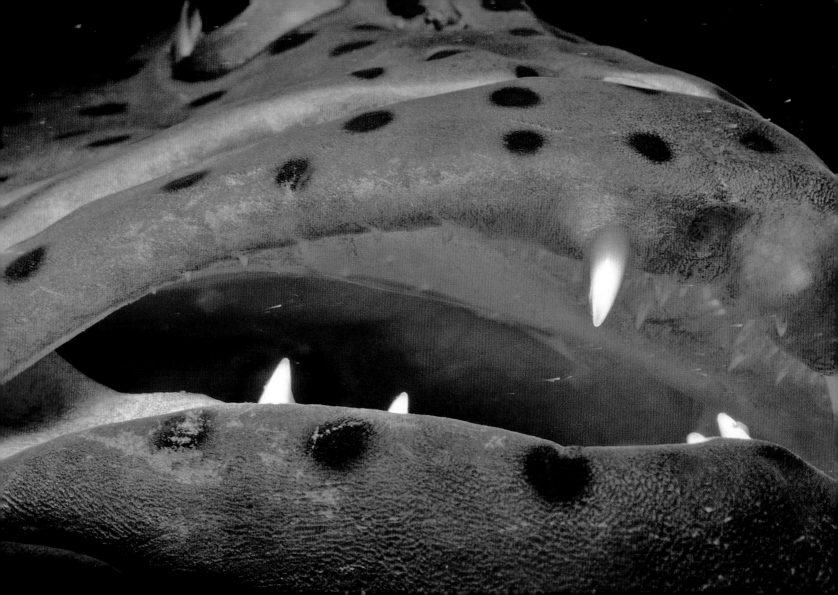

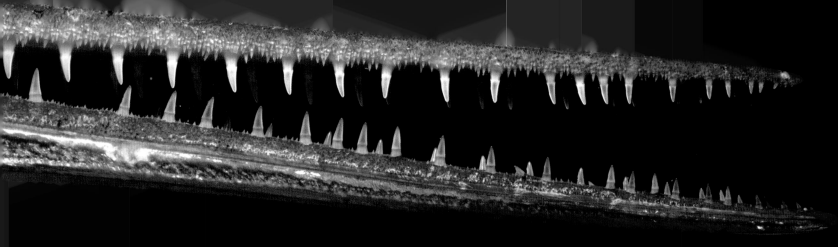

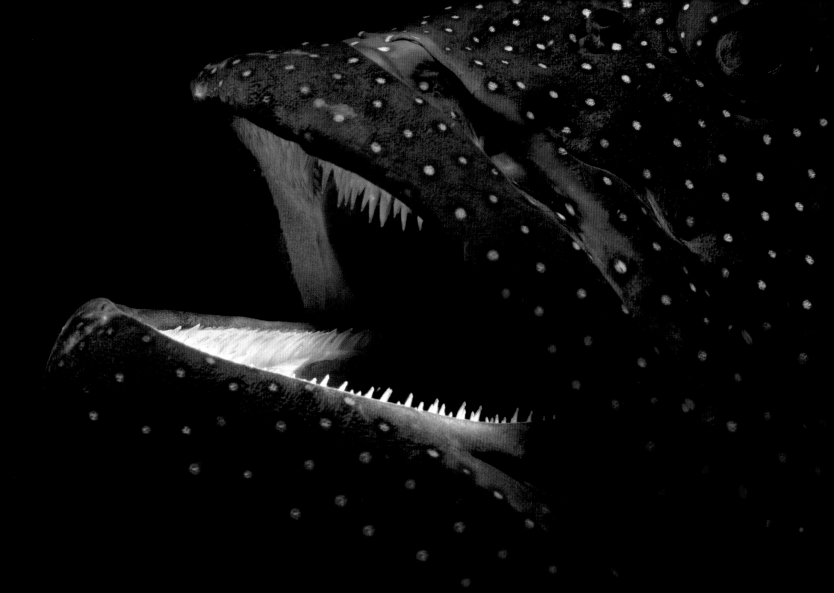

Preceding Page
Peacock grouper, Jackson Reef, Sinai Peninsula, Egypt
Groupers have the ability to rapidly alter the density of their color by expanding
or contracting the color cells, or chromatophores, in their skin. For example, this
peacock grouper can become markedly paler when moving from a dark hole in the
reef over light-colored sand. This camouflage protects it from predators and also lets
it sneak up on prey.

168

169

Opposite
Sand tiger shark, Seal Rocks, New South Wales, Australia
While this sand tiger shark is not a man eater (it feeds mostly on small fish and
crustaceans), its threatening countenance gives it a bad reputation and may be one
reason why it has been a favorite target of spearfishing divers in the past. Today,
sand tiger sharks are a tourist draw in Australia, South Africa, the United States, and
Japan, where scuba divers can easily approach and photograph these terrifying-
looking but relatively harmless creatures. (Most sharks won't let divers near them.)
The species is now protected in New South Wales, Australia.

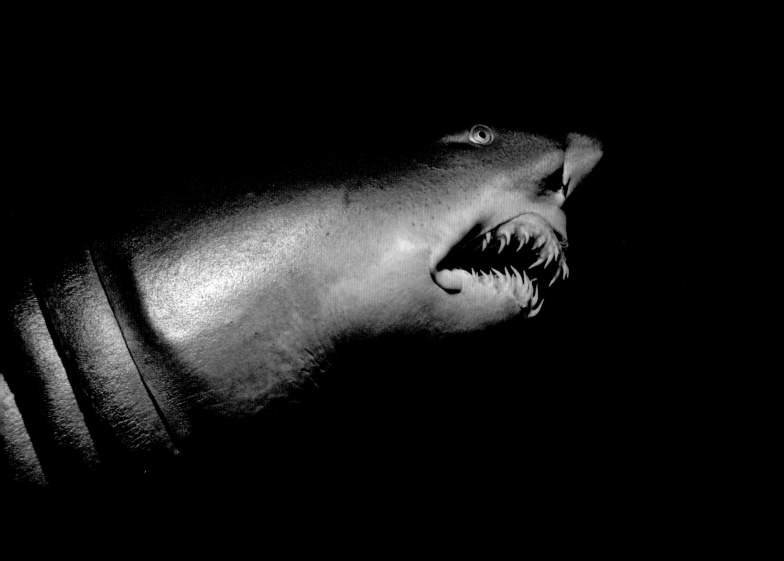

Blotched pufferfish, Sipadan Island, Borneo

Pufferfish, also called blowfish, are known for their ability to quickly inflate their bodies
to two or three times their normal size when threatened. This behavior, achieved by
sucking water into their elastic stomachs, discourages predators but also makes the fish
considerably slower. When not immobilized in their puffed-up defense stance, puffers
can maneuver deftly around obstacles, but they're still a bit slow.

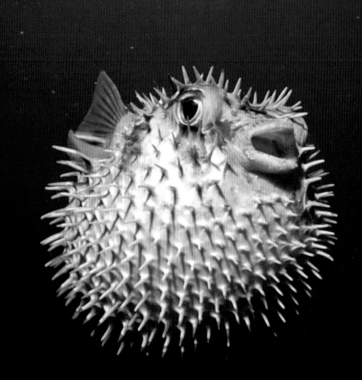

Sand tiger shark, Seal Rocks, New South Wales, Australia

This fearsome-looking beast is a popular exhibit in public aquariums—its three rows of protruding, daggerlike teeth provide the spine-chilling thrill visitors seek. It also adapts easily to captivity and will willingly take food from divers. In the wild, one sometimes encounters large groups of sand tiger sharks in offshore waters, probably pursuing their primary diet, schools of small, bony fish.

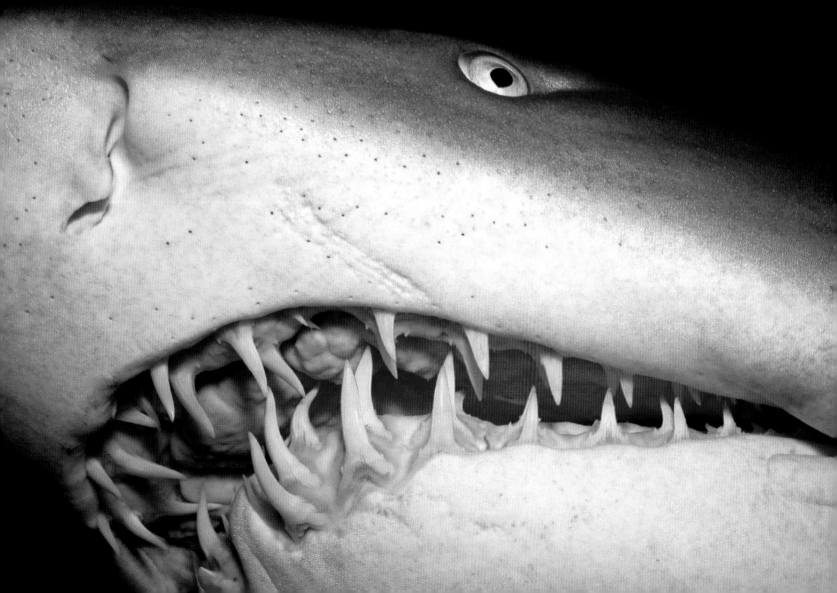

Opposite
Guineafowl pufferfish, Galápagos Islands, Ecuador
A clumsy puffer paddling through the water doesn't seem like much of a match for a hungry shark. But should the shark be foolish enough to try to eat it, a puffer can rapidly inflate itself into a prickly balloon, lodging itself in the shark's throat. Unless the shark can quickly cough it up, both the puffer and the shark will regret the encounter and die a painful death. If the shark manages to expel it, however, it may learn that snacking on pufferfish isn't worth it and pass this information on to its offspring.

Overleaf Left
Sand tiger shark, North Carolina
If looks could kill, you'd die of fright. But while this toothsome sand tiger shark fits the image of the ultimate predator, in reality it's a gentle animal. This photo illustrates a shark behavior known as yawning, which has been observed among various species of sharks, but its purpose is still unknown. In the case of the sand tiger, its jaws can widen to terrifying, albeit relatively harmless, proportions.

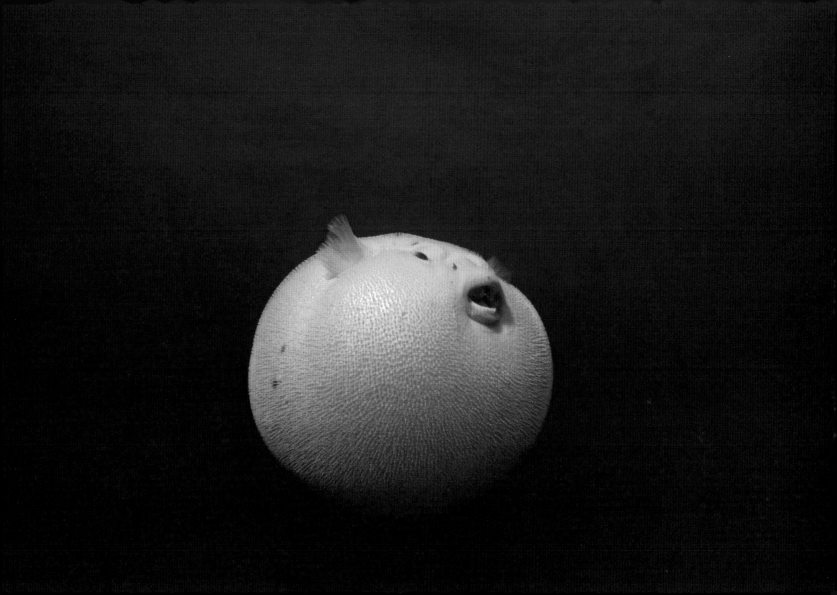

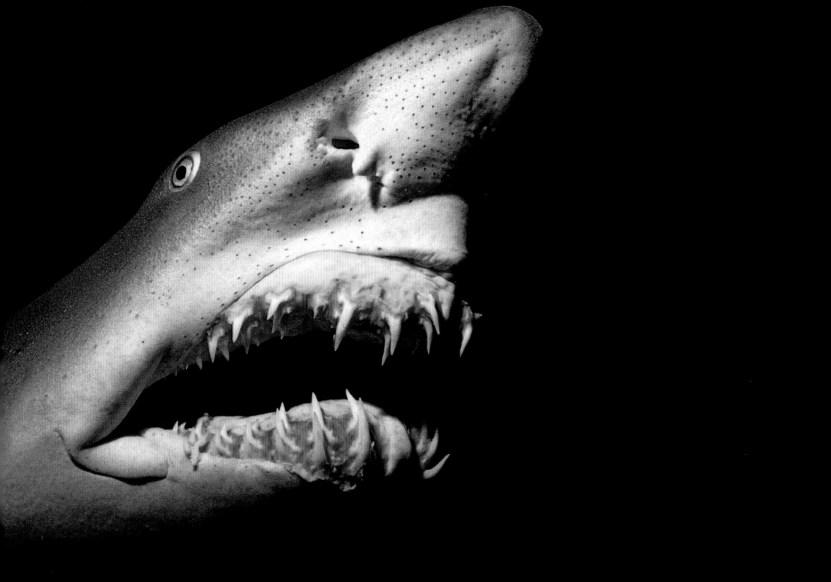

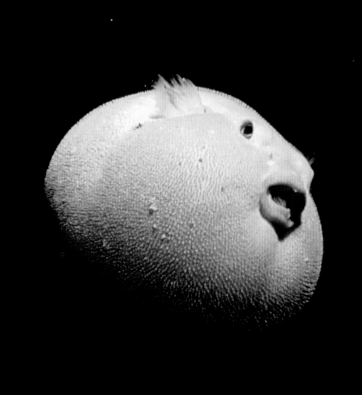

Preceding Page

Guineafowl pufferfish, Cocos Island, Costa Rica

In Japan, the puffer is a delicacy known as fugu. It can only be prepared by a licensed fugu chef, as the eyes, skin, and internal organs of many species are toxic and lethal to humans. However, some species are always deadly, others never are, and some are poisonous only at certain times of the year. A skilled fugu chef will be able to identify the various species and will leave just enough poison in the prepared fish to give diners a pleasant tingling sensation around their mouths, but not so much as to kill them, of course. The Japanese don't seem to mind the risk.

Opposite

Great white shark, Dyer Island, South Africa

There are nearly four hundred species of sharks in the oceans, but the great white is in a class by itself. Once you see Mr. Big, you will never forget him. No other shark awakens such intense emotions and fears. Though they grow up to twenty feet, it's not their length that impresses, but the combination of power and grace, personality and beastly beauty, and a cold-blooded reputation grounded in both fact and fiction that makes us humans sit up and take notice of the great white as king of the sharks.

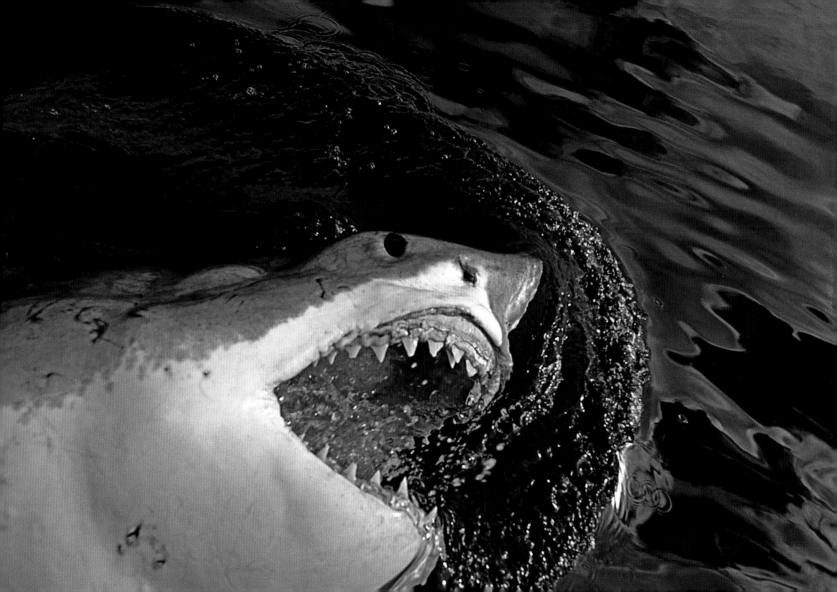

Masked pufferfish, Jackson Reef, Sinai Peninsula, Egypt

They may look cute, but the toxin contained in pufferfish is twelve hundred times more poisonous than cyanide and has no known antidote. Called tetrodotoxin, the poison, which paralyzes its conscious victim to the point of asphyxiation, is produced by bacteria that the fish ingests. It's been estimated that up to fifty people die a year in Japan from tetrodotoxin poisoning. Interestingly, courageous diners who have tasted fugu, and lived to tell the tale, often say it tastes like chicken.

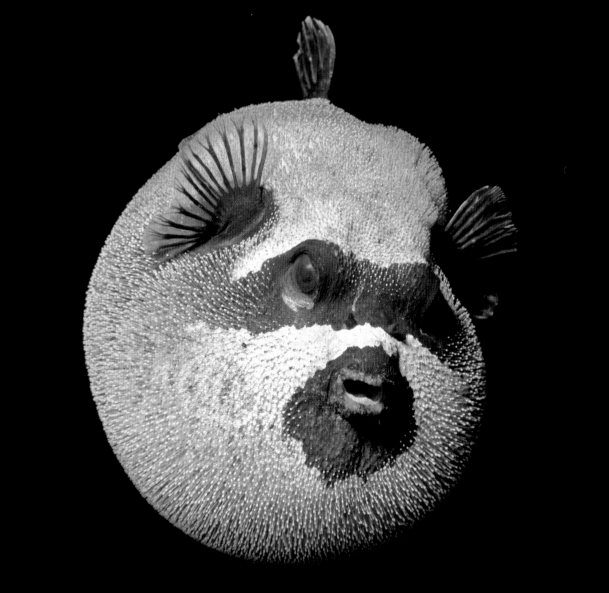

Scalloped hammerhead shark, Kane'ohe Bay, Hawaii

Sharks have excellent eyesight and a keen sense of smell, but they also have sensory organs, called Ampullae of Lorenzini, which can detect electrical fields. Moving fish emit a weak magnetic field, which tweaks these jelly-filled canals that travel from pores in the shark's skin to a bundle of electroreceptors in its head, alerting the shark as to the location of its prey. The ampullae also detect changes in surrounding water temperature.

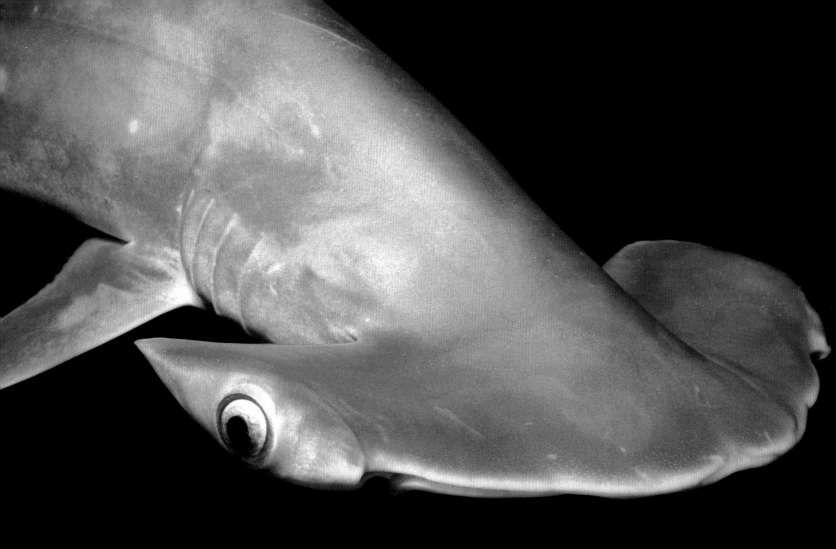

Bridled pufferfish, Andros Island, Bahamas

The eye of the pufferfish is its most vulnerable body part, so sharp spines surround and protect the eye in the event of an attack. Actually modified scales, these spines normally lay flat back against the puffer's body. When threatened and inflated, the fish's taut skin pulls it to intimidating attention.

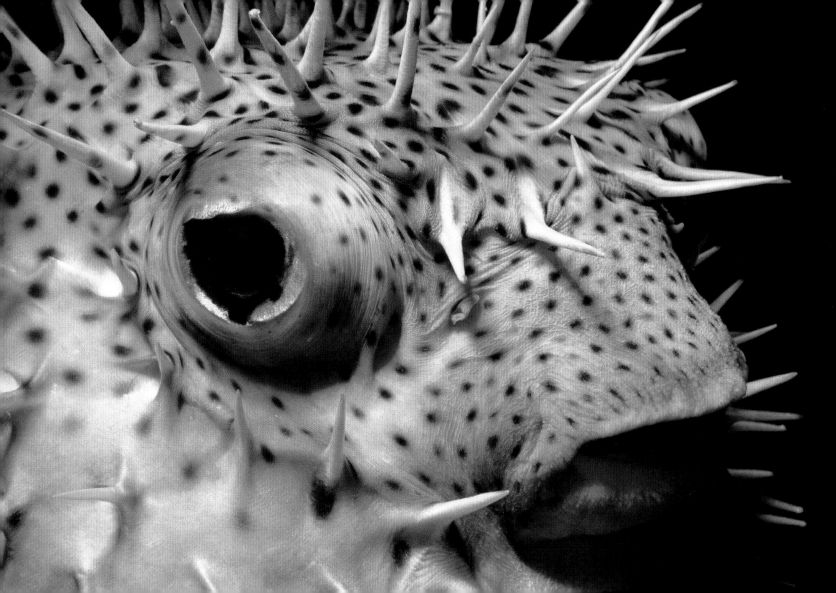

Skin of a porcupinefish, Gordon Reef, Sinai Peninsula, Egypt

A close-up view of the skin of an inflated porcupinefish shows the sharp spines that help to protect it. Look carefully and you'll notice one spine where the sheath of skin covering it has been pushed down. This indicates that the spine has punctured a predator—that predator was my thumb! It was swollen and painful for more than a week.

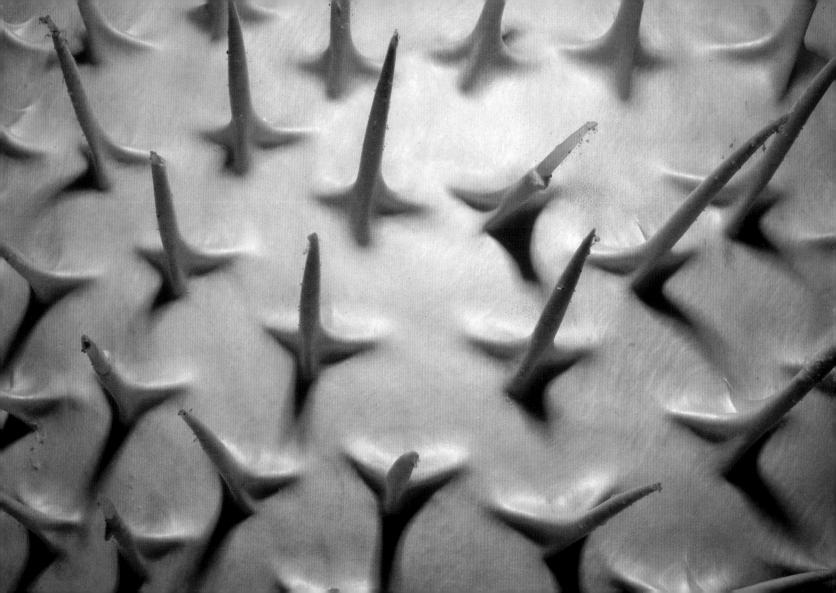

Dorsal fin of a whitetip reef shark, Cocos Island, Costa Rica

The white tip of this dorsal fin explains how the whitetip reef shark got its name. Bony fish have scales that grow over time, but cartilaginous sharks have curved, toothlike scales, called placoid scales or denticles, that stay the same size. As a shark grows, it has to grow more denticles, which form a kind of armor that feels sandpapery to the touch. (Turn the book clockwise to view the image in its proper orientation.)

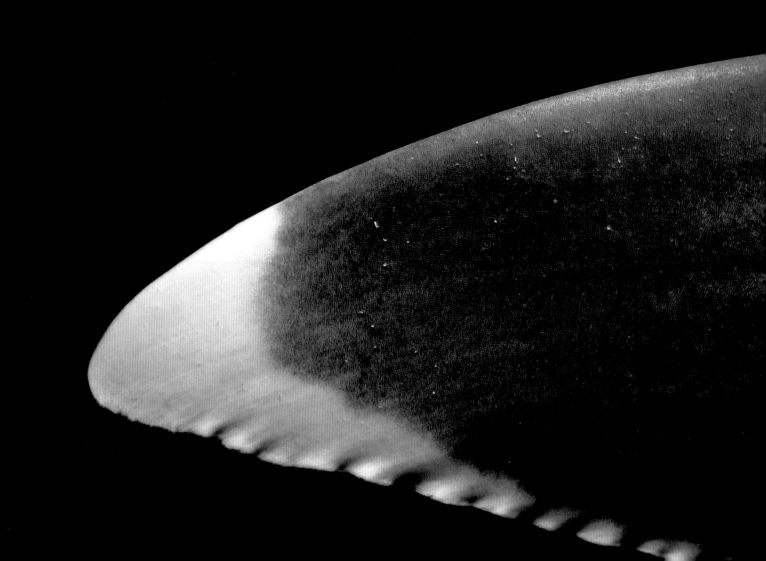

Blue shark, San Clemente Island, California

A long slender body of indigo blue above and stark white below identifies this animal unmistakably as a blue shark. This cryptic coloration helps the shark sneak up on prey. During the day, viewed from below, its white underbelly blends in with the sky; viewed from above, its blue back blends in with the water. During World War II, the sudden appearance of a blue shark's distinctive elongated snout, large eyes, and pointed pectoral fins was the last thing many downed pilots and sailors saw.

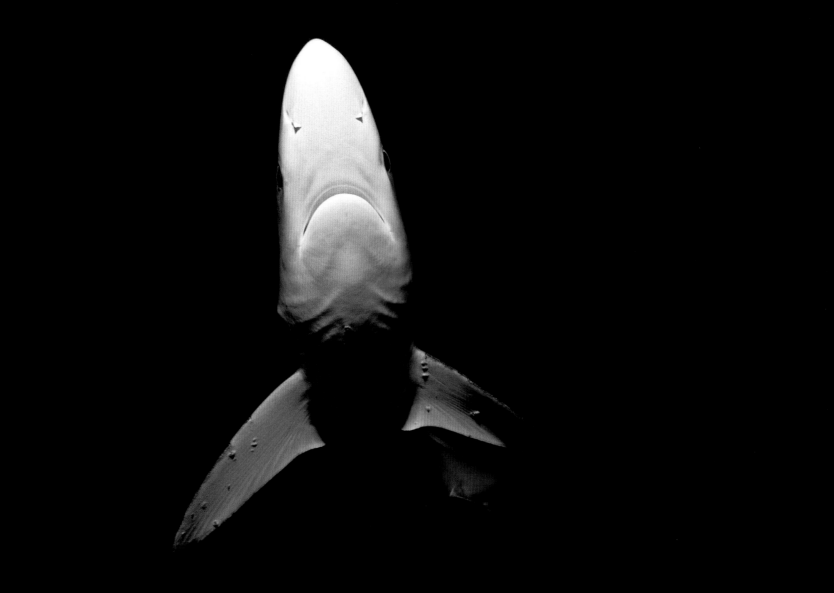

Gorgonian coral, Kimbe Bay, Papua New Guinea

Gorgonians fall in between hard and soft corals in terms of their structure. Though they lack the limestone skeleton of hard corals, they do produce inner cores of tough, flexible protein akin to human hair or fingernails. Most species, including the one shown here, lack symbiotic algae, so, like soft corals, they thrive where dependable currents keep their polyps well fed.

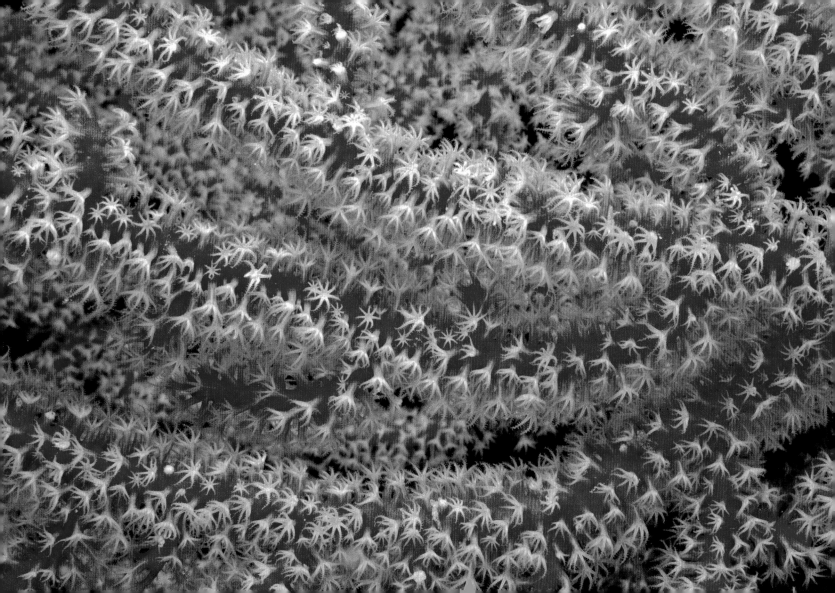

Gorgonian coral, Kimbe Bay, Papua New Guinea

During the day, many gorgonians remain closed for protection; like most corals, their polyps expand maximally only under the cover of darkness. In this photo, you can barely see some of the eight-armed polyps coming out of the skeleton. While the colors are stunning underwater, if you remove these corals from their habitat, they will soon die and become bleached. The colorful versions in dive and tourist shops have been dyed to hint at their former vibrancy.

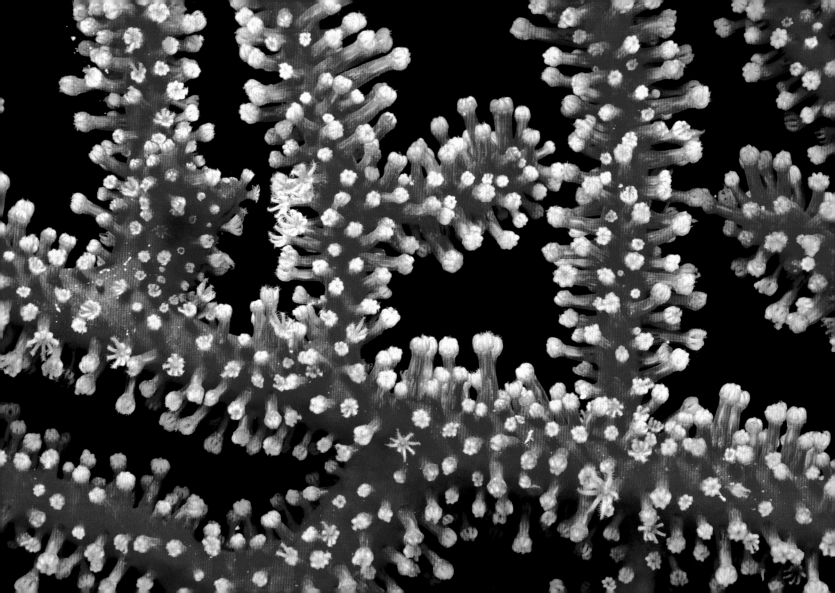

Giant sea fan, Kimbe Bay, Papua New Guinea

The polyps on this gorgonian sea fan are fully expanded and trapping plankton in the night currents. Plankton are bits of organic matter floating about at the mercy of the movement of the oceanic water column. They get their name from the Greek word *planktos*, which means "wanderer." Plankton can be plant, animal, or bacteria. Some animals begin their life cycles as plankton, in their egg or larval stage, before developing the ability to move at will. These microscopic organisms may not be visible to the naked eye, but they are the building blocks of ocean life.

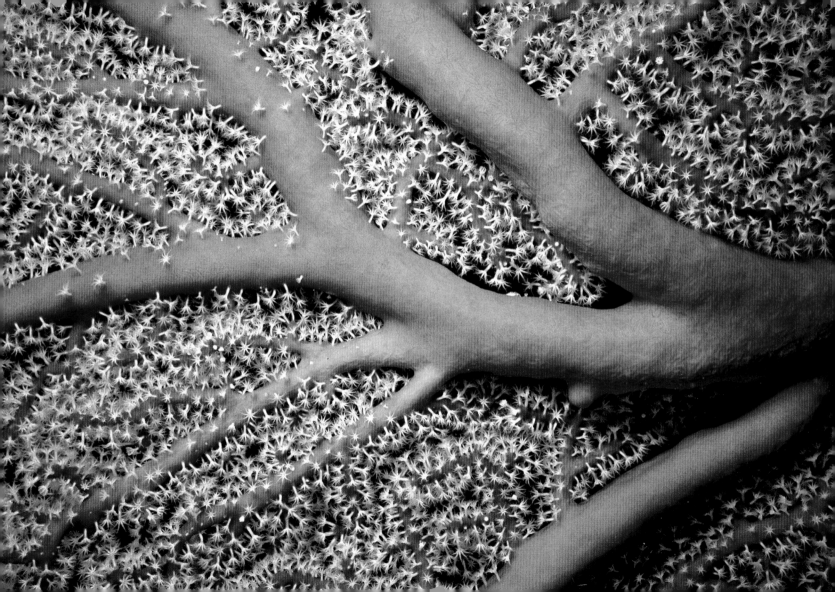

Hingebeak shrimp on an alcyonarian soft coral, Gordon Reef, Sinai Peninsula, Egypt

It was the bulbous blue eyes of this shrimp that I spotted first before the rest of the animal became visible, with its ten candy-cane striped legs. With little more than excellent camouflage to protect it, this shrimp crawls over the prickly alcyonarian soft coral, scavenging bits of organic remains left from the feeding polyps.

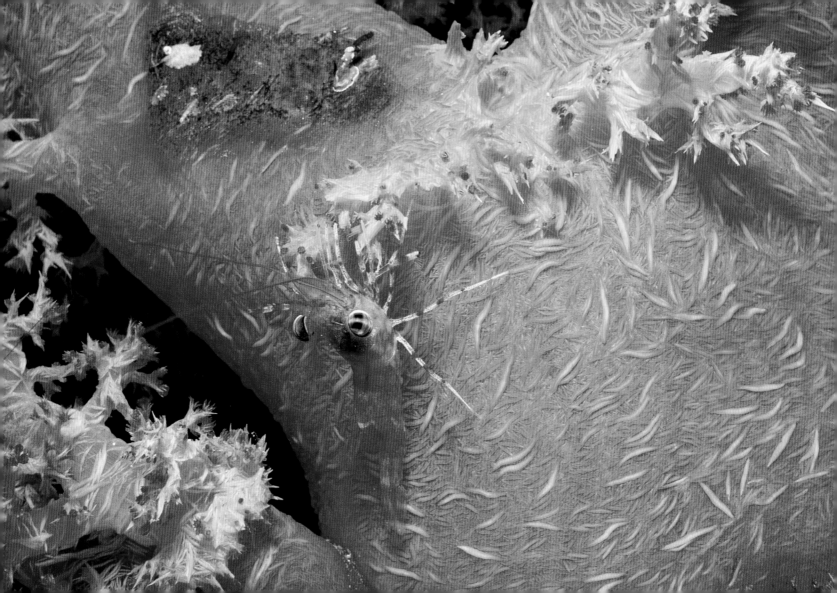

Shrimp in the gill plume of a Spanish dancer nudibranch, Ras Umm Sid,

Sinai Peninsula, Egypt

This shrimp, less than an inch in length, lives symbiotically in the gill plume of the Spanish dancer nudibranch. Usually where there's one, there are two. These cleaner shrimp live in mated pairs. This fellow was alone, possibly the victim of a nasty break-up.

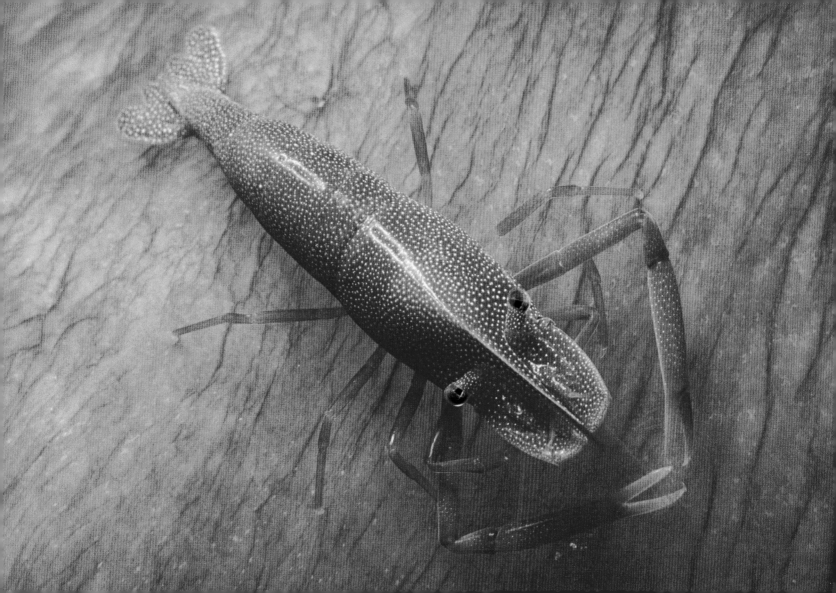

Chiton, Folly Cove, Gloucester, Massachusetts

Armored against its enemies with eight overlapping plates, this mollusk can roll up into
a protective ball when threatened. Its speckled green mantle is spread like a full skirt
over the rock as the chiton grazes peacefully on algae. The animal is able to cling so
firmly to the rock that it is almost impossible to dislodge.

Dark-fingered coral crab, Ras Umm Sid, Sinai Peninsula, Egypt

I love diving at night. It gives me the chance to see and photograph animals that stay hidden during daylight hours, such as this coral crab seeking shelter among anemones and soft corals. Many delicate and vulnerable crabs come out at night, crawling across the reef under cover of darkness. Crabs are able to hunt for prey at night using chemoreceptors on their antennae, mouths, and legs.

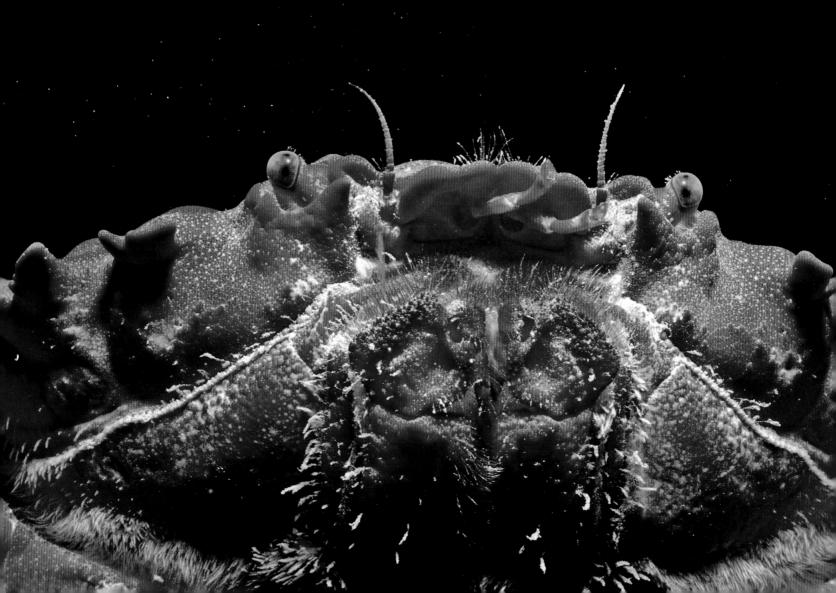

Northern sea stars, Cathedral Rocks, Gloucester, Massachusetts

These voracious sea stars have converged on this spot because it is covered with delicious mussels and barnacles. One on top of the other, they fight for position at the dinner table. Starfish don't have centralized brains but instead have a simple system of nerves that coordinates sensory input from their tube feet, spines, and an eyespot on the end of each arm.

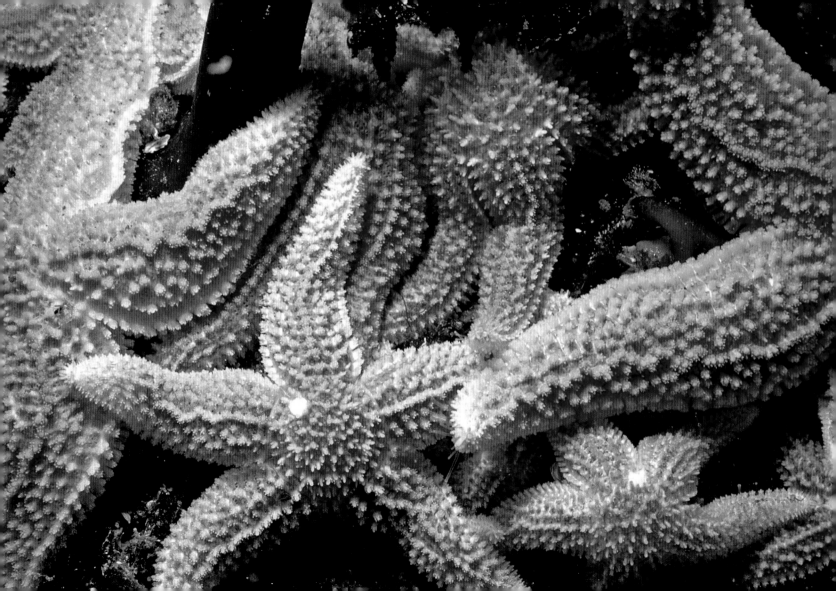

Echinaster starfish, Ningaloo Reef, Western Australia

Born survivors, starfish are able to regenerate lost arms. This individual is in the process of replacing five of its six appendages. It can take a few months or up to a year for a starfish to replace an appendage, but the arm will eventually grow to the same size as the original. In the process, the sea star must adapt to life with the disability.

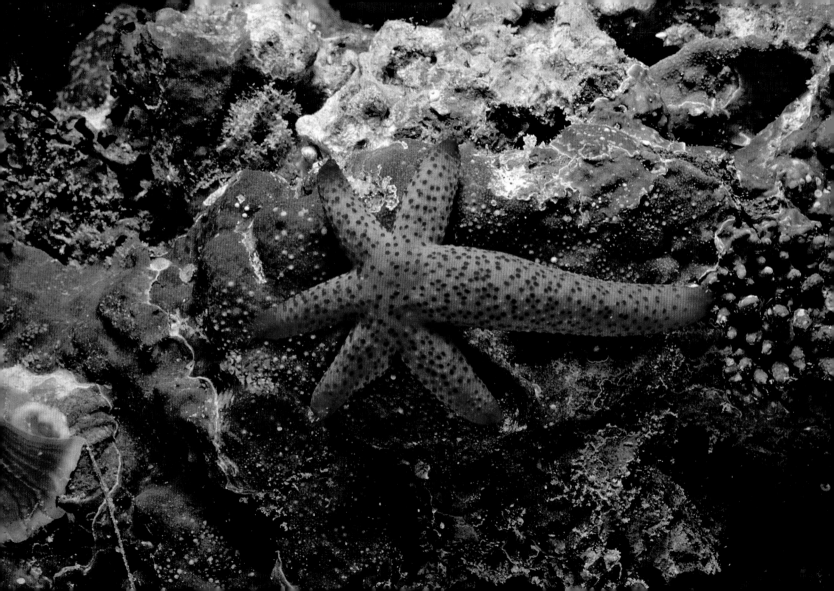

Candy-cane starfish, Ras Mamlach, Sinai Peninsula, Egypt

Poised on soft corals in a cave at night, a Red Sea starfish demonstrates the sort of contrasting red-and-white pattern common among nocturnal and deep-water reef animals. While the coloration may seem rather loud and attention-grabbing, the color red is not visible to the human eye in deeper water, which means that without a strobe light, the starfish actually appears a mottled black, perfectly blending in with its coral backdrop.

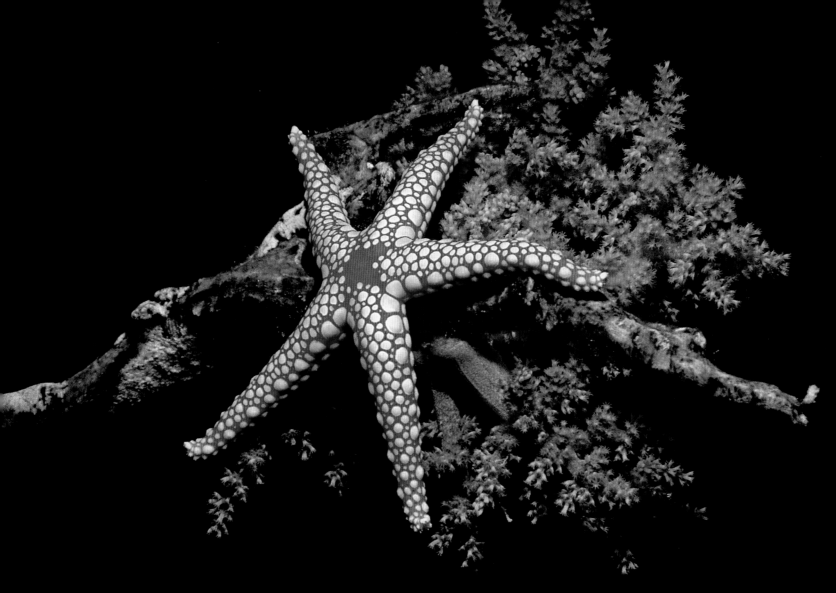

Green sea turtle, Jackson Reef, Sinai Peninsula, Egypt

Streamlined shells and paddle-shaped flippers help make sea turtles excellent swimmers; some have been clocked at twenty-two miles an hour. And though they must rise to the surface every few minutes for oxygen, they're impressive divers. A sea turtle can hold its breath for as long as two hours, slowing its heart rate to as little as nine beats a minute to conserve oxygen. (Turn the book clockwise to view the image in its proper orientation.)

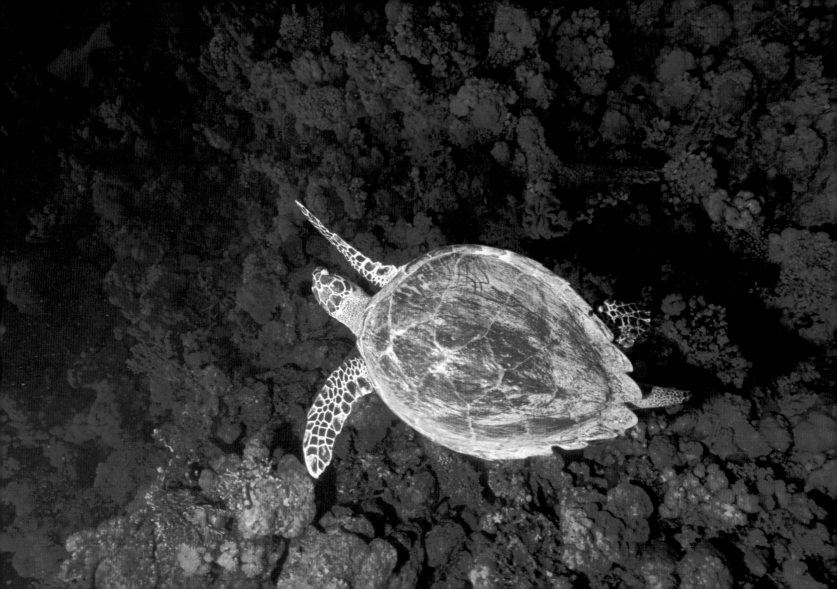

Green turtle, Sipadan Island, Borneo

Sea turtles face many dangers and as a result are themselves endangered. They are killed for their meat and shells and run over by ships; they die from suffocation by mistakenly eating plastic bags, balloons, Styrofoam, and other garbage. Thousands of turtles drown each year from being accidentally caught in shrimp-fishing nets; others become entangled in plastic nets, lines, and buoys, either lost by fishermen or set out for other prey, such as sharks or swordfish. And then, of course, there are oil spills. Unfortunately, sea turtles are easy victims of human excess.

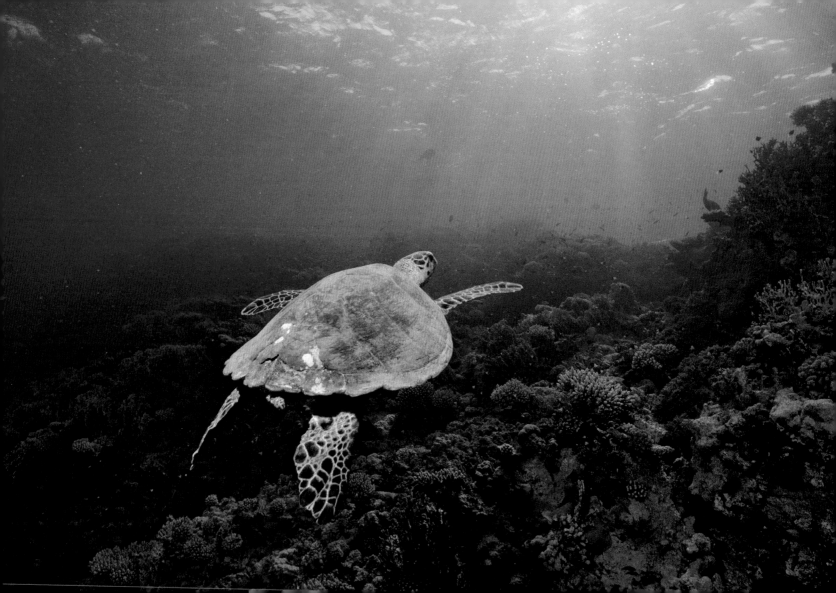

American lobster, Hodgkins Cove, Gloucester, Massachusetts

Strong claws and a hard protective shell make the American lobster a formidable opponent. It has been called the "gangster of the sea" thanks to its aggressive and territorial nature. The lobster's large-toothed crusher claw, pictured here, is used for pulverizing shells (and breaking the fingers of divers who try to catch it!). The pincer claw is razor-sharp and used for extracting and shredding the flesh of prey. Depending on which side of the lobster's body the crusher claw is located, it is considered right- or left-handed (this one is left-handed).

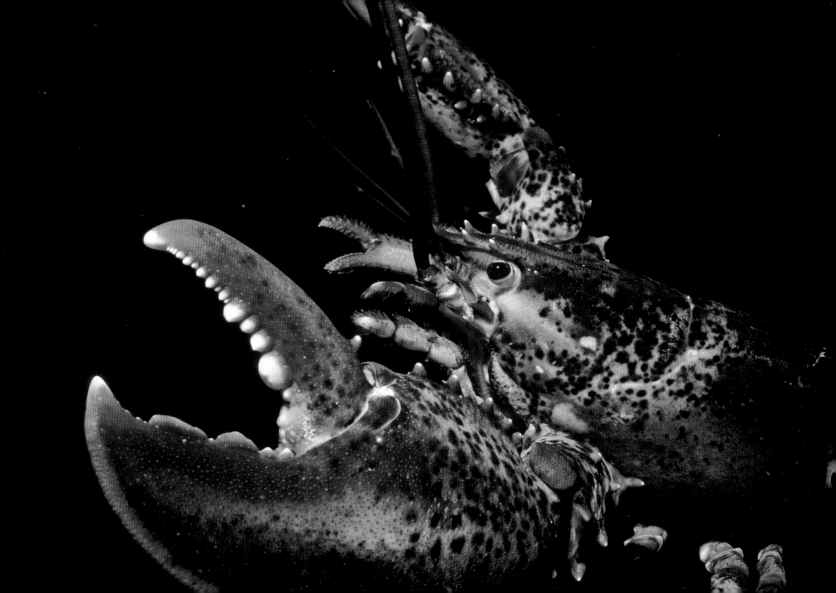

Bearded scorpionfish, Woodhouse Reef, Sinai Peninsula, Egypt

The scorpionfish is one of the most venomous fish on the reef. It sits quietly on the ocean floor among coral rubble. Since it is camouflaged to look like part of the coral reef, most crabs, fish, and other victims never know what got them. Records aren't always reliable, but it's estimated that around 50,000 injuries a year, most of them mild, can be attributed to stings by venomous fish. Most are from a fish acting in self defense, and about half of all injuries are to fishermen.

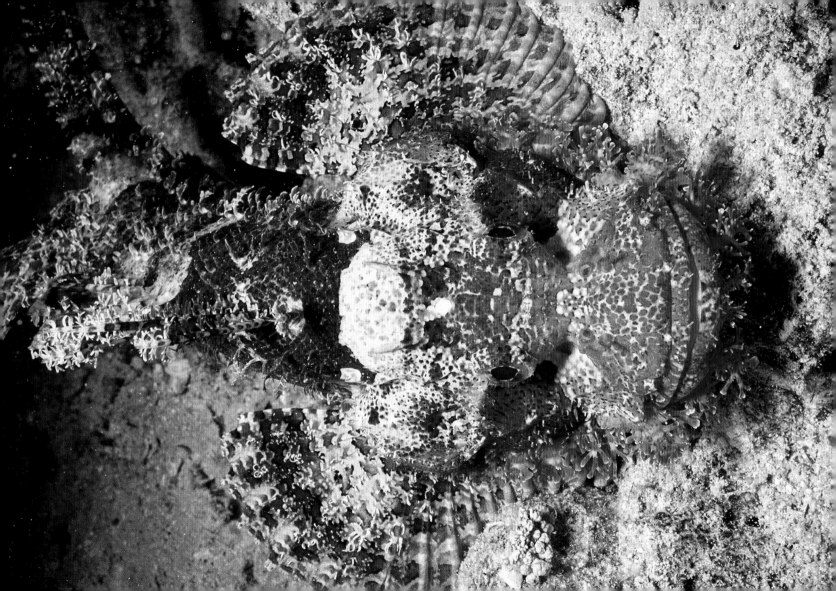

Lionfish, Moses Rock, Eilat, Israel

This lionfish is using its winglike side fins to sweep fish into a corner of the reef where they can't escape. Other times, the lion fish seems to hover midwater, not unlike a helicopter, waiting to gulp down smaller fish that come too close. Lionfish can have up to eighteen syringelike spines that inject potential predators with a venom that is very painful but usually not deadly to humans.

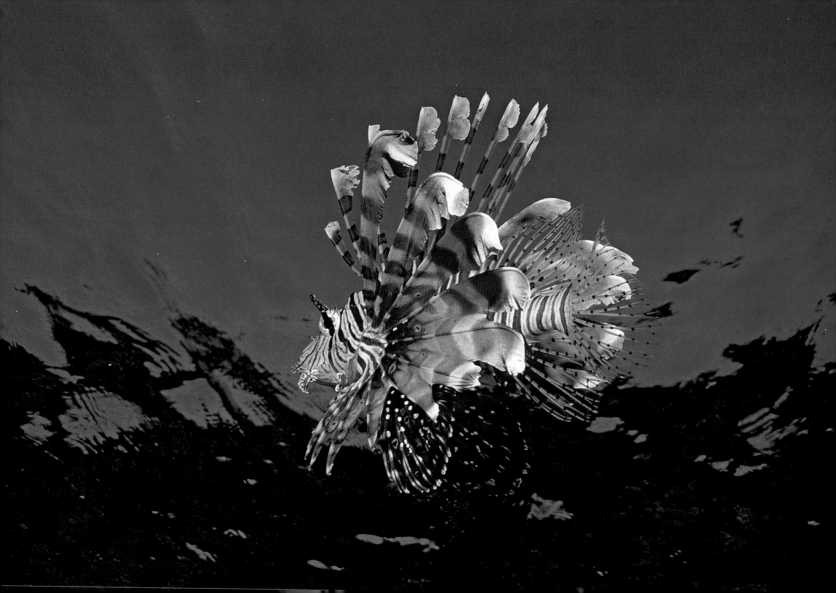

Spanish dancer nudibranch, Ras Umm Sid, Sinai Peninsula, Egypt

A star of any night dive is the rare and beautiful Spanish dancer, one of the largest known shell-less snails. Ranging in color from blood-red to rose-pink, Spanish dancers are rarely seen in the day. By night, however, they emerge. Dislodged from the reef surfaces where they normally graze, these animals undulate gracefully through the water, waving their "skirts" like silent facsimiles of their flamboyant flamenco namesakes.

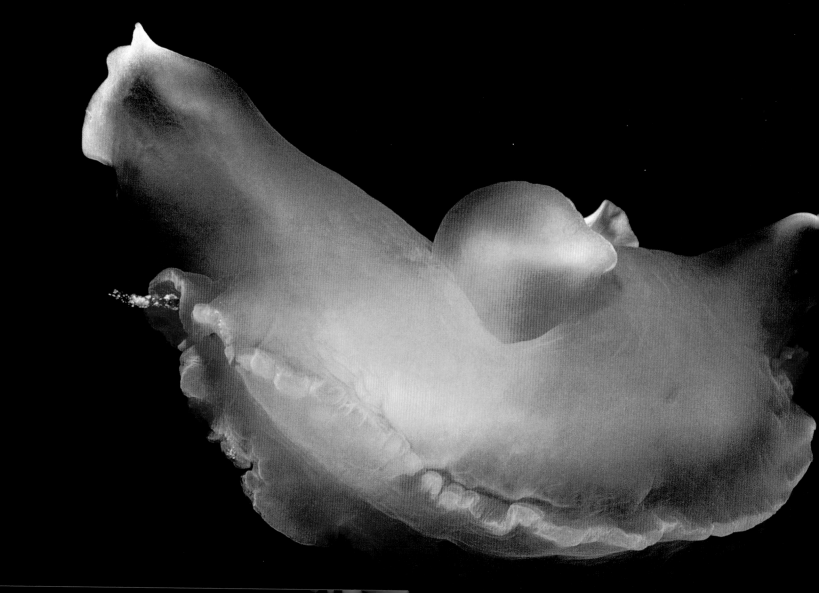

Egg ribbon of a Spanish dancer nudibranch, Ras Umm Sid, Sinai Peninsula, Egypt
Nudibranchs are hermaphrodites, meaning they contain both male and female sex organs and can potentially mate with any member of the species. The so-called egg ribbons of Spanish dancer nudibranchs contain hundreds, even thousands, of eggs. The nudibranch can spawn the egg ribbon in a clockwise or counterclockwise spiral, but scientists aren't sure whether the direction is species-specific or related to the hemisphere in which the nudibranch lives.

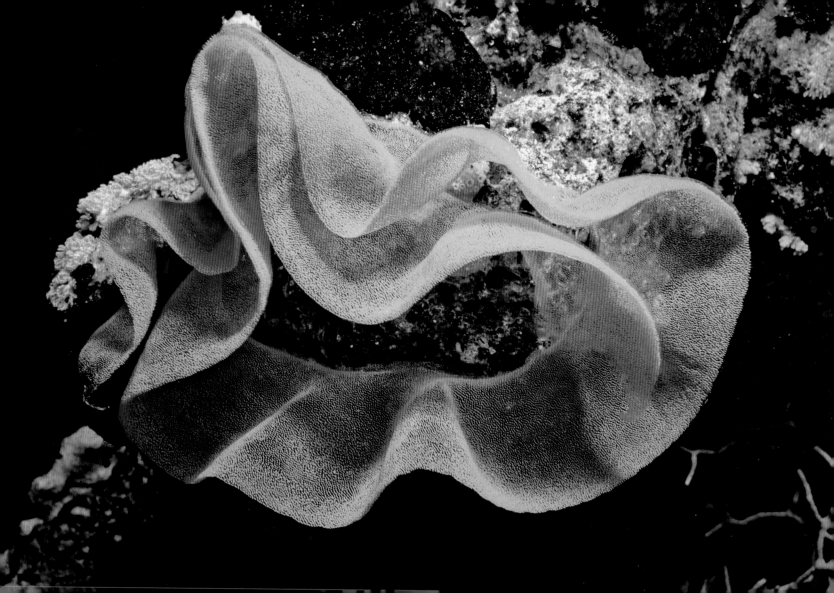

Tubastria cup coral, Ras Nas Rani, Sinai Peninsula, Egypt

Pumped full of water and expanded to feed, these hard coral polyps will retract into their calcium carbonate skeletons at sunrise. Unlike reef-building coral, each of these polyps has its own stony, cup-shaped skeleton it calls home. Since it doesn't require the sunlight that other corals harboring algae do, it can feed at night and retreat to safety during the day.

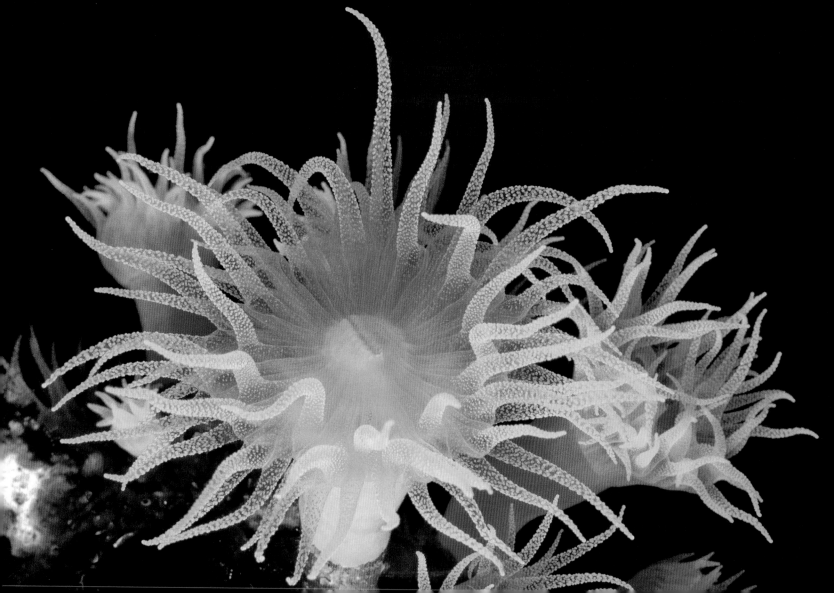

White-spotted rose anemone, Monterey, California

For lack of a true skeleton, sea anemones use hydrostatics and water pressure to keep their tentacles erect when feeding. Having the diameter of a medium-size navel orange when open, this white-spotted rose anemone has now tightly contracted to about the size of a tangerine by expelling much of that water. In this contracted state, the anemone uses little metabolic energy and rests in relative safety from predators.

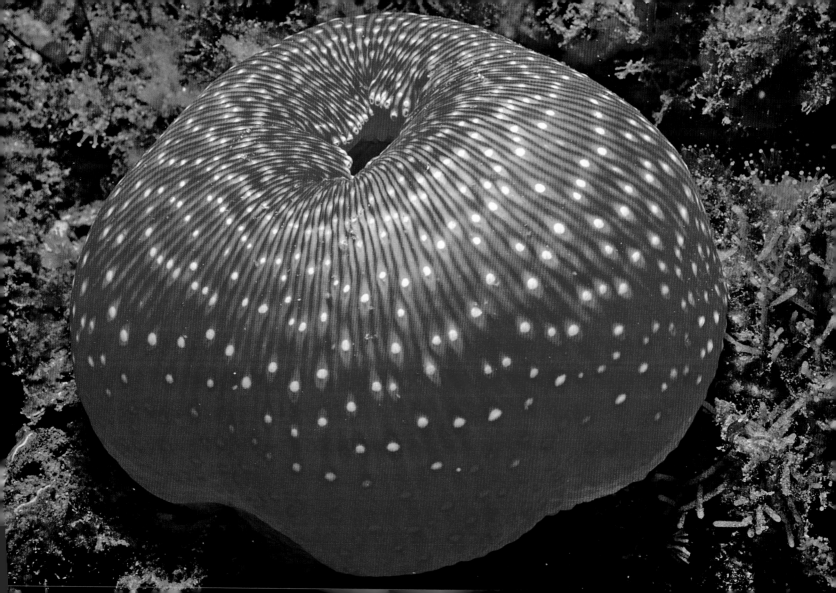

Soldierfish, Great Barrier Reef, Australia

One look at the enormous eye on this soldierfish, and you can be certain it is nocturnal. During the day you can find them hanging out in caves and shadowed ledges, but at sunset they emerge and begin their "day." In addition to having large eyes, nocturnal fish are generally slower and more prone to living alone rather than in schools, and they are usually carnivores. Of course, there are many exceptions, but as they say, the exception proves the rule.

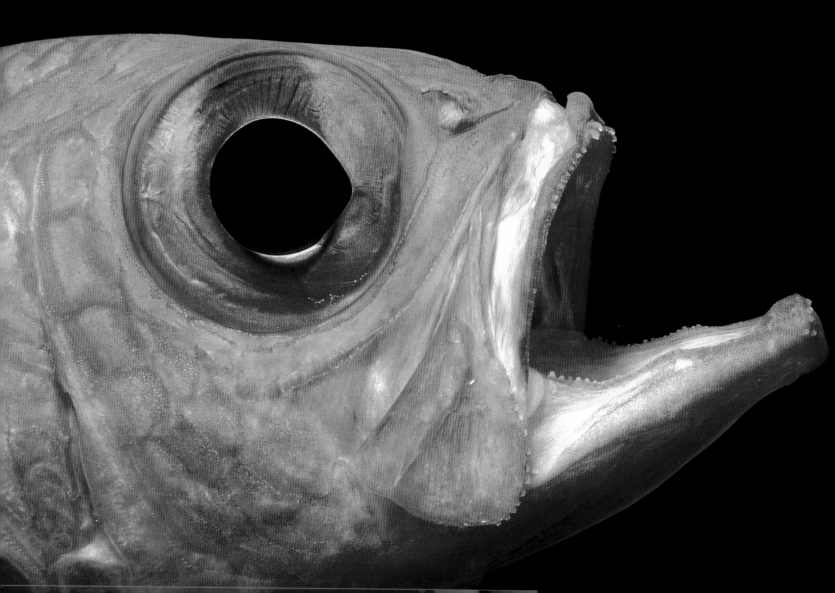

Bluespine unicornfish, Great Barrier Reef, Australia

Unicorn fish—like their relatives, tangs and surgeonfish—use small but conveniently located mouths to crop algae attached to reef surfaces. They get their name from the bony horn on their forehead, although not all unicornfish have horns.

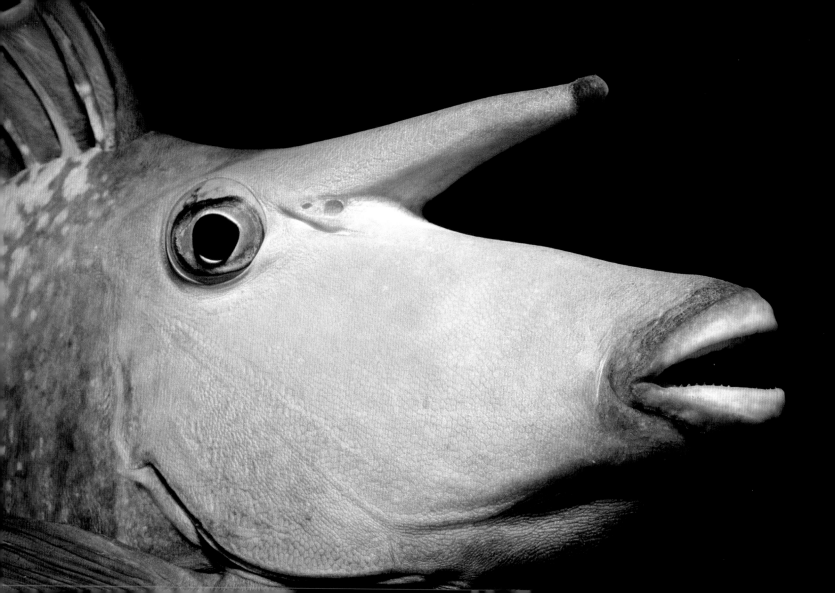

Queen triggerfish, Andros Island, Bahamas

Triggerfish use powerful beaks and adaptable predatory behavior to make short work of even heavily armored sea urchins. By carefully lifting an urchin by a few of its spines and dashing it against rocks, a clever triggerfish can break the remaining spines until the urchin's tasty, soft tissues are exposed. Alternatively, a triggerfish may use its mouth to direct powerful water jets at an urchin, blowing it over and exposing its unprotected underside.

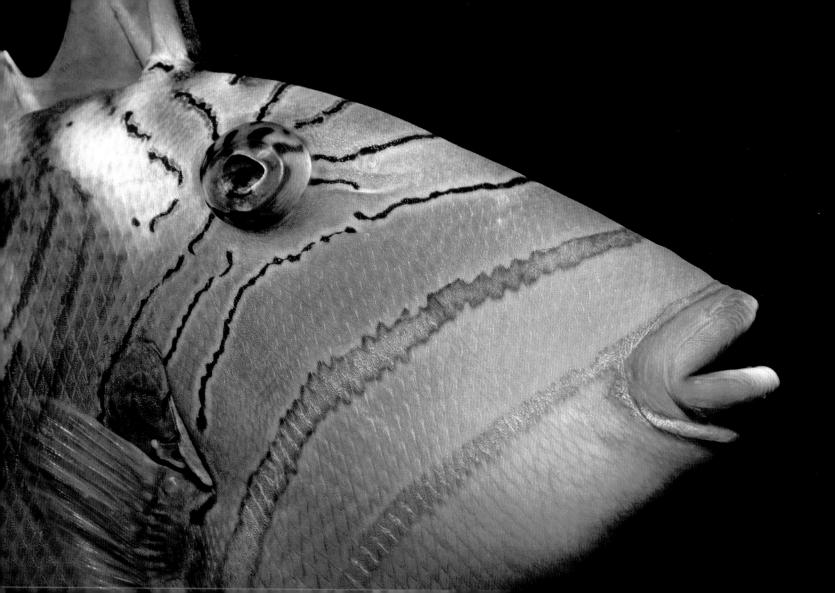

Checkerboard wrasse, Ras Nas Rani, Sinai Peninsula, Egypt

Sandy Red Sea lagoons with a bit of coral are a favorite environment of this species of wrasse. They prefer the hard-shelled prey—mollusks, crustaceans, and sea urchins—that are in abundance there. Its head is blue or green with orange or pink stripes, but this fish gets its descriptive name from the checkerboard pattern of alternating white and black scales on the back of its body.

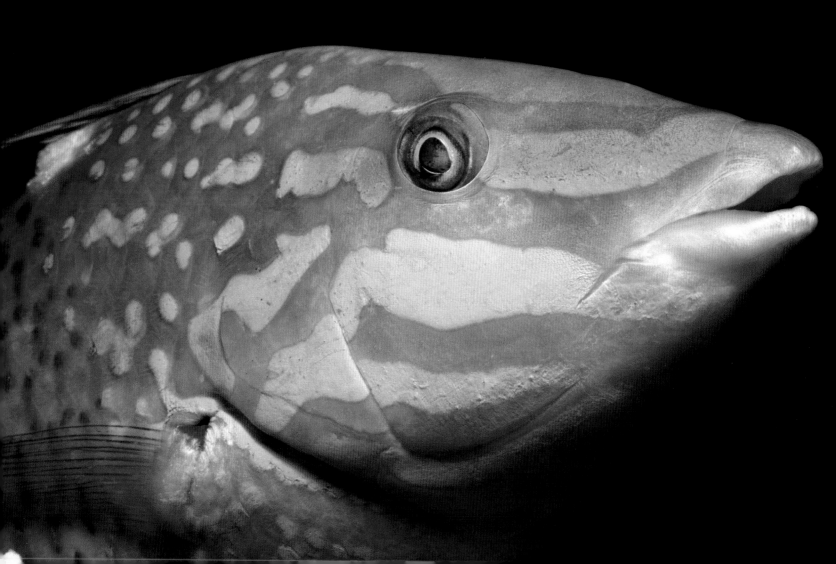

Opposite

Bluetail trunkfish, Ras Mohammed, Sinai Peninsula, Egypt

This bluetail trunkfish, sometimes called a boxfish, is named for its hard external carapace, made from fused, platelike scales. This armor carapace provides adequate protection from most predators, but this fish has another trick up its fin: It can secrete a skin poison, called ostracitoxin, when it is under stress.

204

205

Overleaf Left

Painted greenling, Santa Catalina Island, California

With its pointed snout and two pairs—one above each eye—of cirri (branching, horn-like protrusions good for camouflage), the painted greenling has a very distinctive look. Not only was this four-inch-long fish not afraid of me, but after I finished photographing him, he followed me around for the rest of my dive.

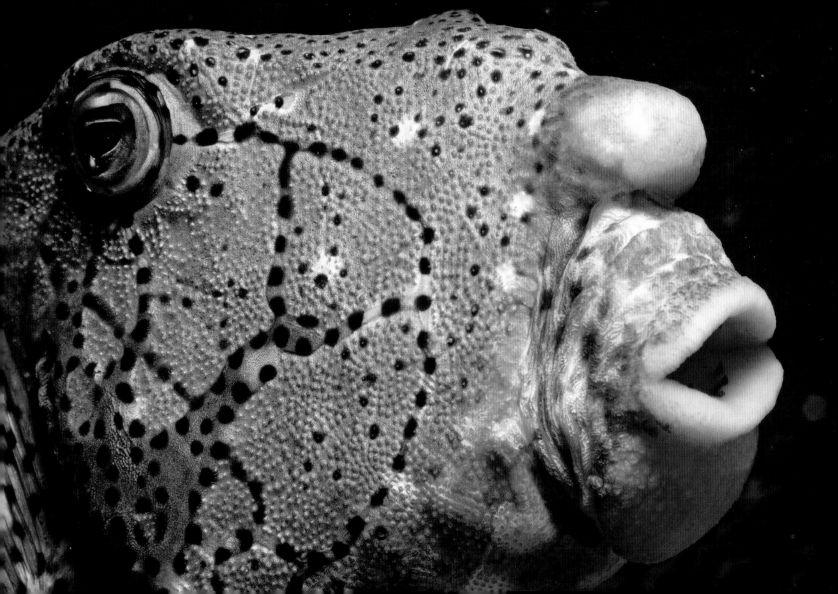

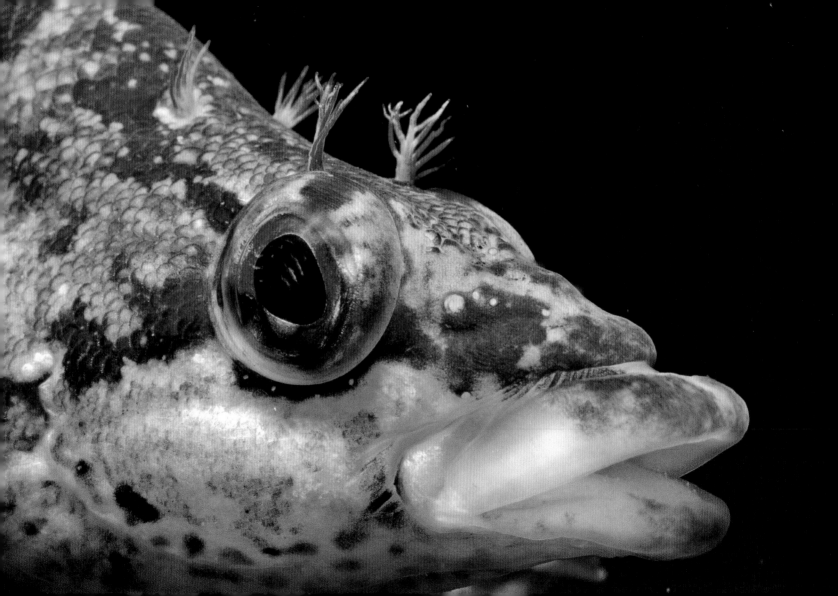

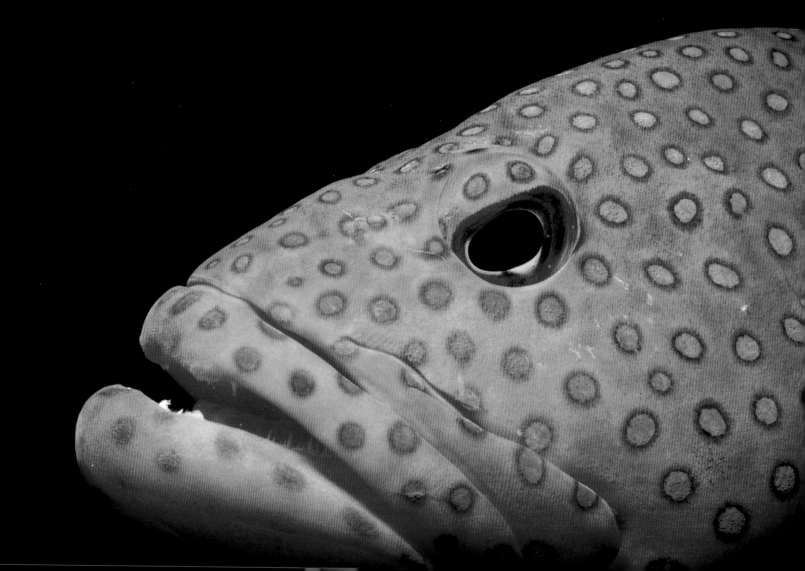

Preceding Page

Coral grouper, Jackson Reef, Sinai Peninsula, Egypt

Coral groupers, common in the Red Sea, are territorial and solitary. One will lie in wait for its unwitting prey, by hiding itself in a crevice or cave. A quick stroke of its long tail allows for a burst of speed and a sudden attack. The grouper then opens its huge mouth, creating a vacuum that sucks in its prey whole.

205

Opposite

Rusty parrotfish, Ras Mohammed, Sinai Peninsula, Egypt

The teeth of parrotfish are fused to form powerful protruding beaklike mouths capable of rasping algae from the porous skeletons of dead coral. In the process, large quantities of the reef structure are consumed. Many divers first notice parrotfish by their rather unpleasant habit of voiding long plumes of excavated waste as they swim past.

206

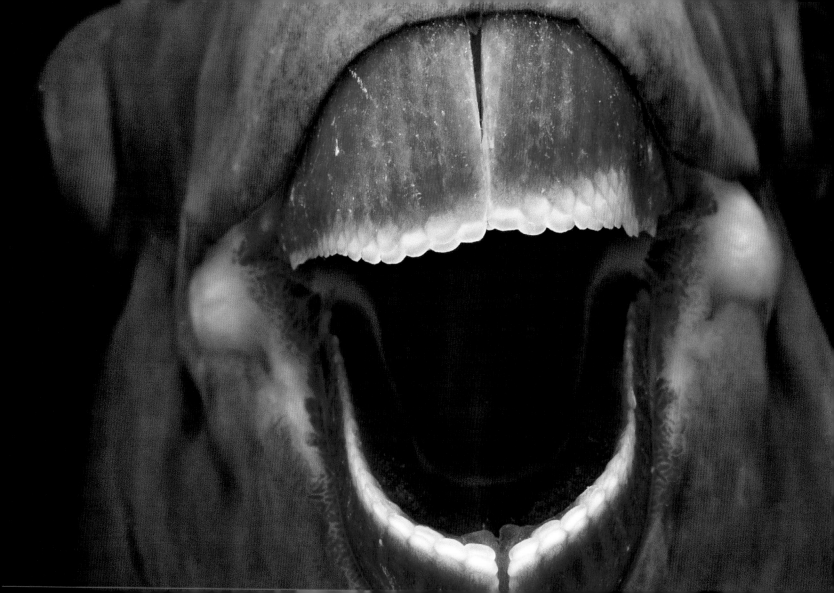

Saddle butterflyfish, Great Barrier Reef, Australia

Take a good look at a fish's mouth, and you can probably guess what it eats. More often than not, fused, beaklike teeth are specialized for scraping algae; sharp inward-pointing teeth (fangs) are for making escape difficult; and blunt molarlike teeth are for grinding shelled prey. I followed this hungry fish for two hours as it started off with an appetizer of algae, picked its way through a first course of coral polyps, then moved on to a main course of a tiny crab it had pulled from between some coral branches, and finally polished it all off with a dessert of fish eggs. A meal fit for a king!

Hawksbill turtle, Liors Garden, Sinai Peninsula, Egypt

Most species of sea turtles are named for some distinctive feature, like this hawksbill turtle, which gets its name from its sharp, birdlike beak. It can poke its sharp snout into small openings in the coral reef to seize shrimp, sponges, anemones, and squid. Its tongue helps it swallow food, but unlike many other reptiles, a turtle cannot extend its tongue to help in catching prey.

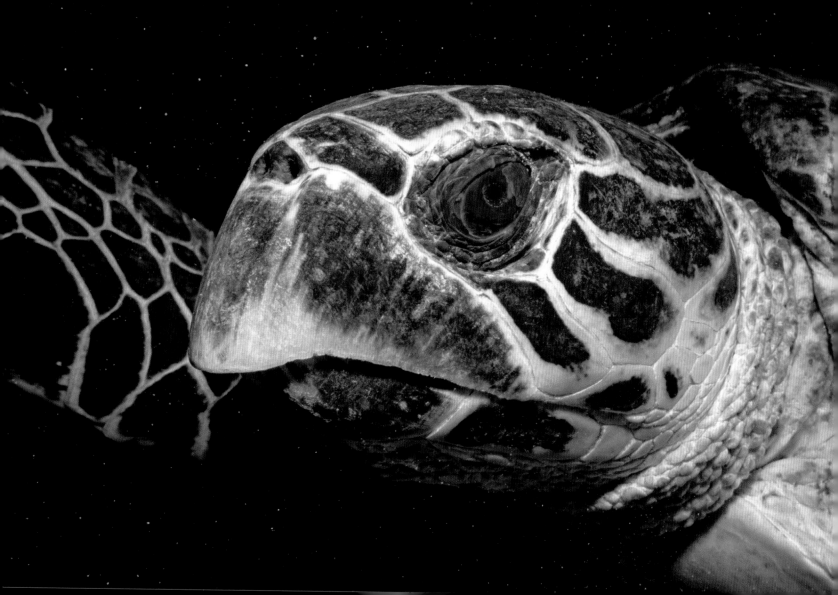

Sea raven, Bass Rocks, Gloucester, Massachusetts

In my opinion, the sea raven, an especially prickly sculpin, is one of the most gorgeously bizarre-looking fish on our planet. It comes in shades of brown and red, and once I even came across one that was yellow. Like the blowfish, the sea raven is capable of expanding its belly with water, although it's not known whether it can deflate at will like the blowfish.

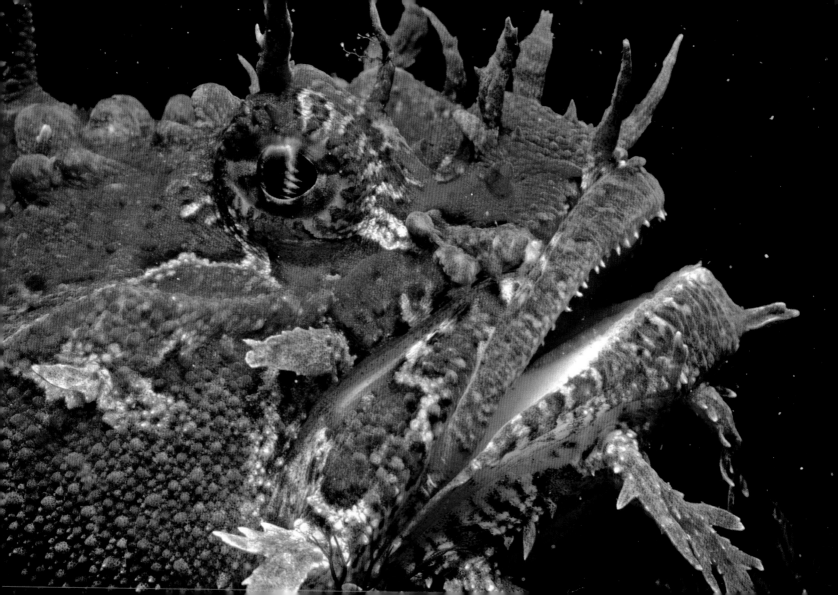

Sapphirine gurnard, Isles of Glénan, Brittany, France

This gurnard tiptoes along the rocky bottom with unusual pectoral fins that appear to operate like feet. A poor swimmer, it flaps its fins like a bird does its wings. During spawning season, it can migrate quite far. The chilly Atlantic is home to many strange-looking fish that are often colored in muted earth tones. While I have never seen sea robin on a menu, there is a classic French bouillabaisse that calls for it.

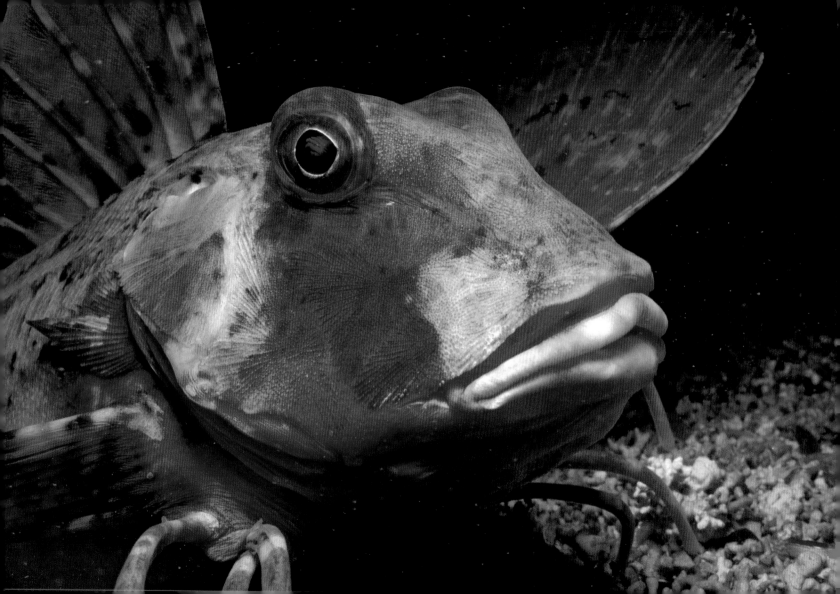

Rainbow wrasse, Ras Mohammed, Sinai Peninsula, Egypt

This rainbow wrasse, poised in surprise after having been roused from sleep in a cave at night, displays the flamboyant coloration, specialized mouth, small eyes, and highly maneuverable fins that typify many species of its family. The wrasse family is one of the largest of marine fish, with more than five hundred species. Their small eyes are one hint that these fish are diurnal, or active in the daytime.

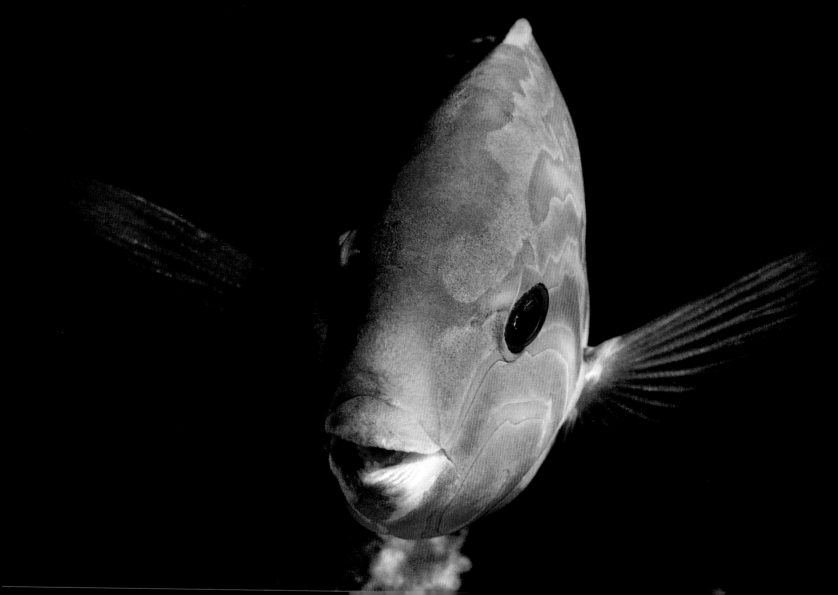

Bullethead parrotfish, Ras Nas Rani, Sinai Peninsula, Egypt

My son, Adam, once asked me what my favorite fish was. I replied that there are so
many amazing fish with incredible patterns and colors, I couldn't choose just one.
This did not satisfy Adam. Forced to choose, my ultimate answer was the bullethead
parrotfish. While individuals can vary greatly, this fish often starts out a drab brown with
a red mouth and matures into this kaleidoscope of color.

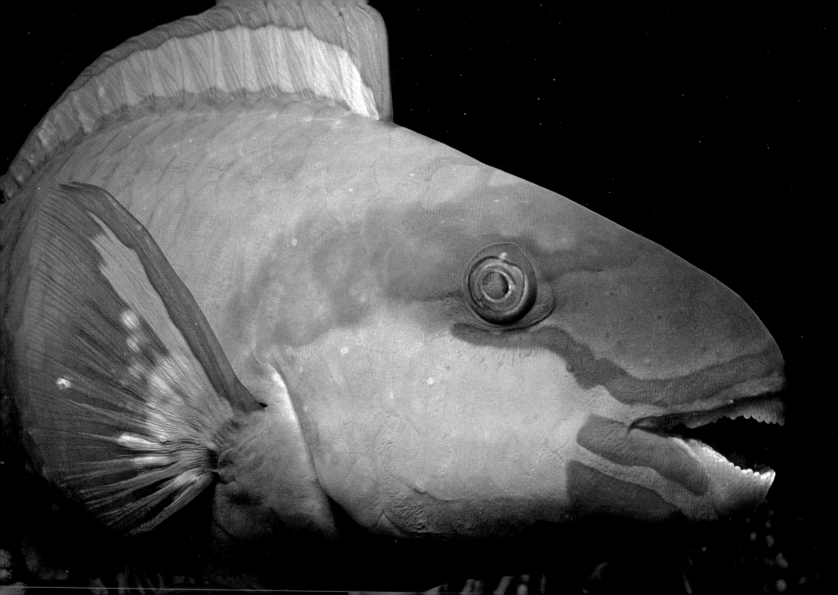

Bicolor parrotfish, Ras Mohammed, Sinai Peninsula, Egypt

A single species of parrotfish may have four different color patterns, depending on individuals' sex and sexual maturity. Parrotfish that are born male will always be "primary" males. But born females can change into "super males," changing color accordingly. Presumably, prospective mates are less confused by the complex coloration changes than I am, because parrotfish spawn year-round, especially in summer. They are pelagic spawners, which means they mate in the open sea where the fertilized eggs can drift far on ocean currents.

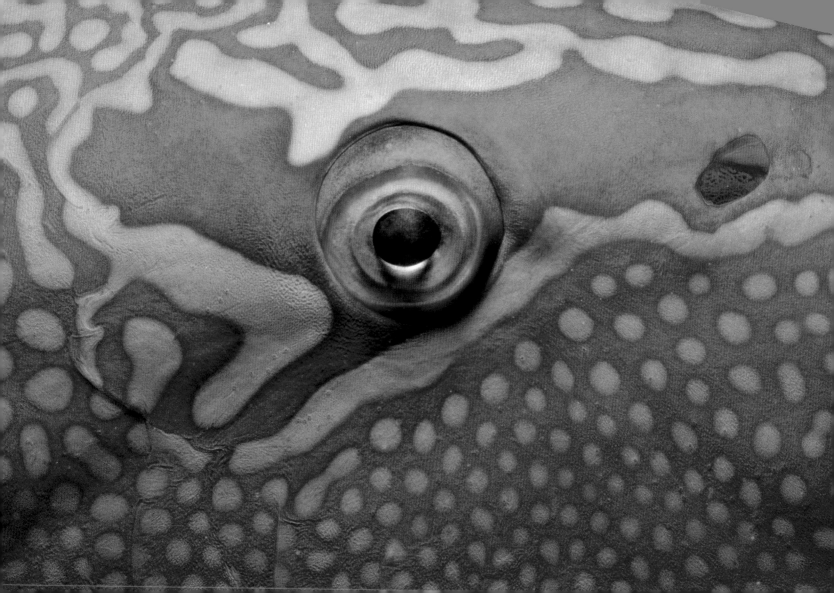

Bicolor parrotfish, Ras Mohammed, Sinai Peninsula, Egypt

In the dead of night, I was able to get within inches of this sleeping parrotfish. A single species of parrotfish may have up to four different color patterns, depending on an individual's sex and sexual maturity. Parrotfish coloration is so complex it's even led scientists to misidentify species. It was once believed there were about three hundred species, but experts today believe that number may be closer to sixty.

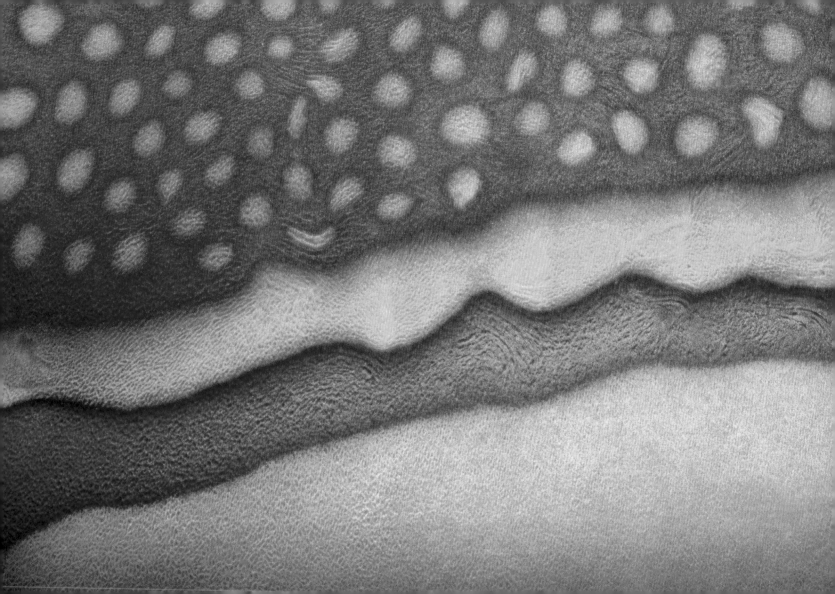

Queen parrotfish, Ras Abu Galoum, Sinai Peninsula, Egypt

The parrotfish has a mouth made for munching. When a tooth on the biting edge wears down, a new one grows forward to replace it. The fish uses this "beak" to knock off chunks of coral, which are ground up by a second set of molarlike teeth in the parrotfish's throat and passed out the other end, as coral sand.

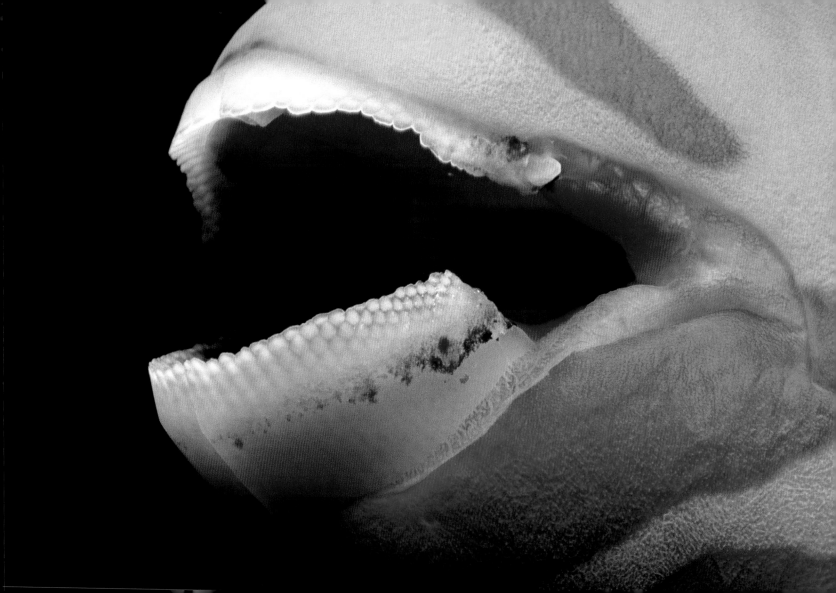

Queen angelfish, Freeport, Bahamas

It's not known exactly how old the Caribbean Sea is (guesses range from 20,000 to 570 million years), but it is a relatively new sea, geologically speaking, and, therefore, doesn't sustain the same level of biodiversity as in older seas. It's also relatively shallow compared to oceans, about twenty-five thousand feet at its deepest level, in the Cayman Trough. It does, however, have this spectacular queen angel.

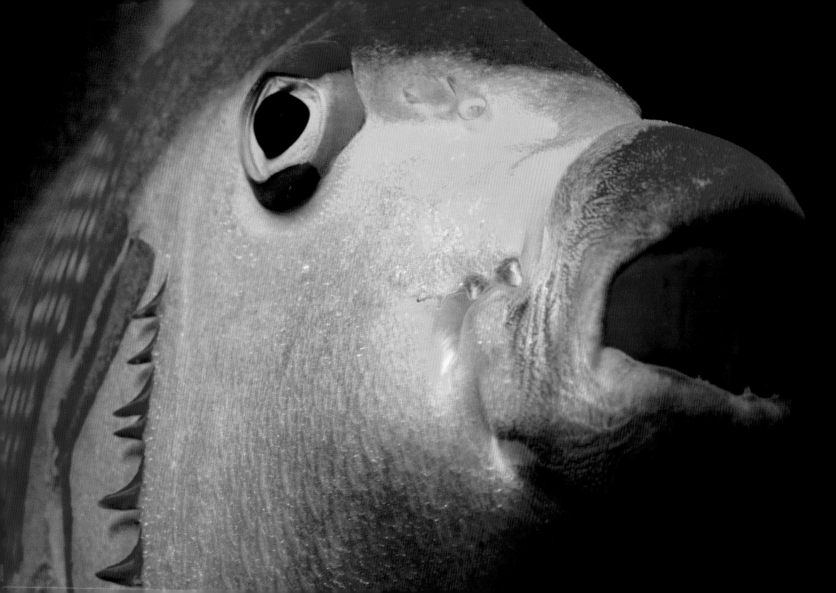

Tail of a queen angelfish, Freeport, Bahamas

Fish fins and scales play games with our eyes, attracting our attention here, diverting it there. Fins are outlined, not just in white or black, but in combinations of white, black, and sometimes yellow and blue (like this angelfish). The queen angel has similar coloration to the blue angel. On very rare occasions, the two species have been known to interbreed, their offspring exhibiting visual characteristics of both fish.

Gill plate of a queen angelfish, Freeport, Bahamas

Gills are as vital to fish as lungs are to humans. They are the organ through which fish "breathe," extracting dissolved oxygen from the water, which is then carried to the fish's tissues via blood vessels that pass through the gills. To help protect this sensitive area, the queen angelfish's gill plate, or operculum, is armored and equipped with hard, sharp spines. Not all fish have gill plates, although most bony fish do.

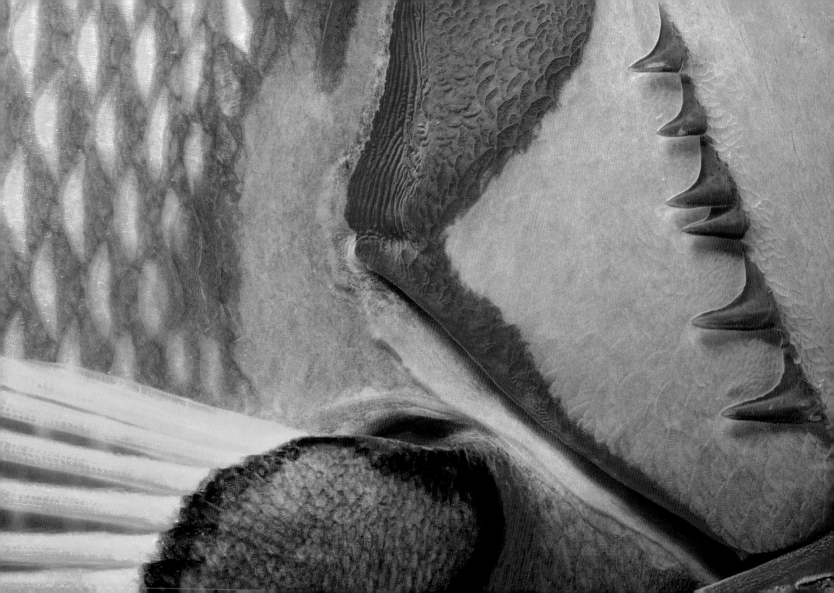

Steepheaded parrotfish, Ras Nas Rani, Sinai Peninsula, Egypt

This diurnal parrotfish has entered a state of deep sleep. Photographing these normally skittish fish is easy once they reach this state of rest; they can be gently handled and surrounded with lights for several minutes before they regain sufficient consciousness to swim away.

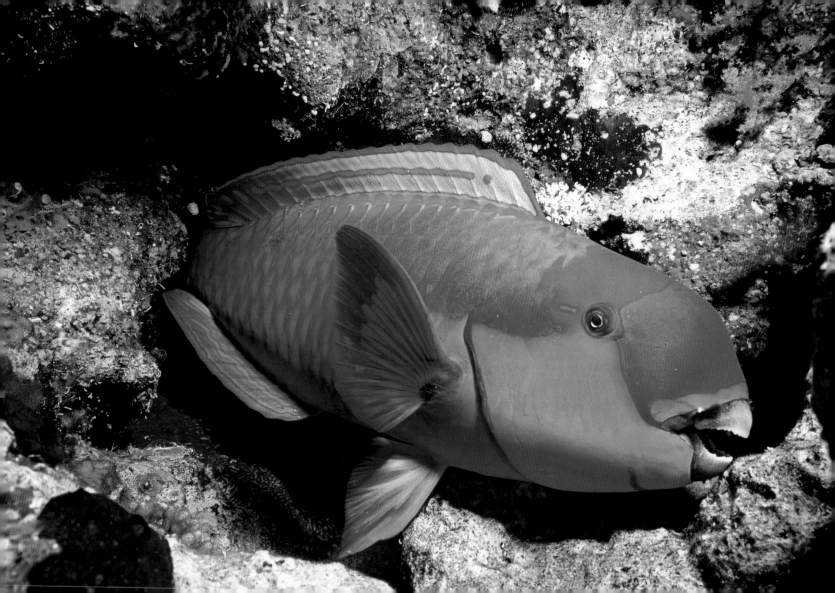

Stoplight parrotfish, Sharks Bay, Sinai Peninsula, Egypt

The mucous cocoon a parrotfish envelops itself in, like a sleeping bag, is secreted from its mouth and gills and protects the fish from hungry predators like moray eels and jacks. They often leave their mouths open while resting, in what looks to me like a sleepy yawn.

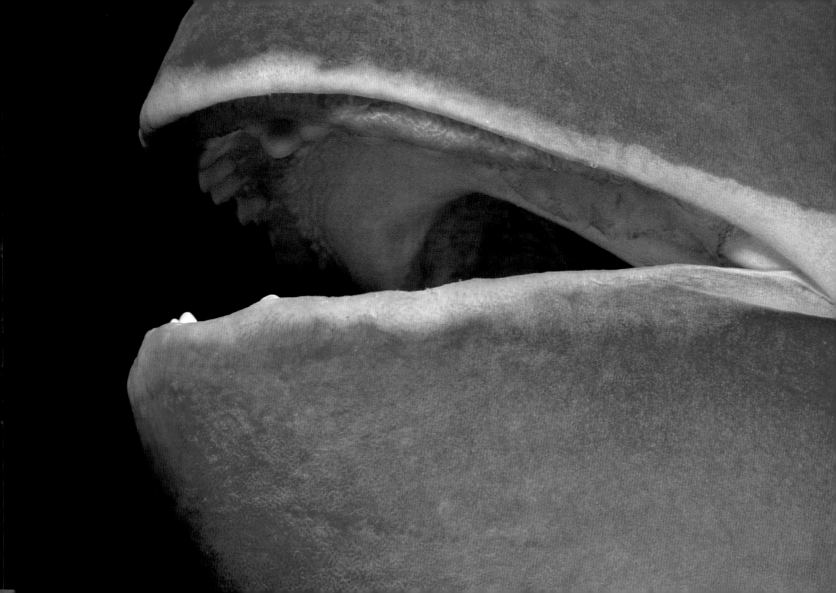

Bicolor parrotfish, Ras Umm Sid, Sinai Peninsula, Egypt

Parrotfish offer a wide assortment of artistic photographic possibilities. They are also responsible for many of our tropical, sandy beaches: The coral they eat is digested and then expelled as sand. Large parrotfish can produce up to a ton of soft, white sand a year. So the next time you're taking a stroll on a beautiful, sandy beach, remember that you're walking on parrotfish poop. How's that for a different perspective!

Steepheaded parrotfish, Ras Mohammed, Sinai Peninsula, Egypt

Behind the gill openings are this fish's complicated respiratory organs. The many folds of a fish's gills increase the surface area over which water can flow. The water flows in the opposite direction of the blood in the capillaries so that, in a process called countercurrent exchange, oxygen is constantly being passed from water and absorbed into the blood.

Blotched pufferfish, Ras Nas Rani, Sinai Peninsula, Egypt

A deflated pufferfish, with its spines retracted, settles into a hiding spot so that it is camouflaged. There it will rest fitfully through the night, neither as comatose as the parrotfish, nor as active as nocturnal species. Fish that are active only during the day, like the pufferfish, are called diurnal. Fish that are active only during sunrise and sunset are referred to as crepuscular.

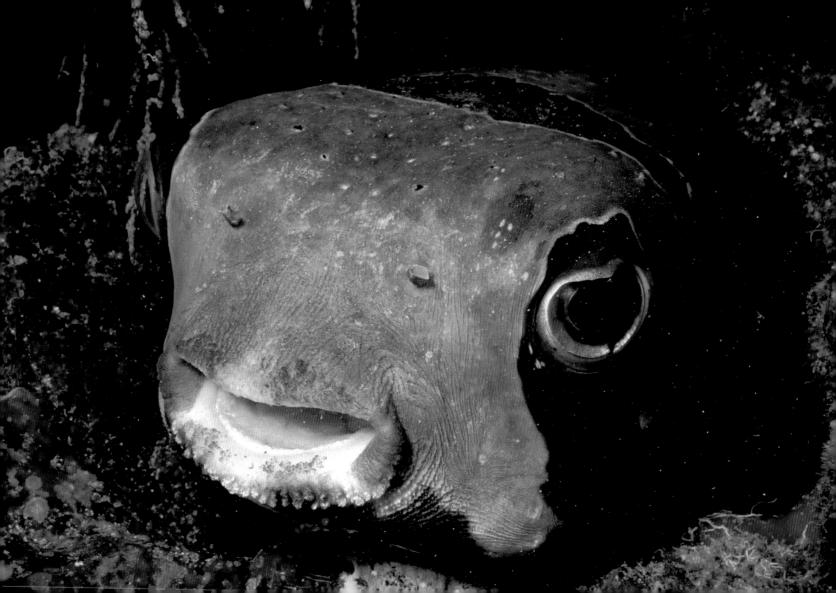

Moray eel, Moses Rock, Eilat, Israel

These cleaner fish go right inside the mouth of the moray eel to pick parasites from its teeth. Even though the moray eats shrimp, crabs, and fish, it wouldn't dream of having these cleaner fish for dinner because they provide such a valuable service. The moray keeps its jaws ajar at all times in order to let water continually circulate through small, round gills on either side of its head.

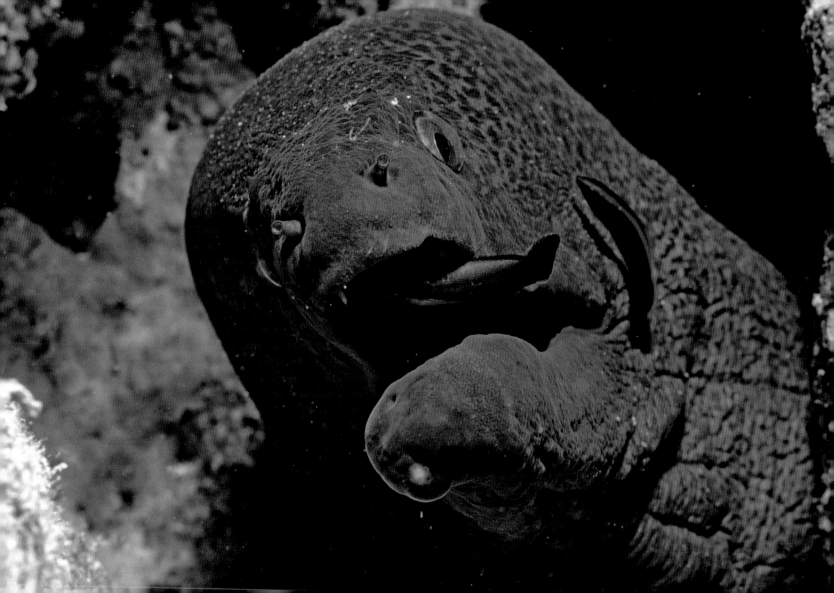

Moray eels, Mapello Island, Colombia

When my friend Avi told me about a spot he had discovered with "an unbelievable number of moray eels," I had to see it. When I lay down to work on a volcanic ledge in the area, hundreds of morays swam all over my outstretched body. It was like a scene from Dante's *Inferno*. They look like snakes, but morays are actually scaleless fish. Here, a group was hiding in wait to ambush prey. Since they have horrible eyesight and feed at night, the morays must use their acute sense of smell to spot the unlucky prey that will end up in their strong jaws.

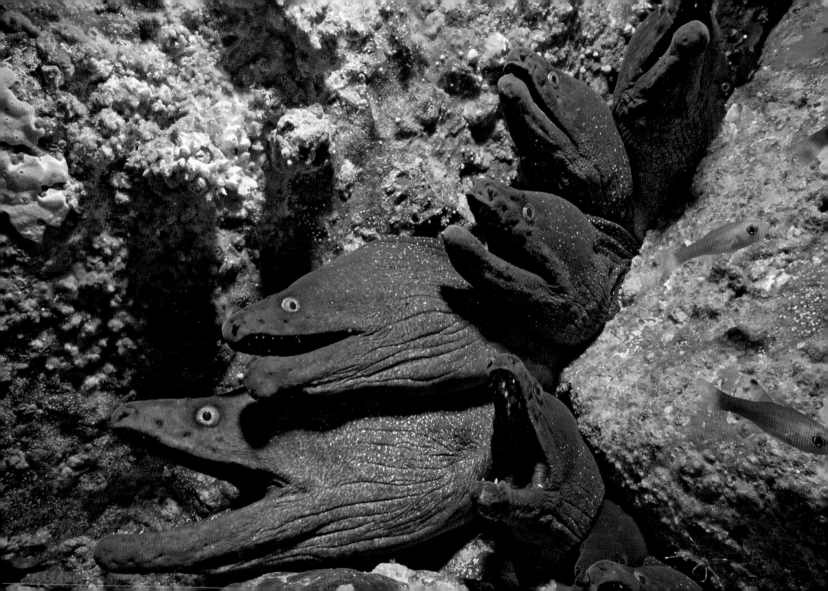

Great barracuda and three yellowspotted jacks, Walker's Cay, Bahamas

Charlie was a resident barracuda at Walker's Cay that was used to being hand-fed dead needlefish. One day I photographed my friend Neal feeding Charlie. Neal would move the fish away from Charlie, wait for me to get in position, then allow Charlie to start to feed. But Charlie decided to take matters into his own hands—like a bolt of lightning (barracuda can move at speeds of up to twenty-seven miles per hour) he grabbed the fish, and Neal received an ugly gaping wound that required thirty-six stitches.

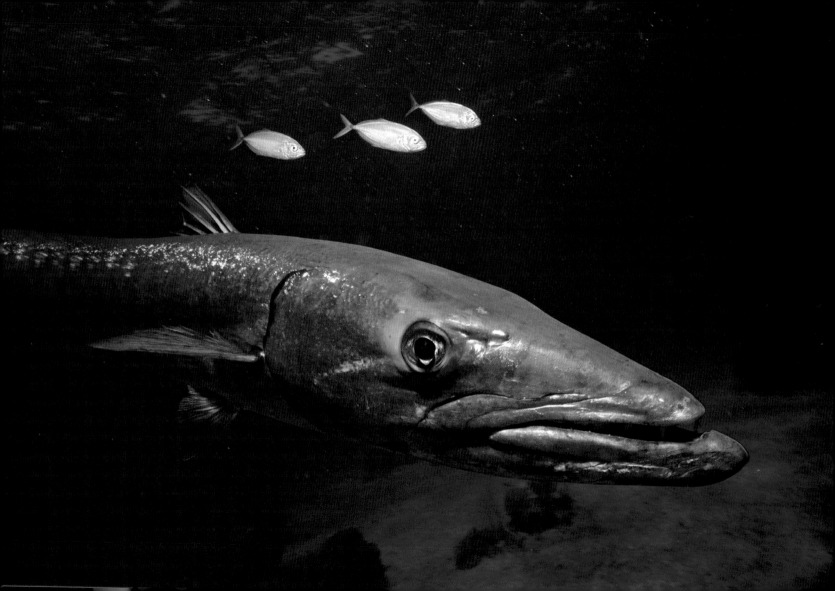

Honeycomb cowfish, Bahamas

The honeycomb cowfish has a sharp spine above each eye to help protect this vulnerable target from predatory fish. If these horns break, they'll grow back. The fish's boxy shape is covered with hexagonal, fused scales, which look something like a honeycomb, hence its name. Its clumsy shape prevents it from swimming very fast; in fact, it swims by ostraciform movement, in which the fish sort of hovers in place—the body stays still but the fins are moving like mad.

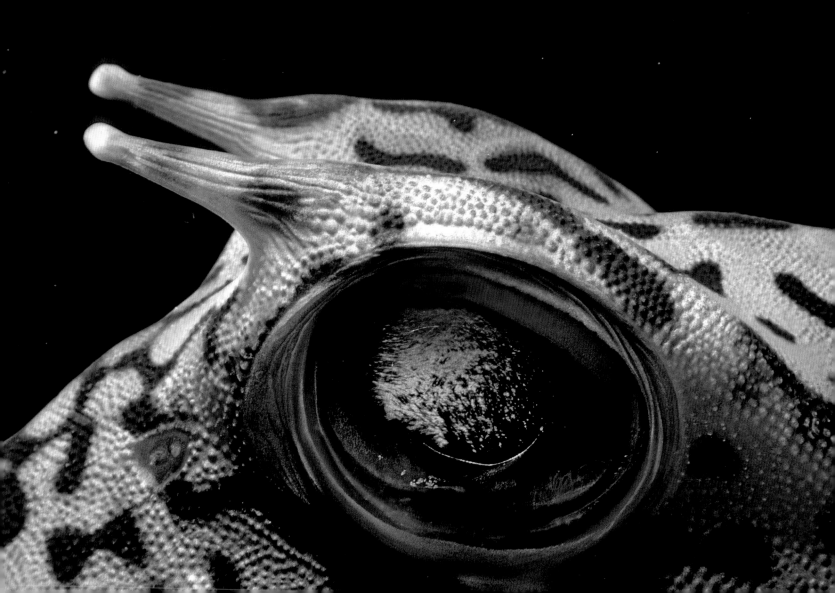

Masked pufferfish, Ras Nas Rani, Sinai Peninsula, Egypt

This pufferfish has taken refuge at night in the branches of a fire coral. From this perch, it searches for tasty crustaceans, sea urchins, and corals to crush and eat with its small but powerful beaklike mouth. The coloration of the "mask" around its eyes helps hide this most sensitive area from predators.

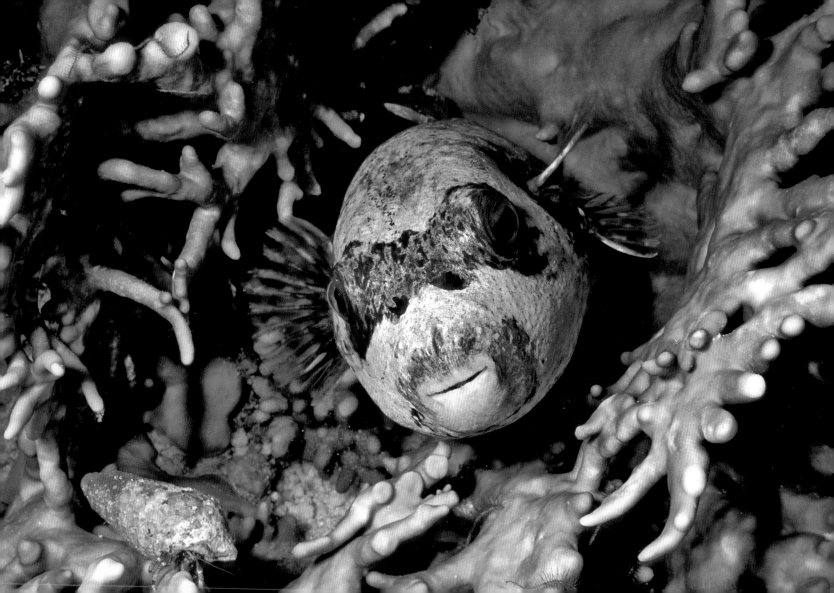

Arabian stonefish, Dolphin Reef, Eilat, Israel

This stonefish was huge, easily the size of a football. It had only one eye and, as proof of how little it moved, actually had algae growing on its body, which is as perfect a camouflage as any I've seen. Resting on a sandy bottom in only three feet of water, the stonefish was in a location that had plenty of small fish swimming past—a veritable smorgasbord of marine life. We all agreed this fish was in an advanced stage of old age, possibly twenty years old, although apparently doing very well indeed, especially for a fish with one eye.

Arabian stonefish, Aquasport Beach, Eilat, Israel

Literally still as a stone, this stonefish lies motionless on the ocean floor. Drab coloring, a lumpy body, and ragged skin that strongly resembles seaweed complete its disguise. It's a bit of a mystery as to why the stonefish has evolved into the most poisonous fish on the planet. The spines along its dorsal and pectoral fins are like poison-tipped hypodermic needles. Many islanders recount stories of an excruciating sting that can cause severe swelling, muscle weakness, temporary paralysis, and even shock. Fortunately, an antivenin developed in the 1950s can prevent death.

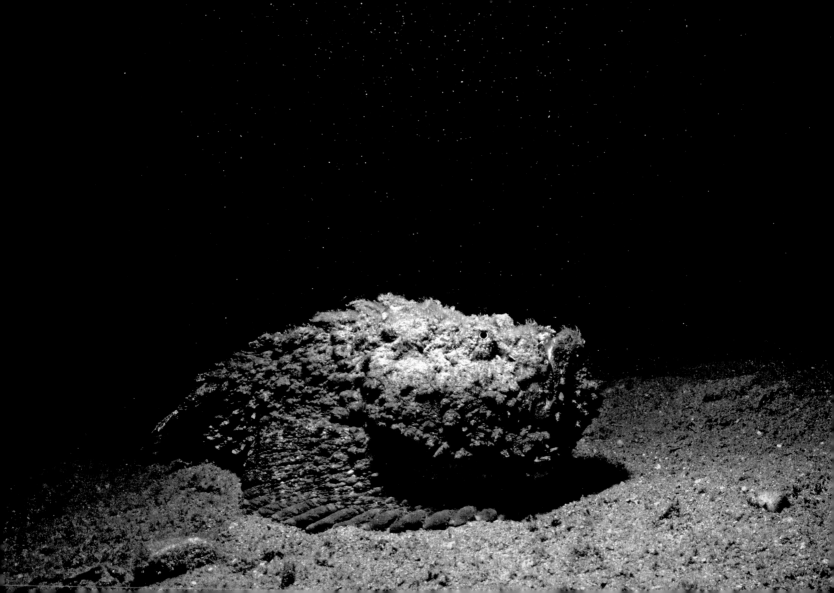

Velvet belly shark, Haifa, Israel

Full-grown at eight inches, this female velvet belly shark most likely is small as a result of
the limited food supply in the deep ocean off the outer continental shelves where it lives,
up to seven thousand feet below sea level. Its enormous eyes, relative to its general
size, are also an adaptation to the limited light at these depths.

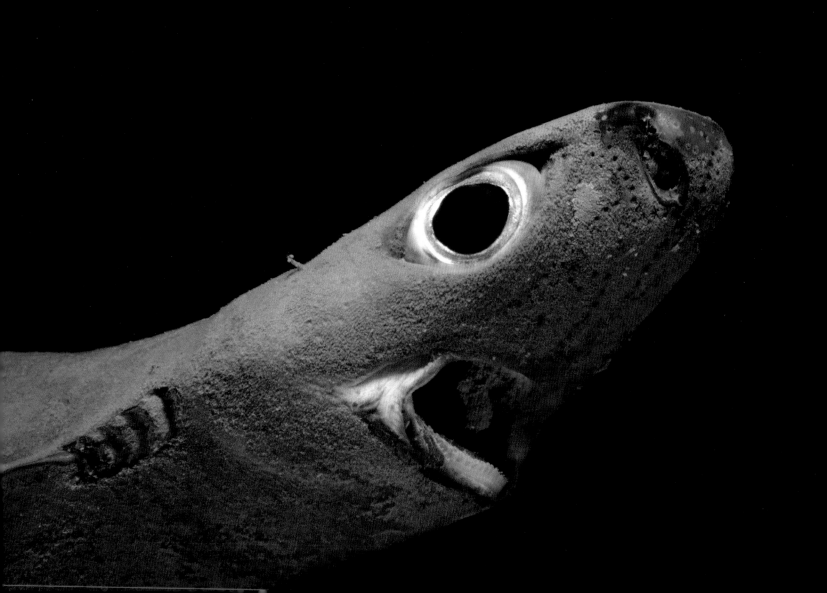

Goosefish, Isles of Glénan, Brittany, France

If ugly is beautiful, then this goosefish, sometimes called monkfish, deserves to win a beauty pageant. It lies camouflaged on the sandy bottom, luring unsuspecting prey with the angling appendage growing from its upper lip. Its enormous mouth and sharp, conical teeth ensnare victims with surprising ease. These voracious consumers will eat almost anything and can weigh up to fifty pounds. Sometimes called the "poor man's lobster," its flesh is surprisingly similar but is uncommon on menus.

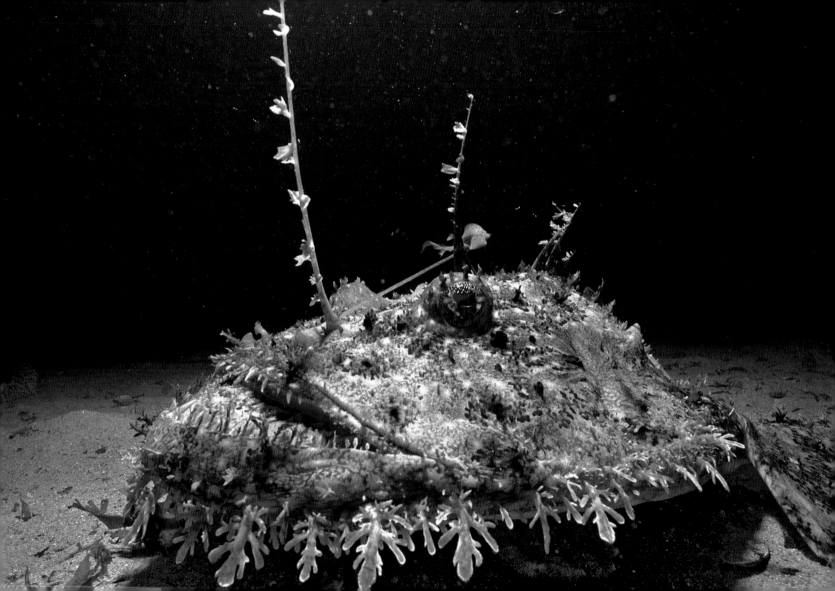

Crocodile fish, Jackson Reef, Sinai Peninsula, Egypt

Crocodile fish are easy to miss. Their coloration and flat profile allow them to disappear into the shallow, sandy bottoms where they are most comfortable. The iris lappets, barley visible here, are part of the crocodile fish's camouflage. These branching, fleshy flaps over the fish's eyes partially conceal its black, telltale pupils, making the crocodile fish practically impossible to spot.

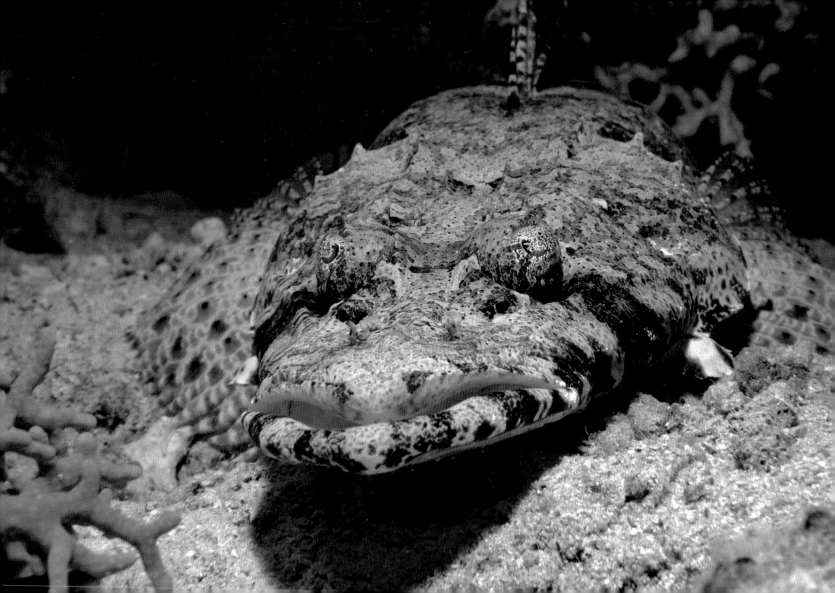

False stonefish, Ras Umm Sid, Sinai Peninsula, Egypt

The near-perfect camouflage of this species conceals the entire fish, including its razor-sharp, venomous dorsal spines, enabling it to hide from potential prey until the victim is within gulping distance. Actually a scorpionfish, as opposed to a true stonefish, this animal's devilish sting has earned it the name *Scorpaenopsis diabolus,* or "diabolical scorpionfish."

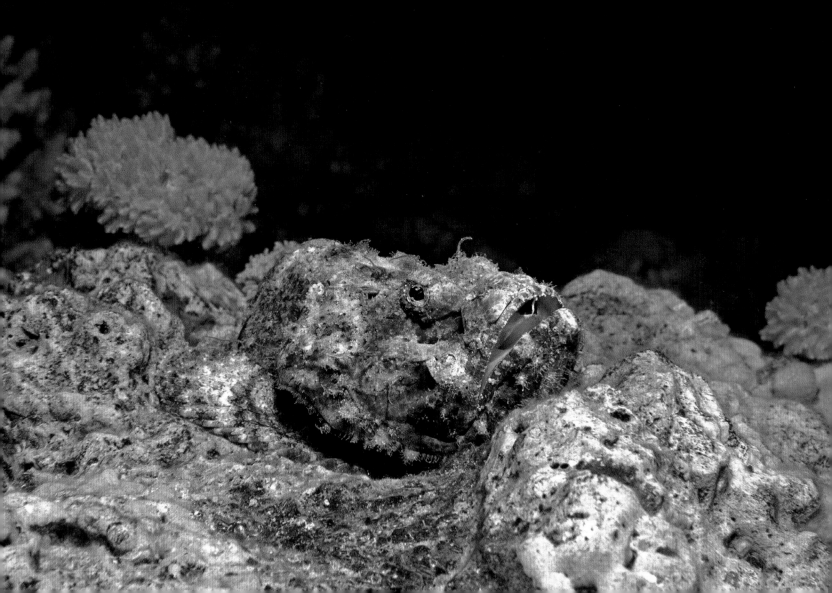

Feather star, Ras Abu Galoum, Sinai Peninsula, Egypt

This crinoid, or feather star, uses a set of ropelike arms to grasp onto a fire coral. The larger, feathery arms extend outward, trapping plankton with tiny tube feet and shuttling the food down toward the echinoderm's central mouth. During the day, crinoids stay curled up in the cracks and crevices of the reef. At night, they'll crawl out on their gangly arms or swim on their feathery arms. In the Red Sea, you'll see them only at night.

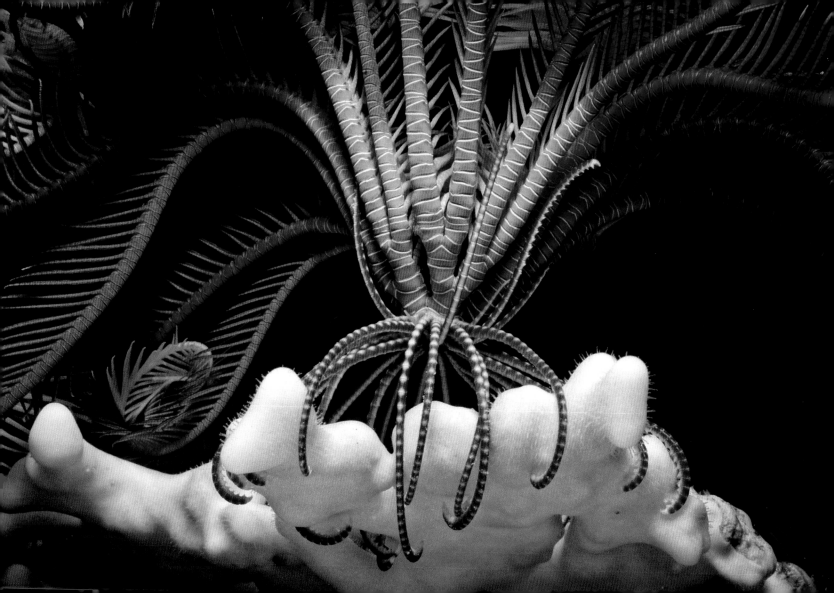

Colonial anemones, Ras Umm Sid, Sinai Peninsula, Egypt

Like corals, sea anemones can reproduce two ways: asexually, through fission, during
which a new animal buds out of the original organism; or sexually, whereby sperm
and eggs are released into the water, and then come together to develop into floating
larvae, which then settle on the substrate. Thus, anemone colonies are formed.

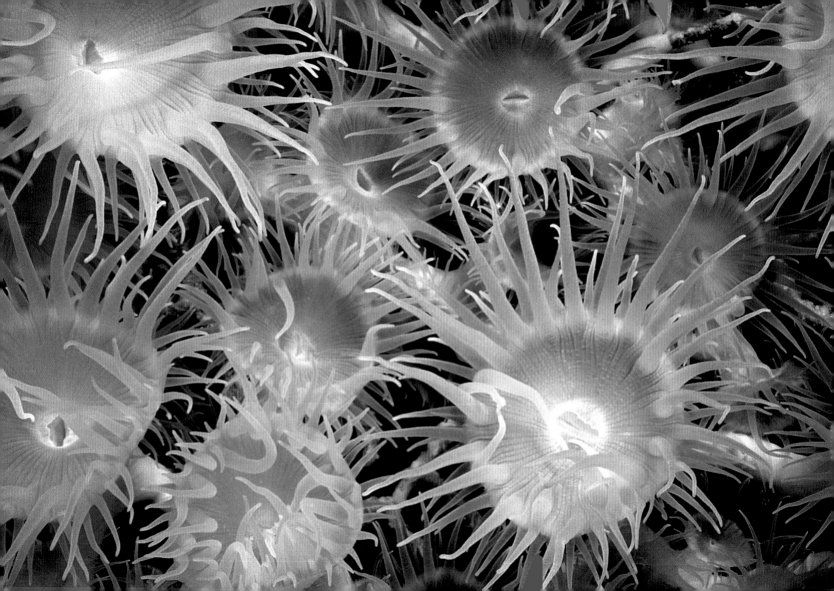

Fallen archangel nudibranch, Puget Sound, Washington

This two-inch-long nudibranch, or sea slug, moves its translucent body over an algae-covered bottom. The nudibranch gets its name from *nudus*, Latin for "naked," and *brankhia*, Greek for "gills." The white-lined, leafy projections on its back are called cerata and are used for breathing, in place of gills. In some species, these cerata are also extensions of the digestive system and can house, for defense purposes, nematocysts that the nudibranch salvages from the hydroids it eats.

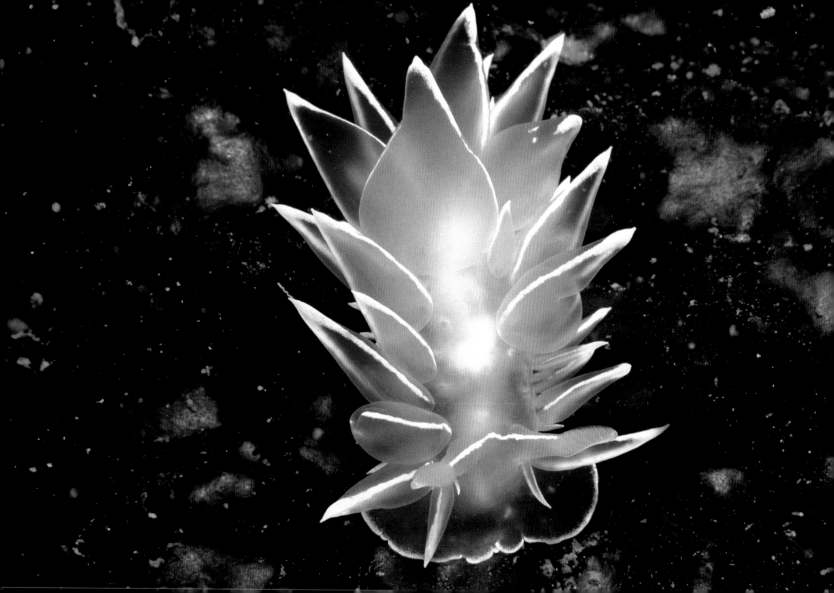

Pom-pom xenia coral, Ras Mohammed, Sinai Peninsula, Egypt

The pom pom soft coral is fun to watch when it's inflated and feeding. Coral polyps of the *Xeniidae* family, called "pulse corals," rhythmically open and close their tentacles in unison. This image captured the frilly tendrils in a tightly closed moment. Scientists don't have an explanation for this behavior but suspect it has to do with increasing water circulation or controlling the amount of light reaching the coral's symbiotic algae. Either way, the coral provides stunning underwater fireworks.

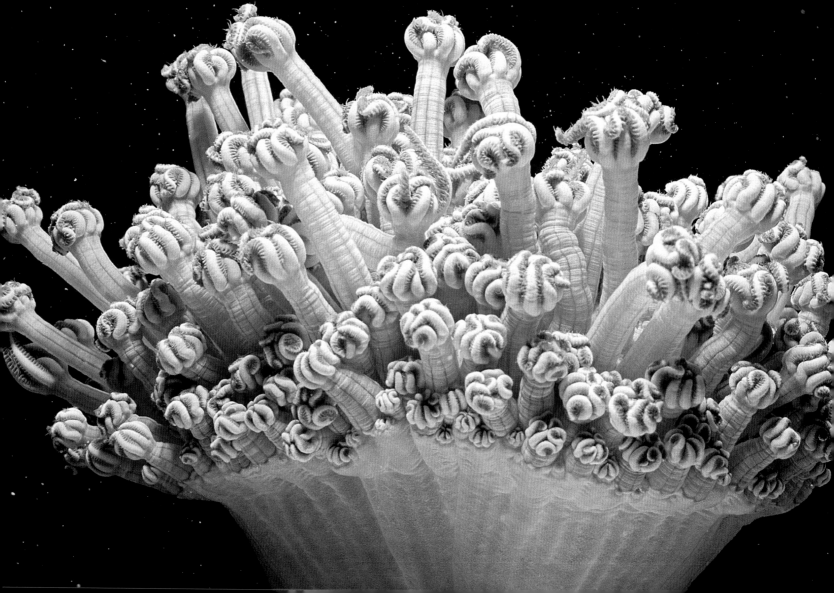

Common sea anemone, Kimbe Bay, Papua New Guinea

It can take a large anemone as little as fifteen minutes to devour a small marine animal. However, not every creature that happens by is in danger. Clownfish are protected, of course, as well as some nudibranchs, which may not be entirely immune to the anemones' sting, but they can eat them, if they're very careful. A nudibranch's digestive tract is protected with a special lining that keeps the nematocysts from firing. It then salvages the stingers to use for its own protection.

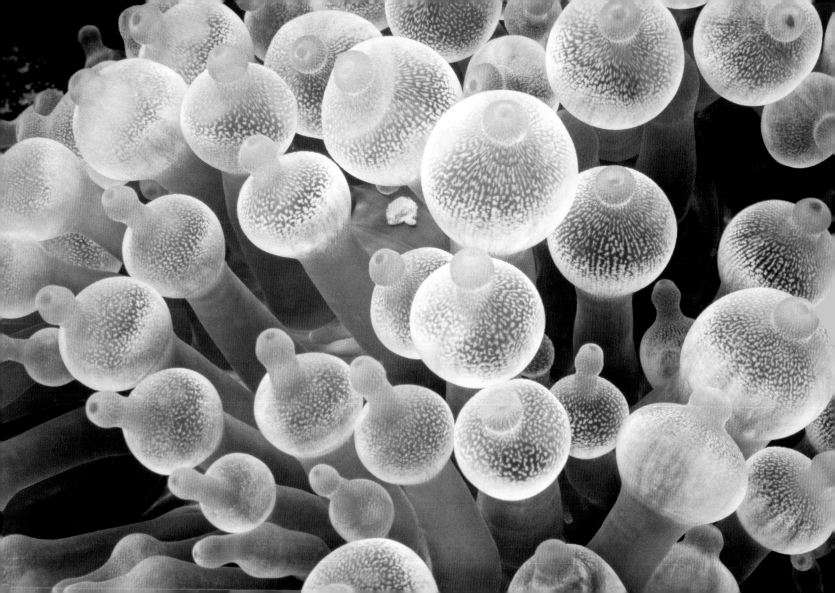

Alcyonarian soft coral, Kimbe Bay, Papua New Guinea

Alcyonarians, which come in almost every color of the rainbow, are among the most spectacular of all marine invertebrates. This photograph clearly shows the alcyonarian's key structures: the polyps with their eight feeding tentacles, as well as the hard spicules, or sclerites, which give the otherwise soft coral its form.

Smooth brittle star, Ustica Island, Sicily

Brittle stars are closely related to starfish. There are somewhere between fifteen hundred and two thousand species. In this photograph you can see the echinoderm's five-part radial symmetry, which means its five equal appendages radiate from a central disk. Interestingly, however, the microscopic larvae of brittle stars are bilaterally symmetrical, or symmetric down a center line. This changes as the larvae grow and settle down onto the ocean floor.

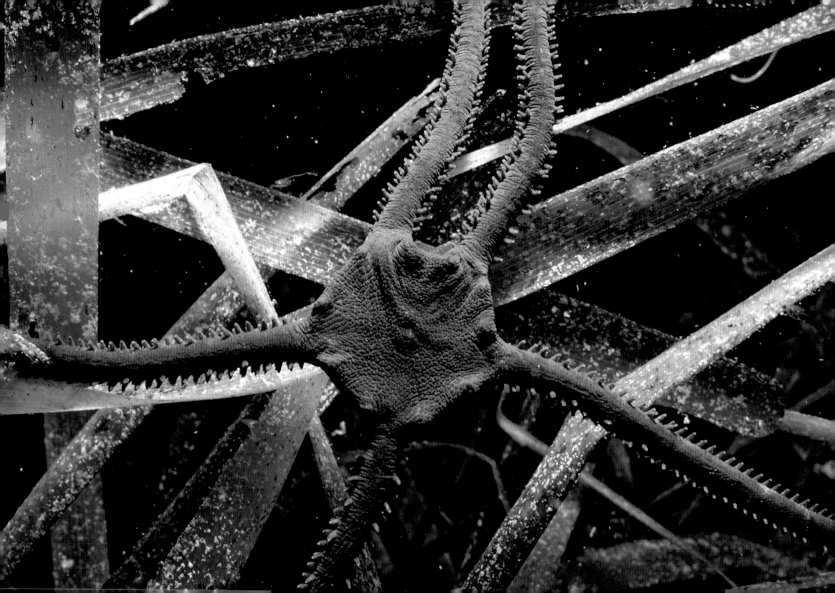

Tentacles of sea anemone, Sha'ab Ali, Sinai Peninsula, Egypt

Anemones capture their prey, defend themselves, and sometimes move with nematocytes. Within each cell is an organelle called a nematocyst, a poison-filled sac enclosing a tightly coiled, spring-loaded dart. With the help of chemoreceptors and microscopic hairlike triggers, the nematocyst is triggered at the appropriate time to the appropriate stimulus. These signals keep the anemone—or jellyfish or coral—from continually stinging itself or wasting these one-time-use cells.

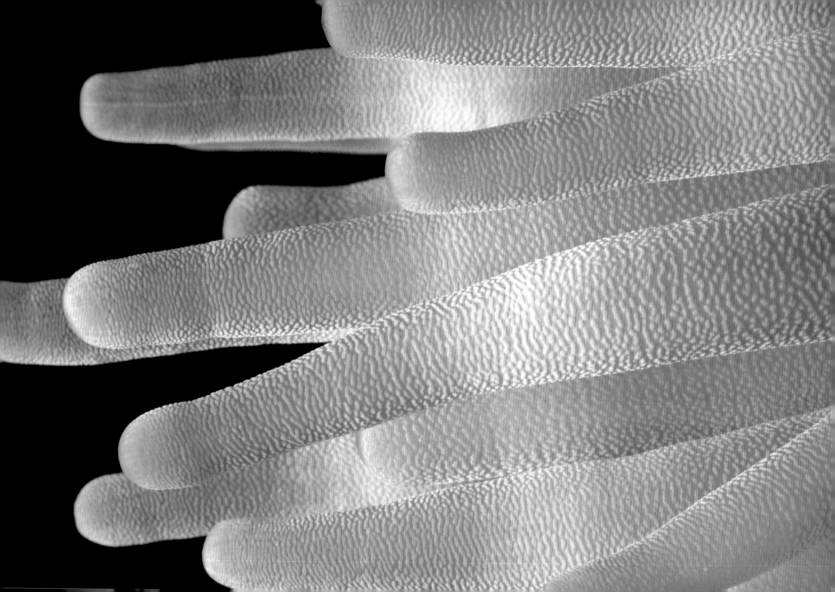

Crown-of-thorns starfish, Gordon Reef, Sinai Peninsula, Egypt

The crown-of-thorns starfish has gotten a bad rap. This echinoderm feeds on coral, and when its natural predator, the triton trumpet, goes into decline, the crown-of-thorns has been known to become overpopulated and devour entire coral colonies. When these starfish population explosions increase, as they did in the 1960s and again in the early 1980s, they can radically change the face of a reef. This is just one example of the delicate, interconnected balance of underwater ecosystems.

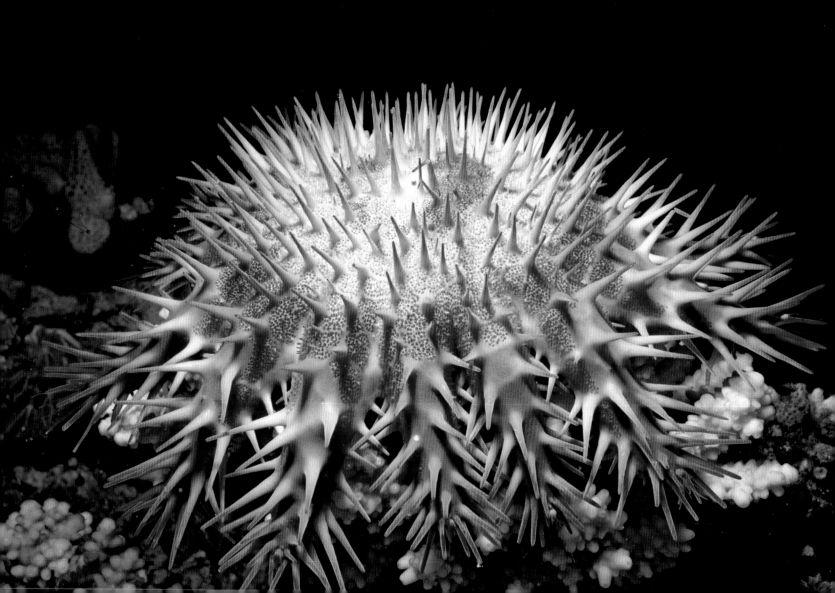

Scallop, Puget Sound, Washington

When we order scallops in restaurants, it's actually the adductor muscle of this mollusk that we'll be eating. In nature, hundreds of eyes peer out from the fringes of the scallop's white mantle. When the eyes detect danger, the adductor muscle claps the scallop's valves together, jetting the animal backward. This scallop's shells are encrusted with pink sponge. I have yet to see a scallop in the Pacific Northwest that does not carry this symbiotic sponge on its shell.

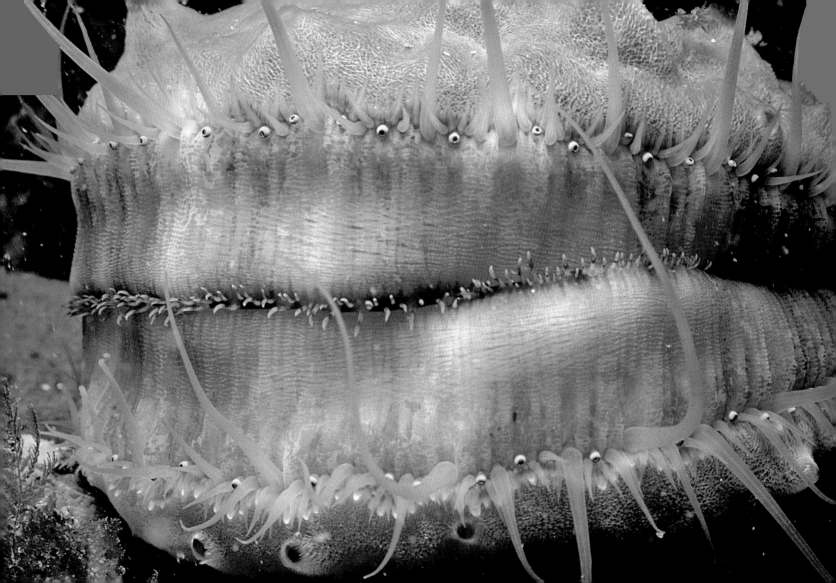

245

Sea anemone, Ras Abu Galoum, Sinai Peninsula, Egypt

This anemone, among the few Indo-Pacific species with stinging cells powerful enough to seriously injure humans, spends most of the day withdrawn into a coral crevice. At night it is more exposed and can cause a wound in a human that's as serious as a score of bee stings—or worse, if you're allergic to natural venoms. On the other end of the spectrum, the sting of some cnidarians will just feel sticky. In any case, it's always best not to take chances, and night divers should be extra careful and alert when they brush up against a reef.

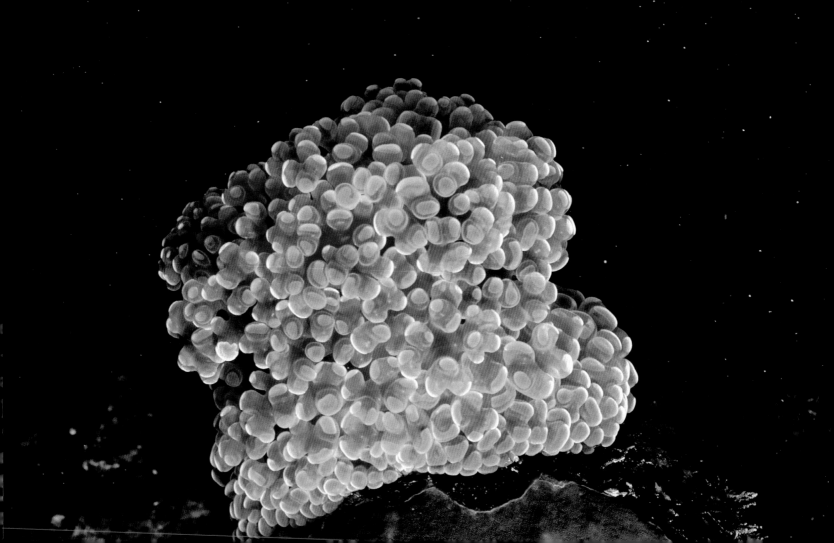

Northern red anemone, Eastport, Maine

Beginner divers might find Eastport, Maine, a tough place to start. You can dive only during the slack tide, once every six hours or so; the visibility is anywhere from five to fifteen feet; and during September, when the New England waters are at their warmest, you can enjoy water temperatures of a balmy 50 degrees Fahrenheit. But the treasures these waters hold are unparalleled in the North Atlantic. On an average dive, you might find ten anemones like this one in a space of ten square feet.

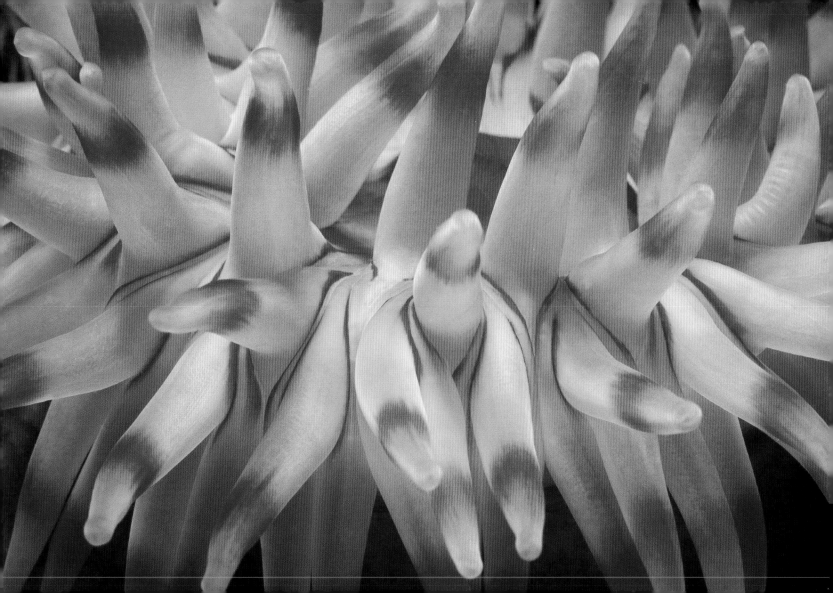

Opposite

Tube anemone, Monterey, California

Double rings of tentacles are characteristic of this tube anemone. It extends its tentacles from a parchmentlike tube anchored in the sand as it sweeps the water for plankton. Encompassing more than 5,300 square miles of Pacific Ocean off the coast of California, Monterey Bay National Marine Sanctuary is one of the largest protected areas in the world—larger even than Yosemite and Yellowstone National Parks. It is home to thirty-one phyla of invertebrates, including this tube anemone, as well as hundreds of fish and dozens of sea mammals.

247

248

Overleaf Left

Caribbean reef shark, Freeport, Grand Bahama Island

The unblinking eyes of a shark are adapted for the low light of the ocean. Some sharks have a light-reflective layer behind their retinas that greatly improves their vision in dim light. These natural reflective mirrors, similar to those in cats' eyes, give their eyes an eerie glow when caught by the beam of a diver's lamp.

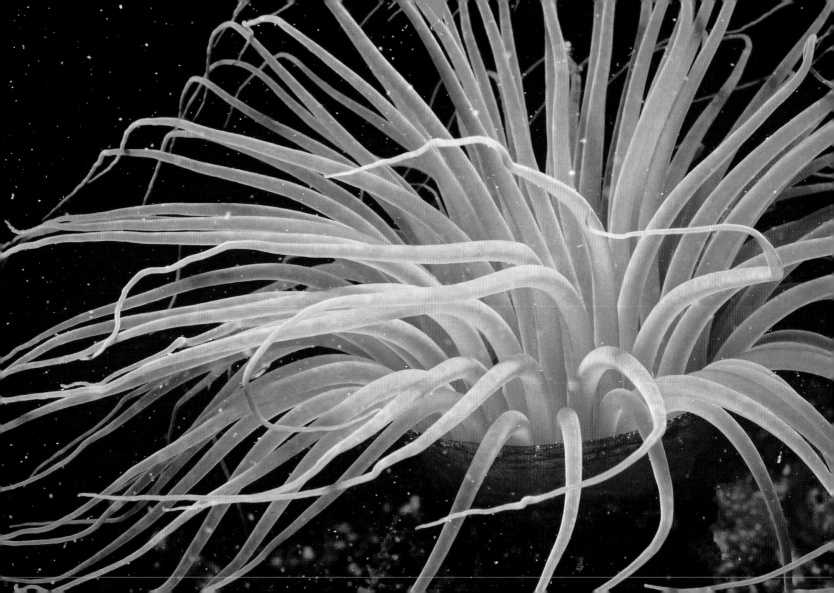

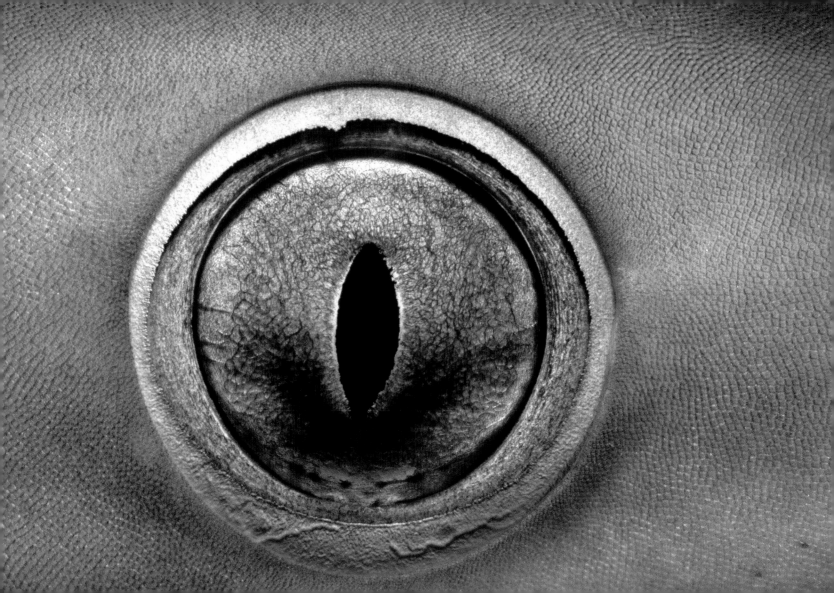

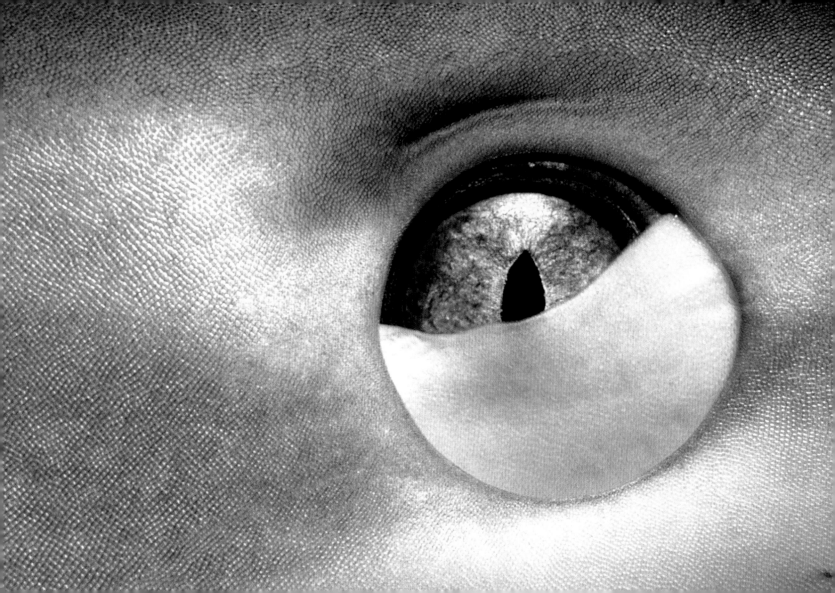

Preceding Page

Caribbean reef shark, Freeport, Grand Bahama Island

A few miles off the coast of Freeport, Grand Bahama, shark handler extraordinaire Neal Watson grabbed this Caribbean reef shark and was able to put it into a trancelike state. It lay motionless in his arms except for the flickering of its nictitating membrane, the transparent flap that sometimes covers the eye for protection, almost like a horizontal eyelid. Despite the fact that Neal wears a protective chain-mail antishark suit, this is a maneuver that should only be attempted by very experienced shark feeders.

248
249

Opposite

Whitetip reef sharks, Cocos Island, Costa Rica

About three hundred miles off the Pacific coast of Costa Rica lies Cocos Island. As night falls here, groups of whitetip reef sharks hunt together, "listening" for the faint electrical signals of fish sleeping in the volcanic rock and coral. Whitetips exhibit common behavior called "site fidelity," which means that when they find a home they like, they tend to stay there. Perhaps this is why Cocos Island is literally swarming with them.

Pacific Ocean

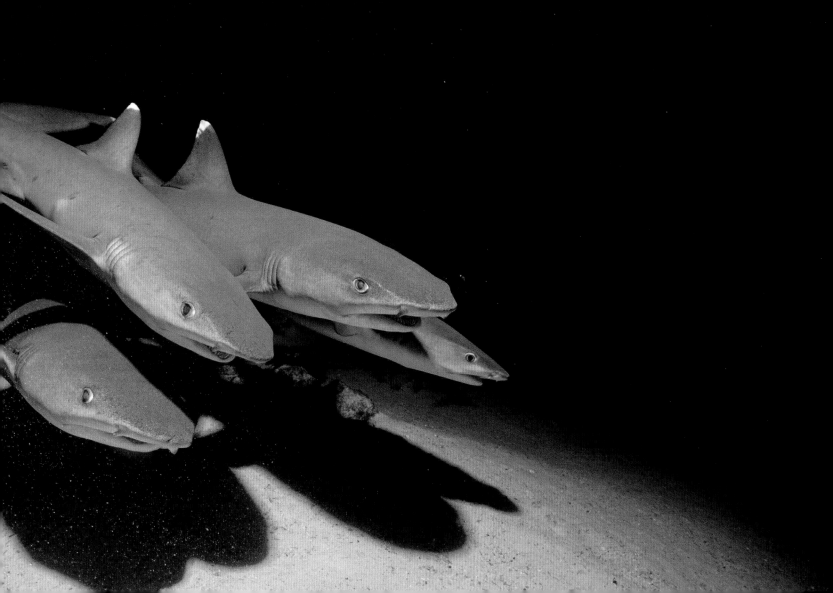

Sleek unicornfish, Ras Mohammed, Sinai Peninsula, Egypt

This unicornfish was photographed alone, in the middle of the afternoon. When evening approached, it joined hundreds of its own kind to form what divers like to call a train, a huge stationary school spread out as much as almost 1,000 feet in length and usually facing into the current. The train will hold its position above a deep-water drop-off and feed on the column of zooplankton that begins to rise from the depths half an hour before sunset. At night, zooplankton rise to the water's surface to feed, descending again with daybreak to avoid predators. But this mini-migration obviously doesn't fool the unicornfish.

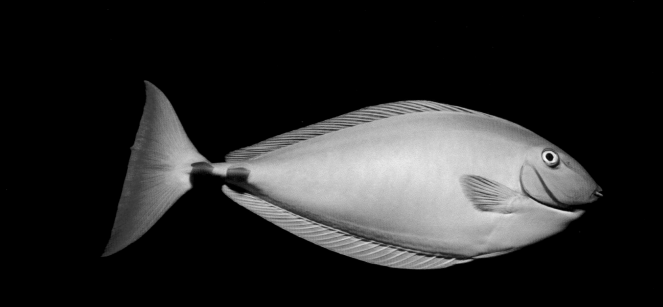

251

Circular spadefish, Ras Mohammed, Sinai Peninsula, Egypt

Every day for a solid week, my assistant and I would visit these three spadefish. While the juveniles can look like brown tree leaves, the adults, who travel alone or in small groups, are quite stunning. These three were always in the same location on the reef. Each day they allowed me to get a bit closer, but there was a limit to our wary friendship—I was not allowed closer than seven feet. I gratefully accepted that condition.

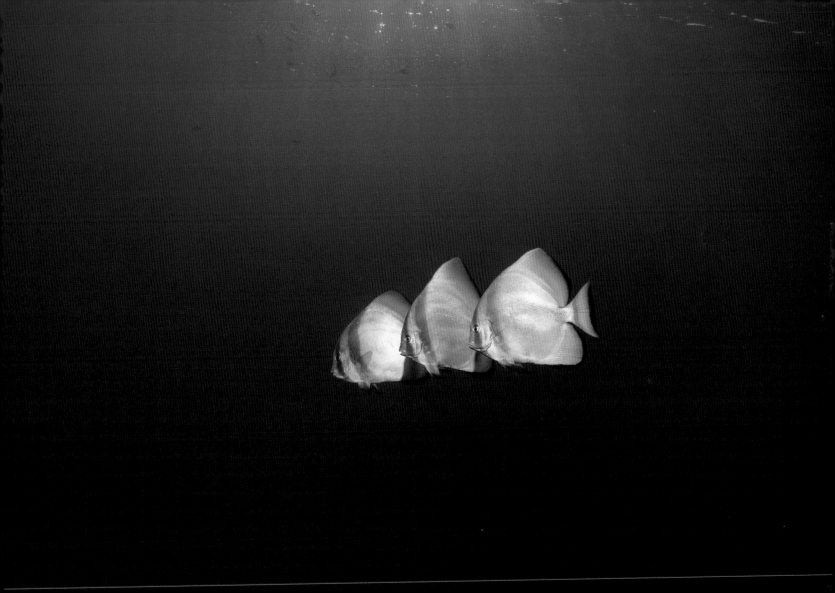

Opposite

Humphead wrasse, Ras Nas Rani, Sinai Peninsula, Egypt

Humphead wrasses are quite wary despite their large size. This fellow had an unusually friendly personality, which may have had something to do with the hard-boiled eggs we fed him. Feeding the wrasses was once a common practice on Red Sea dive operations but is now, fortunately, prohibited. But what a sight it was at the time! He would inhale the egg and, in less than a minute, spit the shell back out. The egg's thin shell was nothing compared to the hard-shelled crustaceans and mollusks this guy normally ate.

Overleaf Left

Bottlenose dolphin, Dolphin Reef, Eilat, Israel

A family of dolphins has lived at Dolphin Reef since the early 1990s, and here tourists have a chance to swim with them. The dolphins seem to enjoy interacting with people. In recent years, much of the research on dolphins has focused on their intelligence, communications, and social behavior, often sparking controversy. But by observing generations of dolphins in the wild and at research centers like this one, scientists are gaining a better understanding of how these mammals cooperate in order to defend the pod, hunt for food, and care for their young.

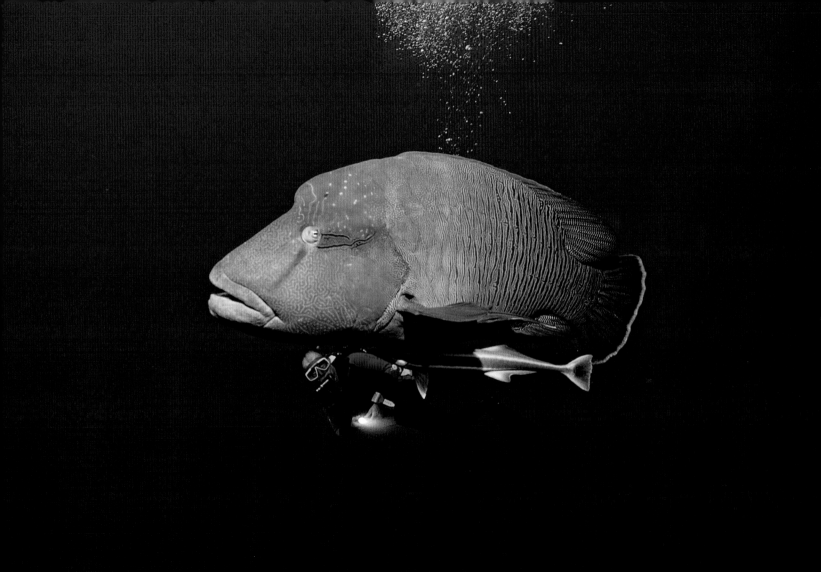

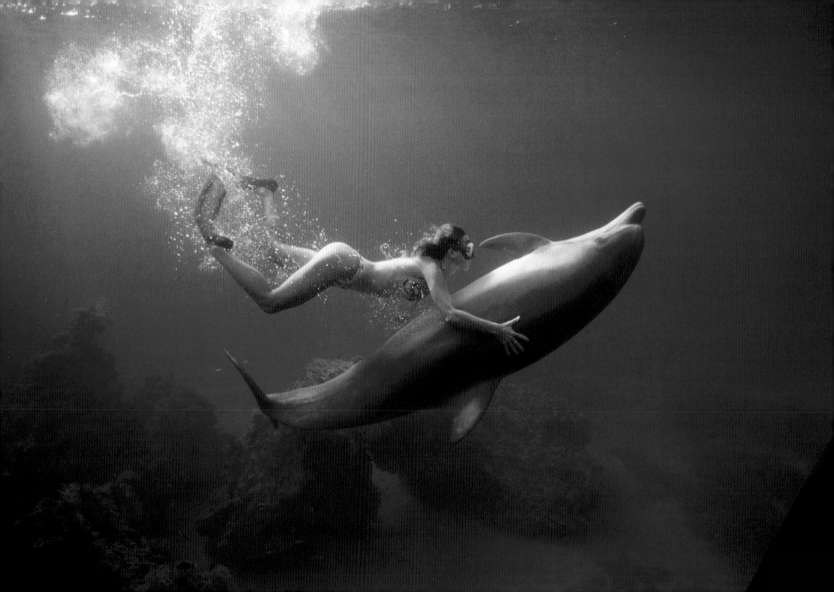

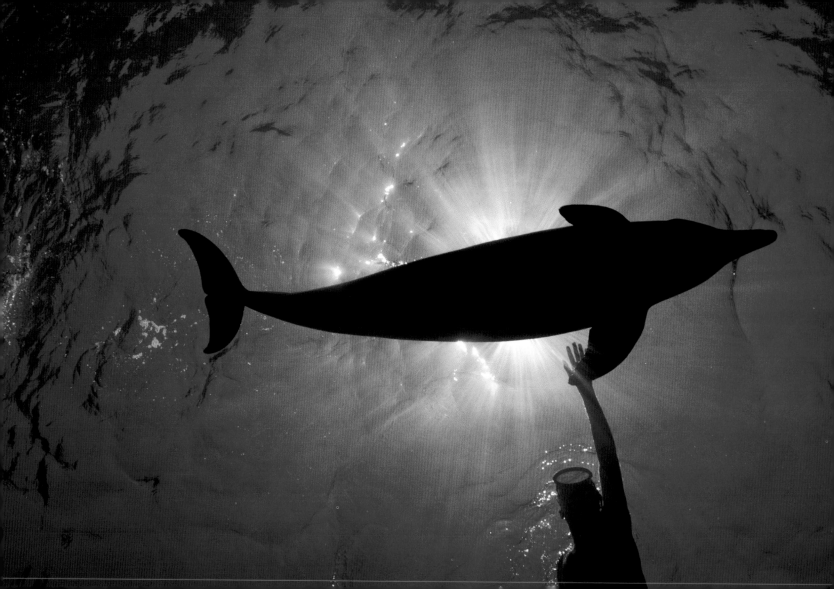

Preceding Page

Bottlenose dolphin, Nuweiba, Sinai Peninsula, Egypt

Countless stories about supposedly smart dolphins abound: Two dolphins at the New York Aquarium rushed to admire painted markings on their bodies in a mirror; in Australia, a mother dolphin taught her offspring how to use a sponge to protect her snout while hunting for prey on the seabed; in Egypt a friendship developed between a deaf Bedouin fisherman and a dolphin named Oleen. One thing seems certain: Dolphins are extremely complex, curious creatures that seem to enjoy interacting with humans.

253

254

Opposite

Blue trevally hunting lunar fusiliers, Jackson Reef, Sinai Peninsula, Egypt

Sunrise is a changeover period on the reef that lasts little more than half an hour: diurnal animals are waking up, nocturnal animals are turning in, and crepuscular animals are in full swing. During this time, the most active on a reef, it's eat or be eaten. This blue trevally was one of a group of almost ten that were herding a large school of lunar fusiliers together; every few seconds one of the blue trevallys would explode into the school and snap one up.

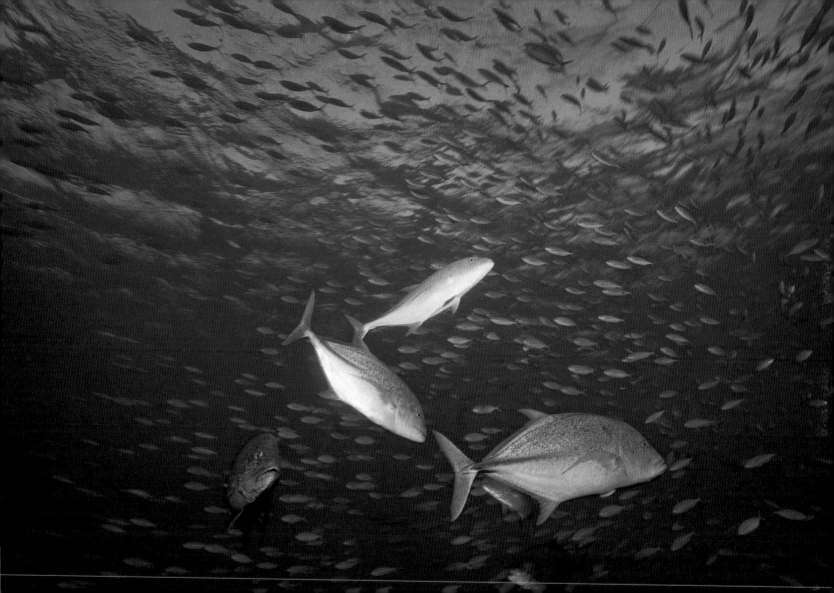

Glassy sweepers, Ras Umm Sid, Sinai Peninsula, Egypt

Glassy sweepers are nocturnal fish that feed on plankton at night and take cover
in caves during the day. However, scientists in Brazil have observed the sweepers
leaving their daytime hideouts for one special errand: When cleaner wrasses swim by,
advertising their services, groups of glassy sweepers will leave their protected site to
have a cleaning.

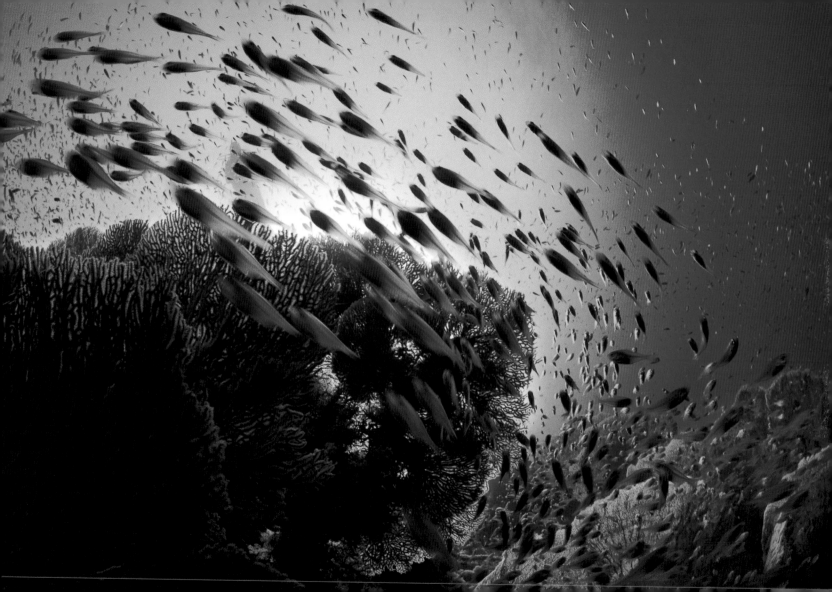

Blackfin barracuda, Kimbe Bay, Papua New Guinea

With its fang-filled underbite, a barracuda may look scary, but its reputation as a dangerous fish is undeserved. Unless provoked, barracuda attacks on humans are extremely rare, although they are curious and will occasionally follow a diver. After two days of my presence, this school in Kimbe Bay stopped seeing me as a threat and allowed me to get inside their school.

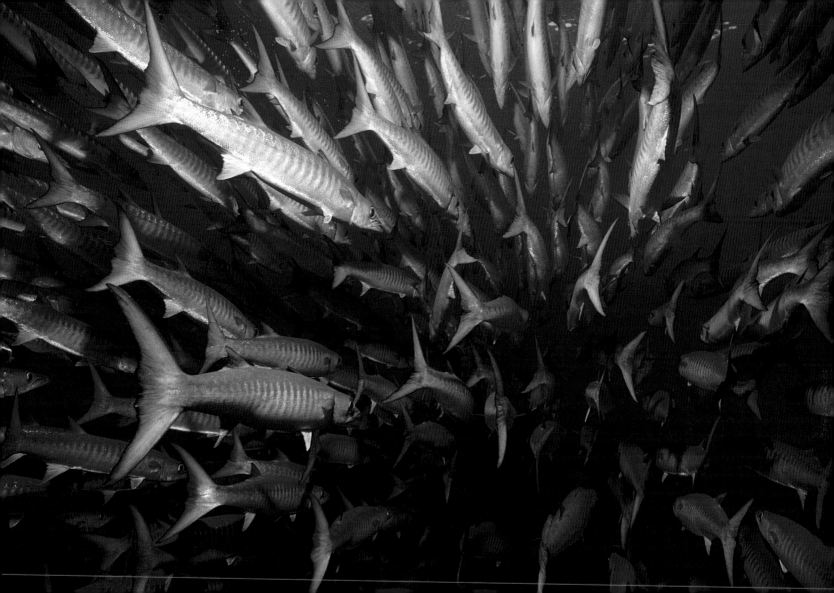

Bluefin tuna, Favignana, Sicily

These bluefin tuna have been trapped in a netted "room" off the coast of Sicily in an annual tuna harvest known locally as the *mattanza* (in Sicilian it means "the slaughter"). These magnificent fish easily reach weights of more than four hundred pounds. The heaviest recorded individual, caught off Nova Scotia in 1979, weighed in at more than fifteen hundred pounds and was fifteen feet long. Bluefin are highly prized for game and food, especially in Japan, where dangerous overfishing for the sushi market has led to a recent international agreement by the government to halve its fishing quota on the bluefin.

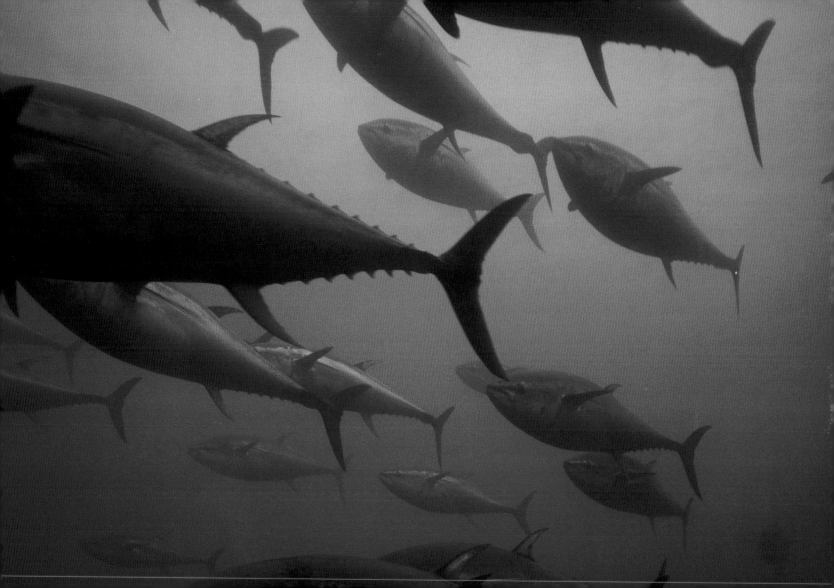

Whitetip reef sharks, Cocos Island, Costa Rica

Having picked up the scent trail of a wounded fish, a group of whitetip reef sharks searches frantically to locate the source. Some believe it's a legend, but it's true: some sharks' sense of smell is so keen, they can detect a drop of blood in a million drops of water. Two nostril-like openings in their snouts—which have nothing to do with breathing—can identify the smell of blood or fish oil up to a third of a mile away.

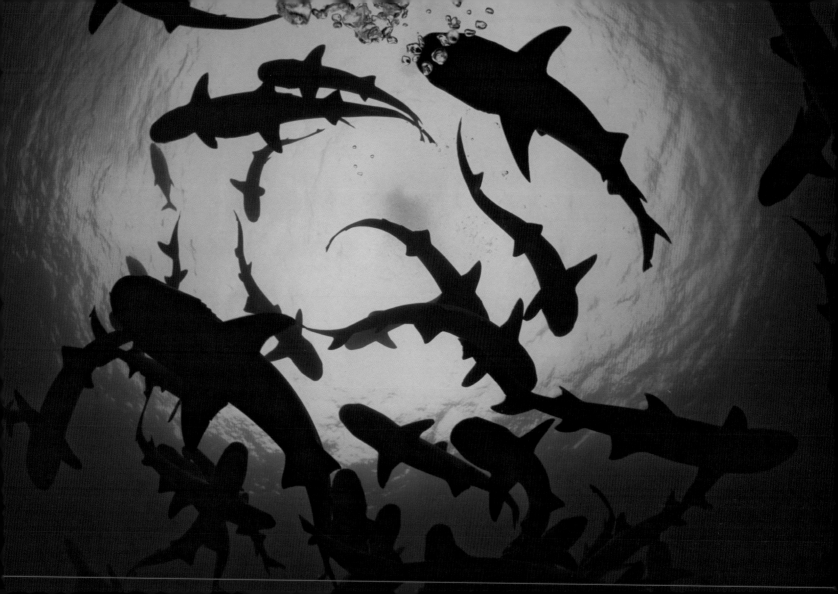

Almaco jacks, Galápagos Islands, Ecuador

Diving around this volcanic archipelago, where Charles Darwin famously developed his theory of evolution by natural selection, is an unforgettable experience. Be prepared for anything. One minute you're looking out into clear, blue water, and the next you are surrounded on all sides by a school of almaco jacks. These giant fish, three-feet-plus long, seem to be attracted to the bubbles ascending from a diver's breathing apparatus.

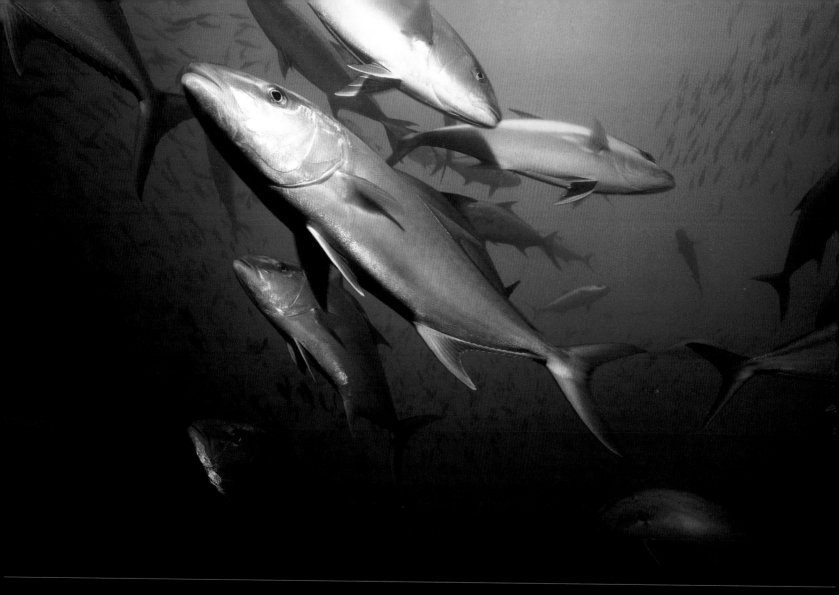

Yellowfin goatfish, Jackson Reef, Sinai Peninsula, Egypt

During the day, a school of goatfish darts along the reef in search of food. Once they locate a nice sandy area, they descend to the bottom and use their barbels, whiskerlike projections beneath their mouths containing chemosensory organs akin to taste buds, to probe for bottom-dwelling invertebrates. Goatfish prefer mollusks, crustaceans, and worms, but, much like their namesake, they'll eat almost anything.

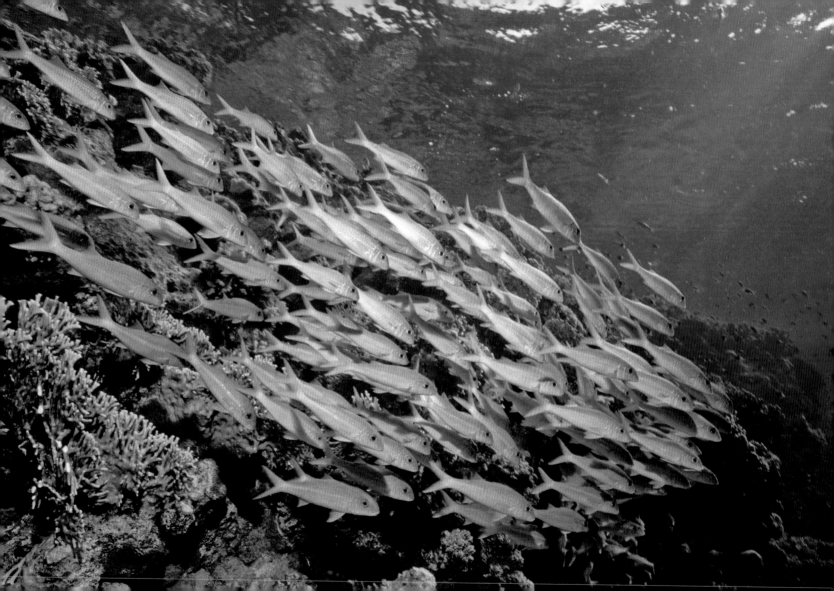

261

Blackfin barracuda, Ras Umm Sid, Sinai Peninsula, Egypt

Salt water is 750 to 800 times denser than air, and this density only increases with depth. Anyone who has been swimming in the ocean knows it's a hard medium to move through quickly. Not for the barracuda. With its pointed head and long, streamlined body, the barracuda is sleek as an arrow and built for speed. Sometimes called the "tiger of the sea," a barracuda lies in wait until it is ready to ambush its prey. Then it rushes at its target, sometimes cutting it in half with the force of its attack and razor-sharp teeth. This speed is one of the reasons adult barracudas have few natural predators.

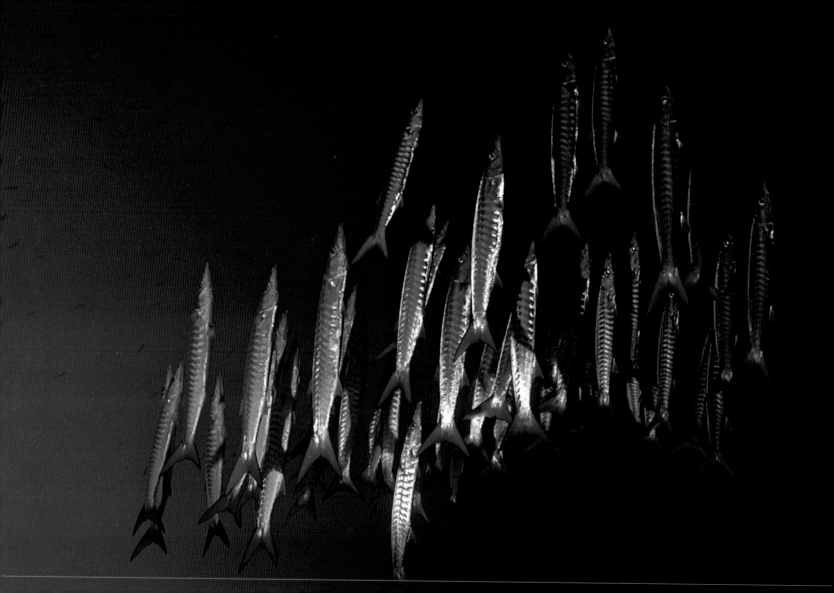

Swordfish, Cocos Island, Costa Rica

Swordfish are found in warm and temperate seas. Today, Pacific populations are protected by international, federal, and state laws and considered to be healthy. However, by the late 1990s, the numbers and size of this North Atlantic fish had dropped dramatically due to overfishing. This prompted a controversial "Give Swordfish a Break" campaign by environmental groups, pushing for increased regulation and a national boycott. Many chefs pulled swordfish from their menus. Since then, North Atlantic populations have reached 94 percent recovery.

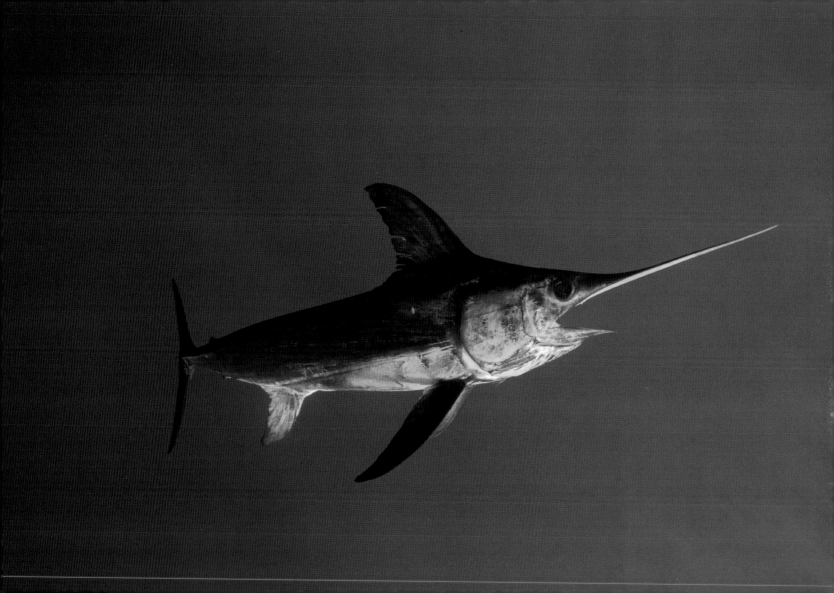

Great white shark, Guadalupe Island, Mexico

In the eighteenth century, French fishermen working the Mediterranean greatly feared that sharks would swallow their small fishing vessels. If a hungry shark followed their boat, they threw loaves of bread to it. If that didn't satisfy, the fishermen would lower a sailor on a rope to the water's surface to make scary faces at the shark. (There's no record as to whether this tactic worked.) The truth remains that while humans kill an estimated twenty to thirty million sharks a year, sharks kill an average of only about ten humans a year.

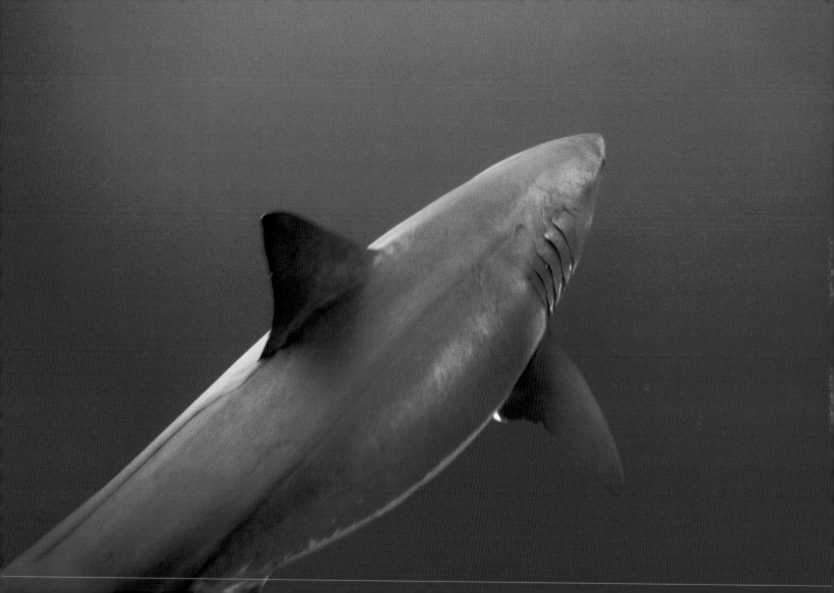

Glassy sweepers, Moses Rock, Eilat, Israel

Schooling has several advantages. The flapping of so many fins creates tiny currents that help push along all the fish in a school, similar to the effect of drafting in car racing. This action reduces friction, decreasing the amount of energy the fish use to swim. The internal lateral line of a fish's body is a sensory organ that helps the fish sense its relation to things around it; scientists think lateral lines help schools stay together, even when they make sudden changes in direction or formation.

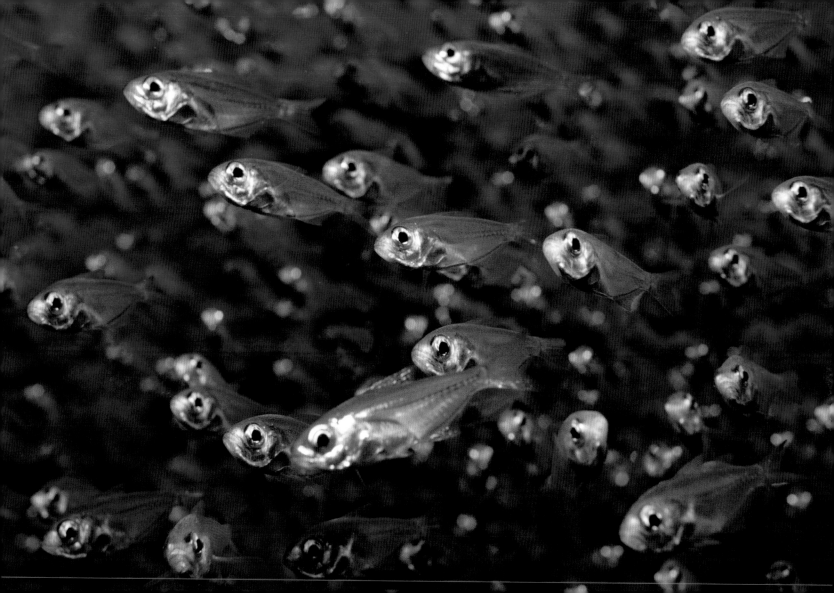

Glassy sweepers, Ras Umm Sid, Sinai Peninsula, Egypt

Milling around in a flowing, shifting swarm, small fish such as these glassy sweepers find safety in numbers. Large schools of moving individuals fill a predator's field of vision, making it difficult for the predator to focus on a single target. As with herds of land animals, the slowest and weakest will be singled out, and only the strongest and most fit will survive.

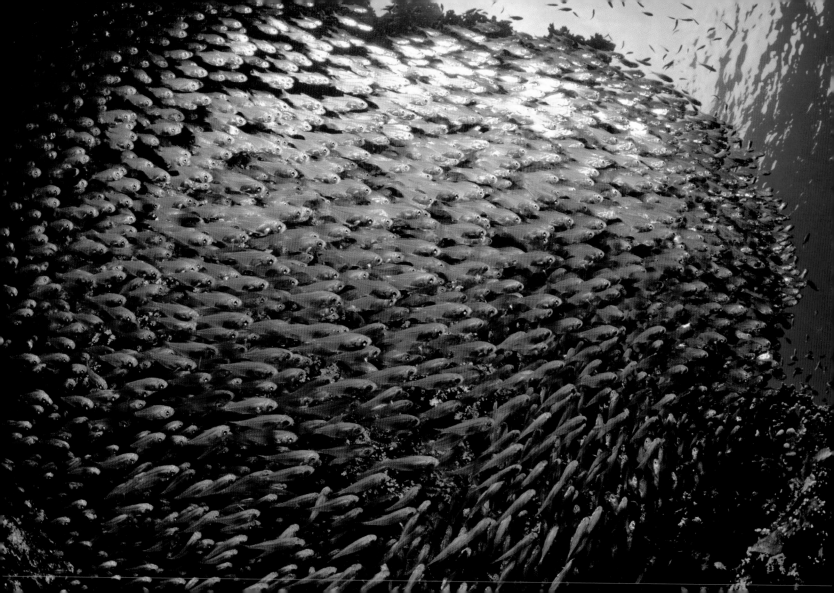

Needlefish, Jackson Reef, Sinai Peninsula, Egypt

This school of juvenile needlefish appeared during the transitional period from day to night. "Needlefish" is actually the general name for a family of more than fifty species, identified by their elongated bodies and long, needlelike snouts. They're found on menus in Europe, although they're not easy to catch with a net and their bones are bright green.

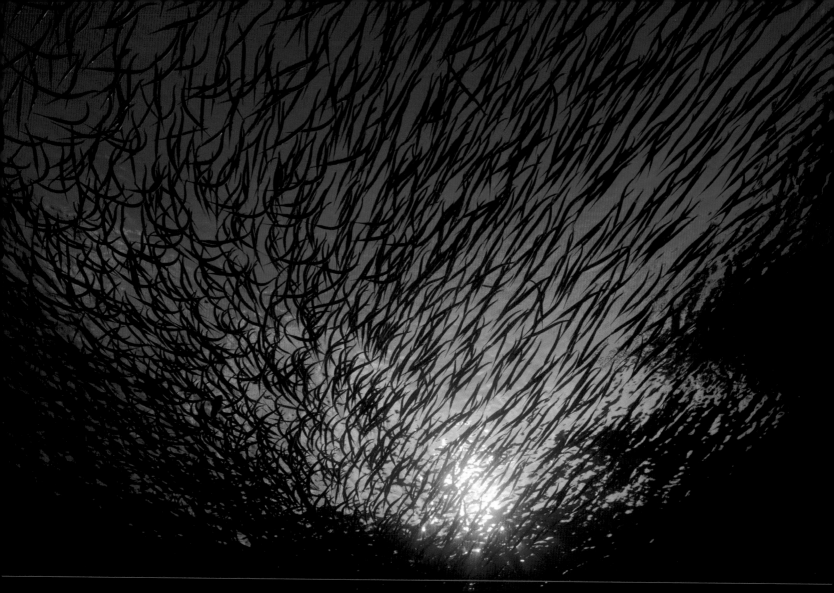

Sea lion, Daphne Island, Galápagos Islands, Ecuador

Hearty marine mammals, sea lions are found in waters ranging from temperate to subpolar, and a specific subspecies is found everywhere in the Galápagos. Playful as puppy dogs, they seem to mock divers' awkwardness. With the astonishing grace of a ballerina and sudden bursts of speed (up to twenty-five miles an hour), they easily swim circles around me whenever I encounter them. In the green and often murky waters, I would lose sight of one only to feel a tug on my swim fins a moment later. Unfortunately, their trust in humans endangers their very survival.

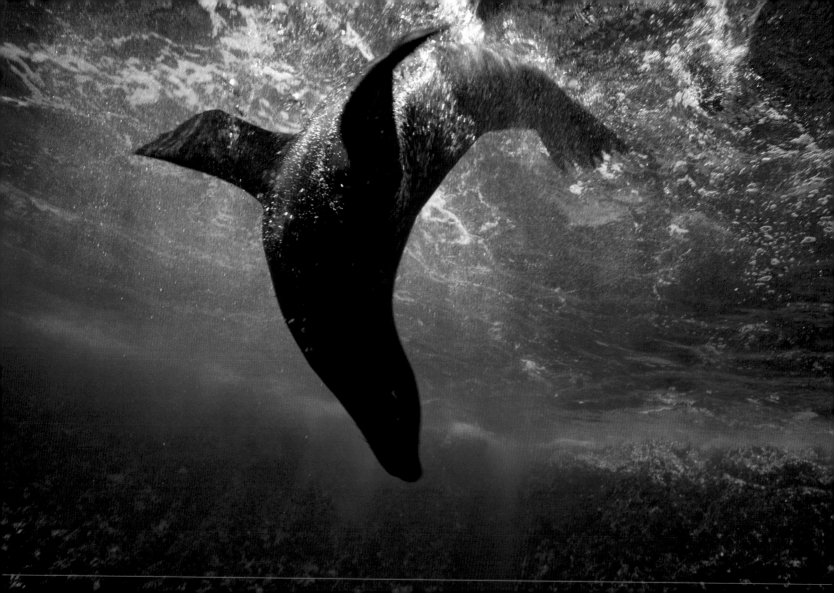

Sea lions, Daphne Island, Galápagos Islands, Ecuador

Sea lions get their name from the loud barking, sometimes roaring, noise they make to communicate. Unlike other marine mammals, the sea lion did not lose its ability to move on land when it evolved into an ocean creature, although its pace on dry ground is lumbering compared to its speed and maneuverability in the water. Warm-blooded animals, sea lions are protected from their cold environment by a thick layer of blubber and thick, coarse fur.

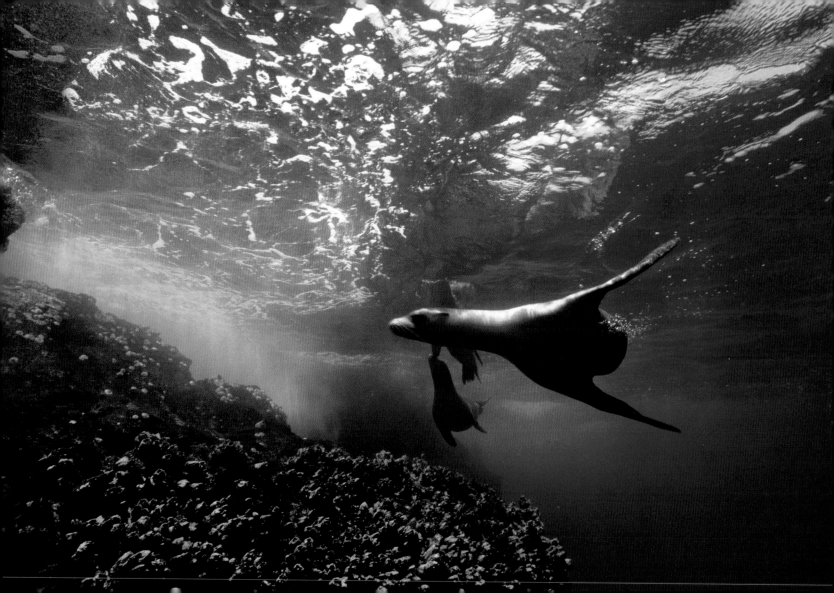

Newborn hawksbill turtle, Sipadan Island, Borneo

Sipadan Island has the largest concentration of sea turtles I have ever seen underwater. One night I was surfacing from a dive and was lucky enough to spot this newborn swimming to freedom in the open sea. It's a perilous journey for newborns, from sand to sea, and most will not make it past the first week. Even if they are lucky enough to avoid predatory birds as they hatch and crawl to the water's edge, legions of new predators await them in the ocean. They will swim frantically for up to two days straight in order to reach deeper, safer waters, but their new shells are thin and soft, offering little protection during their first month.

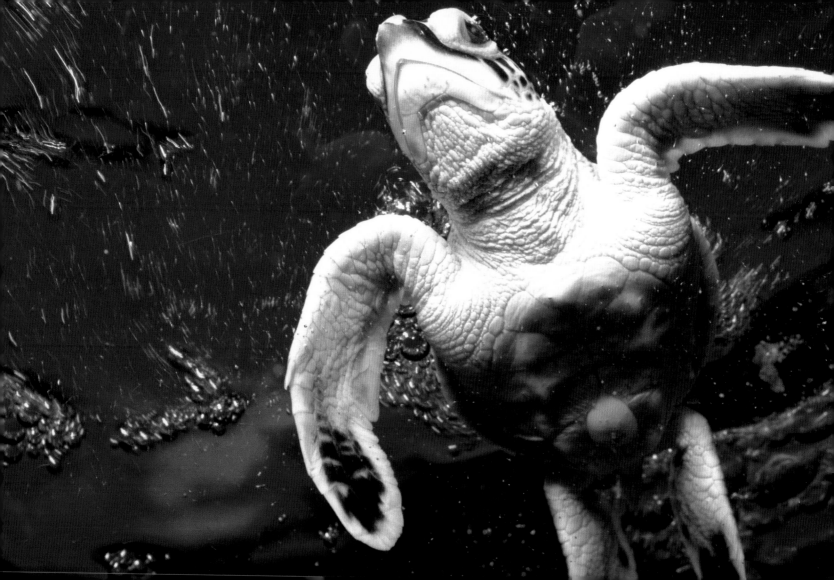

Marine iguana, Fernandina Island, Galápagos Islands, Ecuador

The marine iguana is the only lizard in the world that swims in the ocean, and it's made some interesting adaptations. Waiting on the rocks for low tide, the iguana swims into the shallows in search of algae, which it scrapes from the intertidal rocks with sharp, cusped teeth. Its long, curved claws allow it to grip the rocks so that it's not swept out to sea. The salt that is inevitably ingested during feeding is concentrated by a special gland near the iguana's nose and periodically sneezed out.

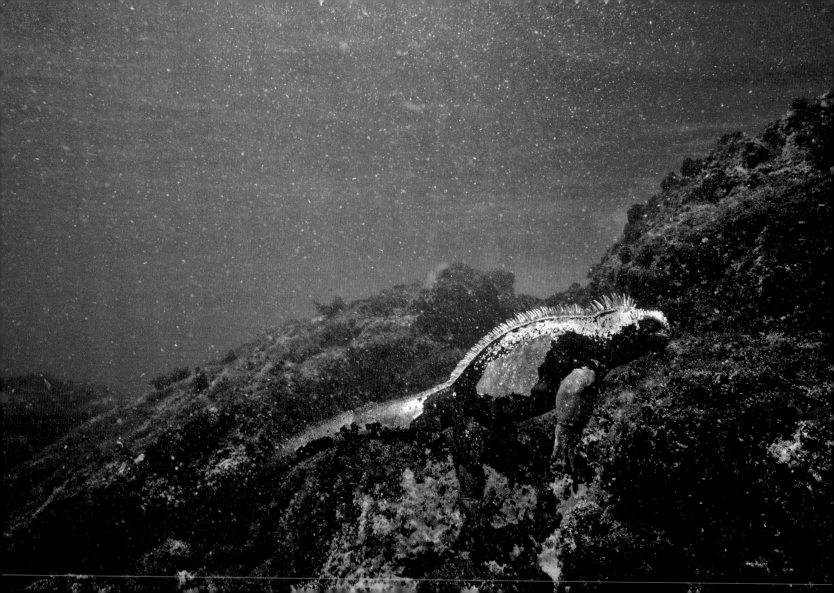

Manatees (mother and calf), Crystal River, Florida

Slow-moving, gentle herbivores, manatees eat up to 20 percent of their weight in vegetation daily. With individuals weighing more than a thousand pounds, a herd can consume the growth a sea-grass meadow produces in one day with little trouble. Also called sea cows, these marine mammals once ranged over far greater areas than they do now. All three living species are considered threatened or endangered, and the leading cause of death by humans is a result of incidents with watercrafts.

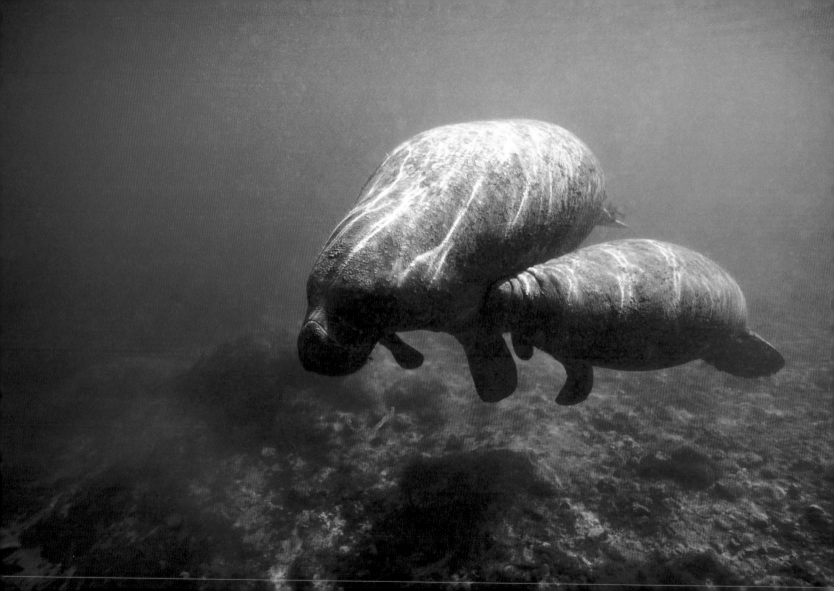

Nurse shark, Walker's Cay, Bahamas

Most sharks must swim constantly to keep water flowing over their gills so they can breathe, but not this bottom-dwelling nurse shark. It has a special respiratory system that pumps seawater through two holes called spiracles, located behind its eyes, and over its gills while it rests on the ocean floor. This reserves energy, allowing the shark to remain sedentary for long periods, giving it a reputation for being sluggish. Nurse sharks are so sedate, in fact, that if you approach them in a nonthreatening manner, a close encounter is possible.

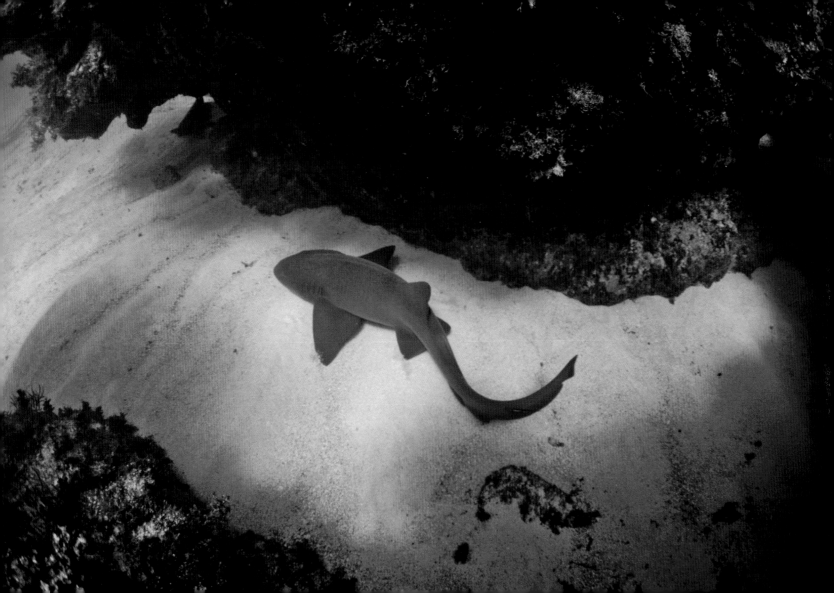

Giant Pacific octopus, Vancouver Island, British Columbia, Canada

It's hard to believe that the giant Pacific octopus is a mollusk, related to clams and snails. Through evolution, the octopus has lost its shell but still bears the phylum's telltale mantle. This saclike body contains all the necessary internal organs, including three hearts. Two hearts pump blood through the gills, while a third pumps the octopus's pale blue blood through the rest of its body.

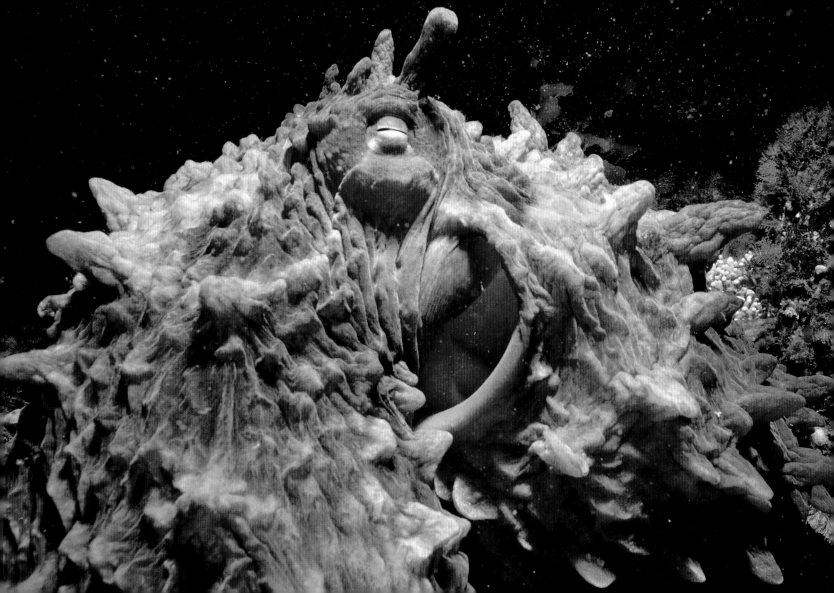

Arabian stonefish, Dolphin Reef, Eilat, Israel

The stationary stonefish waits patiently for dinner to come to it. When a morsel swims too close, they gulp it down in a fraction of a second (one account timed the action at 0.015 seconds).

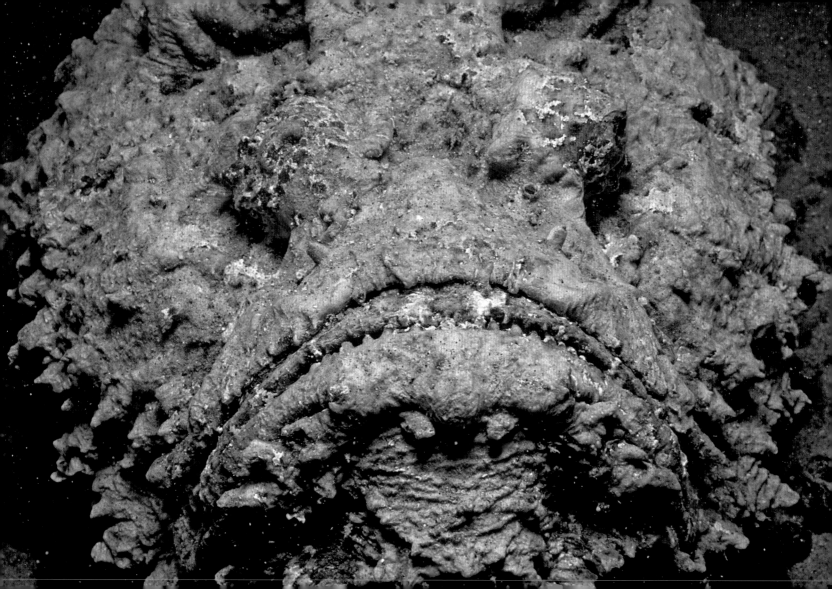

275

Sea raven, Block Island, Rhode Island

This sea raven was well camouflaged in a bed of Metridium sea anemones until my electronic flash illuminated the scene. This coastal fish is well adapted to its cold Atlantic environment: Year-round it produces proteins in its blood that act like a sort of antifreeze, helping it survive in waters ranging from almost freezing to about 60°F.

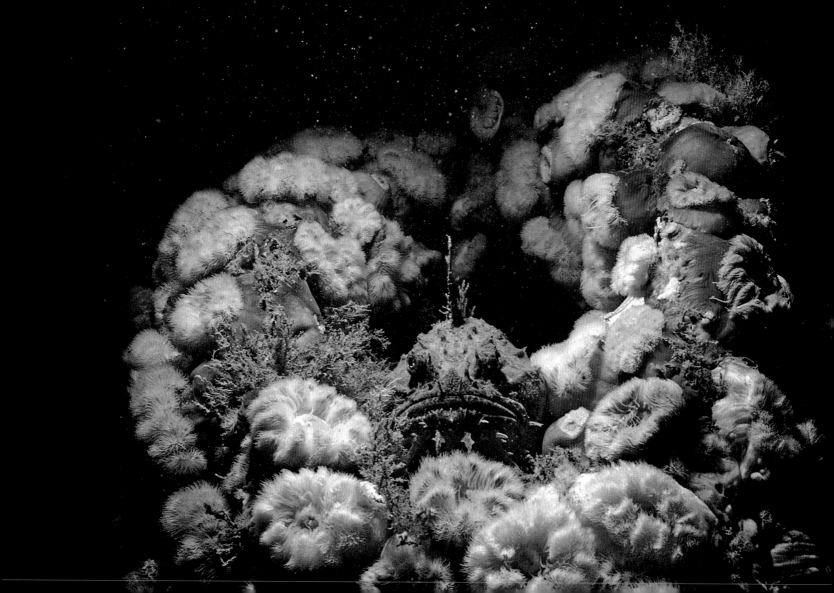

Acorn barnacles, Galápagos Islands, Ecuador

The Victorian zoologist Louis Agassiz described a barnacle as "nothing more than a little shrimp-like animal, standing on its head in a limestone house and kicking food into its mouth." Most barnacles spend their adult lives attached to solid objects by their antennae, which have evolved to become hard, calcareous plates within which the body is enclosed. Barnacles are mainly hermaphroditic and fertilize their neighbors by means of a disproportionately long penis.

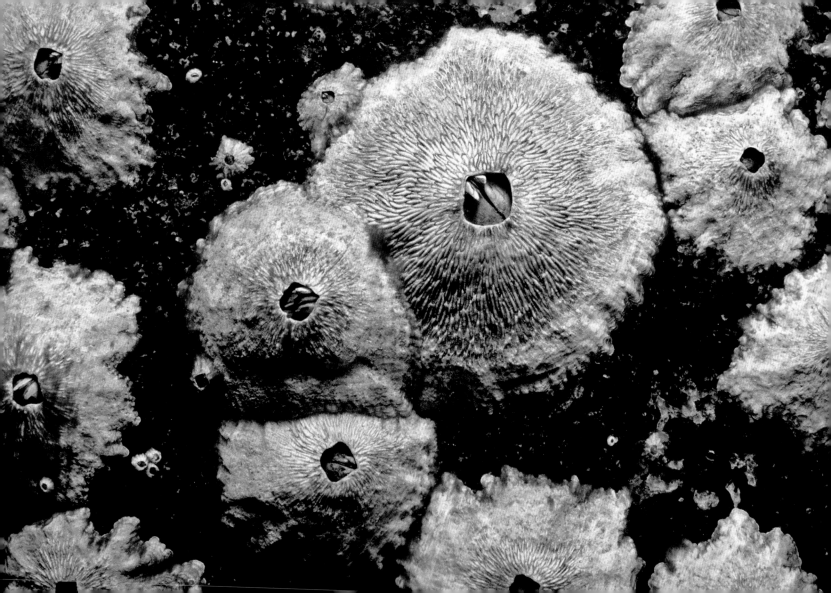

Nurse shark, Bimini, Bahamas

Nurse sharks are benthic, or bottom, feeders that prefer shallow, eel grass–covered
sandy floors. Their snouts are well developed for this kind of predation: Their eyes are
placed far back on their heads, and small mouths on the underside of the snout lead to
a large throat, good for quickly sucking up faster-moving prey. The barbels between its
nostrils search for tasty rays and crustaceans.

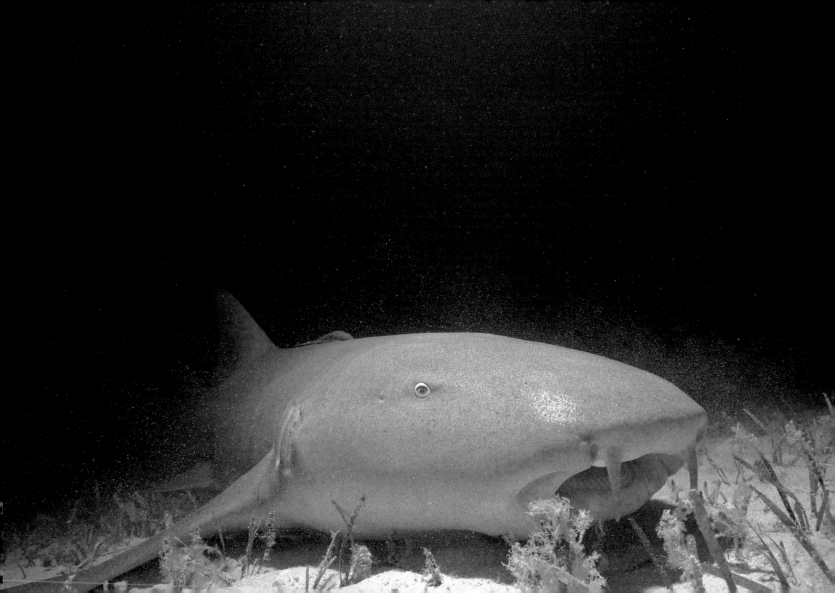

Wobbegong shark, Jervis Bay, New South Wales, Australia

The wobbegong shark is so confident of its convincing camouflage—flat body; yellowish-brown, spotted coloration; and fleshy tassels hanging from its top jaw—that it refuses to budge even when it has been discovered. I slowly inched toward this animal until I was less than a foot from its face. Only after I repeatedly assaulted it with explosions of light from my flash did it finally disengage itself from the ocean floor and wriggle away. I was lucky. When a wobbegong bites, it doesn't let go.

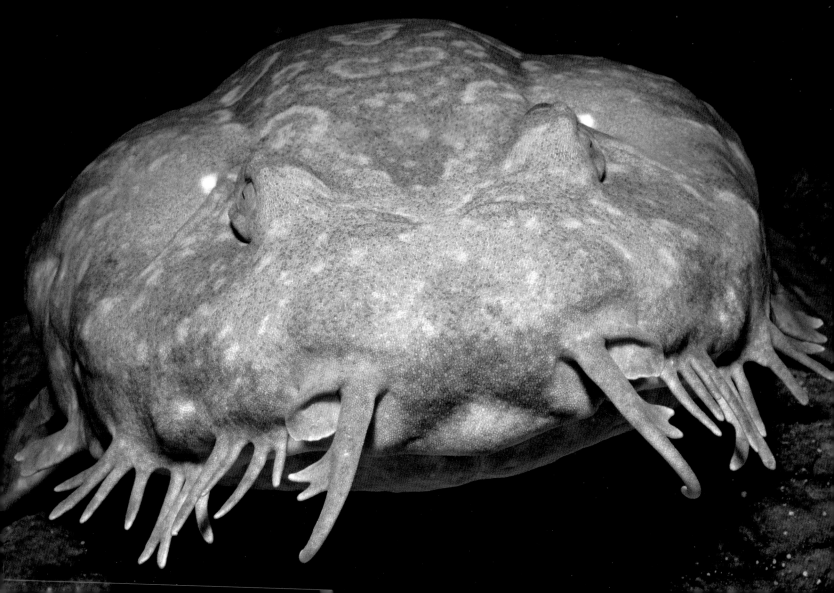

Stalked alcyonarian, Ras Umm Sid, Sinai Peninsula, Egypt

When soft corals, like the ones shown here, die, nothing is left because, unlike stony corals, they don't make calcareous skeletons. One of the biggest threats to these deep-sea corals is bottom-trawling, a common commercial fishing practice where a net is dragged along the ocean floor. A 2006 statement by the UN General Assembly asserted that about 95 percent of damage done to deep-water seamount ecosystems—including damage done to soft corals and the organisms that rely on them—is attributable to bottom-trawling.

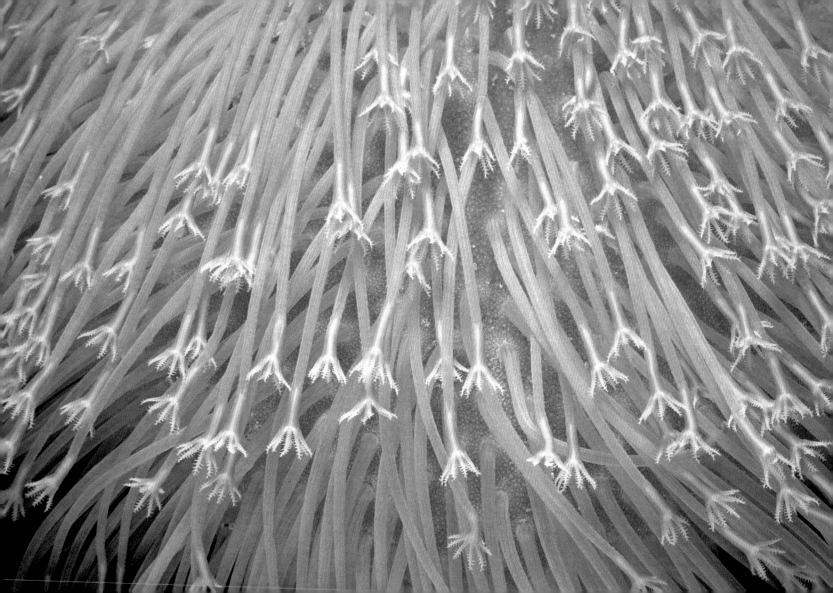

Sheet coral, Grand Turk Island, Turks & Caicos

This coral is much more than just another decorative addition to the underwater landscape, it makes possible the abundant life in these and other nutrient-poor tropical waters. Corals are the great recyclers, using their zooxanthellae to cycle carbon dioxide and oxygen through the water. They also keep plankton levels healthy and create habitats for other marine life.

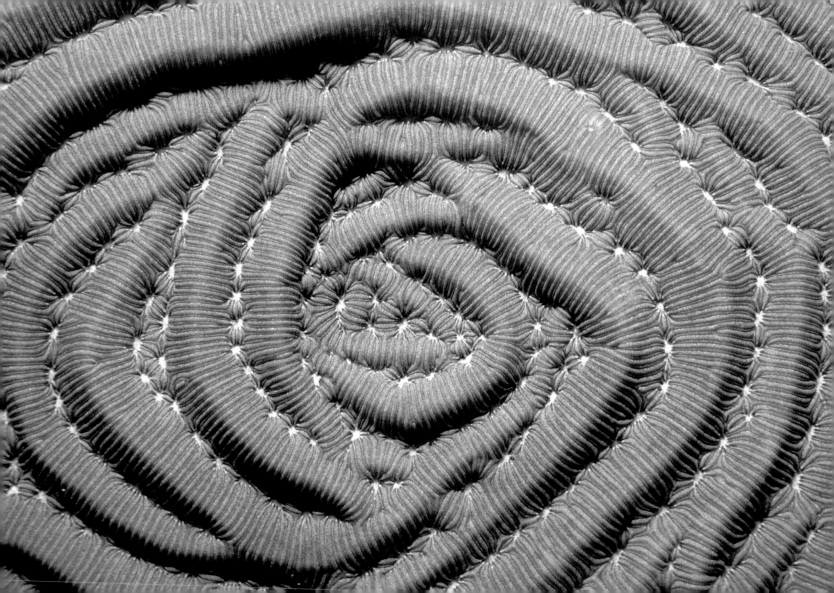

Table stony coral, Kimbe Bay, Papua New Guinea

The variety of stony corals in the waters surrounding Papua New Guinea is mind-boggling, as is the diversity of marine life that relies upon them. It's estimated that, though they cover less than one percent of the ocean's floor, coral reefs support about a quarter of the ocean's organisms. Yet, alarmingly, scientists with the U.S. Coral Reef Task Force predict half the world's coral reefs could be gone in as few as twenty-five years.

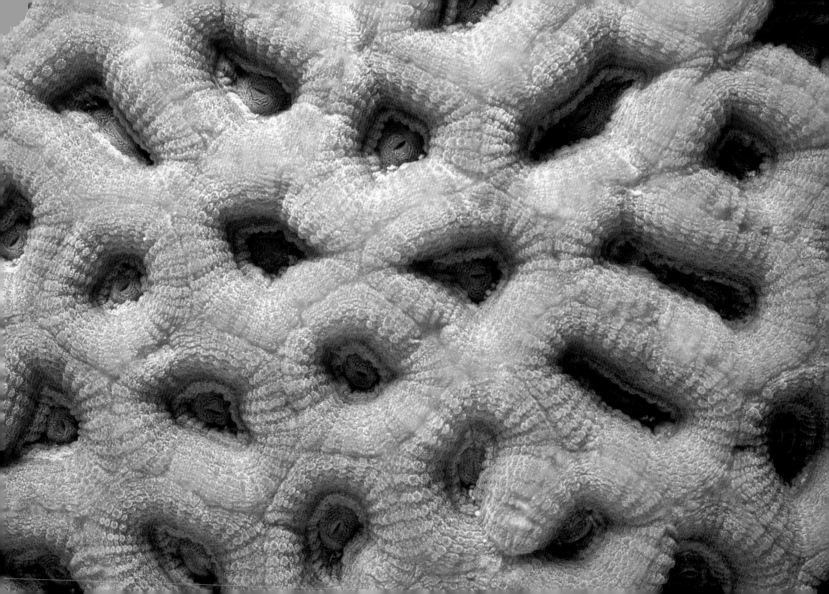

Brain coral, Grand Turk Island, Turks & Caicos

A coral reef flourishes only under a set of specific conditions: 1) clear, fairly shallow water, so that zooxanthellae will receive sunlight; 2) waves or currents to deliver food and oxygen to coral polyps; 3) warm temperatures, ideally 75 to 86°F; 4) salty seawater.

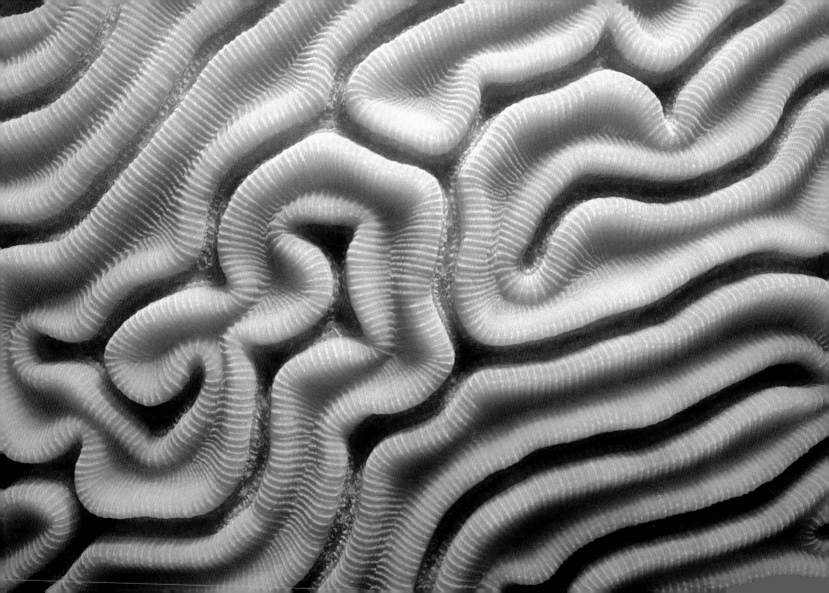

Cushion star, Ningaloo Reef, Western Australia

I've been attracted to close-up details of marine life since I first began photographing it in New England. New England diving can be generally categorized as low visibility: only seven or ten feet on a good day. That quality of visibility forces you to look for and examine details. When I went diving at Ningaloo Reef in the Indian Ocean and couldn't see the tip of my outstretched arm, I was delighted to find this cushion star and capture the crazy bumpy detail of its skin.

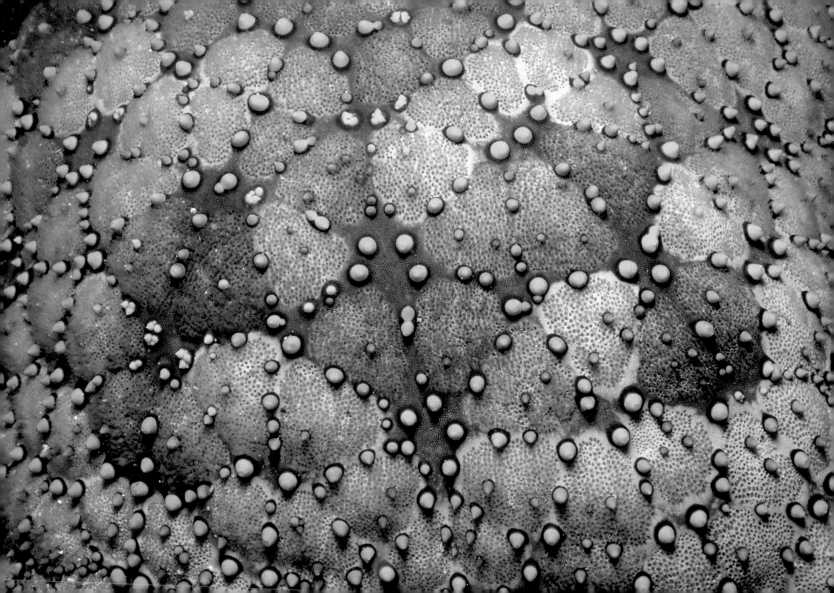

Common sea anemone, North Beach, Eilat, Israel

Close-up underwater macrophotography has no creative limits. The classic definition of macrophotography is when the image on film is larger than the actual subject. Here I envisioned the bulb-tipped tentacles of a common sea anemone as giant balloons.

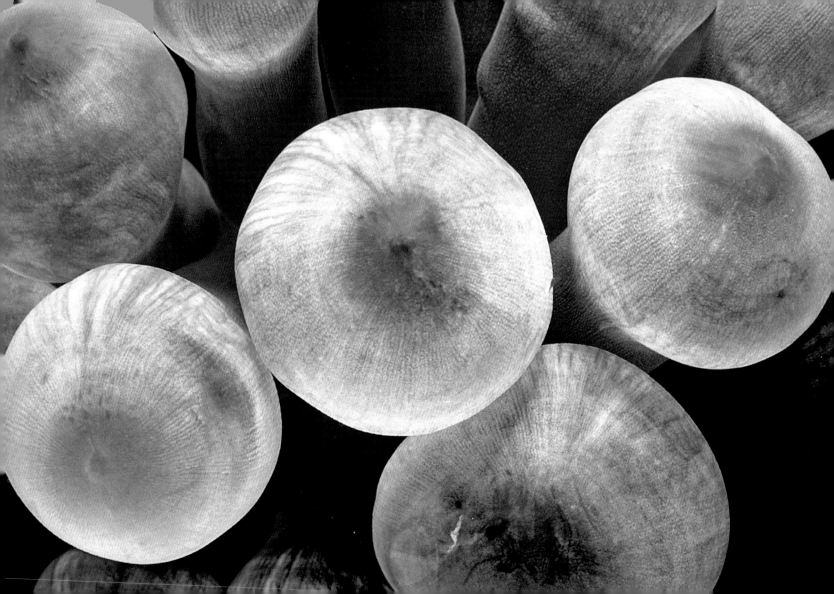

Crinoid, Ras Umm Sid, Sinai Peninsula, Egypt

Crinoids are striking and unusual relatives of starfish and sea urchins. The most common types of crinoids, which are often (though not always) nocturnal, carry two dramatically different types of arms in multiples of five. The long, feathery appendages sweep through the water to gather plankton. The smaller, more ropelike arms beneath are used for "walking" over or grasping coral formations.

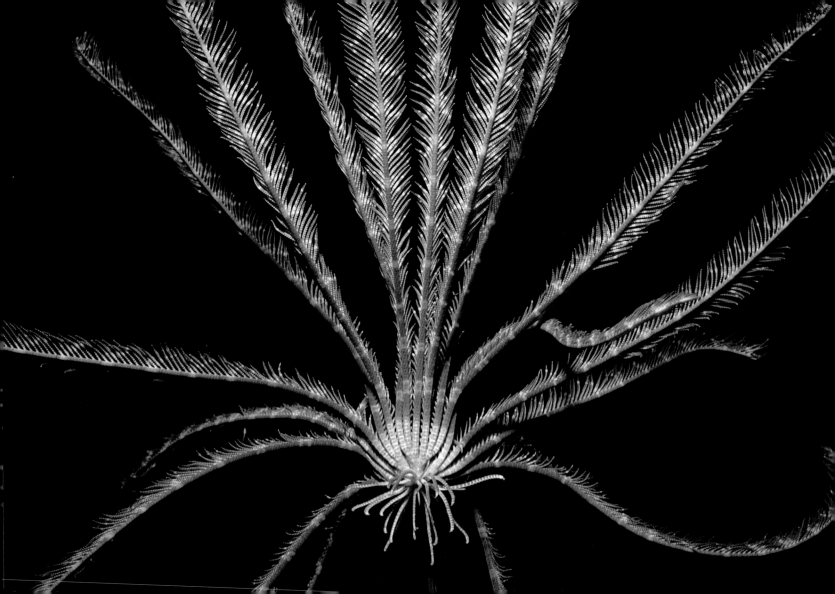

Alcyonarian soft coral, Tiran Island, Egypt

This purple alcyonarian soft coral is deceptively fragile looking. It is actually leathery in texture, but its polyps are still vulnerable to the sharp jaws of diurnal coral-eating fish. This is why most alcyonarians extend to their full, glorious spread only after dark, when this image was taken.

Scarlet Psolus sea cucumber, Deer Island, Bay of Fundy, Canada

This leathery invertebrate, which generally looks like a cucumber-shaped worm with tentacles, has no brain but a healthy appetite. I watched this one as it thrust each of its ten branching tentacles, one by one, into its central mouth to be "licked" clean of captured plankton and organic matter. A full cycle took nearly twenty minutes, then it began all over again.

Aggregating anemone, Santa Rosa Island, California

Cold, temperate marine environments are less explored by divers for the simple reason that most people prefer warm, clear water. But the treasures I find in these environments are every bit as fantastic as those from warm, tropical seas. The fascinating aggregating anemone seen here is a case in point: Inhabitants of the tidal zone, aggregating anemones are usually either closed up at low tide or obscured by crashing, swirling waves at high tide.

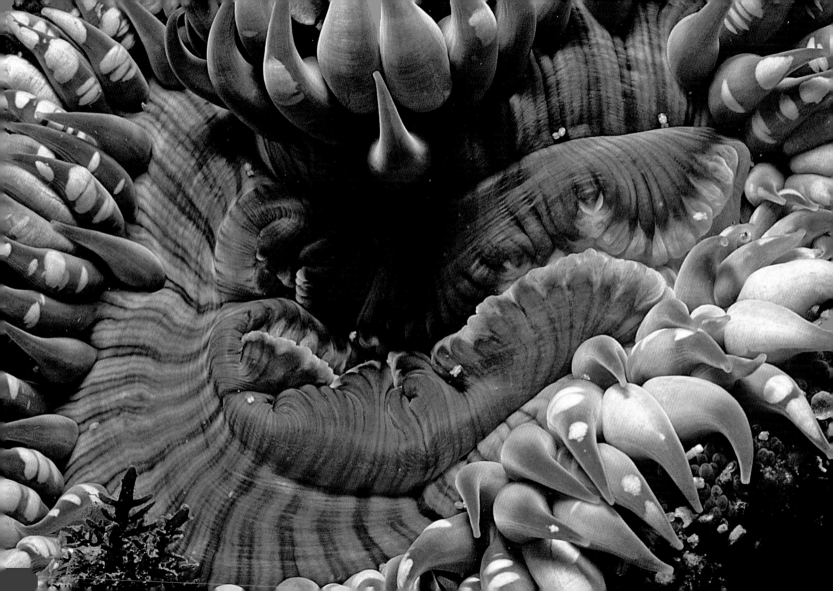

Whitetip reef shark, Cocos Island, Costa Rica

This juvenile whitetip has the perfect blemish-free skin of youth. As a shark ages, its skin becomes scarred by aggressive—or amorous—encounters with other sharks. Two mating sharks can look as though they are locked in mortal combat. A male shark will circle and gently bite at a sexually receptive female before taking hold of her pectoral fin in his mouth and inserting his clasper, a penislike organ located behind his pelvic fin, into her genital vent. The result is a cute little bugger like this one.

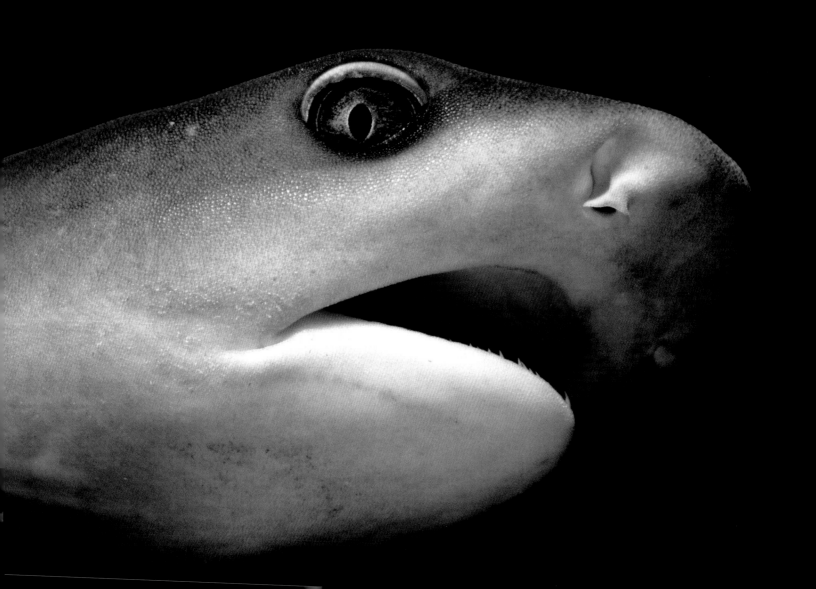

Skin of whitetip reef shark, Cocos Island, Costa Rica

A shark's skin doesn't feel like that of other fish. Instead of flat scales, its skin is covered with spiny projections called denticles, made from the same material as the shark's teeth. If you brushed your hand backward along a shark's body, its skin would feel smooth. But stroke toward its head, and it would feel like sandpaper. On some sharks your hand might even bleed (which is to be avoided at all costs around a shark).

Gills of whitetip reef shark, Cocos Island, Costa Rica

Sharks have five to seven vertical gills on each side of their head. (This whitetip reef shark has five; bony fish usually have one.) Most sharks have to keep moving to force water over their gill membranes, which absorb the oxygen dissolved in the water. Capillaries then take the oxygenated blood to the shark's tissues and organs.

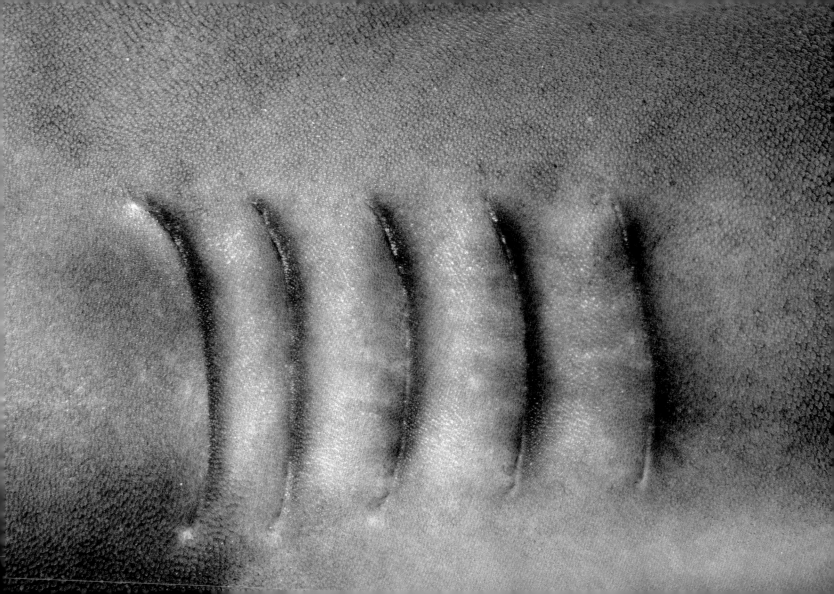

Mouth of whitetip reef shark, Cocos Island, Costa Rica

Most species of sharks have anywhere from six to twenty sets of teeth, lined up like rows of seats in a theater, anchored loosely to the cartilaginous jaw. When a front tooth is lost, another, fully grown, moves up from behind to replace it, usually within twenty-four hours. For this reason, it can sometimes be hard for scientists to estimate the age of a shark, although we do know a young shark may lose an entire set of teeth each week, and a good-sized shark may go through twenty thousand teeth in ten years.

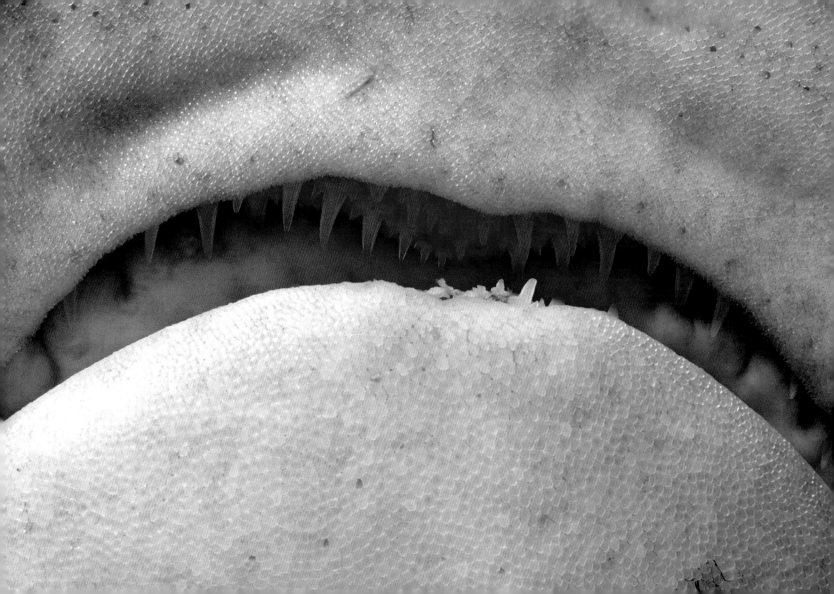

Port Jackson shark, Dangerous Reef, South Australia

Meet the Port Jackson shark. This bottom-feeder is oviparous, which means that the female lays eggs rather than birthing live young or hatching eggs internally. The dark-brown, corkscrew egg-case, housing a single fetal shark, is quite beautiful. The female will pick it up in her mouth and wedge it into a crevice of the reef, leaving it to gestate for ten to twelve months.

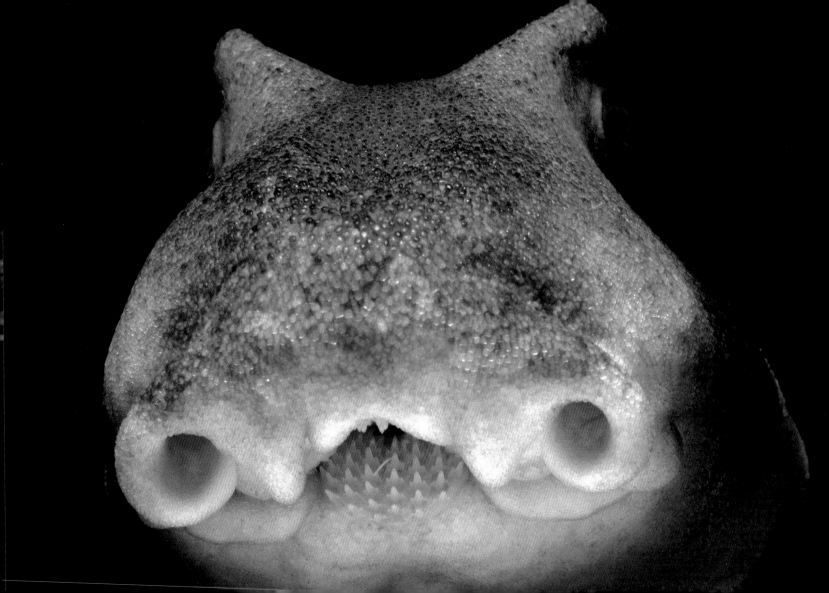

Mouth of a Port Jackson shark, Dangerous Reef, South Australia

This Port Jackson shark's winsome smile gives away the meaning behind its taxonomic name: *Heterodontus*, or "mixed-tooth." You can see the pointed teeth near the front of its mouth grade to blunter teeth toward the back, all the better for armored prey like mollusks, crabs, and sea urchins. Its large, convoluted, piglike nostrils enable it to detect microscopic levels of chemicals in the water.

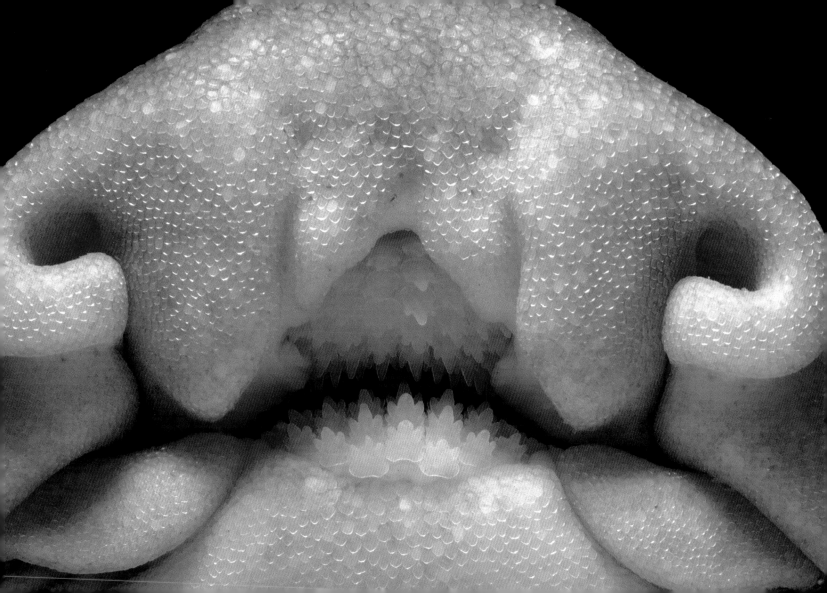

Mouth of a thornback ray, Santa Cruz Island, California

A face only a mother could love! The underside of this thornback ray shows its tiny grinding teeth, which can grip a crab or mollusk firmly before crushing the shell to devour the sweet meat inside. What happens if it swallows something that doesn't agree with it? In 2000, researchers in the UK showed that these rays are able to literally puke their guts out, expelling their stomachs—and any unwanted contents—from their mouths before quickly sucking them back in. They're not alone in this upchucking behavior; other rays and sharks exhibit the same response.

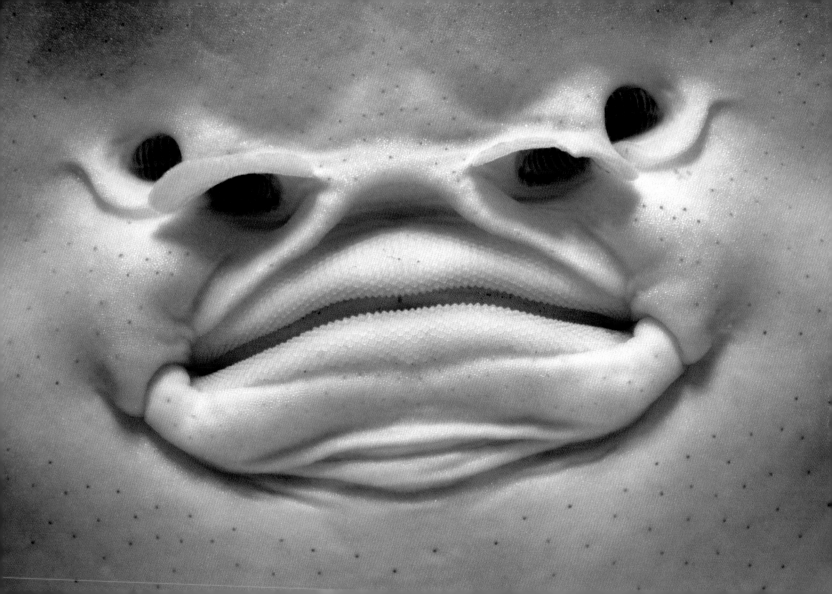

Claspers of a whitetip reef shark, Cocos Island, Costa Rica

Male sharks have two claspers, or essentially penises—one under each pelvic fin. He will use only one clasper at a time, depending upon which side he approaches the female. These pointed claspers can leave their mark in more ways than one—many female sharks exhibit scarring from the rough treatment of their sexual partners.

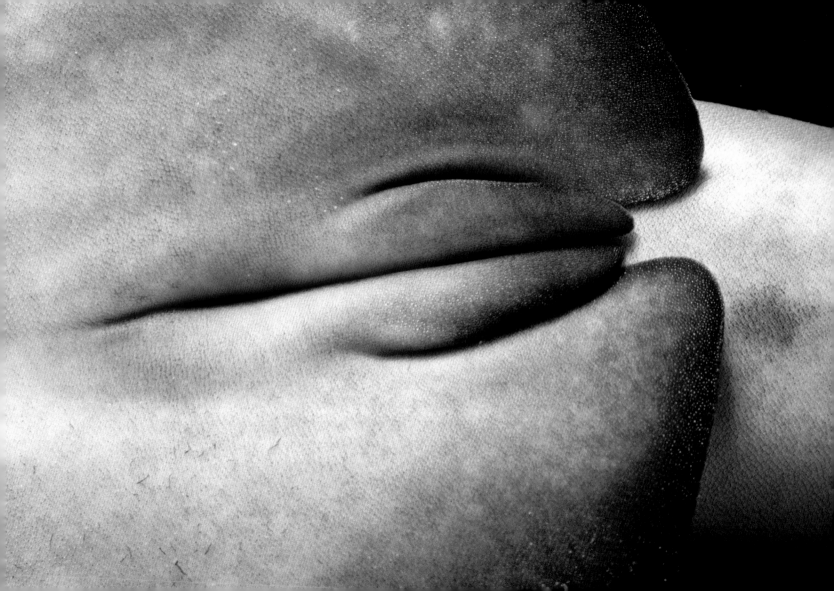

Gills on the underside of a yellow stingray, Grand Bahama Island
The gills of this yellow stingray expand and contract to help pump water through its respiratory system. This allows the animal to remain motionless on the ocean floor, while still receiving enough oxygen to survive. The visible pores around the gill openings are tiny sensory pits connected to its Ampullae of Lorenzini, which feed electrosensory information to the animal's brain.

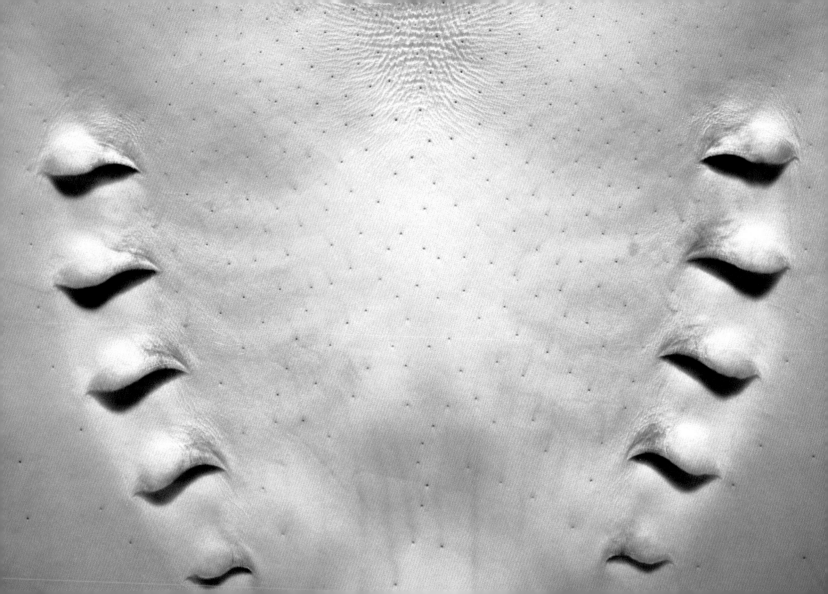

298

Smoothhound shark, Eilat, Israel

A bottom-feeder, this smoothhound shark is well adapted to life on the ocean floor. Its nostrils are located on the ventral, or underside, to help it find prey living on the ocean bottom. Its eyes have extremely powerful reflectors that maximize the dim light reflecting off potential prey. These reflectors are called *tapetum lucidum*, Latin for "carpet of light," and make a shark's eyes probably ten times more sensitive to light than a human's.

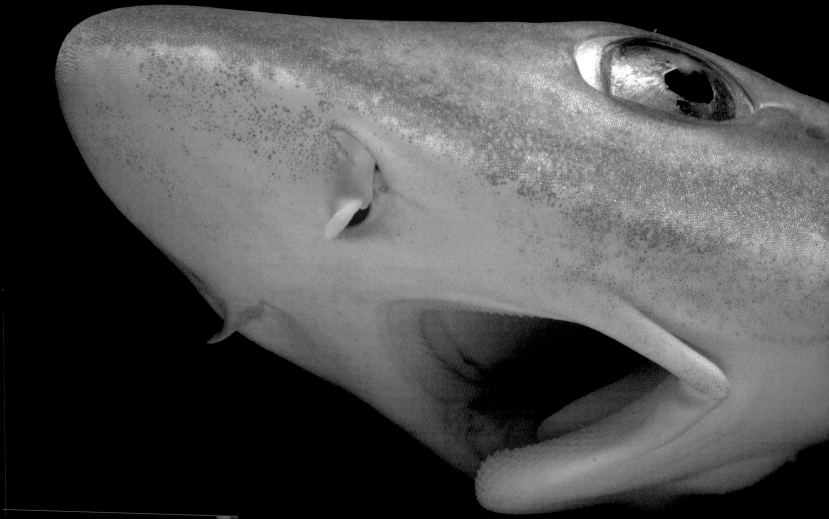

Swellshark, San Clemente Island, California

Many rows of pointed teeth make even the smaller shark species, like this California swellshark (which maxes out at about three feet), effective predators. This shark lies in rocky crevices, waiting to ambush unsuspecting fish and crabs. When it finds itself on the other side of the predator-prey fence, it curls into a U-shape and gulps water to blow itself up to the size of a beach ball, making it appear larger to predators and harder to bite down on or pull out of hiding.

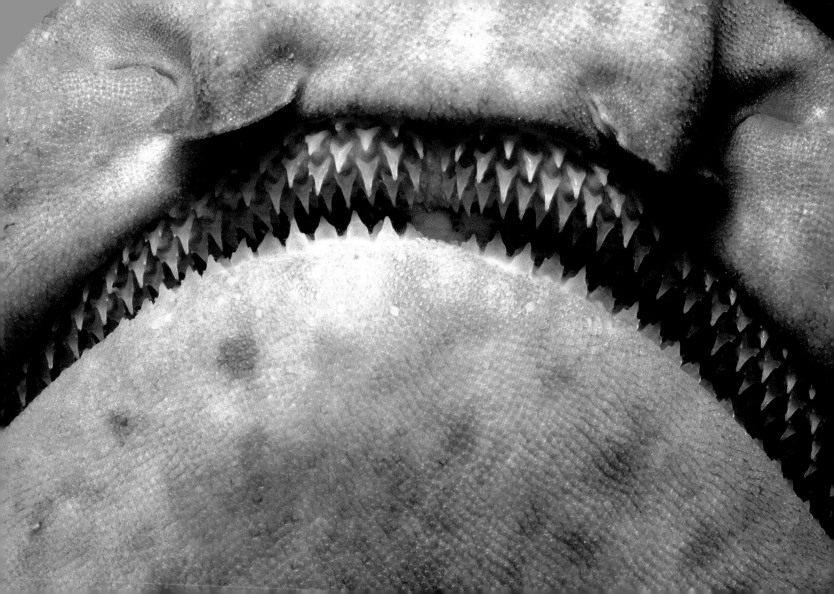

Epaulette shark, Kimbe Bay, Papua New Guinea

The epaulette shark is a member of the carpetsharks, named for their bottom-dwelling lifestyle. Like other benthic feeders, this shark has barbels that help it sniff out prey. In this case, the barbels are connected to the nostrils and mouth by a single groove. If necessary, it can also "walk" on its muscular pectoral fins.

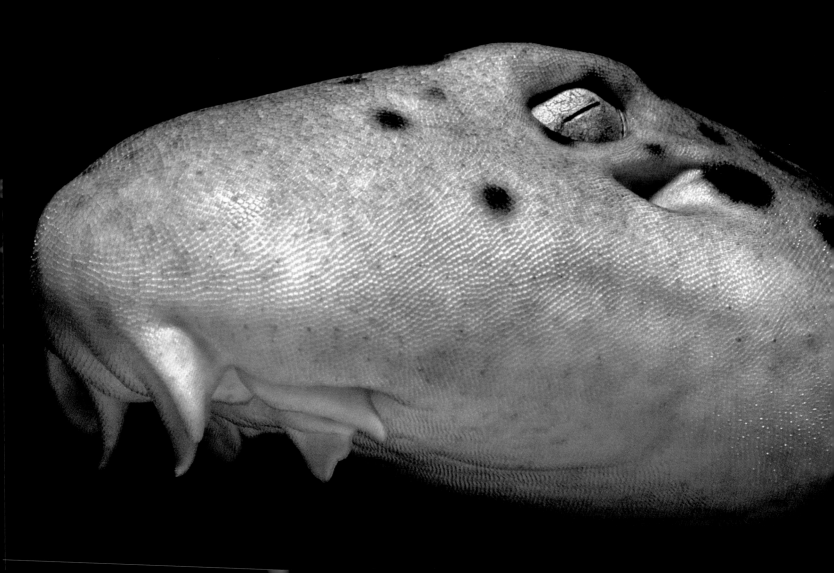

Skin of epaulette shark, Kimbe Bay, Papua New Guinea

At a foot and a half in length, the small epaulette shark needs all the help it can get to avoid becoming an appetizer for a larger shark. The spotted skin of this shark helps camouflage it against the floor of a coral reef or sandy lagoon. It has large black blotches, called ocelli, just in front of its gill slits. Perhaps to a potential predator these spots look like the giant eyes of an invincible opponent.

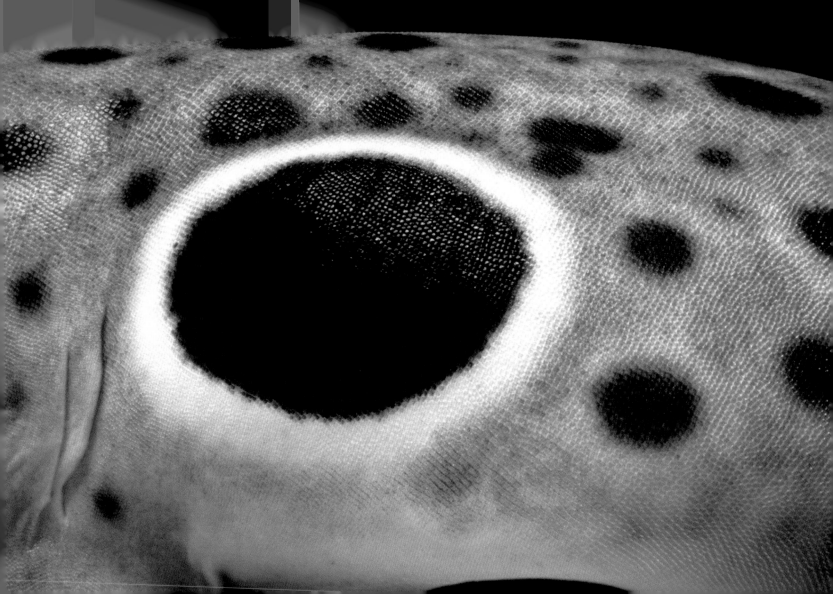

Mouth of a trumpetfish, Gordon Reef, Sinai Peninsula, Egypt

Mouths and eyes give fish the "personalities" and "expressions" we're likely to read into their faces: bold or shy, harmless or menacing, beautiful, coy, outlandish, or just plain odd. Take this trumpetfish, which I found swimming facedown! The trumpetfish is a relative of another quirky animal that also swims vertically: the sea horse.

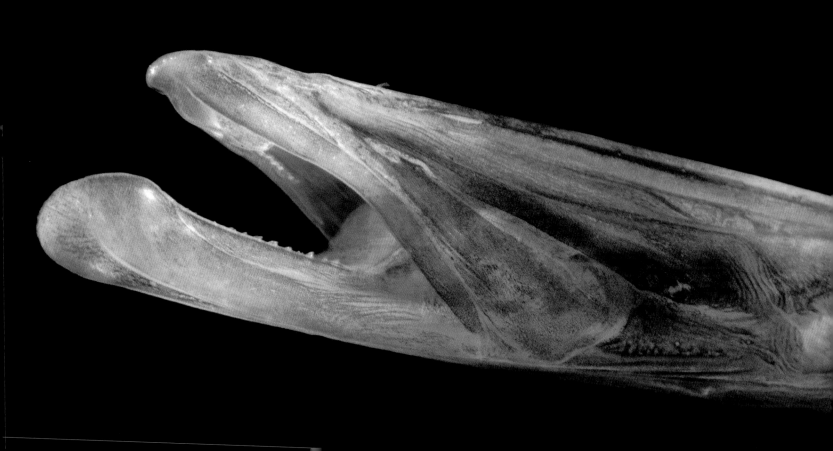

Trumpetfish, Andros Island, Bahamas

Trumpetfish are some of the most interesting fish hunters on the reef. Their long, thin bodies hardly produce a shadow. They usually swim horizontally but frequently position themselves vertically to blend in with coral and to prepare for a lightning-quick strike. The elastic tissue of its mouth flares out like a trumpet's to vacuum up rather sizable animals.

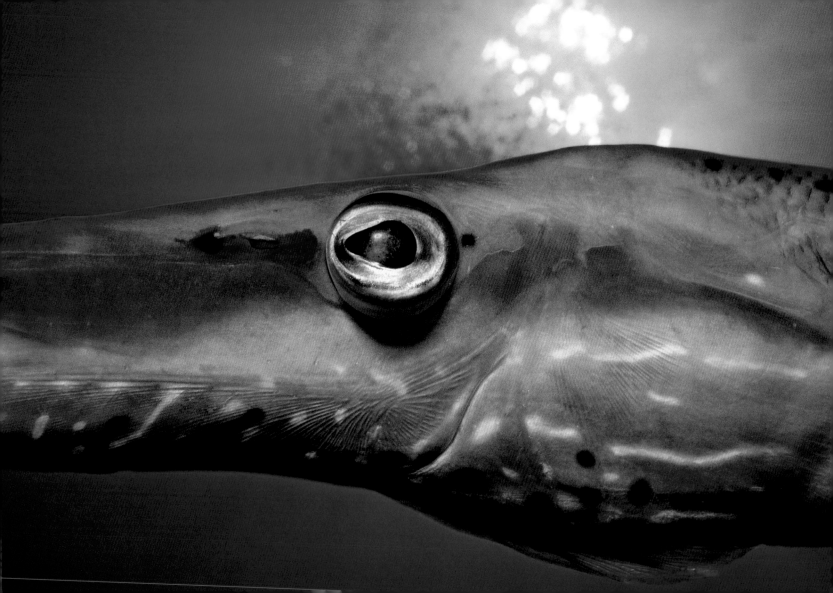

White-banded cleaner shrimp, Moses Rock, Eilat, Israel

This cleaner shrimp is usually found resting in a coral crevice, waving its long, white antennae to attract fish or other crustaceans. When new "clients" approach, the shrimp first touches them with its antennae, after which they strike a passive pose, and allow the shrimp to work over their body surfaces and search their gills for parasites. This shrimp seems to understand that it's good to have friends in high places (on the food chain).

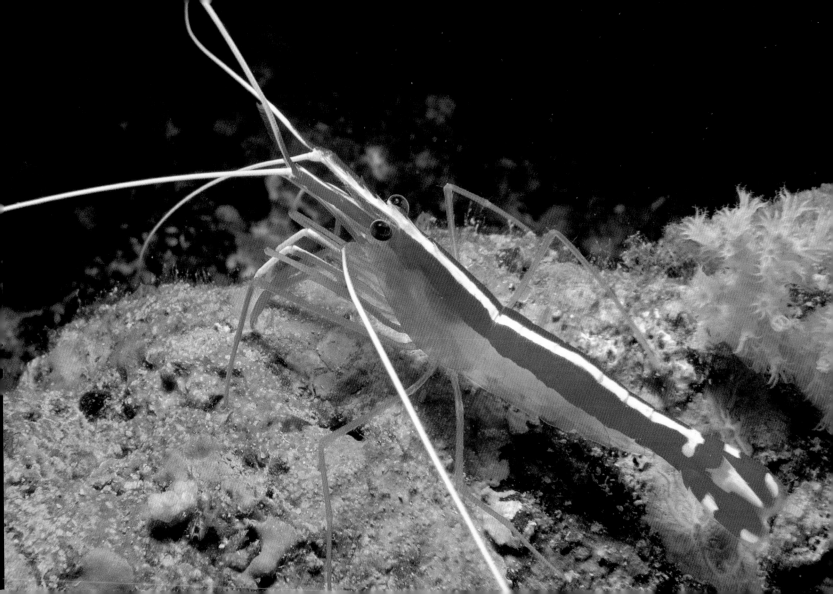

Tridacna clam, Ras Nas Rani, Sinai Peninsula, Egypt

Large specimens of the Tridacna clam, like this one in the Red Sea, are becoming rare. The giant clams, which grow up to four feet across and can weigh hundreds of pounds, are harvested and sold on the black market and in the aquarium trade. In some Asian cultures, its flesh is considered a delicacy. There is hope, however, that coral reef sanctuaries will help protect this fascinating bivalve.

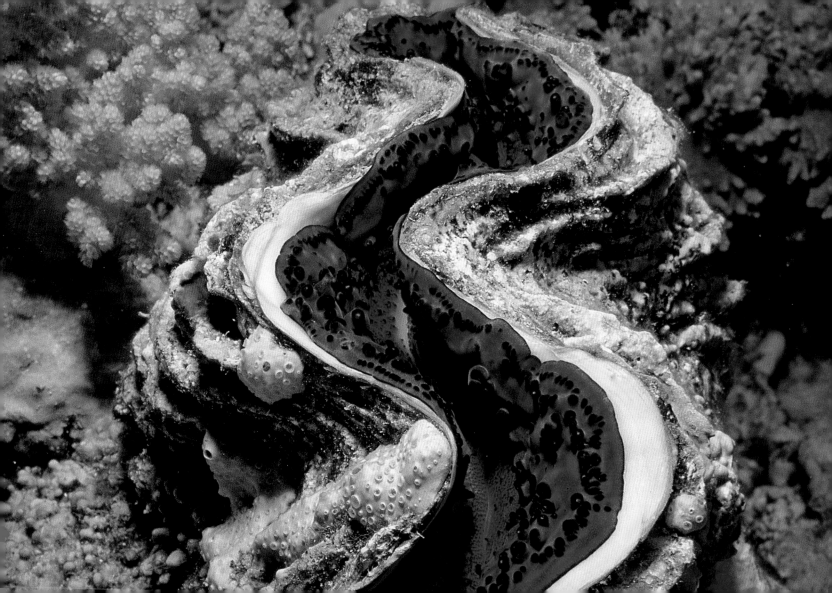

Clown triggerfish, Great Barrier Reef, Australia

When I first saw a clown triggerfish in Papua New Guinea, I almost had a heart attack. What coloration, what design! I'm embarrassed to say how much time I spent trying to get a close-up of this remarkable fish, yet I was unsuccessful. Two years later, working the Great Barrier Reef, I met this docile specimen. This photograph only hints at its wacky design: its belly is covered in white spots on a black background, there's a leopard-print dorsal area, and a mouth that looks like it's covered with yellow lipstick.

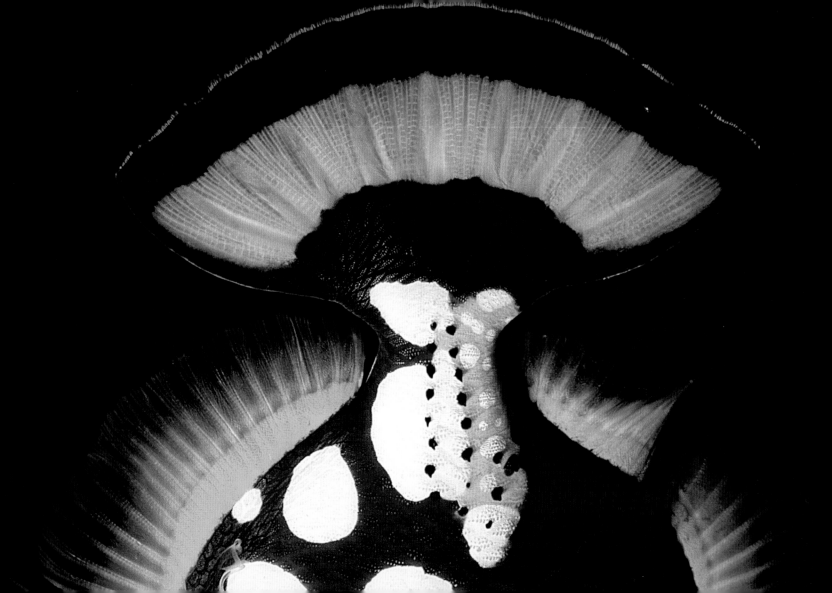

Dorsal fin of a hogfish, Bahamas

The first three spines on the dorsal fin of the hogfish are so prominent, you can spot one from a distance. Coloration and fin modifications are used not only to warn or protect against predators, but also to help in mate selection. Males of this species attract a female harem, whom they court before spawning. Who knows? Perhaps the hogfish with the largest dorsal spines gets the best-looking harem. (Turn the book clockwise to view the image in its proper orientation.)

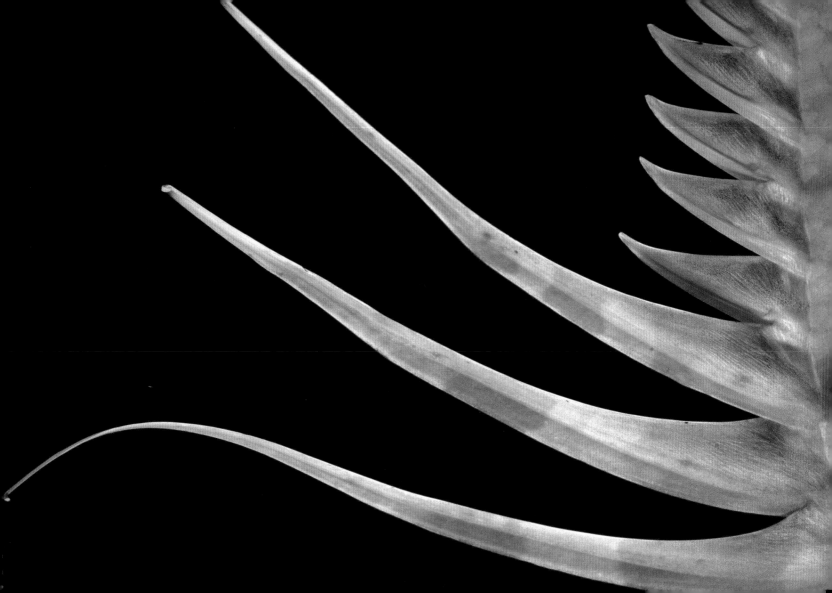

Spine on the tail of an ornate surgeonfish, Great Barrier Reef, Australia

Surgeonfish sheathe spines sharp as scalpels (hence their name) in natural scabbards on either side of their tail base. These fish are generally timid and quick to flee approaching danger, but they change their manner rapidly if cornered. I made this mistake unknowingly one night in a shallow water cave in the Red Sea. My electronic strobe went off, waking the napping fish. My body was blocking its escape. As it made for the cave entrance, it slashed into my thigh, cutting through the wetsuit, which resulted in six stitches.

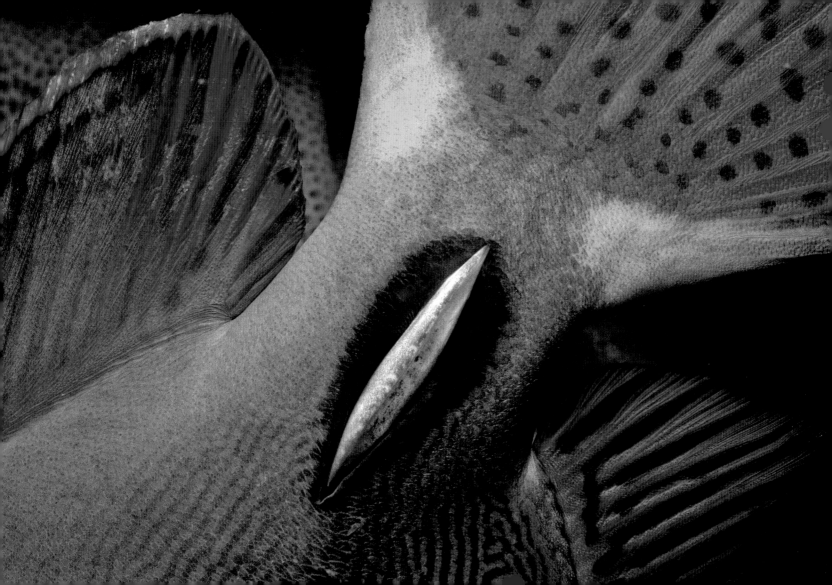

Tail of a stoplight parrotfish, Bahamas

As beautiful as they are, the colors and designs on fish serve a wide variety of purposes: defense, camouflage, mate selection, recognition. Konrad Lorenz, the Austrian scholar of animal behavior, best described these patterns as "poster colors." He believed that the bright patterns on so many tropical fish serve the same purpose as advertising billboards—to broadcast messages, whatever they are, boldly and for all passersby to see.

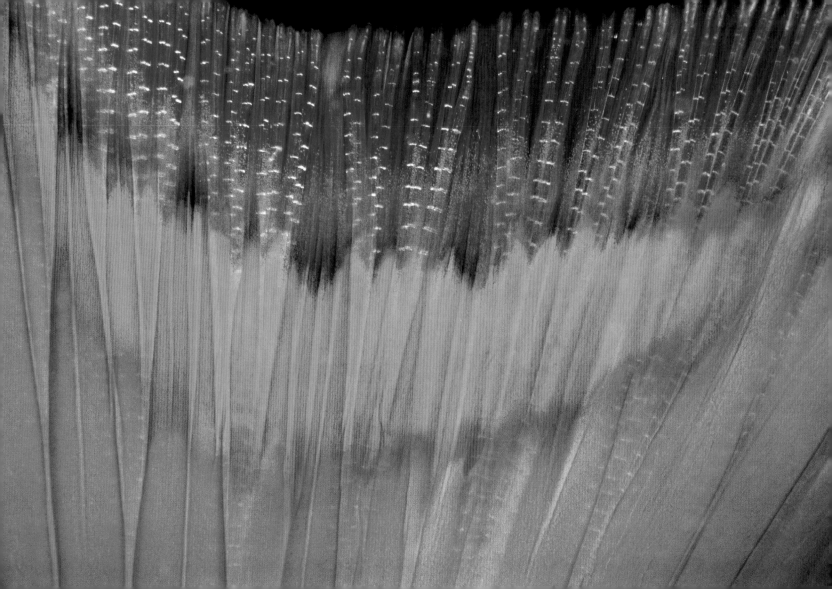

Tail base of a trumpetfish, Bahamas

Trumpetfish have the ability to change color in a flash if necessary to blend in with their surroundings, whether it's hiding behind a rod coral or tailing a group of angelfish. They can appear brown, green, or bright yellow, with dark and light stripes and spots. At night, when this picture was taken, this fish had no such concerns and was its normal rusty brown.

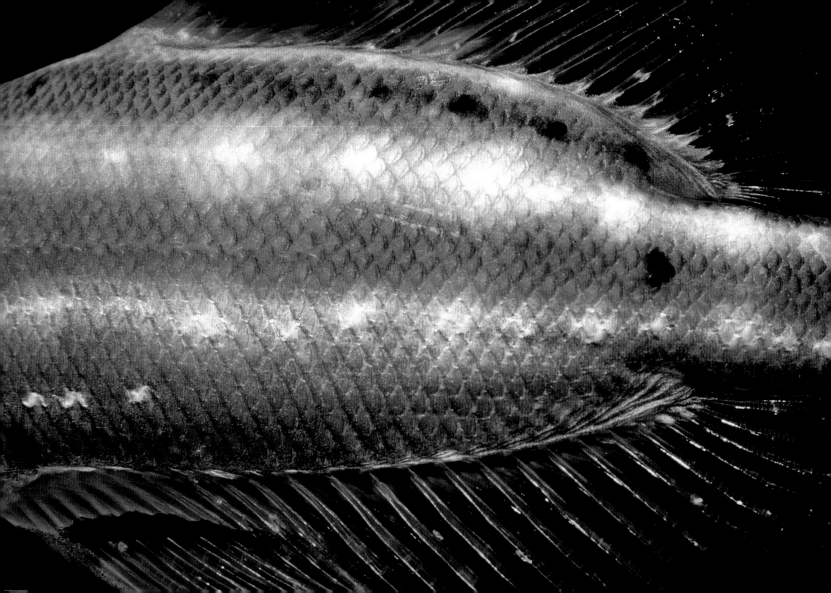

Lyretail hogfish sleeps in sponge, Ras Burka, Sinai Peninsula, Egypt

This lyretail hogfish seems to have found the best room in the hotel. In addition to offering what must be a very cozy accommodation, the sponge serves to mask the fish's odor from potential predators. Having found the perfect hiding place, it's likely this fish will return to this specific sponge every night and defend it if necessary.

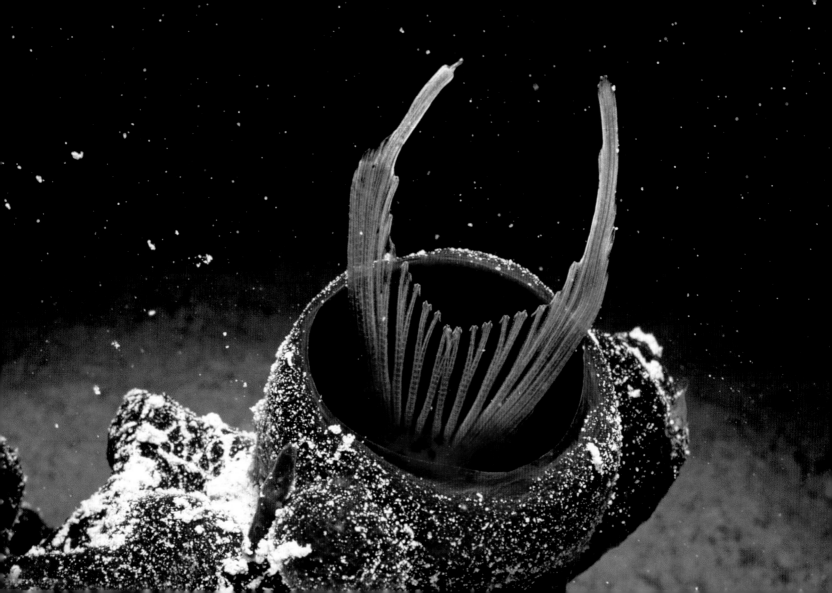

312

Wire coral, Tiran Island, Egypt

Wire corals form long, single, unbranched, wirelike stalks that often twist and coil. If you want to see them, though, you have to dive deep. In the Red Sea they begin to appear after one hundred feet, but the really huge specimens, more than ten feet in length, I've seen below two hundred feet. You'll often find tiny, translucent gobies perched on them.

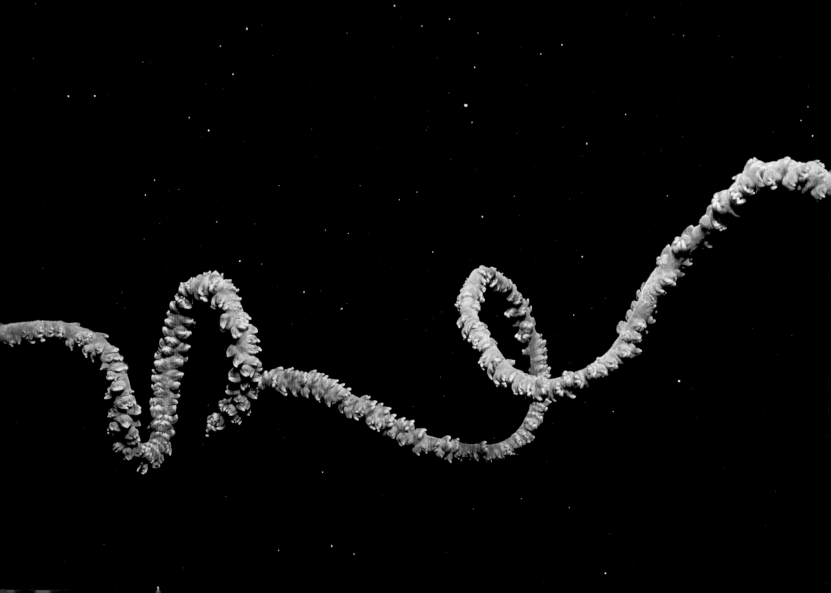

313

Deep-water gorgonians, Ras Umm Sid, Sinai Peninsula, Egypt

Most hard corals virtually disappear at depths of more than 250 feet, to be replaced by deep-water gorgonians, which lack zooxanthellae and, therefore, don't rely on sunlight. Judging strictly by their size and intact habitat, the corals pictured here, at a depth of 285 feet, could pass for hundreds of years old.

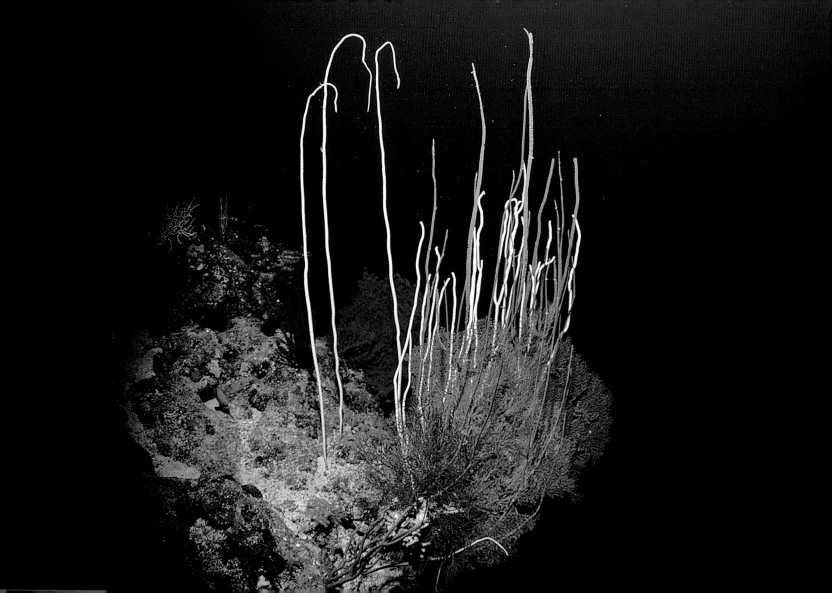

314

Caribbean common octopus, Grand Cayman Island

The octopus eye is a wonder of the underwater kingdom. It is quite complex and has many of the same structures as a human's: pupils, eyelids, irises, crystalline lenses, and retinas. Although most researchers believe that octopuses cannot see colors, their ability to perceive texture and tone makes their eyesight extremely good, better than that of most fish.

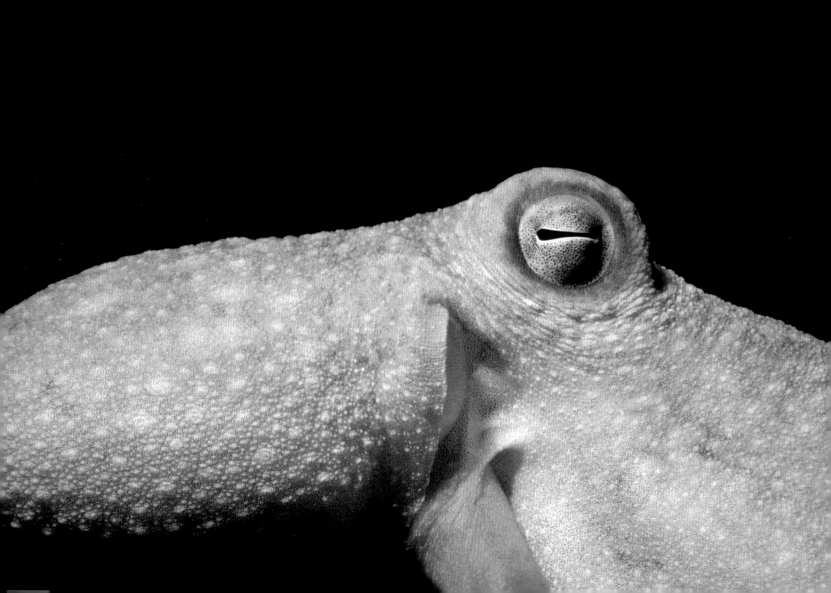

Geography cone shell, Nabek, Sinai Peninsula, Egypt

Cone shells (a misnomer, as they're actually snails) are most active at night. Their beautifully patterned domiciles are prized by collectors but often high-priced, thanks to the danger associated with harvesting them. These are predatory animals that stalk their prey by smell, paralyze them with a venomous harpoon, and then devour them at their leisure. The sting is delivered from the long, tubular appendage extending from its head. Some species carry enough poison to be fatal to humans; others, like the one pictured here, have a sting that is only painful and temporarily debilitating.

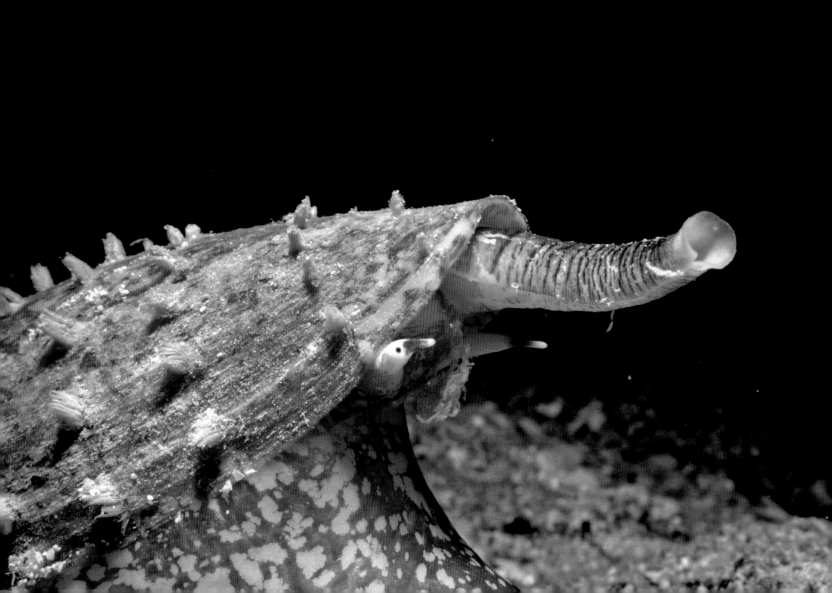

Red-lipped batfish, Malpelo Island, Colombia

I had never before seen more than one batfish at a time, but this juvenile red-lipped batfish (you've got to love the name), about the size of a small egg, was in a group of twenty juveniles spread out over twenty square feet of ocean floor. These fish are disinclined to swim, much preferring to lie on the bottom and hop around on their pectoral fins like lethargic frogs.

Red-lipped batfish, Targus Cove, Galápagos Islands, Ecuador

The Galápagos is full of surprises. This adult batfish, attracted to my light at night, moved up off the ocean bottom and into the water column. I could just make out its scarlet-colored pout and the fleshy horn on its head, which houses an angling appendage.

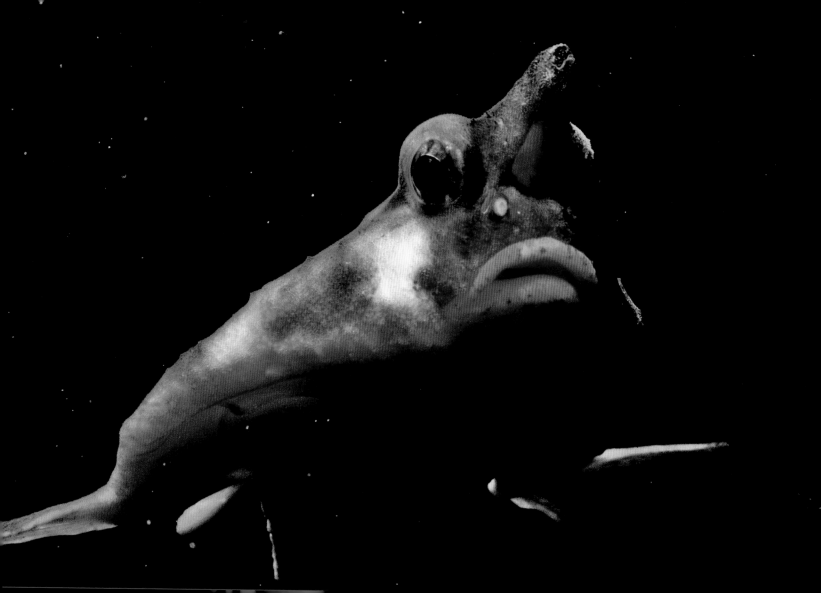

Colonial anemones, Marsa El Muqabila, Sinai Peninsula, Egypt

The stinging cells in these colonial anemones are dangerous only to the planktonic animals on which they feed. Other anemone species, however, like the aggregating anemone, have specialized tentacles used not for gathering food, but for fighting with competing colonies encroaching on their territory. This anemone reproduces by fission, or by producing clones of itself. When it identifies a non-clone, it's wartime. (Turn the book clockwise to view the image in its proper orientation.)

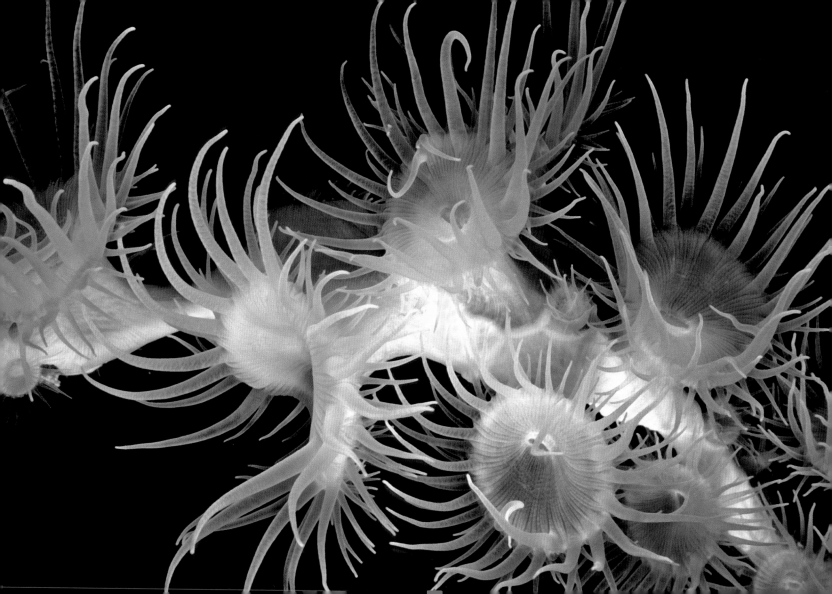

Fire coral, Gordon Reef, Sinai Peninsula, Egypt

Fire coral is not a true coral—it's a hydroid—and it has two types of polyps, which are specialized for either stinging (and, thus, feeding and defending) or reproducing. But like true coral, it depends on zooxanthellae for its energy. Coral can eject its symbiotic algae when it dies from lack of nutrients or when too many nutrients provide for an excess of zooxanthellae. When there's too little, the transparent polyps lose their color, appearing "bleached" like the white half of this fire coral.

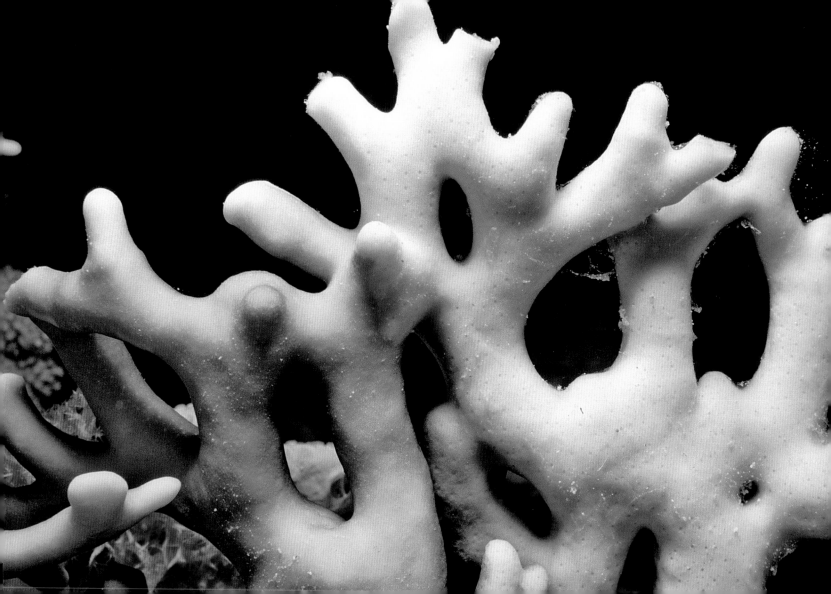

Blue-barred parrotfish, Ras Umm Sid, Sinai Peninsula, Egypt

Fully settled in for the night in a coral nook, this parrotfish has enveloped itself in a mucus cocoon, which prevents its characteristic odor from alerting nocturnal predators to its presence. This sort of protection is especially valuable to fish that sleep as deeply as parrotfish. In the morning, it will take about thirty minutes for the parrotfish to unseal the cocoon and be on its merry way.

321

Gorgonian coral, Ras Umm Sid, Sinai Peninsula, Egypt

The polyps on the sturdy yet flexible branches of this gorgonian coral are closed, which means it isn't feeding. Corals can be a wide array of hues, virtually all the colors of a rainbow, in fact. That is, unless it has died and turned white.

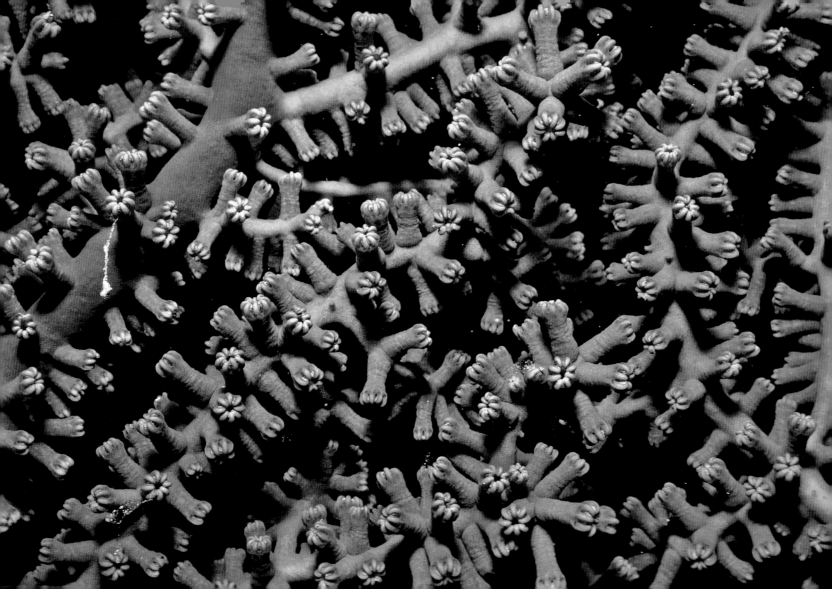

Flatworm, Thomas Reef, Sinai Peninsula, Egypt

Rarely seen by day, scores of these aptly named, paper-thin, half-inch-long flatworms emerge from crevices after dark to graze along the reef surface. They slowly crawl along with the help of a slimy mucus and hundreds of microscopic cilia on their undersides. When dislodged from rocks and corals by currents, flatworms flutter through open water like kites with their strings cut.

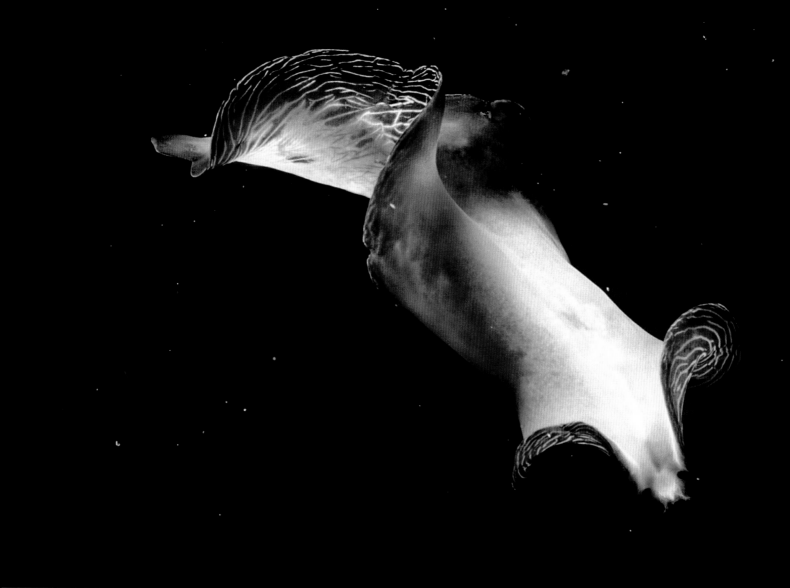

Spotted eagle ray, Natal coast, Durban, South Africa

I came nose to nose with this spotted eagle ray, which is found along tropical coastlines and in muddy bays. It comes inshore daily to feed on buried shellfish, which it excavates by beating its wings near the sandy or muddy bottom, grabbing any dislodged morsels, and crushing them between its strong teeth plates. In open water, this ray can be found schooling near the surface and sometimes even jumping clear out of the water.

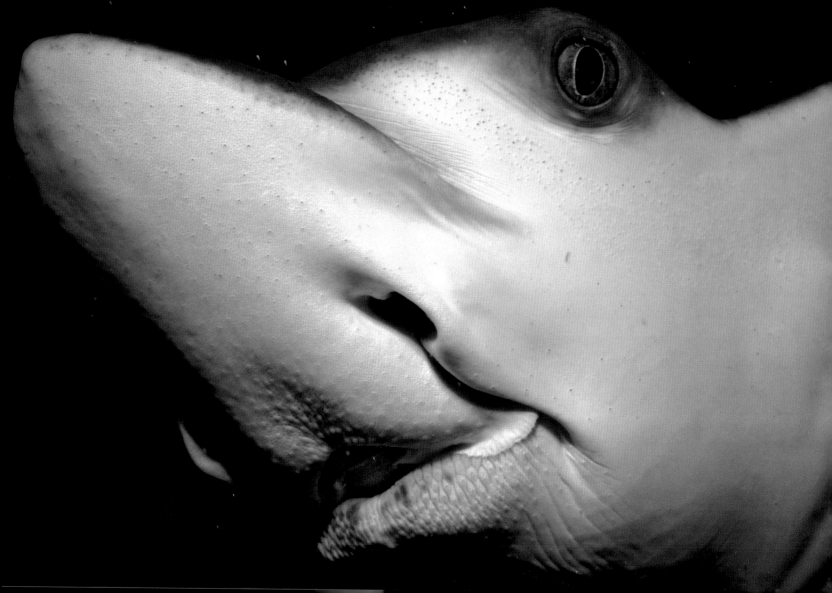

Colony of sea urchins, Isles of Glénan, Brittany, France

There was a small kelp forest in this very location two days before this photograph was taken, but then an army of sea urchins moved in. Like a legion of lawn mowers, they consumed this bed of kelp in no time. Explosions of sea urchin populations occur from time to time. Once their food source has been consumed, they disappear just as mysteriously as they appeared. Some postulate these population booms might be attributable to the decline of the urchins' natural predator, the sea otter.

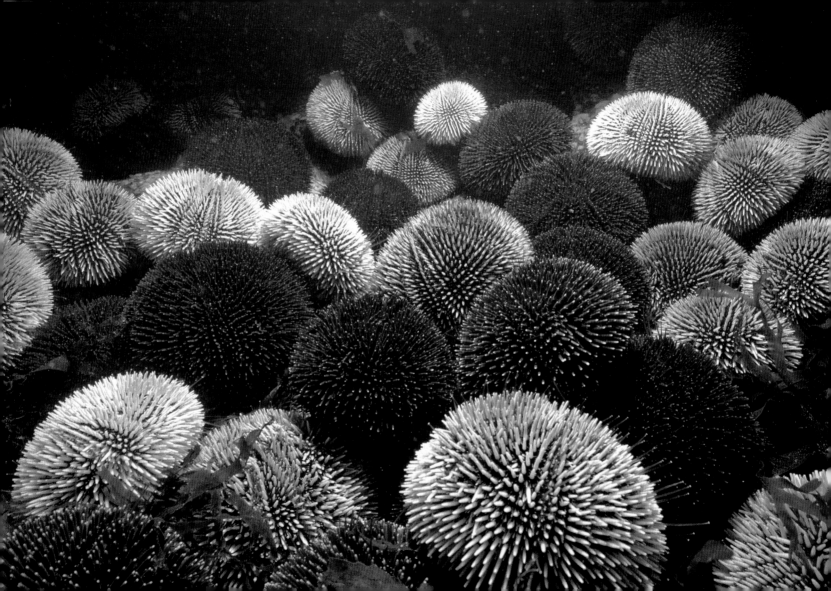

Olive sea snake, Great Barrier Reef, Australia

The ocean is home to only a few reptiles, including sea turtles, marine iguanas, and deadly sea snakes. There are several kinds of sea snakes in tropical oceans, and the venom of some is stronger than a cobra's. Fortunately, they're usually very timid creatures when not provoked, and the hollow fangs with which they inject their poison are far less efficient than those of land snakes.

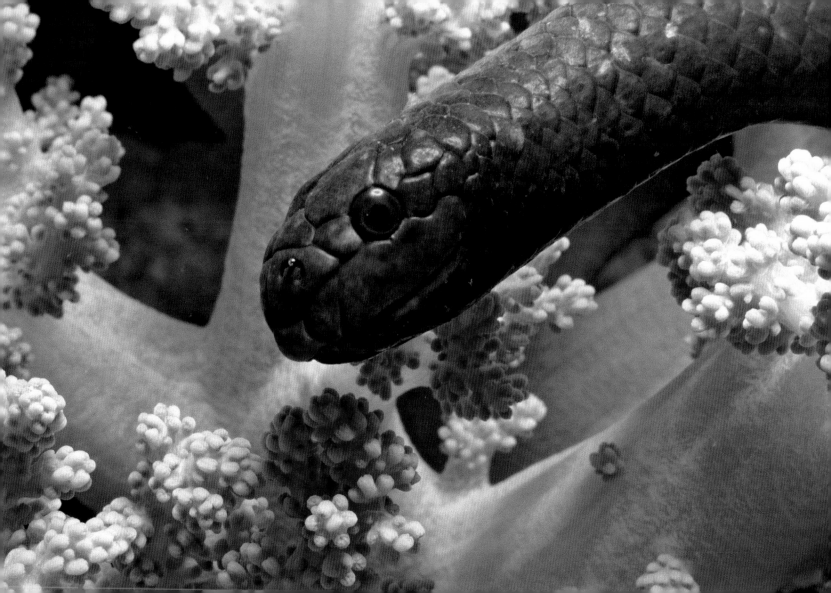

Crocodile fish, Jackson Reef, Sinai Peninsula, Egypt

Camouflaged on a sand and coral bottom, this crocodile fish, no more than twenty-eight inches long, lies in wait to ambush unsuspecting fish and crustaceans that swim by. Its eyes, located strategically on the top of its head, rotate to give it a wide field of view.

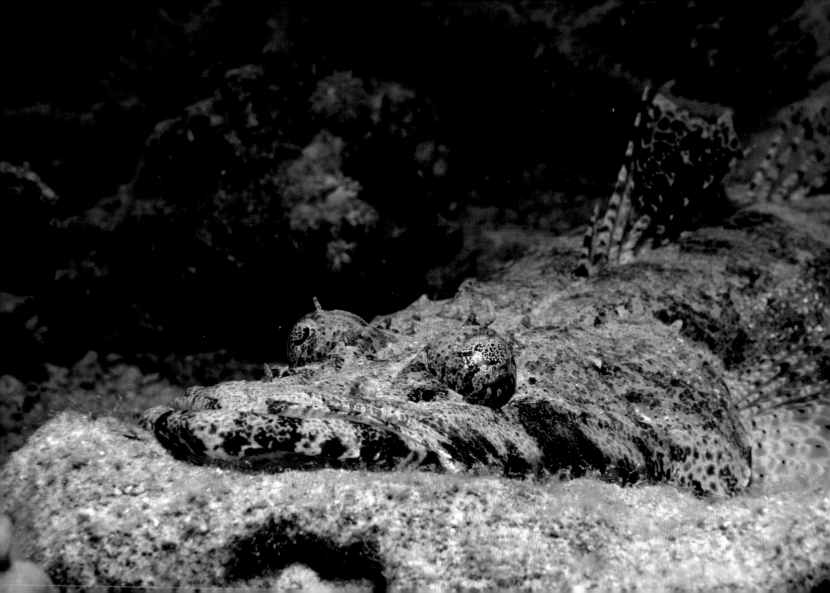

Whitetip reef sharks, Cocos Island, Costa Rica

Whitetip reef sharks are usually found in groups of five or ten, but here at Cocos they can appear in groups larger than a hundred. These numbers might have something to do with the isolation of Cocos; there is no other landmass for hundreds of miles. Or it might be that the recent upsurge in shark fishing for pelagic species has reduced the number of potential predators that feed on the relatively small whitetips.

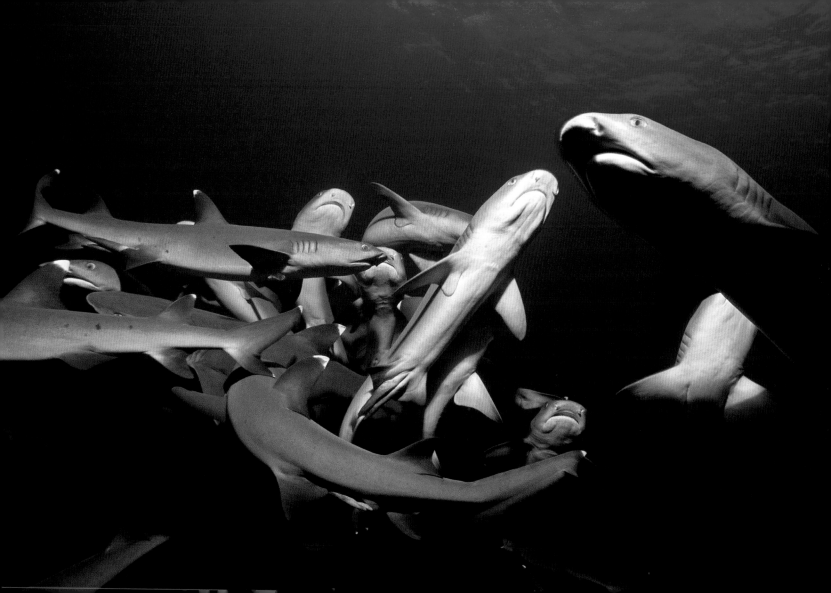

Atlantic rock crabs, Folly Cove, Gloucester, Massachusetts

These Atlantic rock crabs aren't locked in combat; the larger male is holding onto a smaller female that has released a pheromone to attract her suitor. The male will carry her around for weeks in order to mate after she has molted. Females will molt fifteen to twenty times before reaching sexual maturity and mate on their last molt. The female's new shell is soft, leaving her without protection, and the male's behavior protects her until her shell has had time to harden up. Who says chivalry is dead?

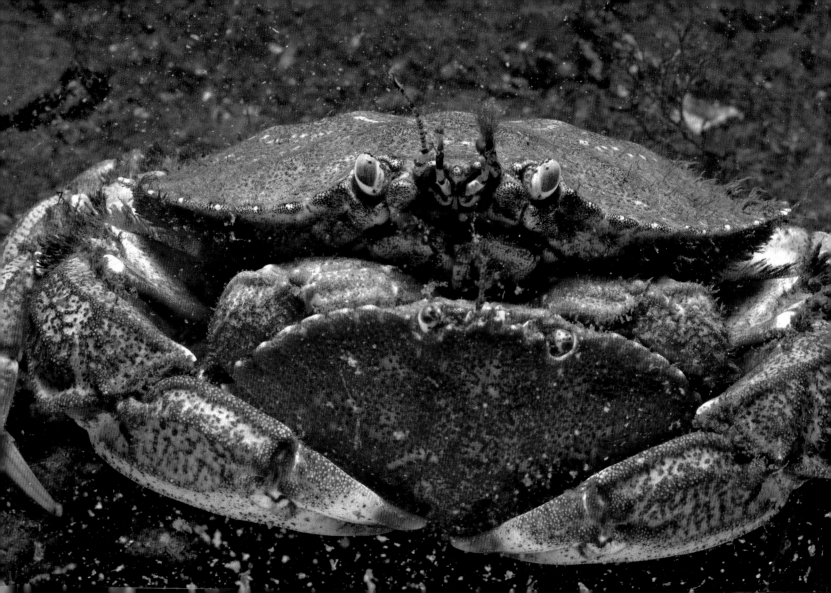

Northern red anemone and a Forbes starfish, Deer Island, Bay of Fundy, Canada

In more than thirty years of diving, I have never seen an anemone eat a starfish—worms, plankton, even fish, yes, but never a starfish. The only explanation I can come up with is that the starfish was somehow dislodged from an overhanging ledge and fell into the open tentacles of this anemone, which reflexively closed around it in an unlikely embrace. When the anemone realizes it cannot digest this meal, it will likely open and release the much relieved starfish.

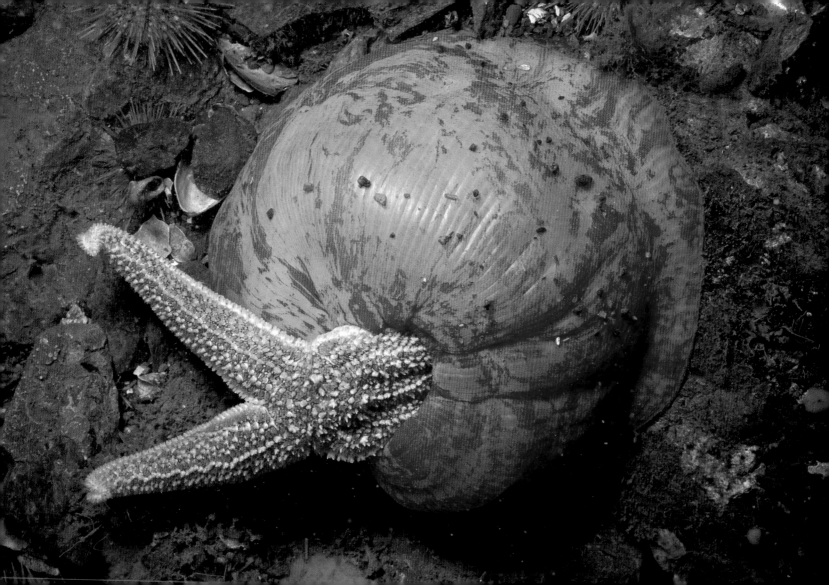

Horseshoe crabs, Cathedral Rocks, Gloucester, Massachusetts

During the spring mating season, it is not uncommon to see a female horseshoe crab with a smaller male in tow. The males escort the females, who carry about 88,000 eggs, to the beach for spawning, before clasping onto them. A living fossil, the horseshoe crab predates most living species, having survived, nearly unchanged, through six hundred million years of evolution. These animals are actually misnamed; they are closer relatives of spiders than of crabs.

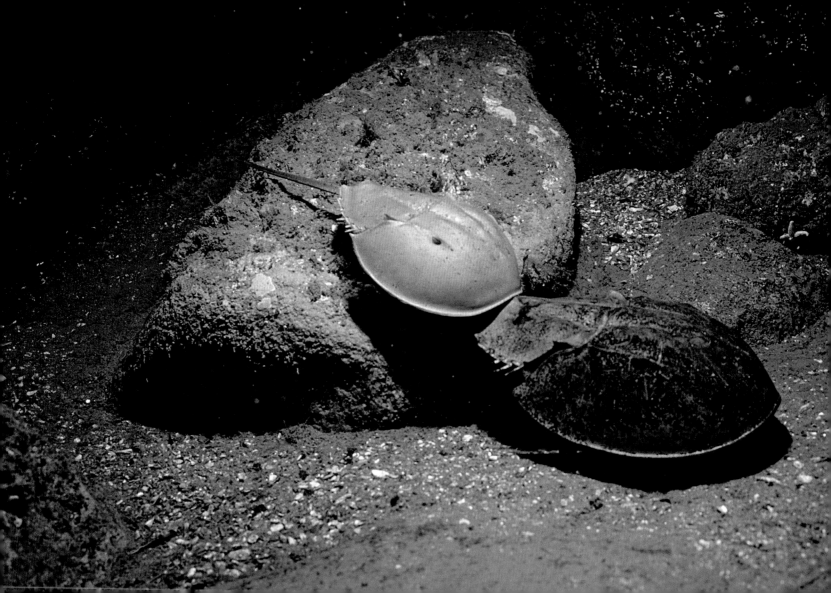

331

Northern sea star, Pemaquid Point, Maine

Born survivors, this northern sea star is in the process of replacing three of its five appendages. While all should grow back to their former length, the more arms that are lost, the slower the process of regeneration. Smaller arms may be less efficient at gathering food, leaving the starfish with less energy for regrowth. However, some species of sea stars are, amazingly, able to regenerate an entire body from a single severed arm.

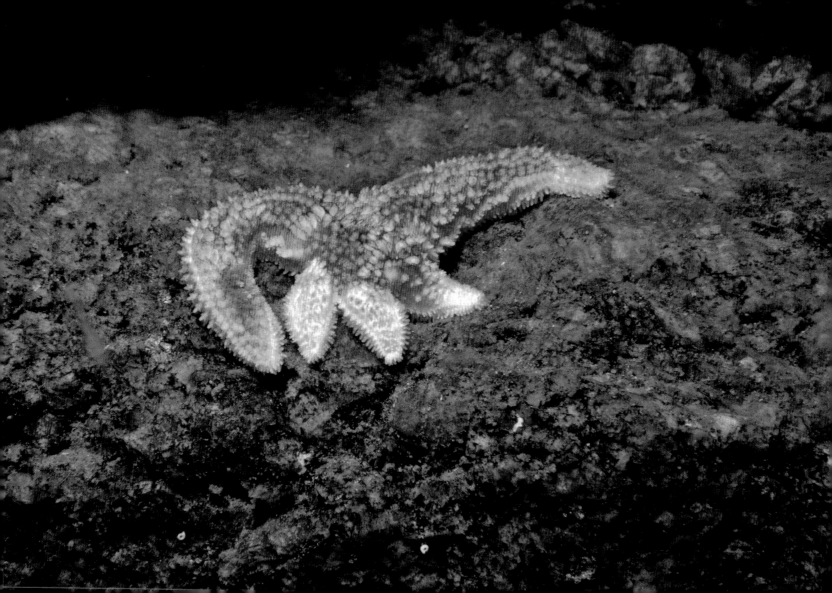

Green crabs scavenging a dead pollack, Hodgkins Cove, Gloucester, Massachusetts

Nothing goes to waste in the sea. A large part of the food chain is scavenging. Scientists have discovered that sea scavengers rely on locating dead food sources by taste, smell, and even sound: the noise of a dead animal hitting the sea floor creates sound waves in the water that alert scavengers even hundreds of feet away. This dead pollack will attract and feed lots of crabs and other scavengers during the next week, after which even its bones will have disappeared.

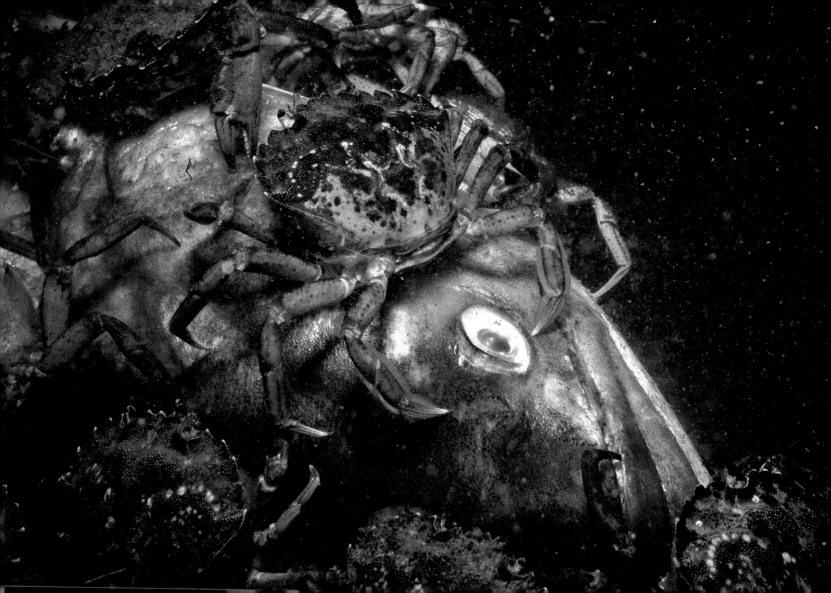

333

Juvenile pelagic fish, Straits of Tiran, Sinai Peninsula, Egypt

Many fish spend at least part of their lives as larvae and juveniles, drifting, feeding, and being fed upon as members of the plankton community before taking up life in their normal adult habitats. This juvenile fish was just an inch long. In order to photograph animals like this, I suspend two two-thousand-watt lamps from the side of my boat in open ocean on a moonless night. This artificial moon attracts and illuminates all sorts of curious life, the larger always feeding on the smaller.

Deep-sea barracuda, Gulf of Eilat, Israel

A friend once told me about a remarkable fish he found at depths of more than half a mile in the middle of the Red Sea. Since I had a few extra days on my hands, I decided to investigate, and this is what I saw. Most barracuda are inshore fish, but there appears to be this deep-water species as well. This fish measured close to three feet in length—the largest ever caught is five and a half feet! Its three long fangs hint that this specimen has made some adaptations to deep-sea living.

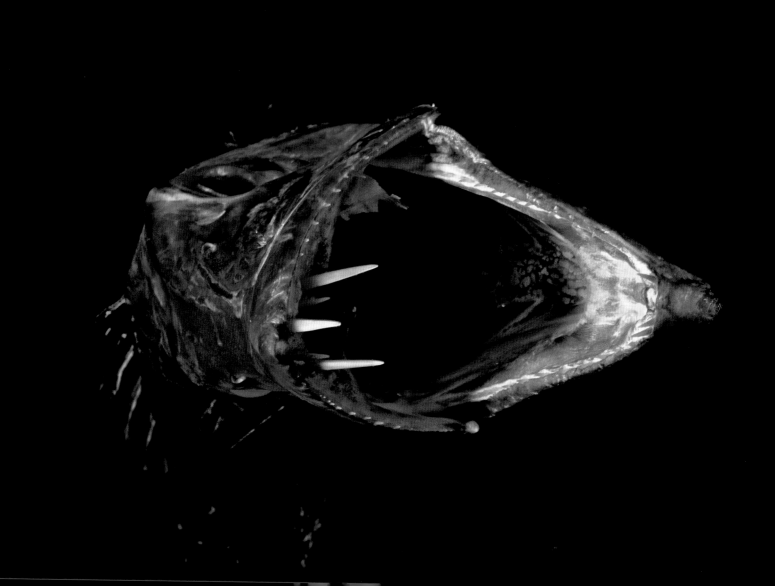

Pelagic octopus, Straits of Tiran, Sinai Peninsula, Egypt

On a moonless night while drifting in what felt like the bottomless sea, I was seduced by the beauty of this octopus, a full-grown adult the size of my fist. Octopuses live in nearly every ocean of the world, although more varieties live in warm waters. Some species are found right next to the shoreline, while others live in permanent darkness hundreds of feet down. Most live brief lives, about one to two years. Even the giant Pacific octopus lives for only three or four years.

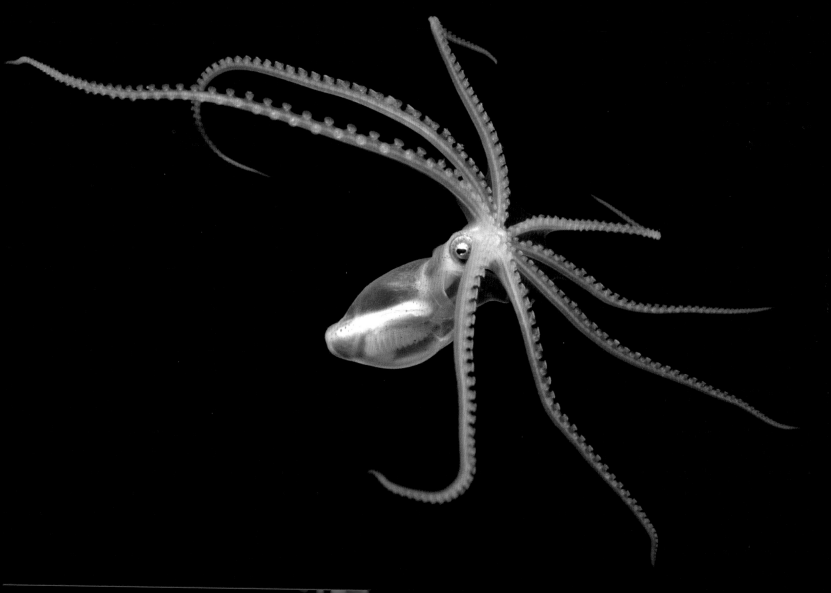

Pelagic shrimp, Straits of Tiran, Sinai Peninsula, Egypt

A pelagic shrimp drifts as part of the planktonic community on a moonless night. This organism falls under the category of zooplankton, microscopic invertebrates that helplessly drift in the water column and survive by feeding on other plankton. Functionally, this makes them consumer plankton, as opposed to producer phytoplankton, or recycler bacterioplankton, all of which play a crucial role in the health of the oceans.

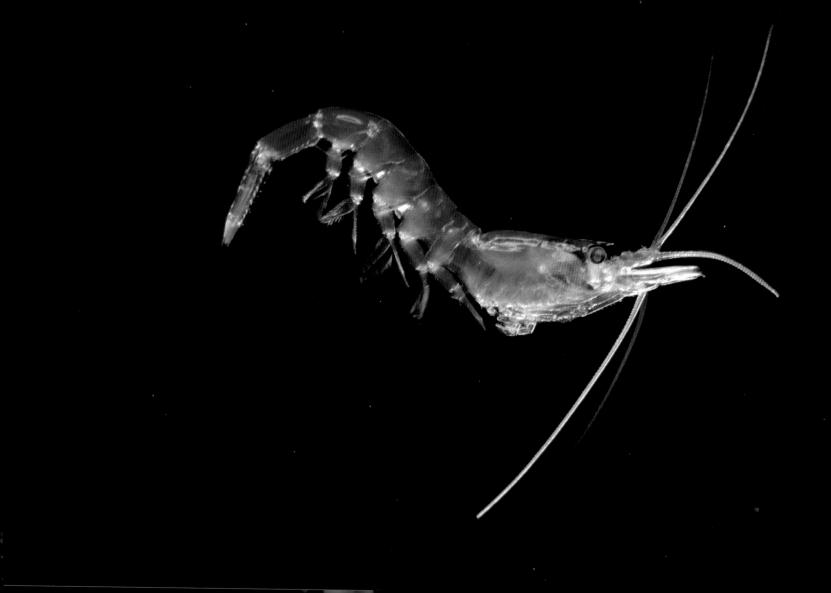

Pelagic squid, Straits of Tiran, Sinai Peninsula, Egypt

Dropping down to seventy feet in open sea at night, I spotted this pelagic squid (an animal many diners are familiar with as calamari). Squid, like their octopus cousins, can change color. This fellow is also bioluminescent, which means it can emit a glowing light from within. Light-producing organs called photophores make two chemicals. When these chemicals mix together they release a pale, blue-green light.

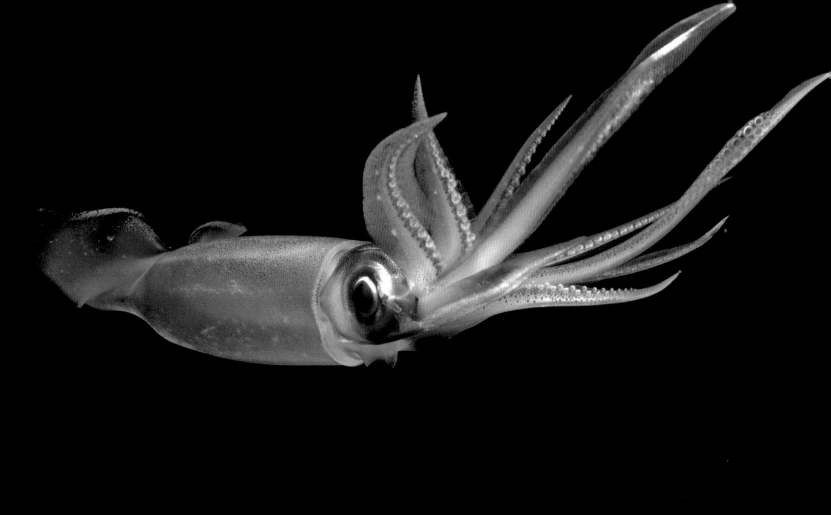

Deep-sea pelagic eel, Straits of Tiran, Sinai Peninsula, Egypt

"What is this?!" I thought, when I found this creature drifting in open sea at two o'clock in the morning. This type of posture—the animal curling its head toward its caudal end—seems defensive. This could be a new species, perhaps of the family anguilliformes, or eels. This was either a drifter or a nocturnal migrator, some of which travel more than half a mile vertically toward the surface at night.

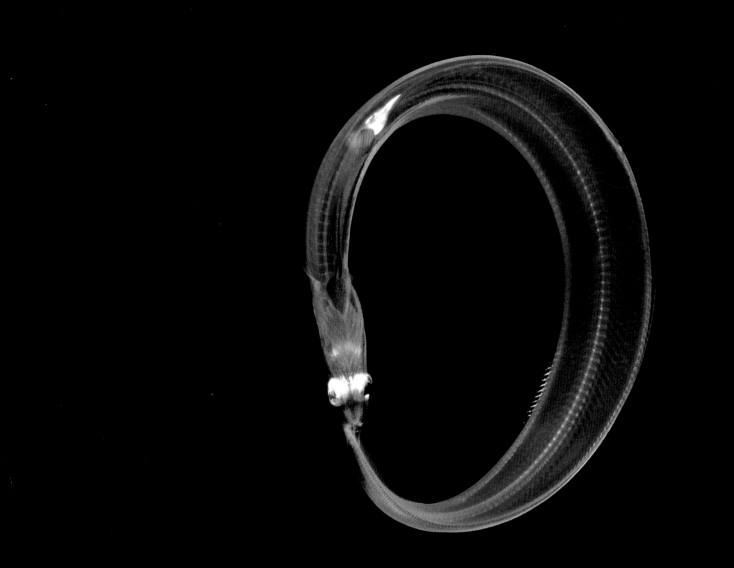

Comb jelly, Ras Mohammed, Sinai Peninsula, Egypt

Slightly longer than an inch, this comb jelly is a delicate, gelatinous kind of zooplankton. So delicate, in fact, that if you touch it, the jelly may very well break apart. Its luminescent glow is light diffracted by the beating of the eight, tiny, comblike plates that propel it through the water. While comb jellies may look beautiful, they are ruthless predators, preying upon even their own kind.

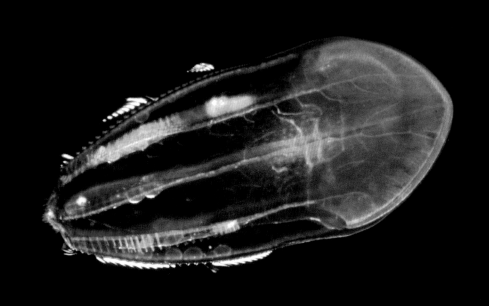

Many-ribbed hydromedusa, Puget Sound, Washington

Little more than a baggy of water, only slightly more organized, this jellyfish is two inches in diameter, and it propels itself through the water with rhythmic pulsations of its transparent bell. This jelly is actually the medusa, or sexual stage, in the life cycle of a hydroid. The medusa first formed as a bud growing out from a polyp, which it separated from; it will soon reproduce, its larvae growing into new polyps.

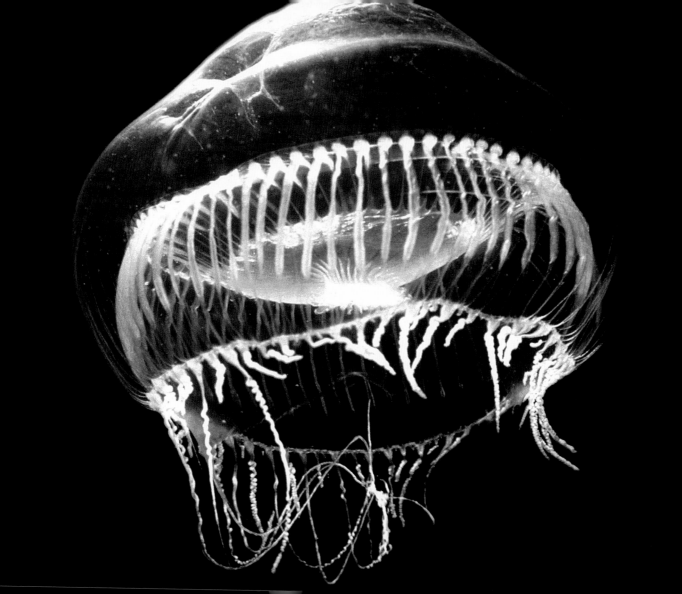

Scalefin anthias, Jackson Reef, Sinai Peninsula, Egypt

Huge swarms of these zooplankton-feeding fish are characteristic on Red Sea coral reefs. The orange ones pictured here are females. Males maintain large harems, and if you remove a male from this group, the dominant female will undergo a sex change to assume the male role.

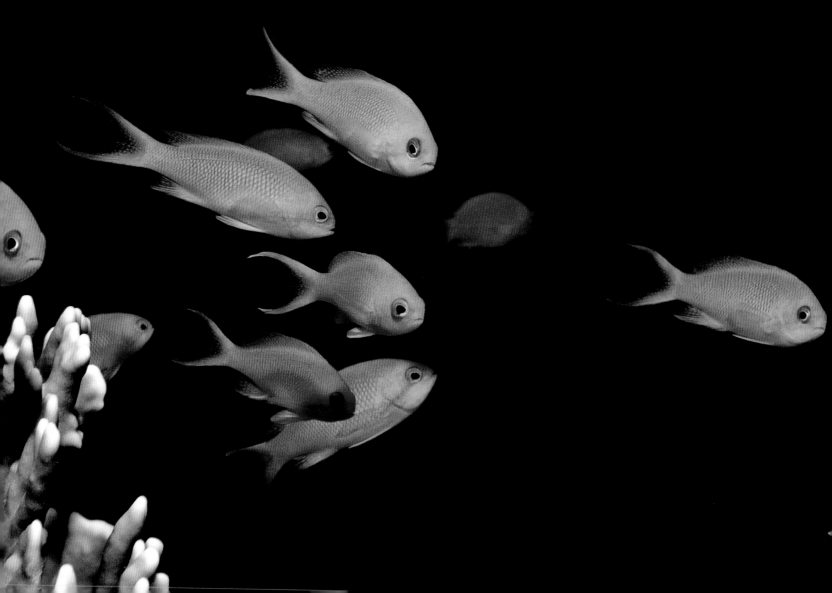

Giant manta ray, Socorro Islands, Mexico

Near the Socorro Islands, more than three hundred miles off the coast of Cabo San Lucas, humans and mantas have developed a kind of relationship. Primarily plankton feeders with no stinger in their tails, this largest of rays is no harm to humans. The giant rays will actually approach divers, allowing them to climb onboard as you see here. This free diver received the ride of a lifetime, whisked through the blue on a magic carpet more than sixty feet beneath the water's surface.

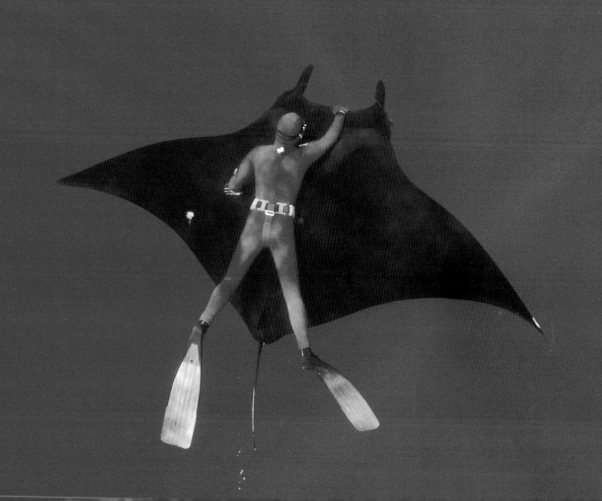

Caribbean reef sharks, Freeport, Grand Bahama Island

The Caribbean reef shark is the star of many shark-feeding demonstrations staged for tourists. After receiving instructions to keep their hands to themselves, scuba divers seeking a once-in-a-lifetime experience are seated on the ocean floor at a depth of forty feet. The shark feeder arrives shortly after with a container filled with fish he or she passes out to sharks eagerly awaiting their free meal. Of course, this may not be the smartest practice. While not particularly aggressive, Caribbean reef sharks have been known to attack divers, especially when bait or speared fish are involved.

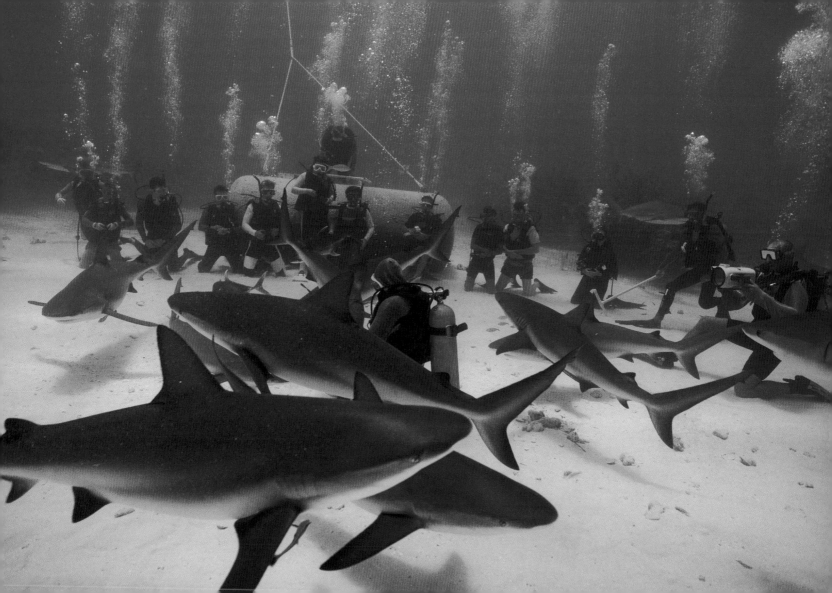

Gorgonian and alcyonarian corals, Ras Umm Sid, Sinai Peninsula, Egypt

As you descend the almost vertical wall of an eighty-foot coral ledge along the Ras Umm Sid dive site, coral gardens that defy description surround you. When the current is moving and the coral polyps are open and feeding, this underwater eden is in bloom.

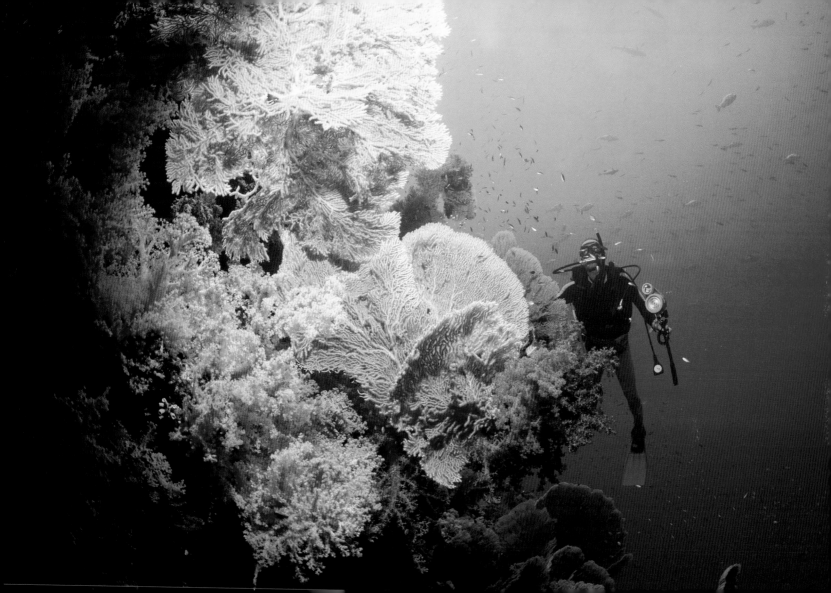

345

Great white shark, Dangerous Reef, South Australia

Today, the great white shark is widely protected, but once a victim of bad press, it was mercilessly hunted in the '70s and '80s. A major problem with this is that great whites reproduce slowly, not reaching sexual maturity until they are at least ten to twelve years old. And, like other sharks, great whites may have only one litter every two years, each litter containing only a few pups. With increased regulation, the population seems to be making a slow comeback, but great whites still need our protection.

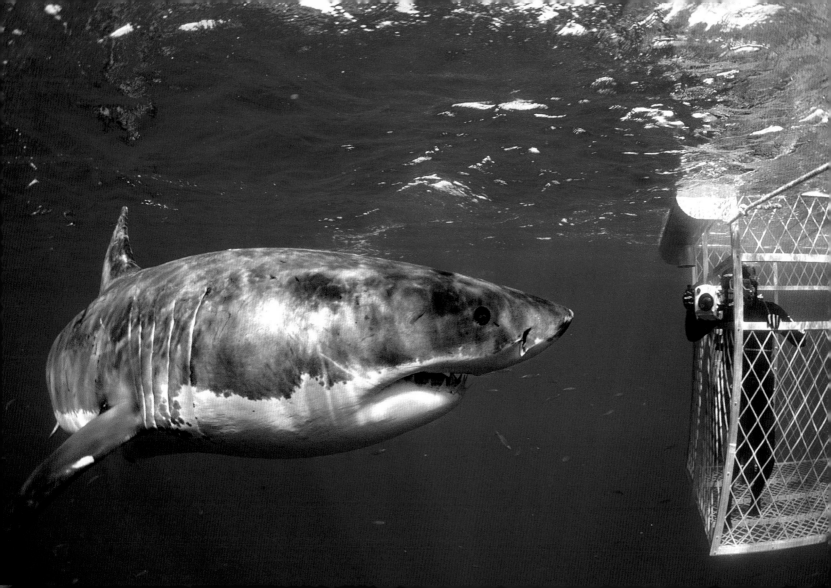

Lior's Garden, Tiran Island, Egypt

After diving the waters surrounding Tiran Island for more than thirty years, I discovered this new dive sight. The coral structure can only be described as fantastic, the depth—not more than sixty feet—is perfect for both scuba and free diving, and the marine life is varied and virtually untouched. Last summer I took my favorite model and diving partner, my fifteen-year-old son Adam. It was difficult getting him out of the water, but when I did, he too was at a loss for words. Pristine reefs have become few and far between. It's up to us to ensure that such reefs will still be here to awe future generations.

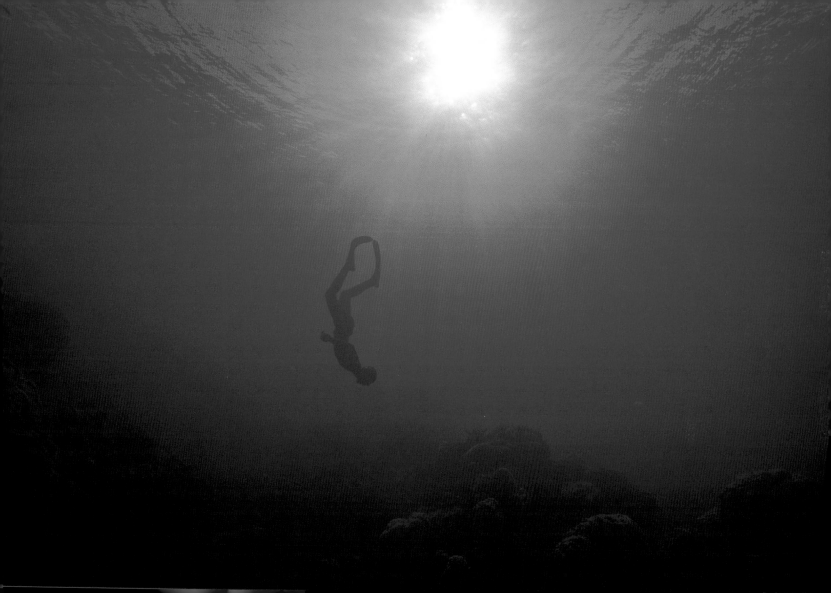

Plate coral, Kimbe Bay, Papua New Guinea

Looking for all the world like a bed of lettuce, plate corals often live in deeper water than many corals. They fan out like satellite dishes to capture the stray rays of sunshine that penetrate the depths. The area of ocean where sunlight can reach, from the surface down, is called the photic zone. Different wavelengths of light, or color, are filtered out as the water deepens. Under ideal conditions, at about three hundred feet, photosynthetic plants and animals can no longer survive. At three thousand feet, there is no light whatsoever. It's a pretty desolate place.

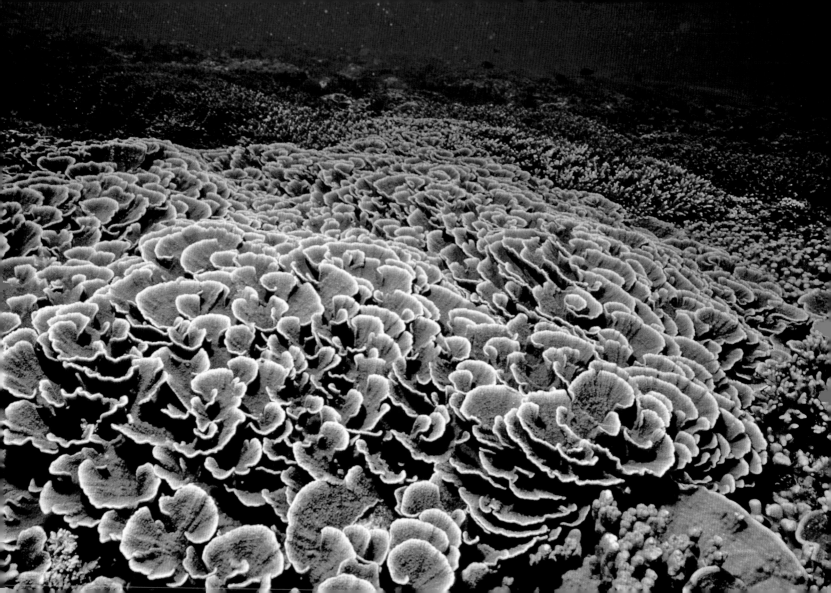

Yellow lettuce coral, Ras Umm Sid, Sinai Peninsula, Egypt

In the Red Sea, beneath the water's surface, where bedrock plunges vertically into the depths, fringing reefs made of corals of all sizes, colors, textures, and shapes cover every inch of exposed rock. The conditions here are ideal for coral growth: The water is warm and clear, due to the fact that there are just enough nutrients and algae to feed reef life without blocking sunlight.

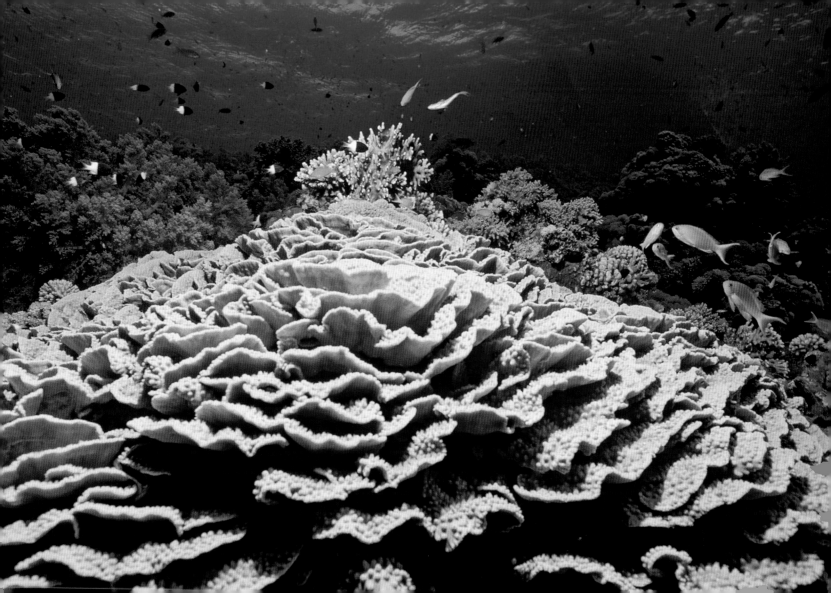

Reef table, Brothers Islands, Egypt

Corals grow in colonies or clumps, their shape determined both by the type of coral and the depth at which they grow. Rounder, smoother corals have seen more wave action, while branched or whiplike corals live in calmer, deeper waters. Their names conjure up vivid images of the variety of shapes on the reef: finger coral, brain coral, cabbage coral, cactus coral, elkhorn coral, and staghorn coral, to name but a few.

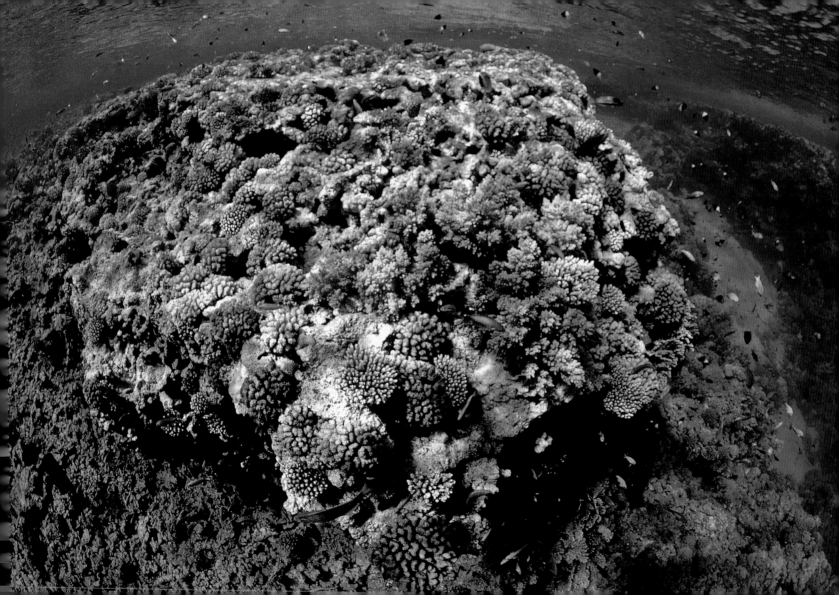

Pajama nudibranch, Ras Abu Galoum, Sinai Peninsula, Egypt

It's quite common in the northern Red Sea and easy to find this jewel of a nudibranch if you know where to look. It's usually found grazing on its favorite food source, sponges, especially a red one known as a red finger sponge. Whenever I see that sponge, I stop to look for pajama nudibranchs. The specimen pictured here is moving through a field of gorgonian coral, possibly eating the sponges found in association with the coral. The bright coloration of nudibranchs is protective, thought to warn potential predators of their unpleasant taste.

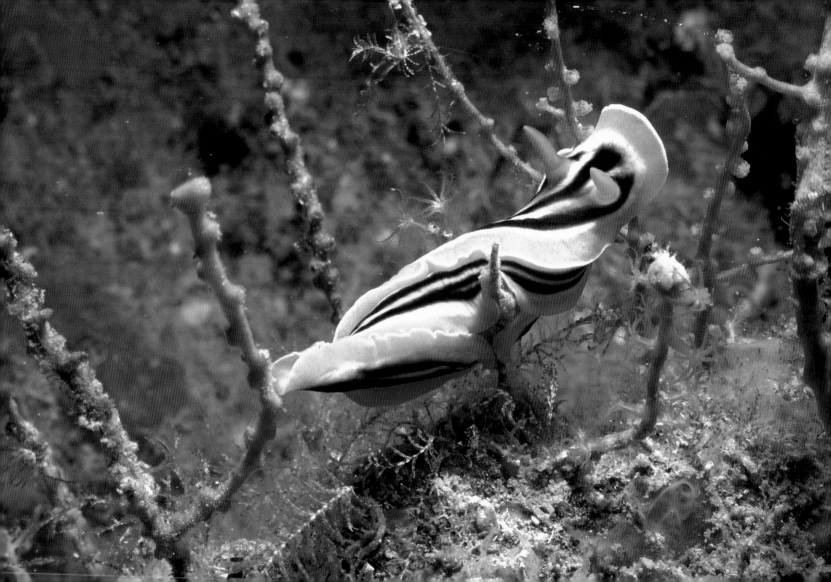

351

Triggerfish, Cocos Island, Costa Rica

At Cocos Island there are strong currents and, at times, powerful wave surges that can suck divers in and toss them against the volcanic outcrops. However, for this triggerfish, coursing through currents and waves is like flying through the clouds, and the nutrients they carry keep both the triggerfish—and his prey—well fed. For divers, it's a double-edged sword: Sometimes the most dangerous sites have the most interesting sights.

Sandy lagoon, Tiran Island, Egypt

At first glance this shallow, sandy lagoon looks practically featureless, but a closer inspection will reveal an entire community of tiny invertebrates and sand-loving fish. Well-camouflaged lizardfish are everywhere; amphipods and copepods the size of a pencil eraser scurry about; and sand mounds periodically erupt, spewing out sand. Nurse and leopard sharks love such an environment and stingrays might consider it paradise on earth. It's not as quiet and peaceful as it seems on first glance.

353

Green jacks, Socorro Islands, Mexico

As the day draws to a close, these diurnal green jacks are looking to corner one last meal, a school of baitfish. However, they cannot let down their guard—there are yellowfin tuna in these waters that love to dine on jacks. From our view at the top of the food chain, humans may find it hard to imagine what it's like to live in constant look-out for predators. You understand why many fish seem to have eyes in the back of their heads—and some actually do!

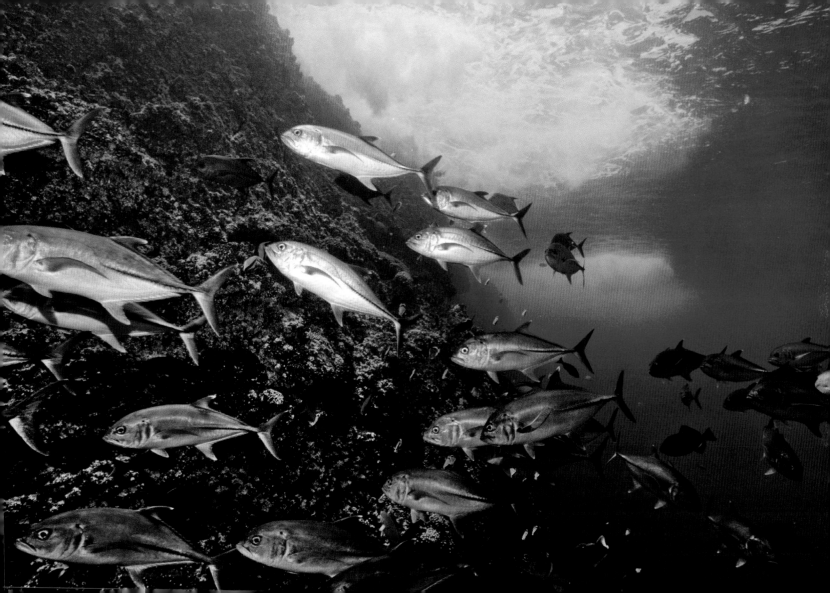

Reef table, Brothers Islands, Egypt

Because of the recent upsurge in popularity of diving the Red Sea and increased development along the surrounding coasts, it is becoming increasingly difficult to find untouched reefs in pristine condition. The Brothers, two small islands located in the middle of the Red Sea, is still such a place. Remoteness has its advantages.

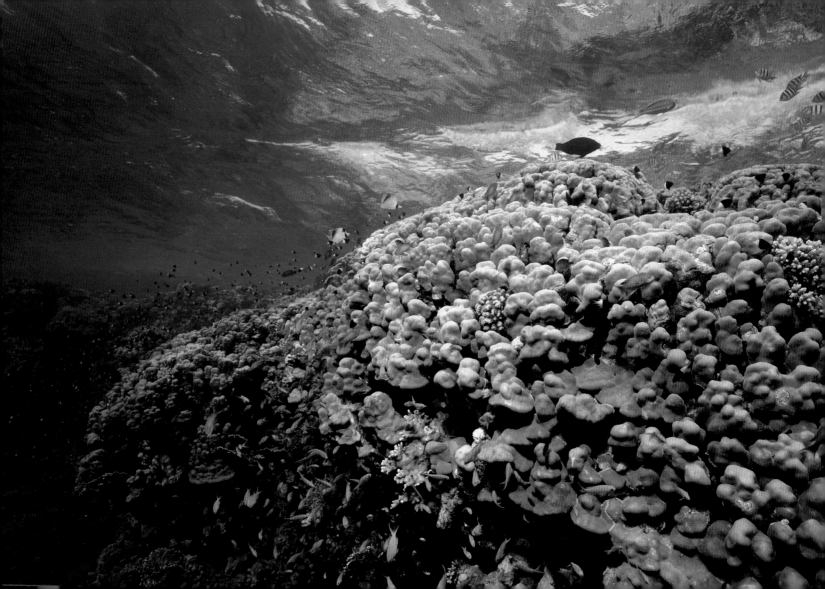

355

Reef table, Brothers Islands, Egypt

I first visited the Brothers in 1982. Thanks to crazy currents, this dive site is truly wild. On one dive, I had been in the water not more than a minute before a whitetip reef shark streaked by chasing a surgeonfish that had darted between my legs. I didn't realize exactly what had happened until my assistant, who couldn't stop laughing, told me back in the boat.

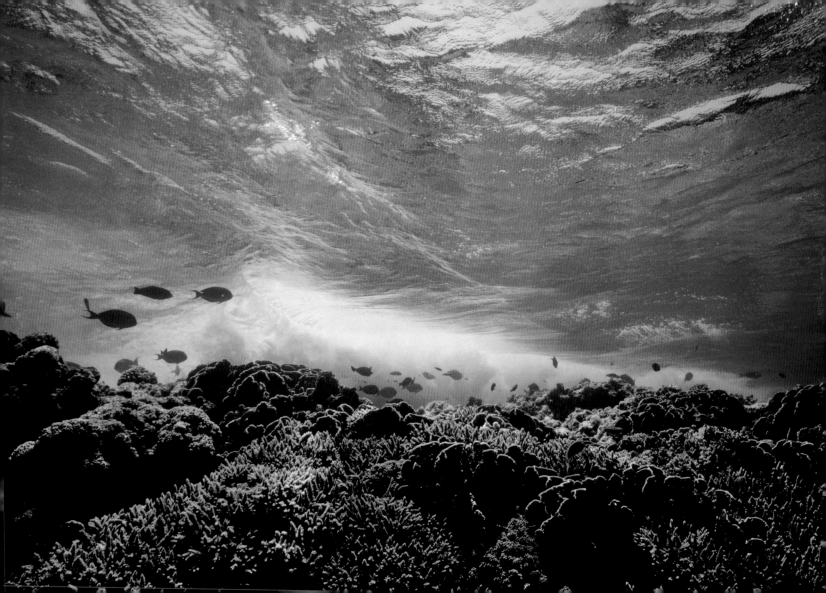

Bottlenose dolphin, Nuweiba, Sinai Peninsula, Egypt

Some species of dolphins migrate seasonally in search of more welcoming habitats with greater food supplies. Migration is more common and tends toward farther distances for species living in temperate waters: When the water temperature drops, they head south. With torpedo-shaped bodies, dolphins can move quite fast, up to seventeen miles an hour. They normally travel close to the surface, as they must come up for air, which they breathe through their blowholes. This is why we often see them skimming through the water just beneath the surface and leaping out of it altogether.

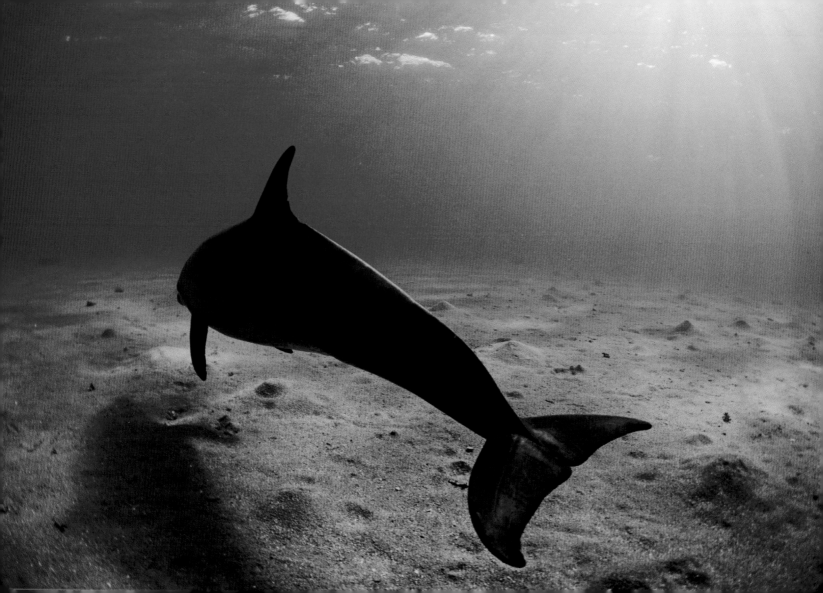

357

Great white shark, Dangerous Reef, South Australia

People often ask me what it's like to work with sharks. As far as I'm concerned, the best antishark device I have ever come across is an underwater photographer with a camera full of film. Sharks are generally cautious fish and tough to locate, even without all the bells and whistles divers wear and the constant stream of air escaping from our breathing regulators. Truth be told, these fish actually seem intimidated by divers, so we have to tempt them with blood, fish oil, meat, and tuna.

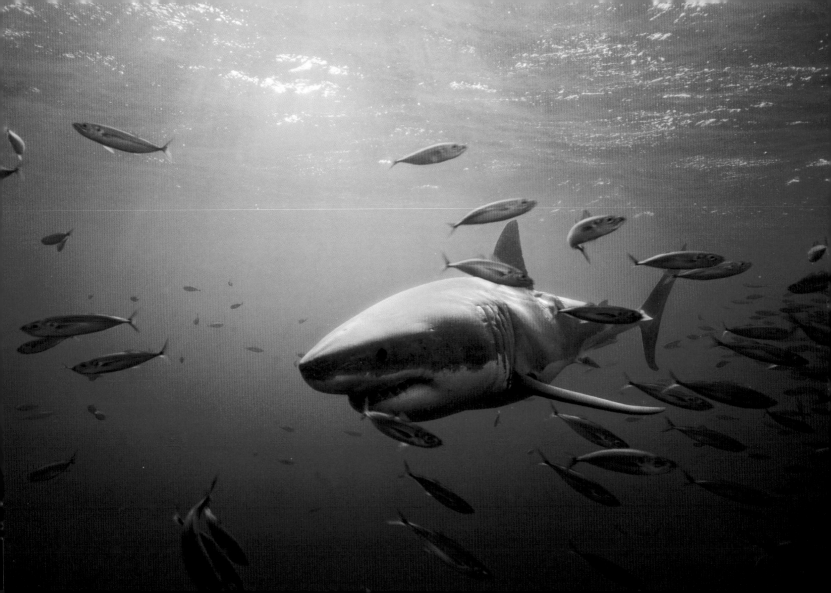

Giant gorgonian sea fan, Ras Mohammed, Sinai Peninsula, Egypt

Giant sea fans like this one, measuring seven feet across, can live to one hundred years old. They provide shelter to the anthias that school around them. Anthias are found in every tropical sea, sometimes swarming in the thousands. The first species was identified in 1758 by Carl von Linné.

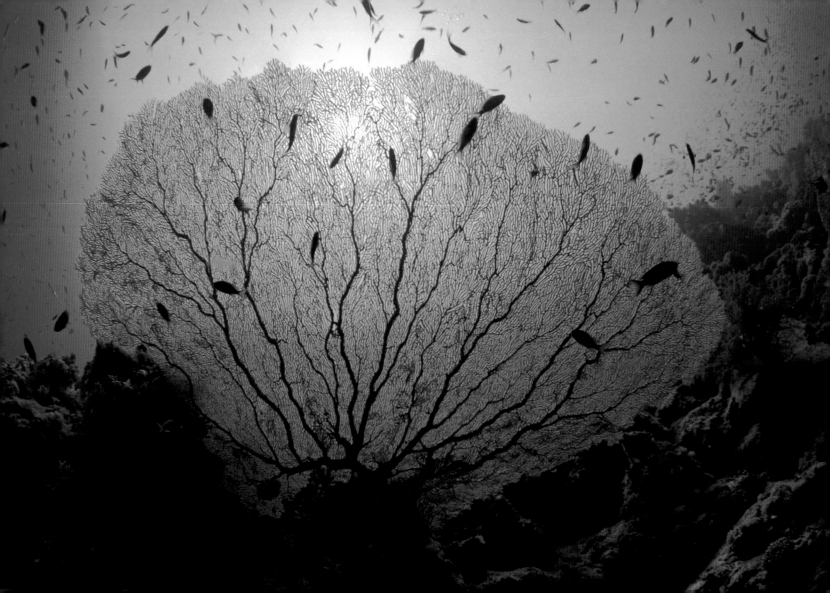

Reef table, Brothers Islands, Egypt

Coral reefs, formed when hard corals lay down skeletons of calcium carbonate, grow in the general shapes of massive boulders, tiny fingers, and huge branching plates. They grow at an extremely slow rate, probably not more than one half to four inches a year depending on variables such as species, temperature, and salinity. This reef table was in shallow water, only sixteen feet deep and beckoning to me.

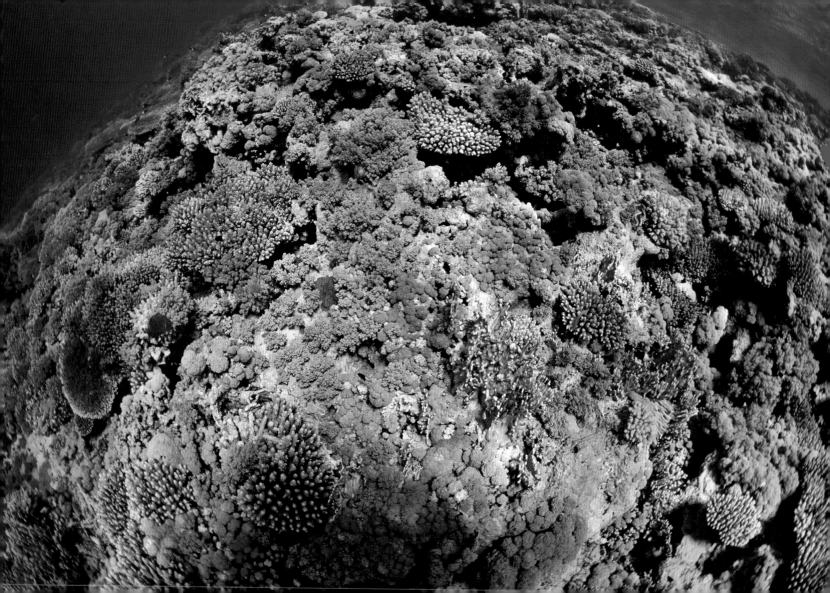

Bottlenose dolphins (mother and calf), Nuweiba, Sinai Peninsula, Egypt

After twelve months developing inside its mother's womb, a baby dolphin is born tailfirst, so that its blowhole comes out last. The mother then pushes the newborn calf to the surface for its first breath of air. The baby may nurse for up to two years, although it begins to capture and play with fish beginning around four to six months of age. It will follow its mother in a group called a pod, consisting of up to a dozen individual dolphins, usually females and their calves or juveniles of both sexes. Adult males live in small groups or pairs, occasionally joining up with the females. Sometimes pods come together to form temporary herds of up to a thousand.

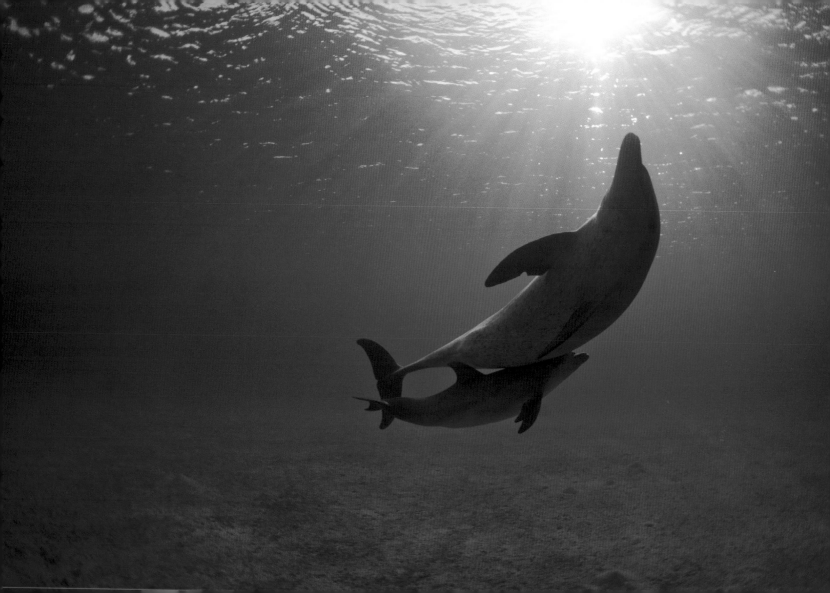

Scalefin anthias, Brothers Islands, Egypt

A school of scalefin anthias hovers close to the reef as the sun begins to set. Within half an hour, every one of these diurnal fish will have hidden themselves in the recesses of this coral, as they prepare to rest through the night. Fish can have pretty specific bedtimes, turning in at almost the exact same time every night, or day.

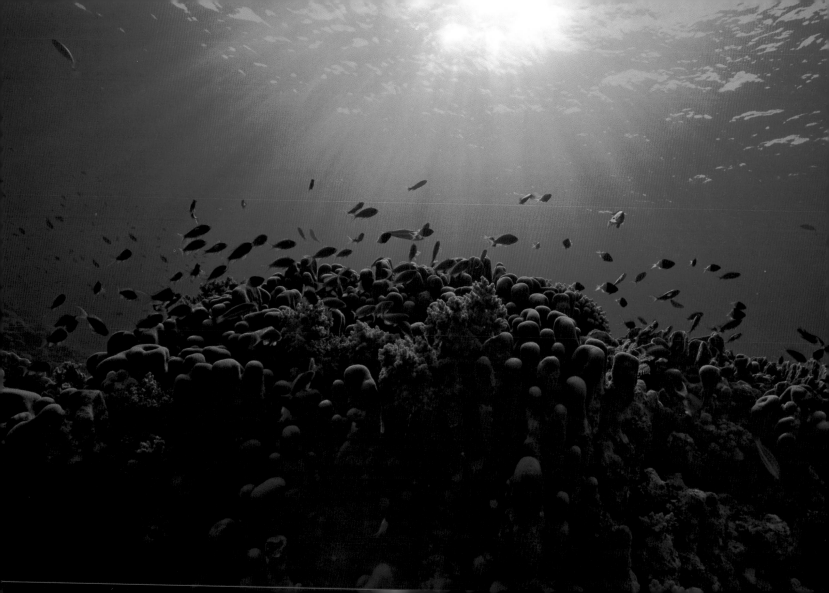

Sandy lagoon, Jackson Reef, Sinai Peninsula, Egypt

One of my favorite spots for snorkeling is this sandy lagoon off the northernmost reef in the Straits of Tiran. The depth is only six feet at high tide, and the lagoon is full of surprises. Here I have seen scorpionfish, stonefish, lionfish, surgeonfish, blue-spotted stingrays, trumpetfish, needlefish, rainbow wrasses, electric torpedo rays, whitetip reef sharks, crocodile fish, and the occasional human being.

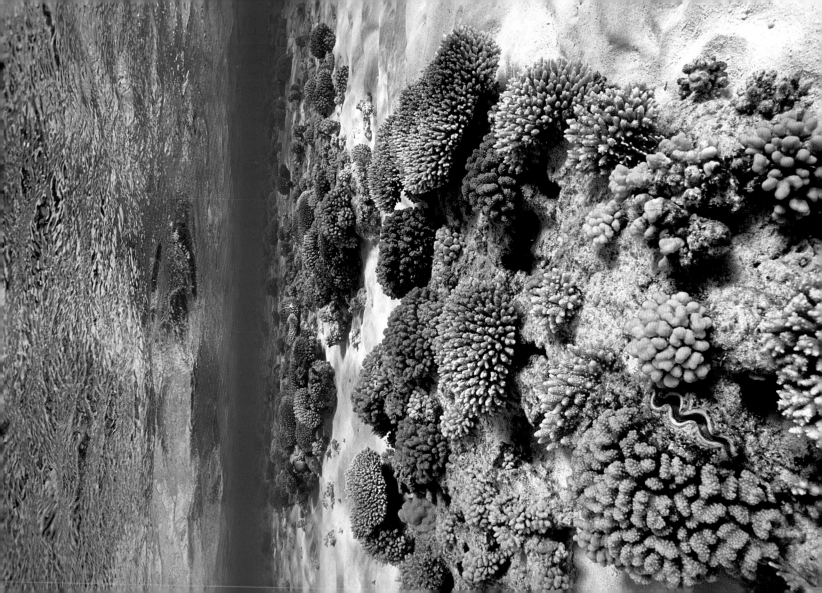

363

Scalefin anthias, Jackson Reef, Sinai Peninsula, Egypt

This is what a classic Red Sea reef looks like at a depth of twenty-six feet: schools of scalefin anthias and a variety of hard and soft corals. Scientists estimate that in some parts of the world, there can be as many species of fish per two acres of coral reef as there are species of birds in North America—that's more than two thousand.

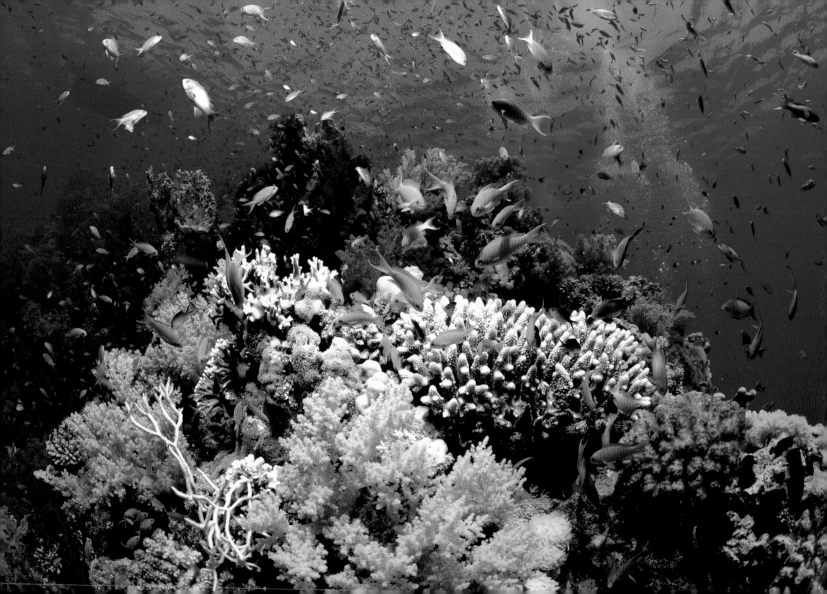

364

Cave entrance, Ras Mohammed, Sinai Peninsula, Egypt

The Red Sea formed as an inlet of the Indian Ocean when the Arabian Peninsula split from Africa due to prehistoric continental drift. It's still widening even today. One hallmark of the northern Red Sea reefs is shallow caves. When swimming past entrances like this one, it is almost impossible to resist a peek inside.

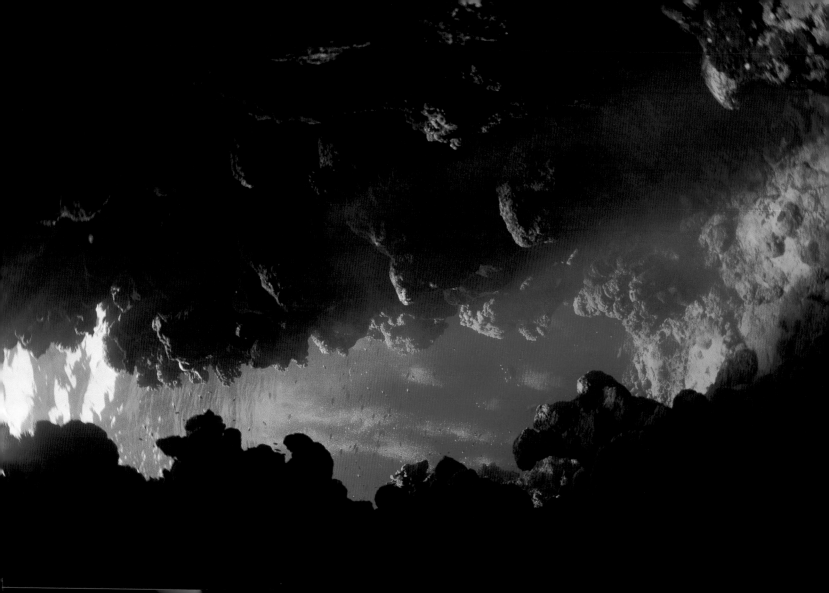

Fringing reef, Palau Islands, Micronesia

Earth is currently in the throes of a biological upheaval unprecedented in the entire history of life on this planet, as human-caused disturbances force animal and plant species into extinction at an ever-increasing rate. Reefs in at least twenty countries—from the United States to Mexico, Indonesia, Japan, and Australia—are in trouble. If we continue with the course we are on, the photographs of *Underwater Eden* will be all that's left of the magnificent reefs and undersea life that populate our planet. They're here today, but will they still be here tomorrow? It's up to us.

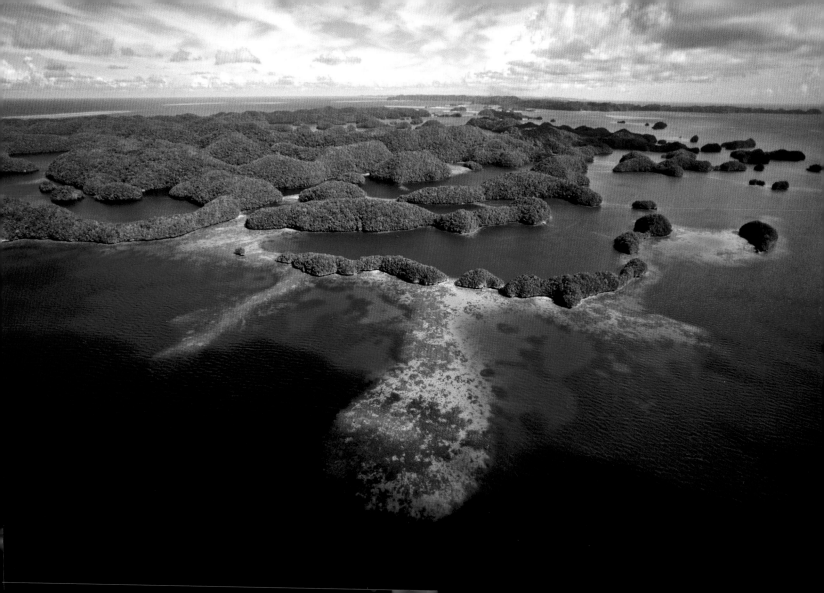

Adult Titles

Cousteau, Jacques. *The Ocean World.* New York: Harry N. Abrams, 1979.

Ellis, Richard, and John E. McCosker. *Great White Shark.* New York: HarperCollins Publishers, 1991.

Humann, Paul, and Ned Deloach. *Reef Creature Identification: Florida, Caribbean, Bahamas.* Jacksonville, Fla.: New World Publications, 1990.

———. *Reef Fish Behavior: Florida, Caribbean, Bahamas.* Jacksonville, Fla.: New World Publications, 1999.

———. *Reef Fish Identification: Florida, Caribbean, Bahamas.* Jacksonville, Fla.: New World Publications, 1989.

Levine, Joseph S. *The Coral Reef at Night.* New York: Harry N. Abrams, 1993.

———. *Undersea Life.* New York: Stewart, Tabori & Chang, 1985.

Martinez, Andrew J. *Marine Life of the North Atlantic.* Camden, Maine: Down East Books, 1994.

Randall, John E. *Red Sea Reef Fishes.* London: Immel Publishing, 1983.

Rotman, Jeffrey L., and Barry W. Allen. *Beneath Cold Seas: Exploring Cold Temperate Waters of North America.* New York: Van Nostrand Reinhold, 1983.

———. *Colors of the Deep.* Charlottesville, Va.: Thomasson-Grant, 1990.

————. *Eyes into Secret Seas*. New York: Rizzoli, 2001.

————. *Undersea Journey*. Vercelli, Italy: White Star, 1995.

Vine, Peter. *Red Sea Invertebrates*. London: Immel Publishing, 1986.

Children's Books

Cerullo, Mary M. *Coral Reef: A City That Never Sleeps*. New York: Cobblehill, 1996.

————. *Dolphins: What They Can Teach Us*. New York: Dutton Children's Books, 1999.

————. *The Octopus: Phantom of the Sea*. New York: Cobblehill, 1997.

————. *Sea Turtles: Ocean Nomads*. New York: Dutton Children's Books, 2003.

————. *Sharks: Challengers of the Deep*. New York: Houghton Mifflin, 1995.

————. *The Truth about Dangerous Sea Creatures*. San Francisco: Chronicle Books, 2003.

————. *The Truth about Great White Sharks*. San Francisco: Chronicle Books, 2000.

The first eight websites were particularly useful in our research for this book.

Undersea Life

www.elasmo-research.org

www.royalbcmuseum.bc.ca

www.flmnh.ufl.edu

www.amonline.net.au

www.marinebio.org

www.mbayaq.org

www.sheddaquarium.org

www.national-aquarium.co.uk

www.npca.org

www.marinebiodiversity.ca

www.acsonline.org

www.coralreefalliance.org

www.sharkinfo.ch/index_e.html?lang=e

www.aims.gov.au

www.gma.org

www.biologicaldiversity.org/swcbd

www.aquariumofpacific.org

www.chesapeakebay.net

Conservation

www.nrdc.org

www.wcs.org

www.nature.org

www.floridaconservation.org

Aquariums

www.wetwebmedia.com

www.marinecenter.com

www.centralpets.com

www.reefkeeping.com

Diving

www.scubadiving.com

www.padi.com

www.naui.com

For Kids

www.seaworld.org

www.buschgardens.org

www.enchantedlearning.com

Acknowledgments

I would like to extend my sincerest thanks to editor Andrea Danese, whose support for my efforts and editorial acumen shaped the prose and photographic choices in this book; to designer Kayhan Tehranchi, whose design sensibility endowed it with its good looks; to writer Kathryn Williams, whose writing skills and marine-science knowledge gave voice to my text; to Isabelle Delafosse-Rotman, my wife and agent, who makes it all happen; to Yair Harel, my ghost-writer; and to Asher Gal, my assistant in the water for the past twenty years, whose friendship, advice, and common sense have made all the difference.

The photographs in this book would not have been possible without the help and support of an army of friends and colleagues who have always been there when I needed them the most: Jane and Bob Altman; Peter Arnold; Nir Avni; Ken Beck; Max Benjamin; Marcello Bertinetti; Mary Cerullo; Carlo De Fabianis; Christine Delafosse-Le Bourhis; René Delafosse; Eric and Jean-Marc Delafosse; Fred Dion of Underwater Photo-Tech; Sophie Donio; Margaret and Jim Estarbrook of United Divers; David Fridman; Helen Gilks; Amos Goren; Tanek Hood; Venita Kaleps; Avi Klapfer; Lior Kravitz; Dexter Lane; Joe Levine;

Oren Lipshitz; Valeria Manferto De Fabianis; Delicia Maynard; Ernst Meier; Sylvie Rebbot; Howard Rosenstein; Dave Ross; Thomas, Matthew, Adam, and Dana Rotman; René and Nate Rotman; Bhavesh Senedhun; Maria Steurer; Sal Tecci; Umbarak Hemid Sobih of Sinai and the Shark's Bay Diving Club; Neal Watson; Jeff Whatley and Howard Hull of the National Geographic Society Digital Imaging Division; Hadas Zion; and Maya and Roni Zilber of Dolphin Reef Eilat.

Editor: Andrea Danese
Designer: Kayhan Tehranchi
Production Manager: Alison Gervais

Library of Congress Cataloging-in-Publication Data

Rotman, Jeffrey L.
 Underwater eden : 365 days / Jeffrey L. Rotman.
 p. cm.
 ISBN 13: 978-0-8109-9311-2
 ISBN 10: 0-8109-9311-2
 1. Underwater photography. 2. Marine biology—Pictorial works. 3. Rotman, Jeffrey L. I. Title.

 TR800.R668 2007
 778.7'3—dc22

 2006100557

Printed and bound in China

10 9 8 7 6 5 4 3 2 1

HNA ■■■■■
harry n. abrams, inc.
a subsidiary of La Martinière Groupe

115 West 18th Street
New York, NY 10011
www.hnabooks.com